R.R.R. Smith

Hellenistic Sculpture

a handbook

387 illustrations

Thames & Hudson world of art

First published in the United Kingdom in 1991 by
Thames & Hudson Ltd, 181A High Holborn,
London WC1V 7QX

www.thamesandhudson.com

British Library Cataloguing-in-Publication data
A catalogue record for this book is available from
the British Library

ISBN-13: 978-0-500-20249-4
ISBN-10: 0-500-20249-4

Printed and bound in Singapore by C.S. Graphics

R.R.R. Smith
was born in 1954, and educated at
Fettes College, Edinburgh and Pembroke College,
Oxford. He spent three years as a Fellow by Examination
at Magdalen College, Oxford, and two years as a Harkness
Fellow at Princeton University. He taught Hellenistic and
Roman art for nine years at the Institute of Fine Arts, New
York University, and is currently Lincoln Professor
of Classical Archaeology and Art at the
University of Oxford.

Thames & Hudson world of art

This famous series
provides the widest available
range of illustrated books on art in all its aspects.
If you would like to receive a complete list
of titles in print please write to:
THAMES & HUDSON
181A High Holborn, London WC1V 7QX
In the United States please write to:
THAMES & HUDSON INC.
500 Fifth Avenue, New York, New York 10110

Printed in Singapore

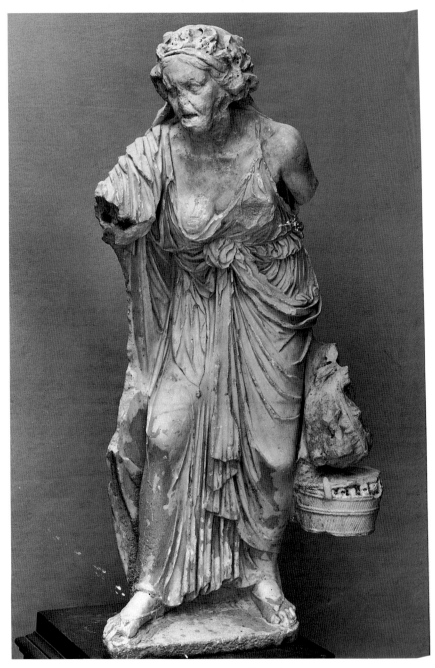

Old Market Woman. Copy of an original of late 3rd cent BC. See [175]

CONTENTS

Part II: Sculpture in the Hellenistic Kingdoms

Chapter One

INTRODUCTION

Some of the most distinctive achievements of Hellenistic sculpture, like individualized portraiture, baroque style, and genre realism, are familiar from their impact on post-Renaissance art. A great range of figure styles that have dominated much of the art language of the western tradition, from over-muscled heroes to plump putti, were first produced in the Hellenistic period. New states of body and mind were explored for the first time in major statues: the decrepit and sensuous, the miserable and ecstatic. Whereas Classical sculpture had worked within a relatively restricted range, the Hellenistic period evolved a much more extensive figure language that was designed to enable the viewer to read or distinguish at a glance the respective head and body styles of, for example, philosophers, satyrs, or Homeric heroes. Variety, subtlety and complexity are the foremost qualities of Hellenistic sculpture.

Innovation did not entail a rejection of the Classical heritage. In some contexts, sculpture continued in a late Classical manner, reflecting the unchanged needs of some sectors of Hellenistic society, notably in the old city-states. The innovations of Hellenistic sculpture consisted rather in a great expansion of the existing repertoire, in terms of both quantity and expression. There were more statues made, more subjects represented, and in a greater range of styles. Sculptors were responding to the new demands of a society whose horizons had been vastly expanded by the conquests of Alexander the Great. Alexander's conquest of the Persian empire had extended the Greek world from the Aegean basin to India. A great era of Greek and Macedonian colonization followed, and the society that emerged in the new cities of the Hellenistic East was more cosmopolitan, more culturally and socially complex – a society that wanted statues of both Athena and Hermaphrodite.

The study of Hellenistic sculpture has some problems of evidence. The Roman encyclopaedist Pliny the Elder says flatly that the art of sculpture died in 296 B C and was then reborn in 156 B C: *cessavit deinde ars ac rursus olympiade CLVI revixit* (*Natural History* 34.52). That is, no art worth the name was produced in that period, and he proceeds not to discuss it. This polemical judgement, which condemned Hellenistic sculpture from a neo-classical standpoint, was borrowed by Pliny from a Greek critic, but it represented received opinion about Hellenistic art among educated Romans. This outright rejection of the Hellenistic achievement in sculpture has far-reaching consequences, in terms

both of what survives and what we can know about it. In spite of all their faults, Pliny's chapters on the history of Greek art are invaluable because we have no other continuous ancient account of the subject. His Hellenistic 'caesura' or 'lacuna', as we will call it, has thus deprived us of much-needed literary evidence. And the widely-held prejudice against Hellenistic art of which it is merely one symptom ensured that Hellenistic statues were little copied in the Roman period. This is unfortunate because, with the great bronzes gone, we have to employ later marble copies to reach a balanced view of Greek sculpture as a whole. There are many great works of Hellenistic sculpture that survive, both originals and as copies, but they are only a small fraction of what there once was.

The purpose of this book is to fill the period left blank by Pliny and to show that it was a time of major innovation. This chapter describes the historical context and the main kinds of evidence that survive. The first part (Chapters 2–8) examines the main elements of Hellenistic statuary, that is, the major types and categories of statue that a top sculptor might regularly be commissioned to make: statues of kings, philosophers, athletes, gods, heroes. These are the categories or *genera* into which a sculptor's oeuvre would be divided (as, for example, in Pliny, *NH* 34.86–91). For us, they are often best and most fully represented by the copies. Images of goddesses and mortal women were not always fully distinguished formally, and in many cases they can be hard for us to tell apart. They are therefore discussed together (Chapter 6), which allows a synthetic treatment of the interesting changes in female representation in the Hellenistic period. The second part (Chapters 9–14) looks at the surviving sculpture found in the major centres and royal capitals of the Hellenistic world – Pergamon, Alexandria, Seleucid Syria, Macedonia and Greece. It is thus divided geographically and is concerned only with provenanced originals. While the originals overlap partly with the major works known in copies, they also provide other categories of sculpture from different social levels. Architectural sculpture, with the unique exception of the friezes of the Great Altar at Pergamon (Chapter 9), was far less important than it had been in the Classical period and is discussed in Chapter 10, together with votive and grave reliefs.

The arrangement, then, is firstly thematic, then regional. The material in the first part covers the early and middle Hellenistic period, concentrating most on the third century. The statues discussed in these chapters are what should fill Pliny's lacuna. The regional chapters cover broadly the whole period, from Alexander to Augustus. Chapter 14 looks at specific changes in the late Hellenistic period and at the arrival of the Romans. Finally, Chapter 15 summarizes what can be said about the chronology of Hellenistic sculpture as a whole and takes the story very briefly into the Roman empire.

Historical background

Alexander died in 323 BC in Babylon at the age of thirty-three, leaving no effective heir. His political legacy was Hellenistic kingship, a new political structure which was superimposed on the old world of the Greek *polis* or city-state. For a generation his leading generals, the Successors (*Diadochoi*), fought over and carved up his empire. In the early third century three main Macedonian kingdoms emerged: the Antigonids in Macedonia, the Ptolemies in Egypt, and the Seleucids based in North Syria. During the third century, several smaller kingdoms were also formed in Asia Minor, modelling themselves on the larger Macedonian ones. Most important of these for us was the Attalid dynasty at Pergamon: we know more about Attalid sculpture than that of any other kingdom. The Hellenistic kingdoms fought, competed, and coexisted with each other until conquered by the Romans, in degrees, starting in the second century BC. The last major kingdom to fall, the Ptolemaic, was extinguished in 30 BC by Augustus.

The political and cultural heyday of the Hellenistic world was the third century. In this period, the kingdoms were relatively stable; the kings ruled with undiminished military and economic power; and the élites of the new cities were unusually creative. The new kingdoms needed not only settlers and soldiers, but also cultural prestige. With the mercenaries went emigrant Greek thinkers, writers, and artists, to lucrative new employment with the kings. This was a pluralist world with a highly advanced urban culture. Literature, learning, and science, often under royal patronage, flourished as never before.

Politically, the period may be easily defined (Alexander to Augustus) and can be divided roughly into early, middle, and late. The early period comprises Alexander and the Successors (*c.* 330–270 BC). The middle period is the time of the established kingdoms (*c.* 270–150 BC). And the late Hellenistic period is first overshadowed, then dominated by Rome (*c.* 150–30 BC). Hellenistic sculpture is not so easily defined or analysed in terms of chronology – not even its beginning and end. Some important features had appeared before Alexander, and others continued long after Augustus, both at Rome and in the Greek East. We will concentrate on the statues produced for Hellenistic kings and the Greek cities before the Roman conquest, the period in which the bulk of the new repertoire was surely created.

The context and function of Hellenistic statues

As in the Classical period, Hellenistic statues were emphatically public. They were set up in public spaces, like sanctuaries or agoras, and in public buildings, like temples and theatres, and they were often public commissions, of a king or city. Statues were not made in the first instance for art's sake, but as objects with a religious, political or social function. They were of course judged aesthetically,

9

but that was not their *raison d'être*. Whatever its subsequent reception, each statue originally had a specific occasion and purpose for its dedication. A statue could have one of four main functions: cult, votive, funerary, or honorific. Of these, the last was an essentially new and important category in this period.

A cult statue (*agalma*) was the image of a god in his temple, that is, the particular local manifestation of that god worshipped in a certain place. It was the visual function of the cult statue to define that local personality. The ancients were always prone to a quasi-magical identification of statues and their subjects – ancient statues regularly moved, talked, wept, and sweated – and cult statues more than others were conceived in some important sense as *being* the god in question. They were usually large and could be bronze, marble, or acrolithic (wooden body with marble head and limbs). Gold and ivory construction, so popular for prestigious Classical cult statues, is also attested.

Votive statues were dedicated to gods in return for divine favour received or anticipated, for example, in war or personal health. Almost any subject was suitable for a votive figure, but the most common were an image of the donor or of the god in question. Votives span the widest range of scale, material, and purchaser – from state monuments to small terracottas. Major state dedications were usually set up in sanctuaries, often for victories, and were generally of bronze. Their function was ostensibly religious, but they were often highly charged politically. Funerary statues were simply memorials for the dead set up at the grave, incorporating an ideal portrait of the deceased. They were private commissions, could be made at all levels of quality, and were more often of marble than bronze. Funerary reliefs or *stelai* were much less costly and were usually preferred to full statues. Indeed, in some cities and cemeteries they may have been mandated by funerary legislation.

Honorific statues were portraits of prominent men awarded by the state in gratitude for significant benefactions. They were set up in the agora, theatre, or a sanctuary and seem nearly always to have been of bronze. Such statues had been awarded occasionally in the Classical period, but became regular only in the Hellenistic period. Their increasing numbers were a symptom of the cities' growing dependence on prominent individuals to cope with needs beyond the state's collective resources. The cycle of benefaction and honour (*euergesia* and *time*) is a familiar feature of city life recorded in thousands of inscribed decrees. In this system of 'euergetism', statues were the highest currency of 'honour'. The increasing use of this honour must have meant that such statues became the staple product of many bronze workshops. And there must be a general connection in the early Hellenistic period between the rise of honorific statues and individualized portraiture. These statues were purely political in purpose, purely secular in meaning.

Patrons and sculptors

Who commissioned what kind of statues, and who were the sculptors that made them? Kings commissioned portrait statues of associates and family members, lavish votive monuments to commemorate victories (for example, the Attalid Gallic groups), and cult statues for the new temples in their cities (for example, the Ptolemies sponsored the cult statue of Serapis at Alexandria). They might also order a variety of decorative sculpture for temples and their tombs. The traditional dedications of the Greek *polis*, on the other hand, were much reduced. There were few new cult statues because there was little temple-building. And there can have been little demand for major state votives because significant warfare and victories – the usual context for such dedications – were monopolized by the kings. There was, however, a substantial increase in statues of public benefactors. These included kings and their associates ('Friends') as well as local leaders and magnates.

Below the royal and state levels, there was a considerable 'private' market catering to various social groups, the family, and individuals. Army units or trade clubs, for example, could commission statues of deities important to them or statues of their personal benefactors. In Athens, the philosophical schools provided a steady trickle of commissions of bronze statues for their deceased leaders. Other workshops responded to the steady family demand for marble funerary statues and reliefs. Individuals would buy, according to their means, small statues and statuettes (bronze, marble, terracotta) to be offered as personal votives or deposited in the graves of loved ones.

The various levels of this market were supplied by a range of sculptors, from terracotta moulders to prestigious court artists. It is not useful, therefore, to generalize about the status of 'the Hellenistic sculptor'. However, if we take only the sculptors of quality bronzes (regular *polis* commissions), it seems they had a remarkably high social status in the Hellenistic period, compared to the Classical and especially compared to the Roman period. This can be deduced partly from literary sources and signed statue bases, but most telling are city records, not concerned with statues, but which show that successful sculptors were active in a variety of socially prestigious capacities. We hear of sculptors at Athens, for example, who were city councillors, priests, and sacred ambassadors to Delphi.

Sculptors could be men of substance. On Delos in the third century, a sculptor Telesinos made for the community a bronze Asklepios and a marble statue of Queen Stratonike free of charge. He also restored other statues in the sanctuary without payment. For this he received a public eulogy and a proclamation at the next games. In this period a bronze statue cost about 3000 drachmas, while a labourer's wage was about one drachma per day. Statues were clearly very expensive in terms of materials (copper, tin), casting facilities, labour and artistic value. Telesinos' liberality shows him to have been a wealthy

citizen. The account of his benefaction also provides two incidental points. Firstly, his workshop did both bronze and marble work. And secondly, statues were given regular maintenance. One honorary decree stipulates that a benefactor's (bronze) statue is to be kept 'shining bright' (*lampros*).

The high social position of the successful Hellenistic sculptor, among the city office-holders, was clearly very different from other periods and, indeed, from our own. A successful sculptor in London or New York may sometimes gain wealth and cultural prestige but hardly a public post. The ancient sculptor was a more central figure in society, that is, he stood very much within the community, close in attitude to his clients and concerned to express their needs and values, rather than to comment on them.

The evidence: literature and inscriptions

If we had been studying Hellenistic sculpture in 30 BC, we would have had at our disposal many thousands of bronze statues together with their inscribed bases telling us their subject, purpose, purchaser, date, and maker. We could also have drawn on a large art-historical literature that discussed the artists' lives, the history of style, and aesthetic theory. Later Roman antiquity melted down the bronzes and did not transmit the literature. The surviving sculpture and written evidence are battered remnants of great traditions. We look first at the literature.

The third century BC was the great period of Greek learning. There were books about everything, and books about books. Technical treatises by artists were already common, but the study of the work of earlier artists was something new. The earliest names in art history are two third-century writers, Xenokrates of Athens and Antigonos of Karystos (both also sculptors) whose writing on art we know from remarks in Pliny the Elder. We also hear of the first artists' biographies, by Douris of Samos, who seems to have been a kind of Hellenistic Vasari. Of surviving writers, Pliny and Pausanias are the most important. Pliny, despite his silence on the period 296–156 BC, is of great importance for his brief coverage of sculpture in the later fourth and early third century: Praxiteles, Lysippos, their pupils, and the statues made for Alexander and the Successors. He also has some valuable lines on Attalid court sculptors and on neo-classicism in the later second century. Pliny's art-historical focus is the received canon of Classical masters. He does, however, bestow contrived praise on the high-baroque Laocoön [143]. We need not censure his inconsistency too harshly: either he was simply responding to a great work, or his judgement was influenced by the fact that the Laocoön was owned by his patron the (future) emperor Titus (AD 79–81). Pliny died in AD 79, while investigating the eruption of Vesuvius. Pausanias' *Guide to Greece* (c. AD 170) stands outside the art-historical tradition preserved in Pliny and describes statues from a more antiquarian or archaeological point of view. He was, like Pliny, a man of his times and of educated prejudice and hence gives little space to

Hellenistic monuments and artists *per se*. Nevertheless, he records much of importance for us: about public portrait statues in Athens, about the Attalid Gallic monument on the Athenian acropolis, and especially about the works of the sculptor Damophon in the Peloponnese [*301, 302*].

Several writers not directly concerned with art or monuments also provide useful evidence. Herodas (third century BC), a writer of short verse sketches on genre subjects (*mimiambi*), describes a visit to a temple and the statues to be seen in it (*Mime* 4). He gives the best insight into the sanctuary context of various categories of Hellenistic statue and shows how temples functioned both as houses for the gods and as art galleries. Athenaeus (*c.* AD 200) preserves long sections of a book on Hellenistic Alexandria by one Kallixeinos of Rhodes of the second century BC. These passages give a detailed view of the glittering cultural life of the early Ptolemies and of the role of art and sculpture in court display. Finally, Diogenes Laertios' *Lives of the Ancient Philosophers* (third century AD), provides interesting details on the context of philosopher statues. Diogenes drew extensively on the works of the third-century biographer and art-historian, Antigonos of Karystos, also used by Pliny.

Inscriptions are also an important documentary source. Literary sources on art tend to be concerned with the novel, the unusual, the atypical. Inscriptions show what was routine; they are also contemporary evidence. A substantial proportion of ancient inscriptions are found on statue bases. An inscribed base can tell us about the location, context, subject, and scale of the statue it once carried – often too, from the statue's 'footprints', its material and pose. The majority of bases were for honorific statues, but we also have bases for royal victory monuments at Pergamon [*121, 122*]. Bases are sometimes signed by the sculptor(s), not routinely it seems, but much more frequently than in the Classical period. Signatures provide a variety of evidence. They can confirm the literary record (where preserved) of famous sculptors at work on top projects; for example, the famous statue of Menander by the sons of Praxiteles. They can add substance to the careers of other great names; for example, Phyromachos and Nikeratos, who worked on prestigious Attalid commissions in the third century. And signatures also allow the reconstruction of family dynasties of sculptors; for example, that of Polykles of Athens. In the cities of old Greece, sculpture was often a family business that can be traced over several generations; for example, in the family of Praxiteles at Athens or that of Athenadoros on Rhodes. We also find that many sculptors were highly mobile, moving to where the best commissions were; for example, Pergamon, Delos, and (later) Rome.

Honorific decrees provide a wealth of information on the circumstances and recipients of public statues, and on the commissioning of the statue (usually delegated to a committee of three citizen *epistatai* or overseers). They tell us about the special divine honours received by kings and the statues made for them. Perhaps the most famous of all, the decree on the Rosetta Stone, goes into

great detail about the making and treatment of the statues of Ptolemy V in the native temples of Egypt. Together, statue bases and decrees make two things clear. Firstly, major statues were usually bronze, and secondly, the steady business of many workshops must have been the production of public portrait statues.

Originals and copies

Contemporary Hellenistic sculpture survives in large quantities: marble statues, marble reliefs, statuettes in bronze and terracotta. But the major bronze commissions are gone. The contemporary marbles or 'originals' that we have, with a number of outstanding exceptions, mostly come from below the top level of artistic production. A large proportion are from the family and private levels, and employ an unchanging 'sub-classical' manner. Such sculptures form a kind of background continuum against which the innovations of the royal and state bronzes took place. They are today called 'originals' in order to distinguish them from Roman copies, but they were often no less derivative in conception. For us, the great bronze dedications of the day are preserved mainly in marble copies and versions made in the Roman period. Unlike us, the Romans had the whole range of Hellenistic statuary before them, and if we are not to distort our view of Hellenistic sculpture we must look carefully at what is preserved in these later reproductions.

The relative merits of Roman copies and Hellenistic originals are easily diagnosed. The originals are 'authentic' works of the period, and we often know their provenance and sometimes their context, but they are rarely from the top of the market. The copies, on the other hand, reproduce major lost monuments by famous artists; but they are of course reproductions, not 'authentic' works from the hand of the sculptor in question. They also have no Hellenistic context. It is obvious, then, that we must examine both originals and copies. One is not simply a pale reflection of the other – they are complementary. There is some overlap between the copies and the best surviving originals, but mostly they tell us about different levels and categories within the statue market. Such a disparity between greater and lesser commissions was not so marked in the Classical period. In the fifth century the formal language of sculpture was much simpler, more economic, and was more easily mastered at varying levels of technical ability. Both middle-grade and the very best work could be quite similar in expressive quality. To ignore the copies of fifth-century works is to miss the iconography of the major commissions, not all the major stylistic options. In the Hellenistic period the best works exhibited a complexity and refinement that was simply beyond the capacity of middle-grade carvers, or, more importantly, beyond the needs of the customers they served.

The lack of meaningful context is an insurmountable difficulty with works known only in copies: possible contexts have simply to be imagined. There are

other, less serious problems which may be outlined under four headings. Under each, a typical objection to the use of copies in the study of Hellenistic sculpture is raised and then discussed.

1. Roman selection

'What is preserved in copies may not have been representative of Hellenistic statuary in general'. The copies, of course, are no more representative of the whole of Hellenistic sculpture than are the originals. Fortunately for us, Roman preferences are obvious. For example, satyrs are more suitable for villa gardens than cult statues or victory monuments. The overall shape of Hellenistic statue production can be mentally restored with little difficulty.

2. Accuracy

'Marble copies are not exact reproductions'. It is clear that not all copies are close replicas. Some are demonstrably accurate, others less so. Each has to be judged separately by the careful comparison of all surviving copies and versions made after the same statue type. Multiple copies are important firstly because they can establish the primary intention to make a recognizable reproduction of a particular statue, and secondly because they provide control on the accuracy of design and detail. Single marbles of Roman date, with Hellenistic subject (for example, a philosopher or baroque hero), but without other surviving versions, can only be judged by their quality and internal coherence – whether, taking all we know from other works, the figure looks convincing as a copy of a lost Hellenistic original.

It is sometimes said that copies of Classical statues were copied more closely, those of Hellenistic statues more loosely. Indeed, at a given level of ability, the relative formal economy of Classical versus Hellenistic sculpture would encourage this. Hellenistic statues, generally, would be harder to copy. There were, however, fine copyists and specialists who were fully capable of reproducing the formal intricacies of the most advanced Hellenistic statues. Given the intention to replicate, the copies could be as good or bad, as accurate or approximate, as the customer could afford.

Aside from the copies, there is a large and diffuse body of marbles of the Roman period with Hellenistic subjects and style in which there was often no intention to reproduce a particular statue – typically, satyrs, nymphs, putti, and the like. They may simply borrow, adapt, or recombine familiar poses and motifs. Whereas true copies intend the viewer to recognize a particular statue (whether as art or thematic decoration or both), these pieces are merely eclectic essays in a Hellenistic manner, transformed into garden decoration. Like the quantities of 'classicizing' or neo-classical figures produced in the Roman period that have no precise connection with particular fifth-century models, these works are not copies – they are rather 'neo-Hellenistic'. The Roman copying industry produced a spectrum of Greek statues, from recognizable reproduc-

tions to diluted adaptations (especially in categories suitable for villa gardens), and we will have to deal with such phenomena as a 'decorative version' of a specific statue. However, a fairly sharp distinction between copies and decorative essays (in Roman terminology, between *nobilia opera* and *ornamenta*) is necessary to make sense of the material.

3. Aesthetic quality
'Copies are stiff, cold, lifeless, slavish, inferior'. Such judgement is fair in many cases but as an overall evaluation it is not: some copies are cold, some are sensitive. This view reflects a modern preoccupation with authenticity, originality, and truth to materials in art. There are several cases of genuine dispute over whether a piece is a copy or the original itself which themselves expose the subjectivity involved in such judgements [8, 84]. The easiest interpretation of such pieces and their modern reception is usually that they are simply fine copies which have been 'promoted' by art historians because of their unexpected quality.

There is also an external factor: restoration. The poor aesthetic showing of many copies in old collections is often due to recutting and (frequently incorrect) restoration in the taste of an earlier era (chiefly 17th and 18th centuries). The greater aesthetic appeal of copies found more recently in the Greek East is not due to any superior sensitivity of Greek copyists (virtually all sculptors in the Roman period seem to have been of Greek origin) but most probably to the fact that, in accordance with modern taste, they are unrestored. The copies in the old collections would probably have looked little different had they been left as they were found. The contemporary eye accords more importance to the 'feeling' imparted by authentic fragments than to a figure's whole iconography.

4. After-life at Rome
'How can we know a given Hellenistic-looking statue of Roman date is a copy of a lost work of the Hellenistic period rather than an example of the continuing evolution of Greek sculpture under Roman patronage?' This is a more serious and interesting question. We have already considered the neo-Hellenistic decorative corpus which is a part of this phenomenon. Such new 'Hellenistic' creations in the Roman period have been hypothesized even in major monuments like the Attalid Gauls [118, 119] or the Belvedere Torso [165]. Such hypotheses lack criteria for testing them, and further hypotheses are required to supply motives for the creation of 'new originals' when the Hellenistic repertoire was already so extensive. With single works, like the Belvedere Torso, only arguments of coherence and probability can be deployed. Historical works (like portraits or Gallic groups) would obviously be very improbable subjects for 'new creation'. The existence of multiple copies can provide, not proof, but some external indication of an earlier, Hellenistic original.

In conclusion, we may say then that while some copies may be unrepresentative, inaccurate, and lifeless, others can be shown to be precise and sensitive reproductions – for example, the best philosopher portraits or some of the baroque groups. To some modern eyes, they are all inferior because not original, inauthentic because in a different material. But some Roman copies were clearly the work of the best sculptors of the day commissioned by the richest patrons (for example, emperors). They are to be regarded less as 'slavish copies' than as brilliant marble translations.

The study of Hellenistic sculpture: schools and development

Given the lack of documentary evidence, what can we really know about Hellenistic statues? Art history normally requires names of leading artists, dates of innovating works, and the places they were made. From these a story of development, regional schools, and influences may be woven. Hellenistic sculpture has few leading names (they have simply not been transmitted) and very few that can be attached to surviving statues. Most studies have therefore concentrated on dates and places, on chronological development and local currents (Attic, Alexandrian, Pergamene). Unfortunately, neither course is a fully valid way of studying the material, partly because we lack sufficient evidence, partly because the stylistic development and regional 'schools' hypothesized are illusory.

As literature and signatures show, many of the best Hellenistic sculptors travelled to different centres, depending on where the most profitable or prestigious commissions were offered. It is therefore probably a mistake to look for clearly defined regional currents. Indeed, it is usually impossible to attribute works to a particular region without external information. The best way to study excavated originals is by city or region. They sometimes show local preferences in technique (most clearly at Alexandria), but this is something different from a major regional trend. The surviving evidence indicates a remarkable stylistic homogeneity over a huge area. Just as one could go from Athens to the Persian Gulf speaking the same Greek dialect (Attic or *koine*), so one would read a common stylistic language in the statues one would see in the Greek cities on the way.

Hellenistic sculpture, like Classical, has been most intensively studied in terms of chronological development, conceived either as a continuous linear evolution or as consecutive phases each with its own formal properties. Sculptures are assigned dates according to the point or phase of organic growth at which they are deemed to have arrived. This notional line of development is usually calibrated in decades or quarter-centuries. Classical sculpture, especially in the fifth century, has a more unified expression whose evolution can be more securely dated and tested in relation to relatively few externally documented works. Hellenistic sculpture, by contrast, has a very wide stylistic range in which

the hypothesis of linear evolution cannot be supported by dated monuments. Clearly, important and rapid changes occurred (for example, the emergence of a baroque figure style), but a consistent gradual development is historically unlikely.

We lack the evidence to understand precisely what happened, but the evolution of Hellenistic sculpture is better seen as an additive process; that is, new forms and styles were added to the sculptural repertoire without older styles being abandoned. We are dealing not with an ever-changing style of the times (*Zeitstil*) but an artistic language that expanded to meet new needs, new patrons, and new categories of subject. We must allow for concurrent styles for different subjects and contexts. Undated works may be placed only in relation to documented works of the same category. Philosopher portraits are obviously of no help in dating statues of Hermaphrodite. Dates are important, and there are dated works, but for some categories they are entirely lacking. Most Hellenistic sculpture can be situated in time and place only very broadly. This does not greatly matter. The interest of these statues lies in what they represent and what they express, not in their year of manufacture.

PART I · THE ELEMENTS OF HELLENISTIC STATUARY

Chapter Two

ALEXANDER AND THE KINGS

Hellenistic kingship was a new and distinctive form of monarchy for which Alexander provided the basic model. The rule of a Hellenistic king was based on personal, charismatic leadership, and within his own kingdom, the king was the state. The creation of a royal portrait image to express the essence and ideology of this new kind of Greek monarchy was one of the first new tasks of leading sculptors. Royal statues in bronze were commissioned in quantity for cities, sanctuaries, and royal capitals. In the third century, kings, being the greatest benefactors, probably received the lion's share of honorific statues. The bronzes are gone, and were little copied in the Roman period. Apart from the fine silver coin portraits, surviving royal portraits consist of many undistinguished 'originals' and a small group of excellent copies. Unfortunately, these are now mostly disembodied heads, whereas sculptured portraits were always full statues (portrait busts were a later, Roman phenomenon). Statuettes, however, can provide some idea of the full figures.

Statue types and attributes

The king's statue could be set off from others by obvious means, like larger scale or prominent position *[1]*, but more important were other elements in the statue and portrait head which told the viewer he was looking at a king. Elevated or special status could be expressed both by external attributes and by 'internal' elements of style. In terms of statue types, there were no royal prerogatives. Like others, a king could be shown naked, armoured, or on horseback. The armoured statue, so popular later for Roman emperors, had a purely military meaning and was the least favoured for the kings. Equestrian statues *[5]* were more common (both naked and armoured) and were perhaps more often used for kings than others, especially in the early period. Most common, however, were standing naked figures, either completely nude or with a short cloak or *chlamys* over the shoulder.

Some royal figures borrow a known heroic or divine pose *[4]*, but by far the most popular format – that is, leaning naked on a spear held with raised arm *[2, 3]* – was derived from statues of Alexander. This statue type was new and had the primary meaning of 'king'. Later it came to signify more generally 'ruler'.

The spear referred loosely to the military aspect of kingship and more specifically to the stated legal basis of the Hellenistic kingdoms as 'land won by the spear', that is, by right of conquest. Alexander had claimed the whole of Asia as 'spear-won land', and the notion remained important for the successor kingdoms. Nudity had long been customary for athletes as well as heroes and gods and had therefore no resounding significance in royal statues. However, since kings, unlike athletes, would not appear regularly in public without clothes, naked royal statues probably had an unreal, elevating air. This quality was heightened by the style of the figures. In some of the better statuettes *[2]* and our one or two major bronzes *[3]*, we see how a taut posture, tall proportions, and an exaggerated muscle style could be used to express a sense of power beyond that of a mere athlete *[48, 49]*.

The only invariable royal insignia worn by kings which appears on their portraits was the diadem: a flat band of white cloth tied around the head and knotted behind with free-hanging ends. It had not been worn by the Persian king (as sometimes supposed) and was of uncertain origin. The diadem was said by some to have been 'invented' by Dionysos and to have symbolized conquest. This was clearly a post factum explanation that combined two important aspects of Hellenistic kingship, that is, military victory and association with the god Dionysos. Dionysos was the most popular 'royal' god, a youthful charismatic figure, who, like the kings, had conquered the East. The diadem became the single insignia meaning 'king', and is always shown on royal coin portraits and usually on sculptured heads.

Royal images could also wear attributes that suggested superhuman, godlike qualities. Some of these were borrowed from the gods, others were newly adapted or invented. The thunderbolt of Zeus or club of Herakles *[230]* were sometimes held in the hand. Animal scalps could be worn on the head: a lion's scalp evoked Alexander and Herakles, and an elephant scalp referred to the eastern conquests of Alexander and Dionysos. Animal horns – ram's, goat's, or bull's – could be implanted in the portrait's brow *[10]* or worn on helmets *[266]*. Ram's horns referred to Zeus-Ammon and were confined to portraits of Alexander. Goat's horns *[4, 310]* were borrowed from Pan, a rustic deity much favoured in Macedonia. Bull's horns were more novel and the most popular *[10, 259, 261, 284]*. They were an obvious symbol of elemental power and referred usually to the god Dionysos, whose most common animal form was the bull. Bull horns were a creative innovation of the royal image, since images of Dionyos did not normally wear them. Some royal portraits also adapted the aegis of Zeus in a novel way, by wearing it as if it were a royal chlamys *[232, 246]*. The available repertoire of divinizing attributes is impressive, but it was in fact used sparingly. Less explicit statements of godlike quality, in the style and features of the portrait, were usually felt sufficient.

Alexander

Alexander's personal royal style provided the basic model for his Successors. He had conquered as a young man and died young; he was thought of as handsome, energetic, charismatic, and gave out intimations of association with various gods and heroes (Zeus-Ammon, Dionysos, Herakles). Philip II, Alexander's father, like the Greeks of his generation, had worn a full beard. Alexander chose to shave, for several possible reasons. Beardlessness maintained the youthful appearance of the time of his great victories, and it evoked the young gods and heroes, like Achilles, whom he emulated. It was also a strikingly new manner of self-presentation that contrasted both with that of his father and that of the Greeks of the city-states. That Alexander was actually young and apparently handsome was merely an historical accident, but one of great importance for the later history of royal portraits and for male self-presentation more generally. To be clean shaven quickly became the new mode among Alexander's officers and soldiers and, we will see, for some others. Portraits of Alexander and a typical Hellenistic king share some essential features: beardlessness, dynamism, thick 'royal' hair, and a variable degree of divinization drawn from the late Classical repertoire of young gods and heroes. The divine or ideal components are adjusted to avoid a simple assimilation or equation with the gods. The king was godlike but separate from the traditional Olympians.

Sculptured portraits of Alexander survive in considerable quantity, some copies, more originals, almost all entirely without external documentation. The major contemporary bronzes, by Lysippos and other famous sculptors, are lost. The surviving originals are mostly posthumous, of middle-grade quality, and often small-scale. They are parts of the extensive posthumous cult of Alexander the god. For the contemporary image of Alexander the king, our best evidence comes from copies. Roman collectors would, like us, have prized contemporary Alexander portraits by name artists and, unlike us, they were in a position to get them. That the major Alexander portraits known in copies are likely to be contemporary is confirmed broadly by their sculptural style, that is, their use of a late-Classical formal structure.

Three Alexander types are preserved in more than one copy: the Azara, the Dresden, and the Erbach. The inscribed Azara herm *[6]*, though poorly preserved, is an important and impressive image. Alexander has long hair arranged around the head in a 'wreath', brushed up from the forehead in a distinctive, off-centre parting, the *anastole* – a personal 'sign' of Alexander seen on all his portraits. The square face combines elements of the real Alexander and a strong ideal structure. He is older, more restrained, more mature than in any of his other portraits – for example, there is no upward turn of the head and neck. The Dresden type *[7]* is younger, with an *anastole* but shorter hair at the back and sides. The strong jaw gives it subtle individuality: it has much ideal form but is still clearly a 'portrait', that is, it could not be mistaken for a god or hero. The

Erbach type [8] has longer hair and is even younger. Of the three it is the most ideal, drawing on images of young Herakles for the face; but it retains sufficient Alexander traits in the jaw and the *anastole* to be recognizable. There are other major Alexander portraits known in Roman marbles, but since no two are close versions of the same type they are of less value.

After his death, the Successors put out various coin portraits of Alexander with divine attributes, as each of them laid claim to the deified king's heritage. We also have original portraits of Alexander carved posthumously from most parts of the Hellenistic world: Macedonia [288], Syria [264], and especially Egypt [9, 249], where Alexander was worshipped both as the founder of Alexandria and as the (pretended) forebear of the Ptolemies. There are clear differences in most of the posthumous portraits from the contemporary Alexanders: longer hair, more youthful, ideal features, more overt dynamism. Here we find the pronounced turn and tilt of the head with the upward gaze, noted in Alexander's appearance by the literary sources. The trend is well illustrated by the contrast between the more mature heroic king of the Azara type [6] and the young Dionysian deity seen in heads from Alexandria [9, 249]. It is this divinized Alexander image that exerted such a strong influence on the later iconography of young gods and heroes (for example, Achilles on Roman sarcophagi).

Kings after Alexander

The evidence for major sculptured royal portraits after Alexander is uneven. We have a disparate assortment of originals: a few fine and many middle-grade pieces. Few of these can be identified by coin portraits because they are mostly very generalized images, less concerned with individuality than the expression of proper royal appearance. The major heads known in copies are more particular, more detailed, more portrait-like; but there are few such copies because generally the Romans were little interested in including kings in their galleries of cultured Greeks. There is, however, one quite exceptional group of ten royal portraits that formed part of a 'specialist' Hellenistic portrait collection, in the Villa of the Papyri at Herculaneum [10–17]. This group is of the first importance. They are marble herms and bronze busts, of varied scale and style, which no doubt reproduce the heads of major royal portrait statues from the period of the Successors and the third century. Several can be precisely identified.

The first are portraits of Demetrios Poliorketes [10] and Pyrrhos [11], both of the early third century. They are youthful, idealizing, and dynamic, very much in the Alexander manner. The Demetrios is more divinizing in physiognomy and in attributes (bull's horns), while the Pyrrhos concentrates on a more heroic, martial ideal. The Demetrios has the 'royal' wreath of hair but carefully avoids the *anastole*. Its features, too, subtly circumvent an overt Alexander appearance.

Demetrios is like Alexander and like the gods but recognizably different from both. One might want to attribute the hard, sharp, sculptural treatment of these marbles to the copyist, but other royal portraits from the same collection and evidently from the same copyist's workshop are in quite different, plastic styles. This stylistic feature, then, had probably been part of the originals, and was noted at this very period among Lysippos' pupils, one of whom, Euthykrates, was said to have favoured a 'severe style' (*austerum genus*: Pliny, *NH* 34.66). Several royal heads from other contexts belong with these two, and together they establish one major strand in the early Hellenistic royal image.

In the same period and at the time of the establishment of the main kingdoms (306–270's), other options emerged. The good king was meant to look young or ageless, say twenty to thirty-five, not younger, rarely older. Some kings, however, especially in the early period, were in fact in their sixties and seventies. In their case, a typical ageless royal portrait would have created too large a gap between image and reality. A more mature image was therefore designed for them that we see best in the bust of the great Seleucid dynasty-founder, Seleukos I Nikator *[12]*. His portrait combines older, more individual features with an ideal royal format, that is, dynamic posture and a thick wreath of hair. Although Seleukos is not shown near his real age (probably 60–70), the portrait well expresses the idea of 'heroic older king'. The striking herm of Philetairos *[13]*, the first ruler of Pergamon, is an extreme instance of the use of older, real-looking features. Philetairos was not a king, merely a local dynast, and thus wears no diadem. His portrait has a dynamic posture but short lank hair and a heavily jowled, middle-aged face which deliberately exceeds the accepted norms of handsome royal appearance. It employs a different, 'lower' portrait style to express 'modestly' his less elevated status.

Through the third century the royal image operated within broad but definable limits. There was no linear evolution that we can trace. Different modes were used to answer the needs of different kings and dynasts. The powerful Louvre Antiochos III *[18]* provides one extreme: hard, tight-lipped, short-haired, expressive of the military/executive aspect of kingship. Some of the unnamed portraits from the Villa of the Papyri complete the spectrum. The 'Epiphanes' *[16]* is a pure godlike, saviour king. The 'Euergetes' *[14]* is an expressive combination of real individuality and royal-divine dynamism. The 'Philadelphos' *[15]* is a calmer, plainer image, closer to the Louvre Antiochos. Princes and undiademed dynasts *[17]* favour this harder image, emphasizing military energy over divinity.

The same spectrum is found on royal portrait coins. The coins also allow us to see some subtle preferences between kingdoms and dynasties. For example, the Ptolemies *[232]* appear quieter, plainer; the Antigonids *[284, 285]* and Seleucids *[259, 260]* are more heroic and inspired; and the Bactrians *[265, 266]* look older, more military. We will see some reflections of these preferences in surviving originals in later chapters, but, viewed more broadly, the royal image shows a

remarkable homogeneity over a huge area. There was a unified Hellenistic royal style with defining traits and limits of variation – in apparent age, hairstyle, attributes, and degree of divinization. Kings were like gods but distinct. They forged their own royal-divine ideal, constructed from a combination of Alexander, divine iconography, and reality.

In terms of chronology, there are few marked changes until the later second and first centuries BC. In this period the late Seleucids and Mithradates VI of Pontus [19, 20] evolved a more consistently idealized and dashing royal image which employs longer curling hair and has a wild, youthful, more overtly charismatic aspect. This was an upgraded, more intensified, or more 'Hellenistic' royal image. As Hellenistic monarchy lost power, royal portraits sought to emphasize more its ideal qualities. This late royal style was self-consciously the aesthetic and ideological opposite of the harsh, realistic-looking portrait style favoured by the leaders of the late Roman Republic, the chief enemy of the kings, to whom we will return later (Chapter 14).

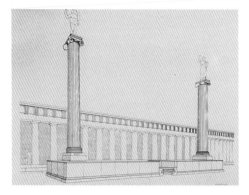

1 Statue monument of Ptolemy II and
Arsinoe II (282–246 BC) at Olympia,
dedicated by the Ptolemaic admiral
Kallikrates. Cf. [230]. (Reconstruction:
W. Hoepfner). p. 19

2 King with spear. Bronze, 3rd–2nd
cent BC. (Baltimore 54.1045. H: 24
cm). pp. 19–20

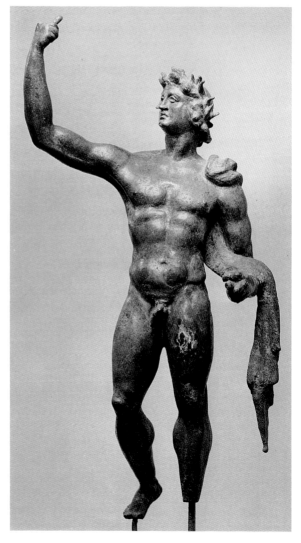

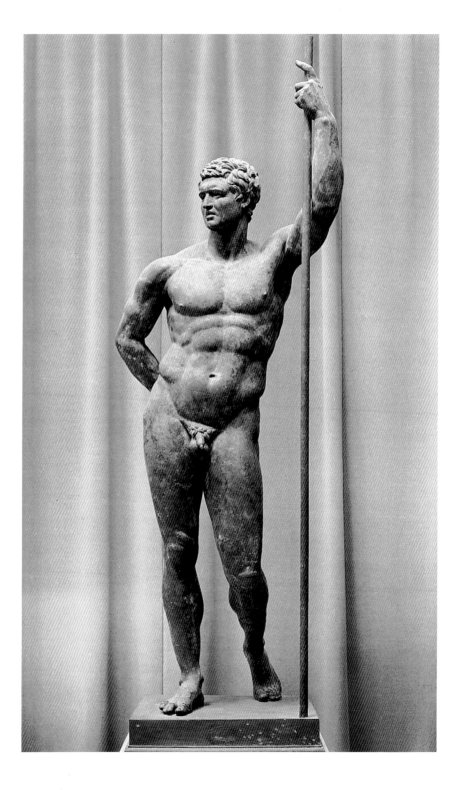

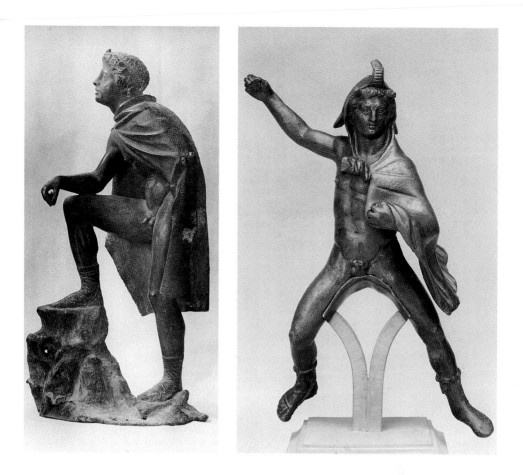

3 *(opposite)* Terme Ruler. Undiademed prince or dynast. Bronze, 3rd–2nd cent BC. (Terme 1049. H: 2.20 m). pp. 19–20

4 Macedonian king, with goat's horns. Bronze, 3rd cent BC. For pose, cf. *[70]*. (Naples 5026. H: 30 cm). p. 19

5 Equestrian king, with elephant-skin cloak. Bronze, 3rd cent BC. (New York 55.11.11. H: 25 cm). p. 19

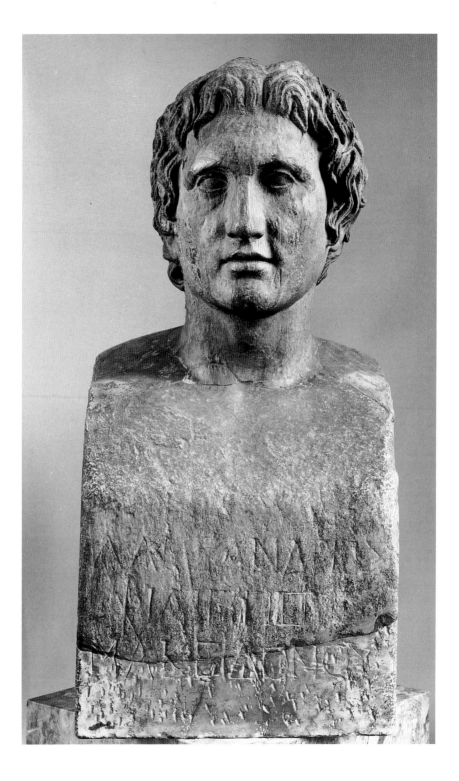

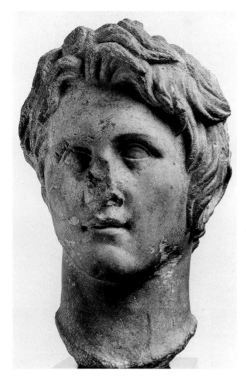

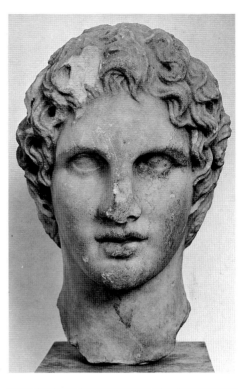

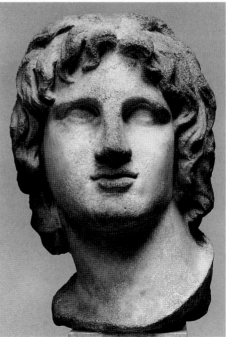

6 *(opposite)* Azara Alexander. Inscribed copy of an original of *c*.330 BC. (Louvre MA 436. H: 68 cm). p. 21

7 Dresden Alexander. Copy of an original of *c*.330 BC. (Dresden 174. H: 39 cm). p. 21

8 Erbach Alexander. Copy of an original of *c*.330 BC. (Acropolis Mus. 1331. H: 35 cm). p. 22

9 Alexander, from Egypt. 3rd cent BC. (British Museum 1857. H: 37 cm). p. 22

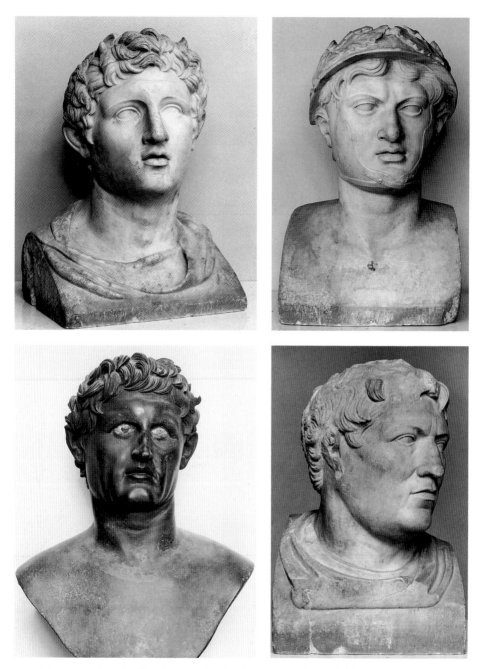

10–13 Ruler portraits from the Villa of the Papyri at Herculaneum, securely identified by coins or other means. Copies of originals of *c*.300–260 BC. 10 Demetrios Poliorketes (306–283 BC). Small bull's horns in hair. (Naples 6149. H: 42 cm). 11 Pyrrhos of Epirus (died 271 BC). Wears oak wreath of Zeus of Dodona. (Naples 6150. H: 47 cm). 12 Seleukos I Nikator (311–281 BC.). Bronze. (Naples 5590. H: 56 cm). 13 Philetairos of Pergamon (283–263 BC). Non-royal dynast. (Naples 6148. H: 43 cm). pp. 22–3

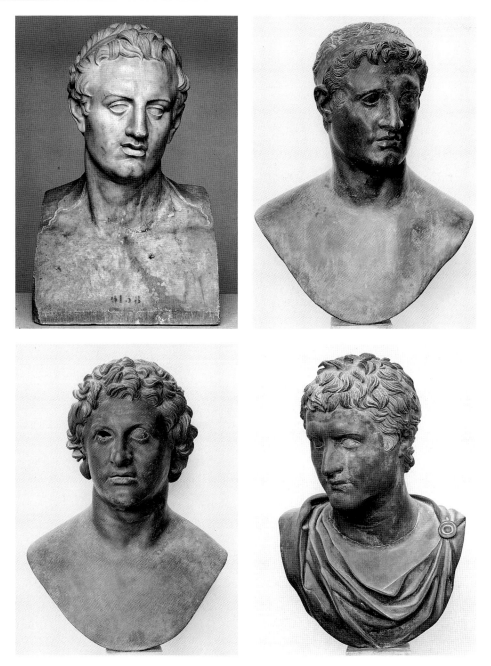

14–17 Unidentified ruler portraits from the Villa of the Papyri at Herculaneum. Copies of originals of 3rd cent BC. 14 'Euergetes'. (Naples 6158. H: 56 cm). 15 'Philadelphos'. Bronze. (Naples 5600. H: 56 cm). 16 'Epiphanes'. Bronze. (Naples 5596. H: 57 cm). 17 Young Ruler. Bronze. (Naples 5588. Bust modern. H: 56 cm). pp. 22–3

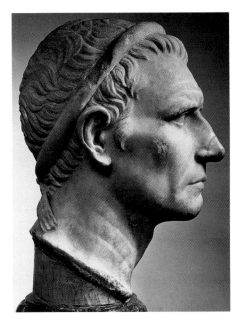

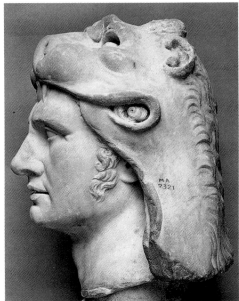

18 Antiochos III of Syria (223–187 BC).
Copy of an original of c.200 BC.
(Louvre MA 1204. H: 35 cm). p. 23

19 Mithradates VI of Pontus (120–63
BC). Wears lion scalp of Alexander and
Herakles. Copy of an original of c.100–
90 BC. (Louvre MA 2321. H: 35 cm).
p. 24

20 Unidentified king ('Ariarathes'),
late 2nd or early 1st cent BC. (Athens,
NM 3556. H: 45 cm). p. 24

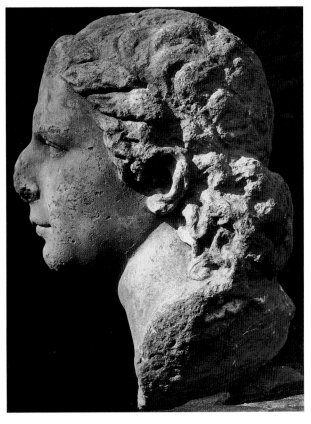

Chapter Three

PHILOSOPHERS, ORATORS, AND POETS

The statue of the Athenian orator Demosthenes [39] could never have been mistaken for an early Hellenistic ruler: royal portraits, we saw, presented the kings as different from, or 'above', the leaders of the old Greek city-states. In this chapter we look at the portraits of these polis leaders: orators, generals, philosophers, and others. (What we call 'orators' were simply city politicians.) In this area, there was strong continuity from the fourth to the third century, but the tradition of civic portraits was transformed by the new circumstances of the early Hellenistic period. The new portraits present a remarkable combination of individualizing realism (they look like real people) with a strong expression of a public role (for example, politician or thinker) which is independent of personal psychology.

Philosophers and orators employed a wide spectrum of portrait styles which together form a loosely defined collective image. This was constituted in large part from external elements of real appearance. Like their subjects in life, the portraits have beards and 'unstyled' hair, and wear the *himation*, the traditional long cloak of elder citizens. Art contributed a deceptively simple, individualizing portrait style and a conceptual elevation of age, mortality, and ethical humility. Their collective self-presentation was in clear opposition to that of the youthful godlike kings. The wearing of a beard and a himation (instead of the short chlamys) became basic signs of being a traditional polis person rather than a royal or court person. Some Greeks followed the new fashion of shaving, others, like philosophers and most city politicians, emphatically did not. Within the collective image there was a basic distinction between the man of pure intellect and the man of action. We look first at the thinkers.

Philosophers

Philosopher portraits were among the most striking and enduring creations of Hellenistic sculpture. They defined an image of the man of thought that lasted into late antiquity and beyond. Many writers and intellectuals went to work for the kings, but the most prominent philosophers tended to remain aloof from royal patronage, offering prescriptive advice from a distance in treatises 'On Kingship'. The philosophers operated from schools and academies mostly in

Athens, and if kings had ultimate political power, the philosophers liked to think they had the arbitration of moral issues. The philosophers were the intellectual spokesmen of polis values, and their portraits were designed to express the power derived from intellectual and moral superiority. The driving concern of early Hellenistic philosophy was ethics: the prescription of different ways of the virtuous and happy life. It was this concentration on theories of practical living that gave the philosophers public prominence in the third century. Their business now concerned everyone and was made more accessible. New, exciting, and convincing theories of personal well-being were offered in the different schools: Cynic, Epicurean, Stoic, and others. Their prescriptions were also often mutually exclusive: opposing ethical systems had to compete, be argued for, be chosen. The purpose of the portrait of a philosophical leader was to express or advertise his distinctive ethical power.

In comparison with kings and politicians, philosophers received very few honorific statues. It is, however, remarkable testimony to their pervasive influence in the Hellenistic world (many had kings as pupils) that they received statues at all. We hear of public statues for some of the great names of philosophy: Aristotle at Olympia, Zeno and Chrysippos at Athens, and Epikouros at Samos. Probably more common were the quasi-public statues set up for the heads of the schools in their academies, usually at their deaths. We hear of these in the wills of Aristotle and of two of his pupils, recorded in Diogenes Laertius (V. 15, 31, 64, 69). Philosopher statues are also cited in Pliny's lists as standard parts of a Hellenistic sculptor's oeuvre (NH 34.86).

Our material evidence for philosopher portraits is excellent. It covers quite evenly the great period of the major schools – the late fourth and third centuries. We have one or two major originals (unnamed) and a superb series of major works preserved in multiple copies, many identified by inscribed examples. Such philosopher portraits were essential appurtenances of the villa of a cultivated Roman. They were usually in the form of herms, that is, the head alone set on a pillar shaft. A full figure, however, was always an integral part of the original portrait: posture, gesture, drapery, and ageing limbs were all exploited to complement the effect of the portrait head. Our bodiless heads must be mentally restored from the range of full philosopher figures surviving.

Most of the major philosopher statue types we have show the master in a seated posture. He may hold a hand to his chin in a gesture of reflection [21], or stretch out his hand as though instructing [33]. Book rolls were common attributes, and various kinds of seat or chair might be used to suggest philosophical ranking (as possibly in the Epicurean school). A standing format was also used, perhaps most often for the physically ascetic and itinerant Cynics [23]. To sit instead of to stand, when combined with other signs, like age and books, became in statues a primary indication of a man of thought (philosopher) versus a man of action (politician or commander). Another invariable external attribute is the philosopher's cloak, a regular himation, but worn without the

usual tunic (*chiton*) beneath. Full citizen male dress normally comprised shoes, a chiton, and a himation draped around both shoulders [*38*]. The philosopher, however, wears a himation only, usually worn in the most 'fashionless' manner, with one shoulder bare. The lack of tunic is a sign of simplicity of lifestyle, and hunched shoulders, protruding stomachs, flabby chests, flat-footed stance are all designed to emphasize age and bodily decay [*22, 24*].

The distinction in portrait style between thinkers and men of action began in the fourth century. Both the ethical and personal style of Hellenistic philosophers owed much to the example of Sokrates. His portrait image was constructed posthumously, from inherited memory and descriptions of his resemblance to a balding Silenos [*25*]. The portrait was revised definitively in the later fourth century, probably by Lysippos. With the Sokrates belongs the posthumous Euripides portrait, of the mid-330's BC, a powerful and striking image which stands at the beginning of a great line of portraits of long-haired, unkempt intellectuals [*26*]. This style was deployed here to express Euripides' reputation as a man of wisdom, a *sophos*. The near-contemporary portrait of Plato, by contrast, was more conservative and 'civic', less overtly philosophical.

From Aristotle's school, the Peripatos, we have identifiable portraits only of Aristotle himself and his immediate successor Theophrastos. The Aristotle [*27*] has a restrained, reflective expression and a memorable individuality in his square, balding brow sparsely decorated with a few lank strands of hair. The Theophrastos [*28*], known only in poor copies, has short hair and clipped beard and seems the dullest, most 'unphilosophical' of the Hellenistic philosophers. Theophrastos' interests were more practical and scientific than metaphysical or ethical – his major works were on natural and political history. We also know that he was closely connected with kings Kassander and Ptolemy I, and his most noted pupil was the pro-Macedonian 'tyrant' of Athens, Demetrios of Phaleron. We may, then, probably interpret Theophrastos' more 'worldly' portrait image as an expression both of his more pragmatic intellectual outlook and of his conservative political stance.

The portraits of the Epicureans present the most distinctive 'school' image. The similarity of the portraits of the three leaders, the master Epikouros and his disciples Metrodoros and Hermarchos [*29–31*], surely reflects the unusually tight, cohesive organization of the school which paid devotional loyalty to the founder. The school had an unusually rigid set of dogma which allowed little room for elaboration or variation of the master's thought. The portraits seem to have been made with clear reference to each other and to express a kind of philosophical dynasty. All three leaders have very similar hair and beard styles: short hair neatly arranged, long well-combed beards, and long narrow faces. They do not have the gnarled, harassed appearance or the emphasis on age and mortality of some contemporary and later philosophers. Their well-groomed appearance was noted in antiquity and contrasted with the unkempt Cynics and Stoics (Alkiphron, *Epistles* 3.19.3). The Epikouros portrait [*29*] has a powerfully

knitted brow that marks out his superior intellectual energy compared to his two pupils [30,31]. They have a studied, ideal blandness that is both a sign of *modestia* beside the master and an exemplary expression of the tranquillity of mind achieved through his instruction. They have achieved the true impassive Epicurean state: the avoidance of pleasure and pain, of earthly commitment. It seems clear the three portraits were made to be seen together, most likely in the Epicurean school, the Garden in Athens. The image type of beatific tranquillity that we see pioneered in the portraits of Hermarchos and Metrodoros was later widely used for late antique and Byzantine saints.

For the Stoics, the other great philosophical school of the third century, nothing so coherent stands out. We have identified portraits of only Zeno and Chrysippos. Zeno, the Stoic founder, had strong roots in Cynic ethics, sharing, for example, their disregard for the material amenities of life. He disdained the secluded establishments of the other schools and taught in the Painted Stoa in the agora in Athens. He was a radical who proposed for his ideal Republic the abolition of various central elements of Greek society and culture: temples, monogamy, law courts, and money. But he was also a highly respected and influential figure in the community and was courted by the king of Macedon, Antigonos Gonatas. He received a public statue at Athens after his death in 263, and it is probably this portrait that we have reproduced in our copies [32]. The portrait has short, almost cropped hair, gaunt severe features, and a plain, square-cut beard, very unlike the flowing Epicurean beards. These features express his uncompromising aspect. It is a striking, even 'radical' image. The portrait statue of Chrysippos [33], the other great third-century Stoic, gives a typical, advanced rendering of the contrast between outer bodily decay and inner intellectual vigour. He is bald and hunched with age, and on his cheeks his beard is composed of patchy, asymmetrical tufts of hair. The faint echoes of ideal form seen in the Epicureans are avoided in the Zeno and completely dissolved in the Chrysippos.

Cynic philosophers can be hypothesized in various unnamed portraits with ostentatiously unkempt appearance [23]. But only one is certain: the Antisthenes [34]. It was made over a century after his death, in the later third century, by the Athenian sculptor Phyromachos, as we now know from a copy of his signature on a base for a portrait of Antisthenes found at Ostia in 1965: *ANTISTHENES PHILOSOPHOS | PHYROMACHOS EPOIEI*. The excellent marble replicas present a vigorous portrait of ethical philosophy, combining 'real' individuality with posthumous elevation. The long shaggy beard and hair have here an ideal appearance, for example, in the up-swept parting over the forehead, a clear allusion to, or 'philosophical' version of, the royal *anastole* of Alexander. The implication seems to be that Antisthenes is a kind of 'prince of philosophy'.

The formal dissolution and surface plasticity used to represent the decrepit bodily shell of men of wisdom is found in extreme form in two major portraits,

each known in a large number of copies: the Hellenistic Blind Homer [35] and the Pseudo-Seneca [36]. Both infuse the image of the ageing sage with levels of ideal feeling and spirit which show that both must be not merely posthumous but also purely fictional portraits of long-dead culture heroes. The Pseudo-Seneca combines exaggerated rhetorical pathos with strong iconographical references to genre works of peasant low life [179]. He is most easily taken as a Hellenistic interpretation of Hesiod, the grim poet of agricultural toil. The other is almost certainly Homer and has a more lofty, restrained pathos. One portrait was perhaps designed to refer or 'reply' to the other: the epic poet of warring heroes versus the poet of sweated labour. We do not have to suppose that the originals were necessarily close in time or place. They were, however, clearly of the same general period.

Orator-politicians

Although civic political leaders received public statues much more often than philosophers, we have few surviving portraits of them. Two great orators and one general, all early, are identified in copies: Aischines [38], Demosthenes [39], and Olympiodoros [41]. Our evidence is simply the result of Roman choice: third-century orators were not admired by the Romans. We have Aischines and Demosthenes in multiple copies because they represented for Romans the great flowering of Classical rhetoric. The portrait of Olympiodoros, an Athenian politician and general of the early third century, survives in only one copy. Other probable portraits of civic leaders of the same period are known in copies but are not identifiable [40].

Their portraits show that the city leaders favoured shorter, more well-kempt beards and hairstyles than the philosophers, as well as an often more outward, dynamic posture. They are mature but not aged, and retain capacity for action. The Olympiodoros [41], especially, combines an ideal, ruler-like energy with the balding maturity of a mortal city leader. The Aischines [38] wears a tunic and himation and stands in a complex three-quartered view, one arm on his chest, the other behind. His overall aspect of debonair, cosmopolitan authority was much imitated in later portrait statues.

The Demosthenes [39], we will see, presents in many ways a contrast. Statues of city politicians might be voted during their lifetime for signal services to the state, but they could also be posthumous monuments set up to mark significant moments of history or the ascendancy of a particular policy associated with the dead statesman. Such statues carried a high political charge. The statue of Demosthenes, one of the great works of Hellenistic portraiture, was such a monument. We know more about the Demosthenes than almost any other ancient portrait statue. It was erected over forty years after the orator's death, in 280/79, to express the apparent vindication in that year of democratic confrontation with Macedon. In 281/80 Lysimachos had been killed at

Kouroupedion, Seleukos I murdered, Ptolemy Keraunos killed, and Macedonia invaded by Gauls. Hellenistic monarchy in Greece seemed in trouble. Demosthenes had been a martyr for the radical anti-Macedonian cause, and was thus an appropriate symbol of a resurgent Athens. The holdings she was recovering in the Aegean must have looked to some like the old Empire fought for by Demosthenes. The moment, as it turned out, was shortlived, but the Demosthenes statue in the agora endured as a political and cultural landmark. It is without doubt this portrait that is preserved for us in over fifty Roman copies.

In their lifetimes, Aischines and Demosthenes had been great rivals and political opponents: Aischines had favoured some inevitable accommodation with Macedon which had been bitterly opposed by Demosthenes. The Demosthenes statue seems clearly designed to contrast with, to answer the Aischines. The Demosthenes portrait head is more fully characterized, more individual, and uses a more sophisticated surface treatment. The more advanced style could be partly due to the later date, but it is also a matter of expression and meaning. The Aischines portrait is confident and straightforward. The Demosthenes is pensive, diffident, and has a knitted brow signifying concentration. His statue wears a himation only, with one shoulder bare, like a philosopher, and stands in an 'artless' four-square pose. Its self-conscious simplicity contrasts with the 'artful' or complex three-quartered pose of Aischines. Demosthenes looks down and has his hands clasped; his appearance is one of troubled introspection. Himation, portrait style, and posture are all borrowings from philosopher iconography, and are employed here to suggest an ascetic, visionary Demosthenes, a political thinker ahead of his time.

At one level, the Demosthenes statue could be interpreted as expressing this viewpoint within the context of early third-century Athenian politics. More broadly it was to be taken as a statue that 'opposed' those of the Macedonian kings, the common enemy outside. The ageing, pensive Demosthenes is opposed sharply to the ideal muscled statues of early Hellenistic rulers [2, 3]. The borrowing of philosopher iconography heightened the contrast. In political terms the Demosthenes was a retrospective monument, embodying dreams of a bygone era. The portraits of contemporary dramatic poets show the civic image of others was moving with the times.

Menander and poets

Successful poets, like philosophers, could be influential men in the third century. Philippides, a poet of New Comedy, for example, was a friend of Lysimachos and was honoured at Athens with a statue for his negotiations with the king on behalf of the city. Epic and lyric poets required patronage and tended to work for kings, as did Kallimachos, Theokritos, and Apollonios of Rhodes. Drama, by contrast, was democratic poetry, the theatre a major polis institution. The

most popular and distinctive early Hellenistic drama was New Comedy, of which the pioneer and doyen was Menander.

Before or just after his death in *c.* 290 BC, Menander was given a public statue in the theatre in Athens made by the best known sculptors of the day in the city, Kephisodotos and Timarchos, the sons of the great Praxiteles. Its signed base was found in the theatre, where it had also been seen by Pausanias (1.21.1). The Menander portrait type *[42]* known in over sixty copies was surely this monument. The Menander stands out from all the philosophers and orators we have looked at in being beardless. He is clearly clean shaven rather than young. He has flat, naturalistic hair, casually side-parted and a handsome, square face. He is shown as aged perhaps in his thirties. Concern and thought are expressed in the turn of the head and the furrowed brow. The naturalism of the portrait is deceptively simple.

New Comedy was concerned with real themes of modern city life. There is intrigue, romance, and the clash of values between the old bourgeois and the new man made rich abroad (the mercenary). It was a drama of modern social behaviour. Menander's clean shaven appearance was surely an indication of his cosmopolitanism. Unlike the Demosthenes, he is shown as a man of his times. Alexander had set a fashion for shaving that could be followed or ignored, and we may guess that adherents of the Macedonian kings, for example their agents or Friends in the cities, might present themselves in this way, but also others for whom it was merely fashionable. There is no overlap between the respective styles of the Menander and royal portraits. He was clearly distinguished by age, hairstyle, and dress (tunic and himation).

There is one other identified portrait of a third-century poet, that of the New Comedy writer Poseidippos *[43]*. It is known in a single copy, the face of which seems to have been re-cut in later times, giving it a 'Romanized' appearance; but the portrait was clearly beardless. The copy is a full statue and shows the poet seated in a chair, wearing tunic and himation, the full civilian dress of the day. The Menander was almost certainly a seated figure of similar appearance.

One would like to know the portraits, for example, of the great court poet Kallimachos at Alexandria, or of an orator-politician in early Hellenistic Rhodes, but virtually all the statues discussed in this chapter were certainly or most likely located in Athens. This is partly a bias of the copies – Romans took Athens as the fountainhead of good and pure culture – and partly a true reflection of the fact that Athens was the major centre of philosophy and dramatic literature. The brilliant new civic portraiture discussed in this chapter was probably created there also. Other cities had statues of intellectuals and writers, but they no doubt followed the lead of portrait sculptors at Athens.

The main portraits we have examined can be arranged in a chronological line: Aischines (*c.* 314), Demosthenes (280), Epikouros (270), Zeno (*c.* 260), Antisthenes (*c.* 230), Chrysippos (*c.* 200). From this, a hypothesis of linear development can be deduced, in which increments of plasticity, realism, or

pathos are observed. There is little truth in such a scheme of development. More significant than changes in time are the differences observable between different categories of person, between poets and philosophers, and between different kinds of philosopher. Furthermore, many portraits do not fit the developmental scheme: the Euripides (330's) looks too 'advanced', others like the Zeno (*c.* 260) look too 'backward'. The Menander (*c.* 290) does not fit at all, forcing some diehard developmentalists to place it in the Augustan period.

The full range of these portrait styles was probably in use by the mid-third century. It is hard to see what formal device or stylistic 'advance' might be lacking in the Demosthenes (280) or the Epikouros (270). Portraits like the Blind Homer and Pseudo-Seneca are often dated later, in the second century, because their advanced pathos is also seen then in the Giants of the Great Altar at Pergamon. But Giants cannot date poets. At best they can provide only a 'latest possible date' or *terminus ante* for the invention of that formal possibility. The baroque intensity of the Homer and Pseudo-Seneca need not be explained by a notional phase they have both reached in a gradual development of pathos and plasticity. It can be interpreted rather as an elevated, epic portrait style designed for the greatest literary heroes of the distant past. In other words, their style was determined as much by Hellenistic conceptions of Homer and Hesiod as by the sculptural advances reached in the decade in which they happened to be commissioned. They could equally well have been made in the middle or later third century.

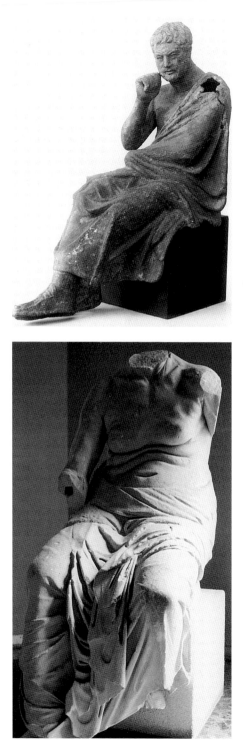

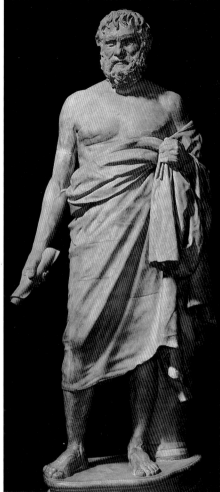

21 *(above left)* Seated philosopher. Small bronze copy of an original of 3rd cent BC. (British Museum 348. H: 57 cm). p. 34

22 *(left)* Seated philosopher, from Klaros. 3rd cent BC. (Izmir 3501). p. 35

23 *(above)* Capitoline 'Cynic'. Unidentified philosopher. Copy of an original of mid–3rd cent BC. (Capitoline 737. H: 1.71 m). pp. 34, 36

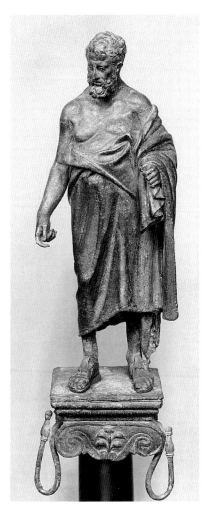

24 Philosopher on a column. Small bronze copy
of an original of 3rd cent BC. (New York
10.231.1. H: 26 cm). p. 35

25 Sokrates (d. 399 BC). Statuette based on an
original of later 4th cent BC. (British Museum
1925.11–18.1. H: 27.5 cm). p. 35

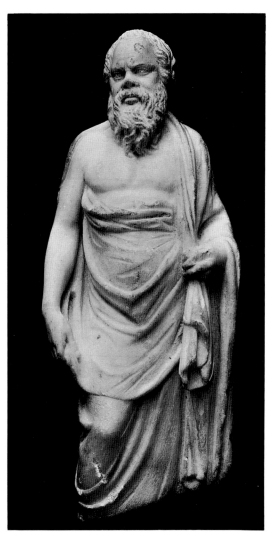

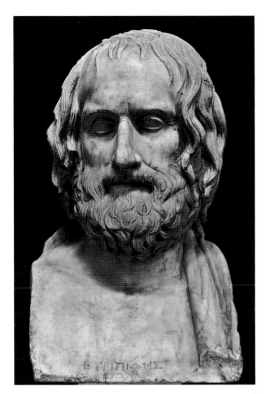

26 Euripides (d. 406 BC). Poet as long-haired sage. Inscribed copy of original of 330s BC. (Naples 6135. H: 47 cm). p. 35

27 Aristotle (d. 322 BC). Copy of an original of later 4th cent BC. (Vienna 179. H: 29 cm). p. 35

28 Theophrastos, successor of Aristotle (d. 286 BC). Inscribed copy of an original of early 3rd cent BC. (Vatican 2901. H: 49 cm). p. 35

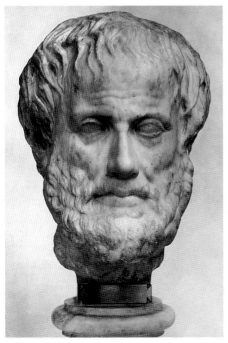

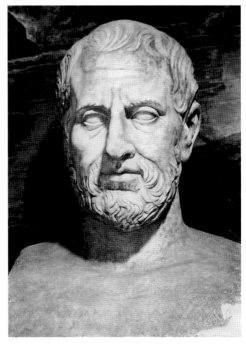

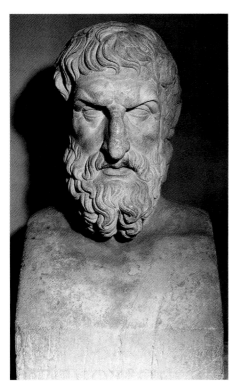

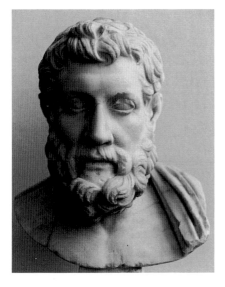

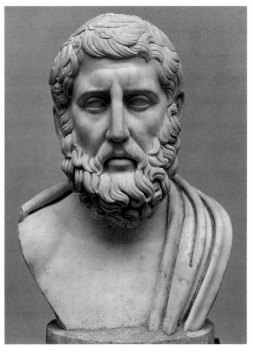

29 Epikouros (d. 270 BC). Inscribed copy of an original of early 3rd cent BC. (Capitoline 576. H: 60 cm). pp. 35–6

30 Metrodoros, disciple of Epikouros (d. 277 BC). Copy of an original of early 3rd cent BC. (E. Berlin. H: 41 cm). pp. 35–6

31 Hermarchos, disciple of Epikouros (d. after 270 BC). Copy of an original of early 3rd cent BC. (Budapest 4999. H: 52 cm). pp. 35–6

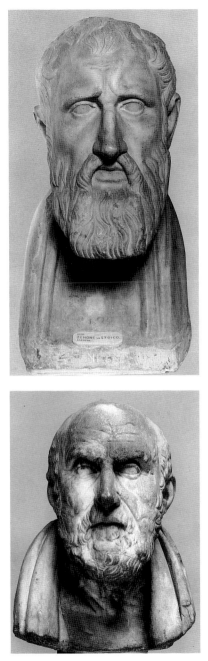

32 Zeno the Stoic (d. 263 BC). Inscribed copy of an original of mid–3rd cent BC. (Naples 6128. H: 44 cm). p. 36

33.1–2 *(below)* Chrysippos, Stoic (d. 206 BC). Copies of an original of late 3rd cent BC. 1 (British Museum 1846. H: 35 cm). 2 (Louvre MA 80. Head is a cast of 1. H: 1.20 m). pp. 34, 36

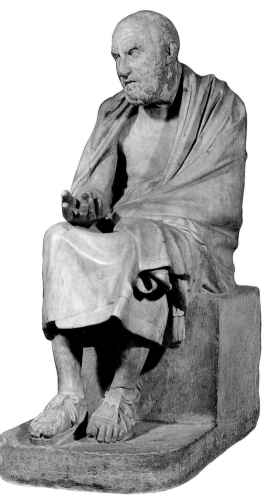

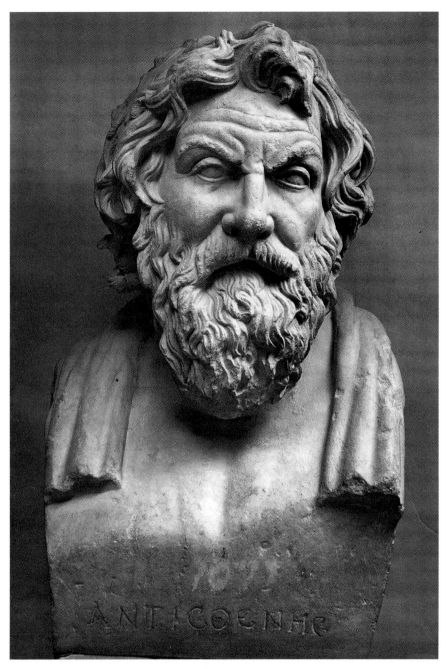

34 Antisthenes, Cynic (d. about 360 BC). Inscribed copy of an original of the later 3rd cent BC, by Phyromachos of Athens. (Vatican 288. H: 56 cm). p. 36

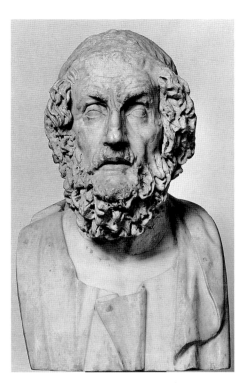

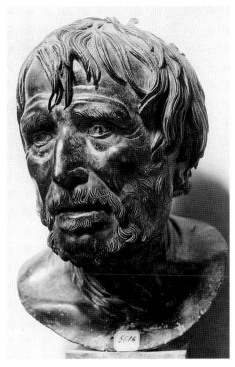

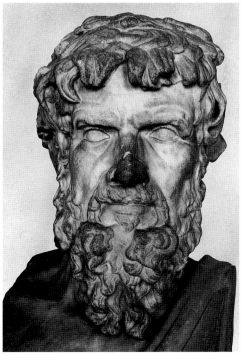

35 Homer. Fictional portrait. Copy of an original of *c*.200 BC. (Naples 6023. H: 33 cm, excluding modern bust). p. 37

36 Pseudo-Seneca. Fictional portrait of early poet, perhaps Hesiod. Bronze copy of an original of *c*.200 BC. (Naples 5616. H: 33 cm). p. 37

37 Unidentified philosopher. Copy of an original of 3rd cent BC. (Louvre MA 544. H: 36 cm, crown to beard-end)

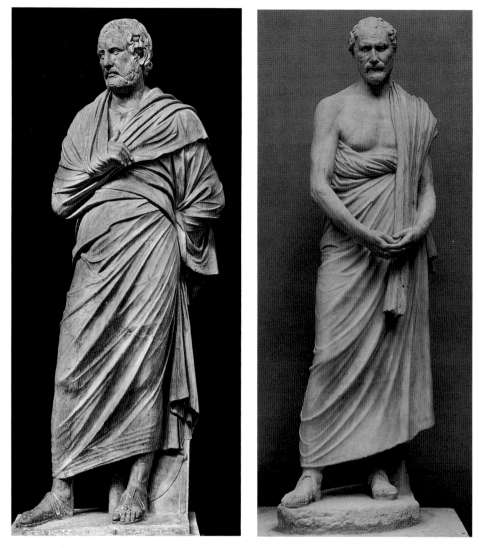

38 Aischines, orator-politician (d. 314 BC). Copy of an original of late 4th cent BC. (Naples 6018. H: 2.10 m). p. 37

39 Demosthenes, orator-politician (d. 322 BC). Copy of an original of 280 BC, by Polyeuktos. (Copenhagen 2782. H: 2.02 m). p. 37

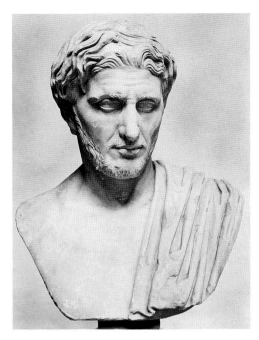

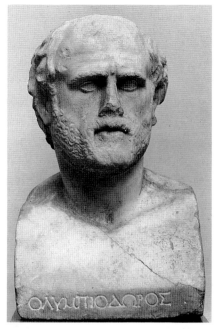

ΟΛΥΜΠΙΟΔΩΡΟΣ

40 Unidentified portrait ('Diphilos'). Copy of
an original of early 3rd cent BC. (Vienna I
1282). p. 37

41 Olympiodoros, Athenian general (active
c.300–280 BC). Inscribed copy of an original of
early 3rd cent BC. (Oslo 1292. H: 51 cm).
p. 37

42 Menander, comic poet (d. about 290 BC).
Copy of an original of early 3rd cent BC, by
Kephisodotos and Timarchos, sons of
Praxiteles. (Venice. H: 40 cm). p. 39

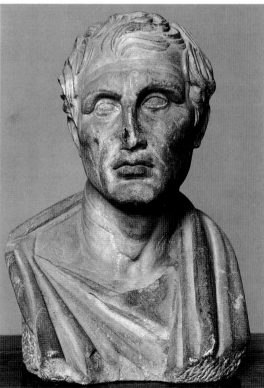

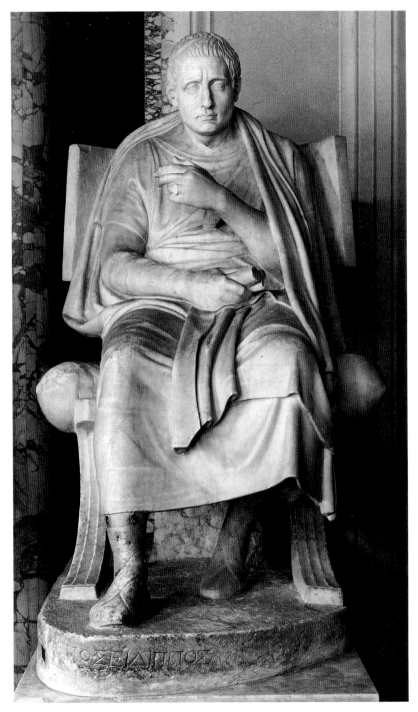

43 Poseidippos, comic poet (d. about 250 BC). Copy after an original of mid–3rd cent BC. (Vatican 735. H: 1.47 m). p. 39

Chapter Four

ATHLETES

In the Classical period, statues of naked male athletes had been a medium for great artistic innovations. Famous names like Myron and Polykleitos had forged their theories of ideal proportions in athlete statues. In the Hellenistic period, athletics remained a central institution of Greek culture, and athlete statues were part of the standard business of a sculptor. The large output of athletic figures is probably reflected in the much greater number of surviving major bronzes from this category than we have for most others. This evidence, unfortunately, does not allow us to trace Hellenistic innovations with any great precision. We have external evidence for some works from the very early Hellenistic period (both originals and copies) followed by a series of fine, but largely undocumented originals. In general, compared to the Classical period, there is a much greater variety of athletic statues, representing different kinds of athlete, from old boxers to young jockeys. This, we will see, reflects partly developments in Hellenistic athletics and partly the 'promotion' of such subjects to the realm of major statuary.

In the fifth century Polykleitos had refined a heavily muscled, sharply articulated scheme of the naked male body /328/. It was a repeatable pattern guaranteeing a desired naturalistic effect, and was imitated for all kinds of athlete statues. Fourth-century athletic statuary can be understood, broadly, as a response to Polykleitos: some continue his basic scheme, despite its increasingly evident artificiality, others adopt a softer, more naturalistic style. These were partly artistic differences, partly differences of expression. The Polykleitan 'cuirasse esthétique' signified a mature, heroic athlete, while the softer style was used for younger and boy-athletes.

In the later fourth century, we have two fixed points: Lysippos' Apoxyomenos (Scraper), known in copies; and the Daochos Monument at Delphi, an original work. The Vatican Scraper /47/ can be attributed certainly to Lysippos on the basis of two passages in Pliny (NH 34.62 and 65). The first says that Lysippos made an Apoxyomenos – which would be insufficient in itself since there is another Apoxyomenos type of this period, namely the Ephesos Scraper /48/. The second passage says that Lysippos made the heads of his figures smaller and the bodies more slender. This applies to the Vatican statue, to the Ephesos type hardly at all. The combination of the two passages makes the attribution of the Vatican figure virtually certain. In the second passage Lysippos is also said to

have created a new *symmetria* (system of proportions) to replace the four-square scheme of Polykleitos. The purpose of this new *symmetria* is explicitly stated to be greater naturalism, and this is evident in the Vatican statue not only in the treatment of the subtly varied muscle rendering, but also in the momentary pose, portrait-like head, and naturalistically tousled hair. An important aspect of the statue not mentioned in the sources is the bold three-dimensionality of the composition, in which one arm is thrust out straight in front of the figure. This deprives the statue of one obvious viewpoint: the viewer must move to the sides to understand the action fully. This is an important beginning, because in some statues of the next generation the viewer will have to move all around the figures to understand them.

Lysippos was still active after Alexander's death, in the 310's, and it is not known when in his long career he made his Scraper. The revised athletic ideal it embodies is already reflected in the row of marble statues set up by Daochos of Thessaly in 338–36 BC at Delphi, representing his victorious athletic forebears *[44]*. The sculptural style and the political meaning of this monument seem precocious. Daochos was a ruler (tetrarch) of Thessaly and a client of Philip II of Macedon. The presence of his monument at Delphi is not only a reflection of Macedonian power over the Amphictyonic Council that controlled the sanctuary, but also an interesing example of the use of Greek cultural forms – here athletic ancestors and athletic statues – by 'outsider' dynasts seeking Hellenic legitimacy. Hellenistic kings later played similar cultural politics in the Greek sanctuaries and cities, only on a grander scale. One of Daochos' fifth-century athletic ancestors included in the Delphi group was called Agias. Lysippos had made a bronze statue of the same athlete for the family's home town in Thessaly, Pharsalos, as we know from its signed base found there. However, there is nothing we know of in the normal working conditions of fourth-century sculpture to suppose there would be any direct connection between Lysippos' bronze Agias at Pharsalos and the (unsigned) marble Agias at Delphi. Indeed other statues from the Delphi group *[44]*, though less well preserved, are more 'advanced', more 'Lysippan' in their wiry proportions, than the Agias. Daochos' statues show simply how widespread the new athletic style was, already in the 330's.

Two statue bases give a vivid contemporary reflection of the new style on a small scale. One, from the Athenian acropolis *[45]*, featured a series of 'Lysippan' figures in low relief in a variety of athletic postures – rather like a condensed series of Muybridge photographs. The other, the base of Poulydamas at Olympia *[46]*, is the only work we have to come directly from Lysippos' workshop. Pausanias (6.5.1) saw a bronze statue of this great athlete at Olympia by Lysippos, and described the highly particular scenes on its base in great detail. The base was found in the excavations at Olympia, and though worn and damaged, its tall, stringy figures give a direct impression of the radical nature of Lysippos' changes in athletic *symmetria*.

The Lysippan ideal affected more than athlete statues. It was used for athletic gods like Hermes, for example, in the early Hellenistic 'Jason' type *[70]*, and no doubt for royal portrait statues. We miss what must have been the connections and subtle distinctions between rulers and athletes in the early royal statues. In comparing statues like the Getty Athlete *[49]* and the Terme Ruler *[3]*, we see mainly a sharp contrast between the soft naturalism of the athlete and the thrusting exaggerated muscles of the ruler.

The tall proportions of the Lysippan canon and a 'stripped' muscle style evolved further in the third century in both athletic figures and other heroic males. An extreme is reached in works like the Borghese Warrior *[54]*. There were no doubt other options also. Among major, copied works, the Ephesos Scraper *[48]* and two fighting athletic figures, in Dresden *[52]* and Rome *[53]* use heavier, stockier proportions. They have a similar interest in realistic musculature and portrait-like heads, but in overall effect they are different from the figures discussed above. They probably belong in the later fourth or early third century.

Wrestling figures were a major innovation we can glimpse in copies. Before he breaks off at 296, Pliny mentions two sculptors who made wrestlers (*luctatores*: NH 34. 76 and 86). Among the copies we have both single figures in action, where the opponent is supplied by the viewer, for example the youthful Subiaco Wrestler *[55]*, and groups of two figures entwined in multi-view compositions, for example the Ostia and Uffizi groups *[56–57]*. The Ostia group is simpler, uses plainer anatomy and is perhaps earlier. The Uffizi wrestlers are more 'advanced', complex, and ambitious. Neither group has other copies surviving, but both look convincingly early Hellenistic in style and composition. They can be supplemented by an extensive series of often vigorous, small bronze groups of wrestlers. The compositional innovations of wrestler groups perhaps lie behind the heroic groups like the Pasquino and Large Gauls (Chapter 7).

In the third to second centuries, we have no external sources to tell us of the major trends in athletic statues, and virtually no major works of this category were copied. We have instead some fine undated bronze originals. These give a random selection of the market, and there is no need to suppose they all reflected the major artistic concerns of their day. The preference of his client, the category of athlete portrayed, and his artistic ability would all dictate how a sculptor responded to the leading trends. The Getty bronze *[49]*, for example, is a highly competent version of the new athletic style but with a rather bland, undifferentiated muscle treatment. This statue, and others like it, are usually assigned fourth-century dates. This is merely the earliest possible period for them. Indeed, they might well be later – examples of the stylistic continuum seen in so much surviving original Hellenistic sculpture. The main concern of sculptors working in such a current was not constantly to update themselves but to make statues like those that had come before.

The softer style employed for young athletes and boys can be seen in two bronze originals of widely differing dates: the famous Marathon Boy in Athens of perhaps the later fourth century, and the Mahdia Agon or 'Contest' [50] of the second century. The Mahdia figure is a typically Hellenistic allegory: it combines the forms of a boy Eros and a young athlete to personify the guiding idea or spirit of the Greek gymnasium. The Tralles Boy [51], known in two copies, is no doubt also an athlete. He has swollen ears and was perhaps a victor at the boys' pankration. This event was introduced at the Olympics of 200 BC (Pausanias 5.8.11).

In athletic statues, as in other areas, Hellenistic sculpture greatly extended the range of subjects represented. Chariot groups and honorific equestrian portraits were known before, but the Artemision Horse and Jockey is our first statuary group of a racehorse in action [58]. The Horse is a beautiful thoroughbred at full gallop, and the Jockey is a boy of uncertain ethnicity portrayed with vivid genre realism – clearly not a portrait but a generic jockey. The contrast of noble horse and lowly rider was no doubt intentional. As in more recent racehorse art, one is left in little doubt as to the relative values of jockey and horse. Ethnic African appearance is used to similar effect in a small bronze boy in Bodrum [60], which was perhaps a rider or groom from a stationary racehorse monument, and again in an impressive monumental relief of a horse and groom in Athens [59].

Specialization in particular events was a continuing trend in Greek athletics from the fourth century. It culminated in the professional athletes of the later Hellenistic and Roman periods who toured an international circuit of games like a modern career athlete. In the Daochos Monument [44] the family's wrestlers looked very little different from the runners. The different training and physique of specialist athletes in the Hellenistic period is represented for us by two bronze statues of unequal quality: the Terme Boxer and the Kyme Runner.

The Terme Boxer [62] is a masterpiece that vividly reflects Hellenistic athletic professionalism. He has a rather top-heavy, over-muscled upper torso and arms. His head is brutally realistic, with cropped hair, low forehead, broken nose, cauliflower ears, numerous facial scars, and a mouth suggesting broken teeth. Yet it is not a true portrait. As in the Artemision Jockey, this is genre realism. Individuality is removed in favour of a concentrated generic expression, whose effect is to reduce his character to 'boxer' and nothing more. The power of the work comes from this contrast: the figure is in an heroic pose, with sharp upward turn of the head, but the identifying features are merely those of a battered old prize-fighter. Although both are heavily muscled and seated, comparison of the Boxer with the Belvedere Torso [165] shows not the essential similarity of conception between the two statues or that they are by the same artist, as has been suggested, but how wide the gap is between the different posture and muscle style of a specialist athlete on the one hand and an elevated baroque hero on the other. The Torso is grand, noble, from the realm of heroic

myth. The Boxer, despite all his training and physique, remains firmly earthbound.

Compared to the Boxer, the Kyme Runner /61/ is a routine work. Bronze statues of sprinters went back to Myron's famous Ladas, known only from literary evidence. The Kyme figure is of interest as our first preserved major example of the type. The formal composition is not well handled, and the modelling seems vapid, lacking sufficient articulation. The head has short cropped hair, cut back at the temples in the Roman manner, and a highly individual, long-nosed face. Unlike the Boxer, this is clearly intended to be a recognizable individual portrait. The rather jarring disjuncture between youthful ideal body and older portrait head is not generally found in statues of the third to second centuries: head and body were then usually intended to complement each other. This was, however, a characteristic of Roman-period statues. We may envisage the Kyme Runner as a successful professional on the athletic circuit in Asia Minor in the first century BC or AD.

Even these few remains of Hellenistic athletic statuary reveal an increased repertoire of subjects and styles: we see wrestlers, runners, boxers, and jockeys all carefully distinguished and defined visually in new statue types. In some of the figures, too, like the Artemision Jockey and the Terme Boxer, we capture some of the supple power and sharpness of detail that was normal in major Hellenistic bronzes.

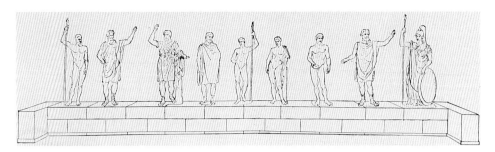

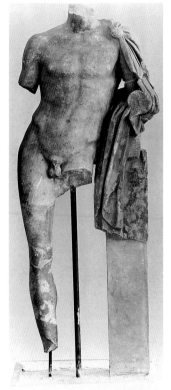

44.1 Daochos Monument at Delphi, 338–6 BC. Thessalian rulers and their athletic ancestors (Reconstruction: E. Gardner, K. Smith). p. 52

44.2 *(left)* Daochos Monument. Sisyphos II, son of Daochos. (Delphi Mus. H: 1.85 m)

45 Statue base from Athenian Acropolis. Athletes talking and scraping after exercise. Their names were inscribed below: the middle pair are 'Antigenes' and 'Idomeneus'. Late 4th or early 3rd cent BC. (Acropolis Mus. 3176 + 5460. H: 48 cm). p. 52

46 *(below)* Poulydamas' base, Olympia. From L to R: Persian king, Poulydamas defeats opponents, Persian women. Workshop of Lysippos, later 4th cent BC. (Olympia Mus. H: 38 cm). p. 52

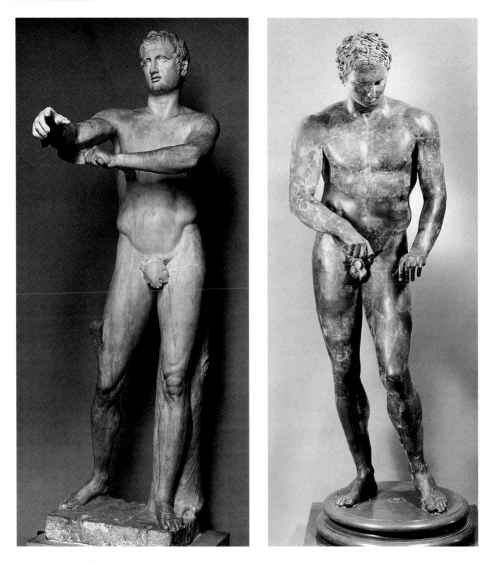

47 Apoxyomenos (Scraper). Copy of an original of later 4th cent BC, by Lysippos. (Vatican 1185. H: 2.05 m). p. 51

48 Scraper from Ephesos. Bronze copy of an original of late 4th or early 3rd cent BC. (Vienna 3168. H: 1.92 m). p. 51

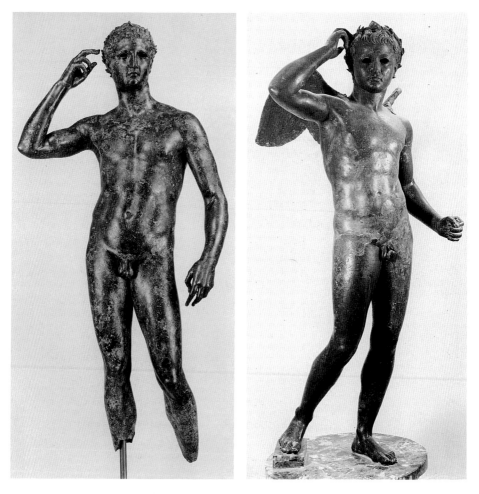

49 Getty bronze Athlete. Later 4th or 3rd cent BC. (Malibu 77.AB.30. H: 1.51 m). p. 53

50 Agon, personification of athletic 'Contest'. From the Mahdia shipwreck. Bronze, 2nd cent BC. (Tunis, Bardo F 106. H: 1.40 m). p. 54

Opposite

51 Tralles Boy. Young athlete. Probably a copy of an original of 2nd cent BC. (Istanbul M 542. H: 1.47 m). p. 54

52 Dresden Athlete. Copy after an original of later 4th or early 3rd cent BC. (Dresden 235. H: 1.98 m). p. 53

53 Conservatori Athlete. Copy after an original of later 4th or early 3rd cent BC. (Conservatori 1088. H: 1.74 m). p. 53

54 Borghese Warrior. Held shield on left arm. Copy after an original of 3rd cent BC. Copy signed on support by Agasias, son of Dositheos of Ephesos, early 1st cent BC. (Louvre 527. H: 1.55 m). p. 53

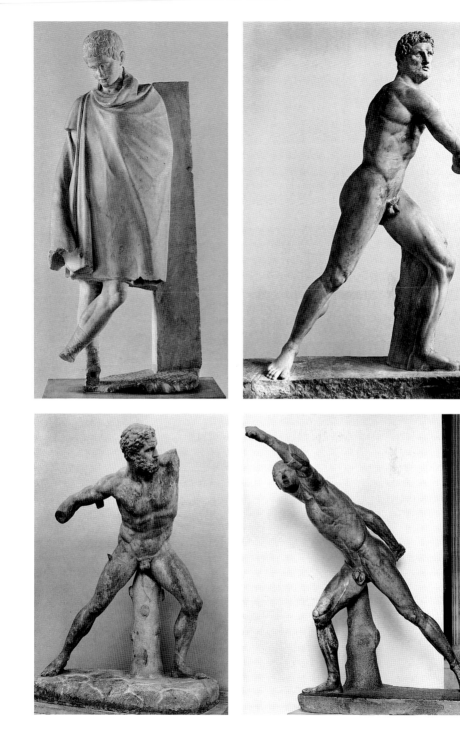

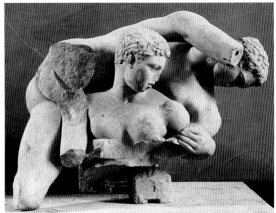

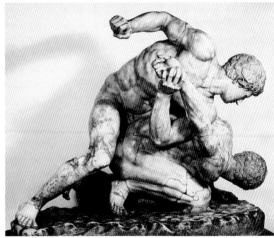

55 Subiaco Wrestler. Copy after an original of 3rd cent BC. (Terme 1075. H: 1.45 m). p. 53

56 Ostia Wrestlers. Copy after an original of 3rd cent BC. (Ostia Mus. H: 70 cm). p. 53

57 Uffizi Wrestlers. Copy after an original of 3rd cent BC. (Uffizi 216. Restorations include both heads. H: 89 cm). p. 53

58 Artemision Jockey (detail). Bronze, 3rd–2nd cent BC. (Athens, NM). p. 58

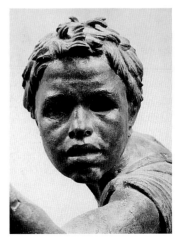

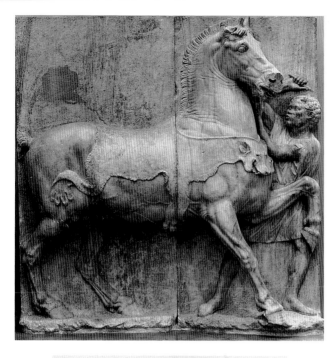

59 Horse and groom relief. 3rd–
2nd cent BC. (Athens NM 4464.
H: 2.00 m). p. 54

60 African slave-boy (a groom?).
Bronze, 3rd–2nd cent BC.
(Bodrum Mus. 756. H: 47 cm).
p. 54

61 Kyme Runner. Bronze, 1st cent
BC or AD. (Izmir 9363. H: 1.53 m).
p. 55

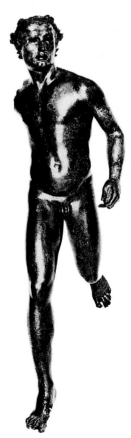

62 Terme Boxer. Cuts and wounds inlaid with copper. Bronze, 3rd–2nd cent BC. (Terme 1055. H: 1.20 m). p. 54

Chapter Five

THE GODS

The ancients worshipped a plurality of gods to which, following Homer, they attached individual personalities. For the major cult of a god, the usual permanent fixtures included an altar, a cult statue, and a temple in which the cult statue was housed. The 'operating media' of divine cult were festivals, sacrifices, and votive offerings. For the Greeks, anthropomorphic gods and the use of divine images were defining features of their culture. Non-Greeks, they liked to think, worshipped animals or mountains. Homer and statues provided the mental construction of the divine world: the poet provided the personalities, and statues provided the visual form. The role of the sculptor was to create or reproduce the recognizable image or 'portrait' of each god, adding local characteristics and attributes as required. In the Archaic period, the prevailing sculptural language had allowed only basic distinctions of sex and age to be made. The Classical period, however, had witnessed the swift creation of a repertoire of divine personalities in statues, like Zeus, Athena, and Apollo, which the Hellenistic world inherited and expanded. There was no innate religious conservatism 'holding back' the stylistic development of divine images. What we see as stylistic development was in reality simply an expression of changing ideas in Greek society about the subjects represented. It is natural, then, that new divine statues would adjust the image of a god to express any altered perceptions of that deity's character.

In the fifth century, the Classical style had been the new realism of the day and had been applied to men and gods alike. Placed beside the self-evidently superior naturalism of early Hellenistic art, Classical representation would be readily perceived as a stylized ideal that aimed to improve reality. The early Hellenistic period saw the beginning of what became the easy and familiar distinction in art between the 'ideal' and the 'real'. It was only when this distinction had been clearly made that the 'real' sphere could start to incorporate meaningful borrowings of ideal form. In the third century, Classical form was retained for male youths (ephebes) and for women as a sign of youth and beauty, and for gods as a sign of elevation. In its purest forms, Classical style became a style of the gods. Hellenistic sculpture usually distinguished carefully between gods and men, much less carefully between goddesses and women. We look here at statues of gods, and at goddesses and women in the next chapter.

For some gods, strong continuity with past conceptions was maintained, but

others (for example, Dionysos) underwent far-reaching changes of character and basic iconography. And there were of course new gods that required visual definition in statues. A significant trend seems to have been towards a more 'international' divine iconography, that is, the creation of more fixed image types for gods like Serapis and Dionysos that were worshipped throughout the Hellenistic world. The multiplicity of city gods with distinctive local characteristics continued, but now there were also international deities serving wider needs. For them a kind of standardized divine iconography was created.

The available evidence, though very disparate, can give a complete, if imprecise, view of the Hellenistic repertoire of divine statues. Proper replicas of major new cult statues are regrettably rare. More common among Roman marbles are versions and reflections of Hellenistic divine figures whose aim was to be recognizable as the particular god in question, rather than as precise reproductions of particular works. Hellenistic cult statues were often, perhaps normally, of marble, and there is quite a range of gods among our major originals, especially from Greece and Asia Minor in the second century. We have impressive single figures from Melos *[304]*, Pergamon *[63]*, and Tralles *[76]*, and remains of entire cult groups at Klaros and Lykosoura *[301]*. The Lykosoura figures give the best idea of the power and effect of a typical Hellenistic cult group and will be described more fully in Chapter 13. Statuettes and coins can also provide good reflections of major works.

The statuary appearance of Zeus had been canonized by Pheidias. To judge from later reflections, Hellenistic heads of Zeus changed both his hairstyle and expression *[64]*. The hair is given a royal *anastole* and hangs lower around the face, and the patriarchal 'portrait' takes on a more sympathetic, caring appearance. Greater naturalism is elevated by baroque touches. From the pool of originals we have a fine headless Zeus statue from Pergamon *[63]*, with massive but restrained muscle style, and a superb colossal head from Aigeira in Achaea *[299]*. The overall appearance of a complete major Zeus can be seen on royal coins in Bithynia *[65]*. Poseidon, the next senior Olympian, follows Zeus closely. He is well represented in statuettes *[66]* and a statue from Melos *[304]*. The latter is a dry, second-century original that employs a highly conservative Classical body style to signify elevation and authority. Asklepios was also patterned closely on Zeus, but Hellenistic Asklepios statues *[67, 68]* increase his beneficent qualities with large infusions of 'pathos', the visual sign for concern.

There are more marked changes among the 'younger' gods, and more marked stylistic differences between them. Hermes, a god of the gymnasium, has two major types, each recorded in several excellent copies: the Farnese-Andros Hermes *[69]*, a beautiful 'classic' contrapposto composition, and the Sandal-Binding Hermes *[70]*, a Lysippan athletic figure in a momentary, 'real' pose. The latter would be hard to distinguish from an athlete if not for its divine attributes. Both should belong in the later fourth century. The international god-hero Herakles, also a god of the gymnasium, employs a heavier, wrestler-

boxer athletic style. Two popular early Hellenistic types, the Leaning Herakles [71, 72] and the Seated Herakles [73], are each known in a wide spectrum of later versions. Neither type has precise copies which is probably to be explained by the colossal scale of the prototypes. In the seated figure Herakles is a commanding deity, while in the leaning type he is the world-weary, mortal hero, the favoured god of the Stoics.

Apollo and Dionysos were among the most popular gods of the period, and they received the most striking Hellenistic re-styling. Their images were also brought so close to each other that in some cases it can be hard to tell which god is represented. They had common cultural interests (theatre), and both had strong royal connections as patrons and ancestors of kings. Dionysos underwent a remarkable transformation, from bearded venerability to Apolline youth. His image, like his mythology, was re-worked for its new role as a model for divinized kings. Apollo had always been represented as young and beautiful, but Hellenistic Apollo often takes on a soft, languorous, effeminate style. This was a new Dionysian element. Such statues were created by the heightening, or 'upgrading' of the style of boy-athletes: a style for gods who were powerful and youthful but not boys. For Apollo, we have fine examples of this style in the Cyrene and Tralles Apollos [75, 76]. The Cyrene type was a major Hellenistic cult statue known (unusually) in several close copies of the Roman period. The Tralles figure is a high-quality 'original' based closely on the type of the Cyrene Apollo. For Hellenistic cult statues it seems to have been quite common practice to make versions of well-known earlier cult figures, without attempting a precise replication of style or detail (see also [185] and [305]). In both figures, the languid air and relaxed posture of one arm above the head are greatly heightened by the colossal scale and the richly varied, luxuriant modelling. The drapery around the thighs (preserved in the Cyrene statue) frames and draws attention to the genitals. The clear homoerotic effect may be taken as a response to the new passion for naked Aphrodite. The extreme languor need not imply a later date. Softer boy-like representations of Apollo had been available since Praxiteles' *Sauroktonos* or 'Lizard-Slayer', a precocious 'genre' Apollo of the later fourth century. We lack similar monumental evidence for Dionysos. There are however some fine Dionysos statuettes [78] and some good figures from a wide range of Roman marbles [77]. And among originals, there are two large heads, both probably of the third century, from Delphi [79] and Thasos [80]. They provide sensitive portrayals of Dionysian sexual ambivalence.

The most important new god of the period was Serapis, a Hellenized version of the combined Memphite Osiris and Apis Bull (Osor-Apis). The cult of Serapis was 'invented' and instituted by Ptolemy I at Alexandria, but his worship quickly spread through the Greek world. The model for his image was his cult statue at Alexandria made by the younger Bryaxis. Scale and materials probably ruled out precise replication, but a fair idea of the figure can be formed from innumerable later versions [81, 82]. It was a throned, draped figure with

frontal aspect and a bearded patriarchal head, close to that of Zeus, but usually with four locks lying on the forehead. This was a new senior deity represented in a conservative manner.

Good examples of new gods in 'modern' style are provided by Eros and Kairos. The statue of Kairos (Opportunity) by Lysippos, known only in reliefs *[85]*, was very much a monument of the new age – a learned, literary allegory. In Greek, abstract nouns and hence most personifications were feminine. Kairos (like Agon) was a rare male allegory. He embodied a concept close to, but much narrower, than Tyche (Luck or Fortune). Kairos never became a popular deity, perhaps because the need he answered was subsumed in the worship of Tyche. The statue was also iconographically complex and carried an unusual number of symbolic attributes, which may have hindered both its comprehension and its later transmission. Eros was a much more successful junior deity. He first appeared in his own right in major statues in the later fourth century. Both Praxiteles and Lysippos made Eros statues. Those of Praxiteles, at Thespiai and Parion, were the most discussed by ancient authors. An attractive statue of Eros as a boy stringing his bow is known in an exceptional number of replicas *[83]*. The similarity of Eros' ostensible age and of his composition to the Kairos could suggest it was a work of Lysippos (its usual attribution). The number of copies, however, would better accord with the great popularity in later sources of Praxiteles' Eros at Thespiai. In this figure, Eros is conceived as an individual deity with a distinctive personal power. In the only later major figure known in copies, the Sleeping Eros *[84]*, the god has become a harmless baby. There are many decorative versions of this composition, and it is a short step from here to the wingless putti that later multiply in the world of Dionysian art.

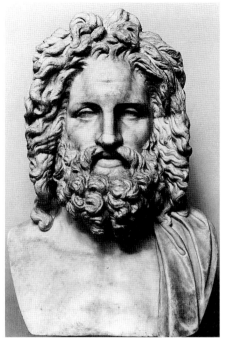

64 Zeus from Otricoli. 1st cent A D. Based on an early Hellenistic type. (Vatican 257. H: 53 cm, bust modern). p. 64

63 Zeus from Pergamon. About 200–150 B C. (Istanbul. H: 2.31 m). p. 64

65 Zeus. Silver tetradrachm of Prusias I of Bithynia (230–182 B C). p. 64

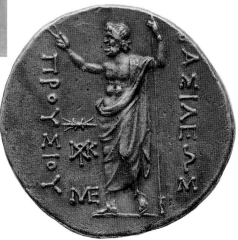

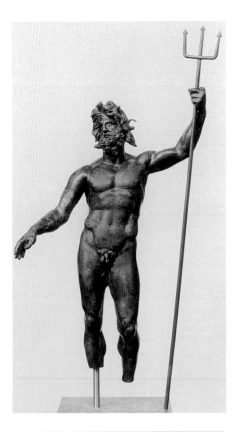

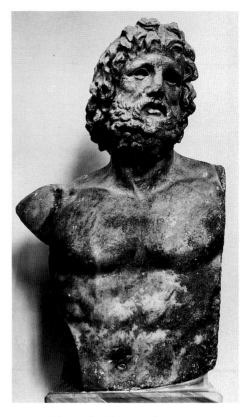

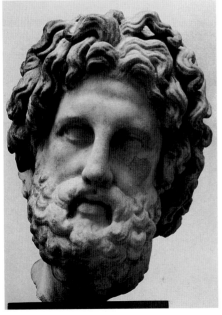

66 *(above left)* Poseidon. Bronze, 2nd–1st cent BC.
(Munich, Loeb 18. H: 29 cm, trident modern). p. 64

67 *(above)* Asklepios from Mounychia. 3rd–2nd cent BC.
(Athens NM 258. H: 1.00 m). p. 64

68 *(left)* Asklepios from Melos. 3rd–2nd cent BC.
(British Museum 550. H: 53 cm). p. 64

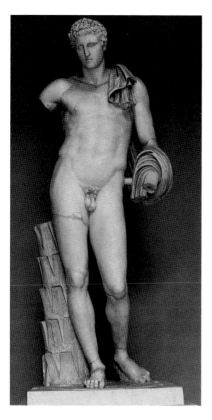

69 Farnese Hermes. Copy of an original of late 4th cent BC. (Vatican 907. H: 1.95 m). p. 64

70 Sandal-Binding Hermes. Foot on tortoise (from which Hermes created the lyre). Copy (from Perge) of an original of late 4th cent BC. (Antalya Mus. 3.25.77. H: 1.62 m). p. 64

71 Leaning Herakles, from Cypriot Salamis. Roman period. Based on an early Hellenistic type. (Nicosia. H: 72 cm). p. 64

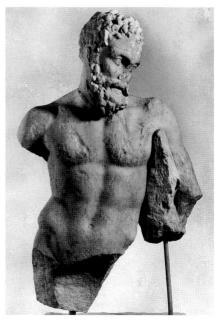

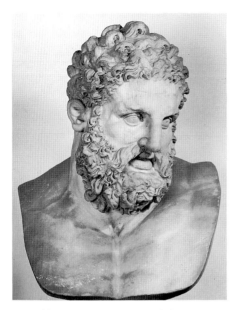

72 Herakles. Version of Roman period after same type as [71]. (British Museum 1776.11–8.2. H: 98 cm). p. 65

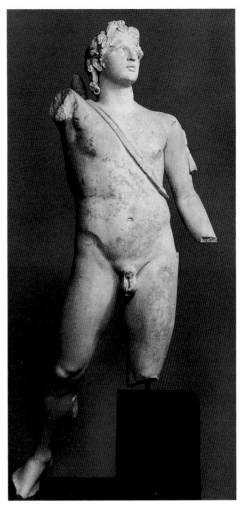

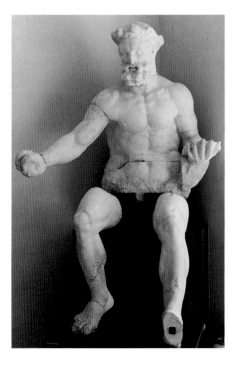

73 (left) Hercules from Alba Fucens (central Italy). Cult statue, c.100 BC. Based on an early Hellenistic type. (Chieti Mus. 4742. H: 2.70 m). p. 65

74 (above) Apollo from Civitavecchia. Copy after an original of late 4th or early 3rd cent BC. (Civitavecchia, Mus. Communale)

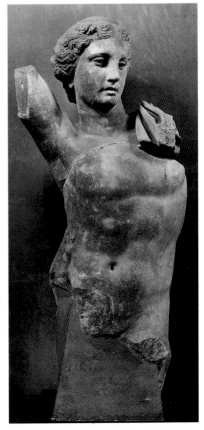

75 Cyrene Apollo. Copy of an original of 3rd–2nd cent BC.
(British Museum 1380. H: 2.90 m). p. 65

76 Tralles Apollo. Hellenistic version after same type as /75/.
(Istanbul M 548. H: 1.92 m). p. 65

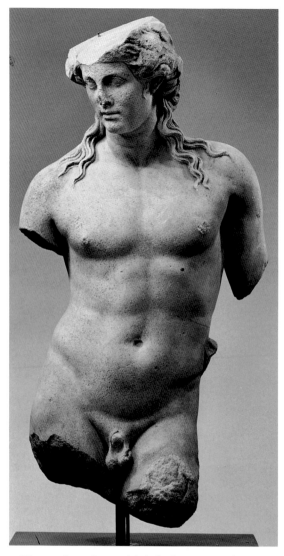

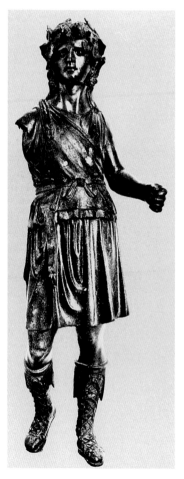

77 Dionysos. Copy after an original of 3rd cent BC. (Basel M 18.
H: 1.02 m). p. 65

78 Dionysos from Acarnania. Bronze, 3rd cent BC. (Athens
NM 15209. H: 47 cm). p. 65

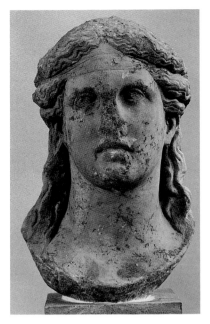

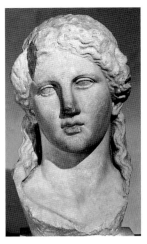

79 *(left)* Dionysos from Delphi. 3rd cent BC. (Delphi Mus. 2380. H: *c.*50 cm). p. 65

80 *(above)* Dionysos from Thasos. 3rd cent BC. (Thasos Mus. 16. H: 29 cm). p. 65

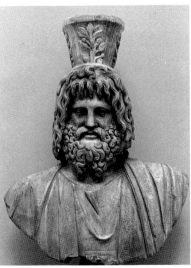

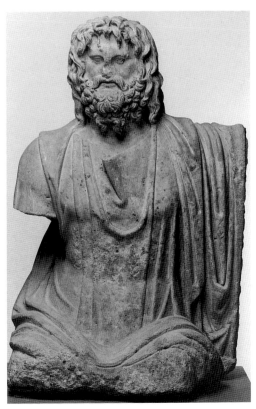

81 Serapis from Alexandria. 2nd cent AD. Based on an original of early 3rd cent BC. (Alexandria 22158. H: 84 cm). p. 65

82 Serapis. 2nd cent AD. Based on an original of early 3rd cent BC. (Cairo JE 86128. H: 95 cm). pp. 65, 206

83 *(left)* Eros with bow. Copy of an original of later 4th cent BC. (Capitoline 410. Modern: feet, right wing, arm with bow. H: 1.23 m). p. 66

84 *(above)* Sleeping Eros. Bronze copy of an original of 3rd–2nd cent BC. (New York 43.11.4. L: 78 cm). p. 66

85 Kairos ('Opportunity'). Carries scales and razor; has winged feet and head shaved behind. Opportunity is precarious and hard to catch. Relief version of a statue by Lysippos of later 4th cent BC. (Turin. H: 60 cm). p. 66

Chapter Six

GODDESSES AND WOMEN

Statues of Hellenistic goddesses, queens, and women can sometimes be difficult to tell apart without external indications. Statues of women were generally more homogeneous than male statues which, we have seen, differentiated fully and subtly between various gods and types of men. Female homogeneity in art reflects broadly the fact that Hellenistic women were indeed a relatively homogeneous group in a largely male-orientated world. Two striking trends or innovations in Hellenistic female representation stand out: firstly, statues of naked Aphrodite, and secondly, statues of élite and upper-middle-class women. The prominence of both categories is connected in some way with a partial change in the circumstances of Hellenistic women and attitudes to them. First, we will look at other, 'draped' goddesses, then at naked Aphrodites, and finally at mortal women.

Draped goddesses

Roman copies have left a vast record of draped goddesses of the fifth and fourth centuries, and very little of their Hellenistic counterparts. As with the senior male gods, the late Classical iconography of familiar goddesses like Athena and Artemis continued, with some updating of stylistic features. The Piraeus bronzes of Artemis and Athena [86] may be taken as typical of both late Classical and early Hellenistic. The Artemis of Versailles type [87], known from close copies, gives a more inspired account of the virgin huntress from the same period. The full weight of continuity and tradition can be felt in some major originals, like the superbly dull Themis of Rhamnous [296] or the Lykosoura goddesses [301]. The two finest goddess statues of the early period, the Large and Small Herculaneum Women [88, 89], known in many copies, were later extraordinarily popular as body types for Roman statues of older and younger women. Their original subjects are unknown – perhaps Demeter and Persephone, mother and daughter, whose respective ages and characters they express. Their refined drapery compositions were the new style of c. 300 BC.

New challenges were offered to sculptors by two important goddesses, Tyche and Isis. Unlike Serapis, Isis was not a deity newly unearthed, but an Egyptian goddess already familiar to Greeks. She achieved immense success as an international goddess, becoming all things to all worshippers. Serapis had

been 'created' in his first cult statue, but Isis had no single authoritative model for her Hellenized image. Her influential cult statues of early Hellenistic Alexandria are irrecoverable. There seem to be few close versions of one or more particular Isis statues, rather there is a range of figures in which sculptors translated the Egyptian goddess into Greek sculptural language, while keeping some tell-tale attributes of her Egyptian origin. These figures range widely in scale, and in date from Hellenistic to Roman *[90, 251, 312]*. The goddess generally wears a distinctive dress, with central 'knot' below the breasts, and long 'corkscrew' hair with or without further Egyptian headgear. She is young, often slender. The corkscrew curls are the indelible identifying feature of Greek representations of Isis: they were a creative adaptation from earlier Greek sculpture, a kind of neo-Archaic borrowing employed to suggest the age and 'otherness' of the Egyptian goddess.

Tyche (Fortune) is a good example of a familiar Greek concept raised by new circumstances to the rank of deity. In the new world of the Hellenistic East, where birth was no guarantee of success and virtue not always effective, personal luck achieved considerable elevation. It was, however, not this personal and fickle Tyche that was given statuary form and an 'official' divine character, but rather a state version of the goddess who looked after whole cities. City Tyches were an admirable solution to the lack of particular, locally-based city gods in the many new foundations in Asia. Old Athens had Athena, Ephesos had Artemis, but a brand new colony in faraway Bactria could claim the protection of no local Greek goddess, except that city's own Tyche. The early Seleucids were the greatest city founders, and it is appropriate that the city Tyche we know best, that of Antioch, was a Seleucid monument. It seems to have provided the basic model for many other city Tyches.

Antioch on the Orontes was founded in *c.* 300 BC by Seleukos I Nikator and became the Seleucid capital. The Tyche of Antioch, we are told, was made by Lysippos' pupil Eutychides (Paus. 6.2.6). It is known in a series of statuettes *[91]* that are firmly identified by later coins of Antioch which show the Tyche seated on her rock, palm in hand, and the youthful Orontes swimming below. The statue must have been astonishing in terms both of its artistic innovation and its daring 'casual' conception of a deity. It is also our earliest fully multi-view composition. Its intersecting triangular planes and the turning posture make a pyramidal design with many natural viewpoints. As far as one can tell from the small copies, the drapery style was also innovative in its distinction of different dress materials. The mural crown, indicating 'city', was a creative adaptation of the tall *stephane* or tiara-like head ornament worn by some goddesses. The statue, as was usual, was displayed outside, but its rock base is the first we know of to use part of the sculptural composition to adapt the monument to its setting. The figure was quite unlike any previous seated goddess. Its pose gives it an unusually 'real', accessible quality. This aspect becomes clear when the Tyche is compared to a statue of a young seated girl, like the Conservatori Girl *[92]*, a

fine copy of an early Hellenistic (grave?) monument. The mortal girl is a little coquettish and has a more dynamic, more momentary pose than the goddess, but the two have clear formal affinities.

Another early Hellenistic statue of Tyche showed the goddess standing and holding a cornucopia, symbol of the plenty that her worship will secure – it became the standard attribute of Tyche and of her Roman equivalent, Fortuna. The type is known in later versions, of which one, from Prusias-ad-Hypum [93], is a particulary vibrant and engaging re-elaboration of the figure. Beside the cornucopia, it adds further symbols of bountiful prosperity: a plump infant and a remarkable fruit-harvest construction worn on the head of the goddess.

The creation of a very different kind of goddess is illustrated by the Aphrodite of Aphrodisias. Sometime in the later Hellenistic period this Carian city made a new statue of its famed goddess which represented, not her contemporary, Aphrodite aspect, but her ancient Anatolian form. This archaicizing cult statue is known in good copies and versions, one of which was excavated at her temple [94]. The columnar figure was probably a version of an old idol, but the fact that it was a new, late Hellenistic version or re-edition is revealed by the consistent inclusion of the Three Graces (handmaids of Aphrodite) in the relief decoration of the figure's dress, in their usual Hellenistic composition.

The Muses were also new to major statuary. Six appear in relief on the extant base of a cult group by Praxiteles at Mantinea in the mid-fourth century, but from probably the early third century all nine received new and separate definition in statue cycles. At least two groups are known among the copies. One entire Muse cycle is shown on the second-century Archelaos relief [216], with which figures known in full-size copies also agree [95]. A wide range of postures and of contemporary female dress style was employed to establish individual identities for them. Variations of the best known Muse figures were later very popular on Roman sarcophagi, there expressing the cultured milieu of the deceased.

The Nike of Samothrace

Statues of the goddess Nike or Victory had a long past as war monuments. The Nike of Samothrace [97] is a traditional figure in the new style of the Hellenistic baroque. The goddess strides forward with her right foot just touching the deck of a ship. The hips turn one way, chest and shoulders the other, giving the body a violent torsion. She wears a traditional thin chiton, belted under the breasts and flattened against her torso, and a thick cloak that falls over her right leg and flies out behind. The enormous wings have a meticulously detailed feather design. The whole is an extraordinary expression of powerful forward motion.

The Nike has, for us, a rare status in being both a contemporary work and one that must have been a famous monument in its day. We also know something of its original setting and can deduce its approximate historical context. The

monument was set in a rectangular exedra built into a hill overlooking the sanctuary of the Great Gods at Samothrace. The forepart of the grey marble warship was placed as though sailing obliquely out of the exedra. The type of ship, a light war vessel (a *trihemiolia*, some experts say), is carved with full naval precision. The winged Nike (of white Parian marble) is just landing on the ship's deck: the vibrant movement of her dress stresses her 'real' epiphany. The figure is a powerful combination of bold composition and virtuoso drapery carving. It was made to be seen from its left three-quarter view, as is clear not only from the position of the ship in the exedra and the less finished carving on the right side, but also from the greatly superior aesthetic effect of this viewpoint.

A very similar Nike appears on a ship's prow on coins of Demetrios Poliorketes [96], after his great naval victory over Ptolemy's fleet at Salamis in Cyprus in 306 BC. The Samothracian figure used to be restored on the basis of this coin, holding a trumpet in her right hand. The discovery in 1950 of a right hand that must belong to the statue ruled out this reconstruction since the hand seems not to have held any attribute. How the arms of the statue should be restored remains unclear. The Nike has been dated anywhere from 306 BC to the battle of Actium in 31 BC. Current dogma makes it a Rhodian monument for a sea victory of 190 BC, won by the Rhodians with the Romans over the Seleucids. This hypothesis has been variously based on the evidence of marble type, a fragmentary inscription, pottery, and style. The argument is as follows. The ship's grey marble is supposedly Rhodian. A fragment of signature could be restored with the name of a known Rhodian sculptor. Pottery of *c.* 200 BC is said to have been associated with the exedra. Style suggests the later third or second century, but no Rhodian naval victory is known after 190. Therefore, 190 is the date. Unfortunately none of this works. Rhodian marble and sculptor, even if correctly diagnosed (both doubtful), prove nothing about the dedicator, and the fragment of inscribed signature has no recorded connection with the exedra. The pottery has proved chimerical. And the stylistic date is still an issue, since all three Hellenistic centuries have seemed possible to different eyes.

A combination of history and style favours broadly the early or middle Hellenistic period. Precise chronological assessment of the style is difficult because there are no other Victories to compare, certainly no dated Victories of comparable scale and quality. The figure does not exhibit the major formal innovations of Hellenistic drapery: the chiton blown against the body was used in many Classical figures. The rushing Iris in the Parthenon west pediment is very similar. The Nike merely writes this formula in a baroque language of more massive bodily forms and more virtuoso carving. History can help. Samothrace was a prestigious sanctuary controlled and patronized by kings, by the Ptolemies and increasingly by the Antigonids of Macedon within whose sphere it fell. When finally defeated by Rome, the last Antigonid king, Perseus, fled immediately for sanctuary on Samothrace. The Ptolemaic fleet controlled the Aegean for the first half of the third century, but without fighting any great

battle that we know of. Ptolemaic hegemony in the Aegean was broken by Antigonos Gonatas at the great sea battle of Kos in the 250's. After this victory, Gonatas made dedications at Delos, the headquarters of the Aegean island league, and a second dedication like the Nike at the 'home' sanctuary on Samothrace would have been natural too. This battle or the victory of Demetrios in 306 remain the most likely historical occasions of those we can document. The trumpet-less hand of the Nike shows only that the coins of Demetrios do not copy the statue. It cannot disprove that the statue and the similar coin design might celebrate the same victory. Style might seem to suit the 250's better, but the Demetrios coin type remains the only valid dated point of comparison.

Naked Aphrodites

Naked Aphrodites were perhaps the most striking and important addition to the regular output of divine statuary in the Hellenistic period. Aphrodite was the goddess of sex and sexual love: *ta Aphrodisia*, literally 'the things of Aphrodite', was the regular Greek expression for sex. Some statues in the later fifth century had made attempts to represent her erotic aspect through clinging drapery. This, however, was as much as the times allowed. There had been naked females in art before: courtesans and maenads on vases, Niobids and Lapith women in architectural sculpture, where disrobing is motivated by narrative context. It is clear, however, from the loud reverberations in our sources, that the Knidian Aphrodite of Praxiteles was an astonishing novelty. Pliny, for example, has a story (*NH* 36.20) that the island of Kos, which had commissioned the statue, found it unacceptable and bought a draped version instead; the rejected nude was then bought by Knidos. The novelty of the Knidia was clearly this: it was the first monumental statue of Aphrodite that was both completely naked and a cult statue.

The statue *[98]* can be recognized in a long series of marble copies and versions, thanks to Roman coins of Knidos that clearly show this figure. Without these coins we would not know the Knidia from its Hellenistic followers. The Knidia was immensely influential and created at a stroke the ideal for the sexually attractive Hellenistic woman. Its grace and beauty were renowned. The soft forms of the body have few of the points and internal lines of articulation that helped so much in the replication of male statues, and the effect of the copies is varied, often weak. Some versions of the head *[106]*, however, have considerable impact. The head has a full, oval face and centre-parted hair that defines a triangle on the forehead. It has a more sympathetic expression compared to the leaner ideal of Artemis. The statue's nudity has a residual narrative motivation: the goddess is undressing (or dressing) before (or after) a bath. She leans forward slightly, legs together, one thigh forward, making a gesture of modesty. Her nudity was clearly intended as an expression

of physical sexuality and to evoke an erotic response.

The Knidia is the only naked Aphrodite for which we have documentary evidence. There are several other important figures known in copies, but we have no evidence for when or where they were set up. The Capitoline Aphrodite /99/ was clearly a type of major importance. It accepts the basic ideal of the Knidia, but makes some changes. The hair is tied in a distinctive large knot on top of the head – a more complex, imposing arrangement. The weight-leg is changed, and the external motivation for the nudity, the bath towel, is omitted from the pose in favour of a pure modesty gesture which has the effect of drawing more attention to the figure's nakedness. The body also seems to have been more naturalistically modelled. Thus pose and style both subtly increased the goddess' sexual aspect. It is generally agreed that the statue was created after the Knidia, but it cannot be known, without further points of reference, whether in the later fourth, third, or second century. The Medici Aphrodite /100/ has a different type of head but basically the same body pose as the Capitoline, and it is unclear if it is a variant of the same statue or a copy of a different statue.

That we should not dismiss the Medici too quickly as an independent type is suggested by the interesting case of the Aphrodite of the Troad. An Aphrodite statue in the Terme Museum /101/ would be considered a Capitoline-Medici variant were it not for an inscription carved on the side of its base: 'From the Aphrodite in the Troad – Menophantos made it'. Menophantos is clearly the copyist, not the original sculptor, and among Roman copies this is a rare and precious record of the origin of the statue being reproduced. It provides our only quasi-documented Aphrodite after the Knidia. That Menophantos was indeed reproducing a particular statue (which one might have doubted from the quality) is confirmed by another replica of the same figure, in the Louvre. Menophantos perhaps specified the original from which his copy was drawn because the figure was not in the usual Knidia-Capitoline repertoire and might easily be taken for a generic variant. The Aphrodite in the Troad was no doubt a major cult statue, perhaps early Hellenistic.

The most striking Hellenistic nude Aphrodite is probably the Crouching Aphrodite /102/, known in a core of a few but precise copies. There is also a range of decorative variants of the type. The body has a voluptuous sexuality, the head a dynamic turn and unusual strength of expression. The pose restores the Knidia's bathing motif, and its 'narrative' crouching posture avoids the direct sexual confrontation posed by the standing Capitoline-Medici figures. The posture and almost genre motif are unlikely for a cult statue. It was no doubt a major votive. A passage of Pliny mentions among various Hellenistic statues in the Porticus Octaviae at Rome a 'Venus washing herself' (*NH* 36.35: 'Venerem lavantem se *sededalsa*, stantem Polycharmos'). The manuscripts of the text, however, are not clear to whom the statue is attributed: either a sculptor whose name is garbled among the letters *sededalsa* or to one Polycharmos. The

statue could be the Crouching Aphrodite since Pliny seems to contrast it with an Aphrodite standing ('stantem').

There are two other Hellenistic Aphrodite types prominent in the archaeological record: the Anadyomene (hair-binding) and Sandal-Binding Aphrodites. The various reproductions of each type share only a familiar pose or motif. The Anadyomene motif is employed for a highly variable range of figures both full-scale and small [103]. It may have been inspired by Apelles' famous painting of Aphrodite Anadyomene which had a canonical status equivalent to the Knidia. The Sandal-Binding Aphrodite appears almost exclusively in small figures but with a little more consistency of pose and proportions. Both types probably evolved as favoured votive figures, without the impetus given by a famous statue.

There was also a half-naked (or half-draped) option. Among the copies there are replicas and versions of two major types known after copies from Arles [104] and Capua [105]. The copies give a more coherent picture of the Arles type. There is external evidence for neither. Some have considered one or both earlier than the Knidia – a stage on the road to total nudity. More likely both are examples of revisionist 'modesty': they maintain enough nudity to signify the sexuality of the goddess, but escape the potential social problems raised by full exposure. The half-draped Capua type was echoed in small-scale, popular versions and provided the basic model for the famous Aphrodite of Melos or Venus di Milo [305]. This latter statue seeks to give the goddess a more 'classic' dignity: she has a matronly body and heavy, fifth-century features with a blank, solemn expression. The figure remains impressive, but, placed beside the original of the Crouching Aphrodite, it would probably have seemed rather dull. The Melian Aphrodite is an original of the second century, but its clear relation to the Capua type reveals the misleading nature, in this context, of the term 'original'. It is the same relationship that we saw between the Tralles and Cyrene Apollos [75, 76].

Interpretation of naked Aphrodites

With the Knidia and Hellenistic Aphrodites, the female nude entered its dual role in the history of art as the object of both ideal composition and male voyeurism. Its historical origins are of some interest. The emergence and popularity of the naked Aphrodite in art no doubt reflects a change in male attitudes towards women – itself probably a direct result of a change in the social standing of women. We should be clear at the outset that we are dealing with a society in which men controlled almost all aspects of art production and in which statues were oriented primarily to male viewers. Hellenistic women of course looked at art works, but what they might want to see expressed in male and female statues, in as far as that might be different from a man's viewpoint, was not a consideration in their creation.

In the Classical period, when Aphrodite was normally a draped matron, the wives and daughters of upper-class men – the men who set moral norms – generally remained in the home. For these men, private social intercourse with non-family women of equal standing was effectively impossible. The result was the aristocratic romantic ideal of paedophilia. The gymnasium was its context, and naked athletic statues were, partly, its visual expression. The homosexual ideal and its social base continued to flourish in some sectors of Hellenistic society, but beside it an ideal of heterosexual romance was also socially promoted. There were two factors which probably account for this phenomenon. Firstly, in the new cities of the East, women achieved more public freedom, and a measure of personal access between men and women of equal status became possible. Changed male attitudes and a degree of female autonomy, at least in practical terms, are well reflected in literature. Much New Comedy centres round middle-class heterosexual romance, and in Theokritos we meet free women walking in the streets of Alexandria on their own (*Idyll* 15). Medea, a daunting 'outsider' in Euripides, becomes a sympathetic, 'feminine' figure in Apollonios. The second factor was the Macedonian kings. At a general level, monarchy reduced the sharp supremacy of the male citizenry which reigned in a democratic polis. Many kings also engaged publicly and aggressively in heterosexual activity, as witnessed by innumerable royal mistress anecdotes. But most important was the high public prominence given to Hellenistic queens in whom resided the assurance of dynastic continuity. The queens in turn provided strong role models for other Hellenistic women.

The changed circumstances of Hellenistic women and attitudes towards them are expressed in statues in two very different ways: on the one hand, by the naked Aphrodites, and on the other by the draped women. The Aphrodites express a new male erotic ideal, while the upsurge in female portrait statues reflects the increased social prominence of women, especially in the middle and late Hellenistic periods. The two kinds of statue are different expressions of related social phenomena.

It has recently been argued that Hellenistic Aphrodites express some negative male attitudes to women. For example, their fleshiness or leaning postures have been interpreted in the light of ancient physiognomical writers as indicating female cowardice, shamelessness, and guile. Generally, however, statues were not made to make pejorative statements. The Aphrodites were designed rather to express a wholly positive (male) view of female sexuality. They should be read not in the light of physiognomical writers (who were concerned with diagnosing the moral defects in the personal appearance of men), but of the vigorous male debate about the relative merits of a male or female erotic ideal. This debate continued in the Greek East well into the imperial period, from Plato to Plutarch and beyond. Its fullest literary remains are Plato's *Symposium*, a dialogue by Plutarch, and a later dialogue preserved among Lucian's works. The Lucianic dialogue is the most explicit, and it is appropriate that it was

prompted by and set during a visit to the temple of Aphrodite at Knidos. The issue, discussed frankly by the two protagonists, is simply which is better for men: sex with boys or sex with women. The language of their debate, spoken as they enthusiastically examine both the front and back of the Aphrodite, makes quite clear the strong positive evaluation of the sexual feelings aroused by the statue. In the dialogue, the debate was triggered by the story of the sexual assault on the Knidia by a man who had been accidentally locked in the temple one night. This story, very widely reported in other sources, illustrates the strongly erotic reception of the statue. There was also a parallel story in which a man sexually assaulted Praxiteles' statue of Eros at Parion. Independently the two stories were intended as simple homages to the astonishing naturalism of Praxiteles' carving. Together, they vividly illustrate for us both the ancient debate on sex and a response to statues with which we are quite unfamiliar.

An erotic response to naked Aphrodites, then, was appropriate. The goddess, however, is always shown as 'modest', despite her nudity, and as essentially passive. The statues are also blithely non-explicit in genital detail. It was a basic principle of Greek art that it record all the visible essentials of the human body. The smooth, unparted genital surface of the Aphrodites is a rare and presumably highly significant departure from this principle. One may contrast the very detailed treatment of genitals on male statues. Indian sculpture, for example, has goddesses with finely carved sex-parts which rule out any bogus aesthetic arguments for the Aphrodites. Accurate female genitals on statues, we can only surmise, might have been deemed too immodest, or have been felt unconsciously to be sexually too aggressive. It is possible that on marble statues Aphrodite had painted pubic hair, but it is strange then that it has no three-dimensional value. Male pubic hair on statues was no doubt painted but is always carved in its full natural volume. Although female genital depilation seems to have been a common practice in ancient Greece, it is not clear *a priori* what practice would be appropriate for Aphrodite. The Knidia and Hellenistic Aphrodites represented the goddess of sexual love as such, but for whatever psychological reasons, she was at the same time, in this crucial detail, 'under-represented' by art.

Draped women

Portrait statues of Hellenistic women were always clothed. Naked female portrait statues, women in the guise of Venus, were later an extraordinary phenomenon only among the Roman bourgeoisie of the imperial period. The heads of Hellenistic female statues were not regularly portrait-like. Instead, context and statue type would indicate 'mortal' woman, while precise identity would be left to the inscribed base. Detached heads can thus be hard to tell apart from those of goddesses [108, 109]. Generally they are strongly ideal constructions, based closely on the fuller-faced Aphrodite ideal or (less

commonly) the leaner Artemis ideal. Often there is a slight modulation in the hair or face indicating 'portrait' but any appearance of physiognomical individuality is rare. It is even more difficult to tell queens from other women, unless they have unequivocal insignia or are certainly identified – both rare outside Ptolemaic Egypt (Chapter 11). A few queens adopted a stronger portrait image, but for the most part women were confined within the narrow range of an ageless, non-specific ideal whose only signification was 'beauty'.

Greater 'individuality' and expressive power were invested in the many imaginative variations on the draped standing figure [110–117]. Many are headless but still eloquent. Undocumented statues might sometimes be goddesses, but most seem recognizable as contemporary women by dress and posture. The common 'pudicitia' pose, for example, in which the arms are folded under the breast and one hand held to the face, was a gesture of restrained modesty, of self-containment or female *sophrosyne*, and was used only for mortal women, indeed was most appropriate for them. In general, the complex elaboration of drapery schemes was employed to indicate the real contemporary 'modern' dress of mortal women, in contrast to the simpler Classical dress still often used for Olympian goddesses. 'New' goddesses, like the Muses, Tyche, and other allegories, might be given contemporary dress indicating their youthful 'modernity', but their identity would also be shown by context or attributes. Such dress, anyway, was clearly evolved in the mortal sphere – just as the dress of the 'old' goddesses had been in the Classical period.

Draped women in marble survive in large quantities. Some were no doubt grave statues, but increasingly they were honorific or commemorative statues. The consistent use of marble for major figures may partly be specific to women and partly due to the increasing use of marble in general in the later Hellenistic period. The quantity of draped statues reflects the greatly increased social prominence of women in the propertied urban classes. This trend begins in the middle Hellenistic period and continues in the late Hellenistic and into the Roman period. Mostly the statues are massively constructed, matronly figures, that express the temperate values of the married bourgeois woman. Some wear dresses and cloaks of thick material like Classical figures, that wholly conceal the body. These probably indicate 'older' women, in terms of age or more conservative outlook. Much more popular, however, is an inversion of Classical drapery style: a very thin mantle or shawl worn over a thicker dress, instead of a heavier cloak over a thinner dress. The fine mantle is usually pulled or wrapped tightly around the body to reveal prominent curves at hips and breasts [113]. The combination of a young beautiful head, modesty gestures, body-revealing drapery, and massive proportions creates a highly interesting mixture of signals about the propriety versus the erotic potential (held in check) of the desirable Hellenistic wife.

The figures are often composed on a broad base-line above which the draped body tapers to the hips and from the hips to the shoulders. The thick dress spills

over the feet and base, concealing the legs completely, while the thin mantle clings to and reveals the upper body. This tapering composition becomes exaggerated over time. The representation of the thicker dress beneath the fine mantle was a striking technical innovation, perfected by the early or middle third century. The dress folds beneath are larger and simpler, and are often made to run counter to the pull of the fine shawl over them. This complex development quickly became part of the stock-in-trade of the Hellenistic sculptor. The innovation is not a simple example of autonomous development. The thin mantle was a real new garment, made either of fine Egyptian linen (*bussos*) or Koan silk (the *Coae vestes* referred to by Roman writers). It was expensive and worn on statues to express status. A change in real dress fashions and in patrons' wishes prompted this brilliant formal innovation.

It is not always possible to draw a sharp line between the draped women of the later Hellenistic and Roman periods, but two important distinctions stand out. Firstly, an individualized 'real' portrait becomes a regular option only in the imperial period, under Roman influence. Secondly, the stereotyping of the statue, that is, the repeated copying of the same draped figure types, is little known in the Hellenistic period but becomes very common in the imperial period. The two phenomena are obviously connected. In the Roman period, with a real-looking portrait, the 'individuality' of the statue becomes unimportant. Conversely, in the Hellenistic period, with stereotyped ideal heads, the endless variety of the statues could give an illusion of individuality and 'portrait' reality. To this end Hellenistic figures weave a thousand complex variations from the simple variables of pose, dress, and drapery patterns. Many used the same motifs and poses, but none seems a copy of another statue. The variety continues in the imperial period, but is joined by the vigorous production of copies and recognizable versions of known, often 'old-master' goddess statues (for example, the Large and Small Herculaneum types) carrying portrait heads.

The precise chronological development of surviving Hellenistic draped statues has been much analysed, but is unknowable and probably a mirage. The main lines of innovation and their approximate chronology are known from a few externally dated examples, but the dates of undocumented pieces cannot be determined closely. An earliest possible, or 'upper', date may usually be assigned, but rarely a firm 'lower' date. The typical statues begin the third century and swell in number in the second century and later. The externally dated pieces, including divinities, are as follows. The Tyche of Antioch (*c.* 300 BC) is a new goddess in modern dress [91]. Some of the better bronzes show that it may have employed the 'transparent mantle' effect. In the early and middle third century, we have the Themis of Rhamnous and Nikeso of Priene. The Themis [296] is an old goddess in conservative dress. The priestess Nikeso [111] shows an interest in contrasting textures in the old mode of a thick cloak over a thinner dress. In the second century, from Delos, we have Kleopatra (138–37

BC) and Diadora (140–30 BC), both fine examples of the mainstream developments discussed above [113, 114]. Then in the early first century, there is the remarkable group from Magnesia [116] of the family of L. Valerius Flaccus. He was the governor of Roman Asia in either c. 99–98 BC or 62 BC (there are two possible candidates of this name). The group consists of his mother Baebia, his wife Saufeia, and his daughter Polla Valeria, who are shown in Hellenistic manner with purely ideal heads. The daughter gives us the more modest drapery style of a young girl [cf. 115]. The mother and wife show the continuing tendency to broad-based, massively proportioned figures. An important complex of some forty high-quality draped female statues from Pergamon [183, 184] should also be mentioned here. Not only do they give a staggering range of variation within a fairly homogeneous group, but they are also broadly dated to the royal period at Pergamon, that is, c. 240–133 BC. They provide a solid body of certainly mid-Hellenistic draped females. The majority are headless, and it is not now clear whom precisely they represented.

Also important in this context are the Tanagra figurines [117], the small terracotta ladies named after a cemetery at Tanagra in Greece, but produced all over the Hellenistic world. They dominated Hellenistic terracotta production, are broadly datable, and survive in very large quantities. They represent a different social level from the great marbles, namely the urban lower-middle and artisan classes: women like the festival-goers in Theokritos' *Idyll* 15 or the temple-visitors in Herodas' *Mime* 4. Chronologically, they add much to our evidence in the third century, when large female marbles were probably more rare, and show the strong elements of continuity with fourth-century draped figures. In drapery style and female representation, the Tanagras imitate their betters. There are, however, some differences. The Tanagras are usually slighter figures, less massively proportioned, often less conservatively posed. They can talk, laugh, play, dance, and make music. Clearly this is partly due to their role as movable votive ornaments, where a narrative element might be appropriate, but it also expresses a more singular preoccupation with beauty and elegance and less with the matronly values of the propertied wife. Many may be representatives of the demi-monde of theatre-players and courtesans. They thus complement the marbles both chronologically and socially.

The Tanagras are also of great value for their lively polychromy. All ancient marble statues once had realistically coloured eyes, hair, and clothes, while bare flesh was left white. Traces of painted eyebrows, eyes, lips, and hair are often preserved on marble heads, and their effect can be broadly reconstructed. Some idea of the impact of full polychrome draped figures, however, is provided only by the Tanagras. They are painted in broad bands of bright blues, reds, yellows, often with gold edging. Similar colouring should be mentally transferred to the draped marbles.

86 *(right)* Piraeus Athena. Bronze, later 4th cent BC. (Piraeus Mus. 4646. H: 2.35 m). p. 75

87 Artemis from Leptis. Copy of an original of later 4th cent BC. (Tripoli). p. 75

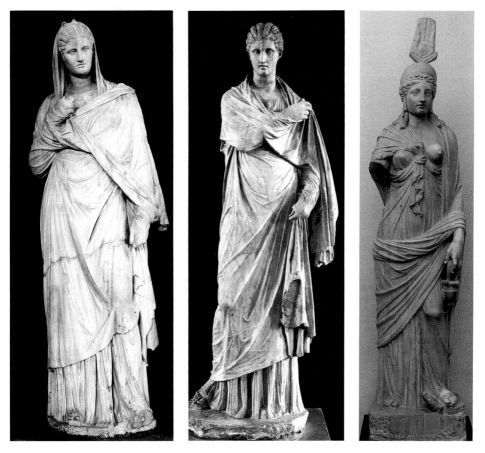

88 Large Herculaneum Goddess. Copy of an original of *c*.300 BC. (Dresden 326. H: 1.98 m). p. 75

89 Small Herculaneum Goddess. Copy of an original of *c*.300 BC. (Dresden 327. H: 1.81 m). p. 75

90 Isis from Alexandria. 1st–2nd cent AD. (Alexandria 25783. H: 1.85 m). p. 76

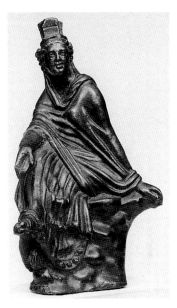

91 Tyche of Antioch. Small bronze after an original of *c*.300 BC by Eutychides. (New York 13.227.8. H: 10 cm). p. 76

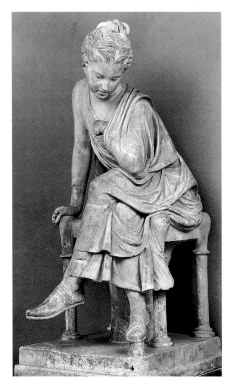

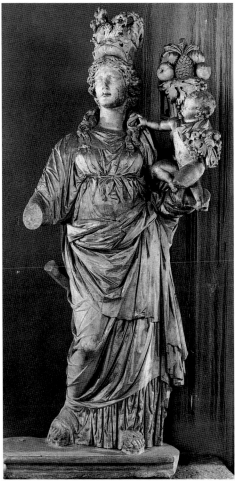

92 *(left)* Conservatori Girl. Copy after an original of early 3rd cent BC. (Conservatori 1107. H: 1.08 m). p. 76

93 *(above)* Tyche from Prusias-ad-Hypum. Later 2nd cent AD. Elaborated from an early Hellenistic type. (Istanbul 4410). p. 77

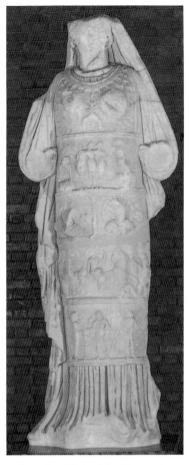

94 Aphrodite of Aphrodisias. New version
of old Anatolian goddess. Copy of an
original of 2nd cent BC. (Aphrodisias Mus.
62.62. H: 2.36 m). p. 77

95 Leaning Muse. Copy of an original of 3rd cent BC.
(Capitoline 2135. H: 1.59 m). p. 77

96 Nike on prow of warship. Silver tetradrachm of
Demetrios Poliorketes, c.295 BC. p. 78

97 *(opposite)* Nike of Samothrace. 3rd cent BC. (Louvre
MA 2369. H: 2.45 m). pp. 77, 241

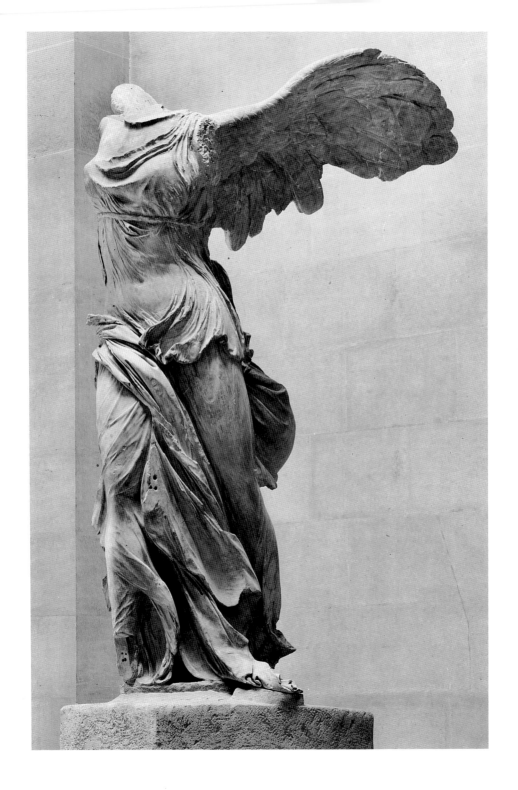

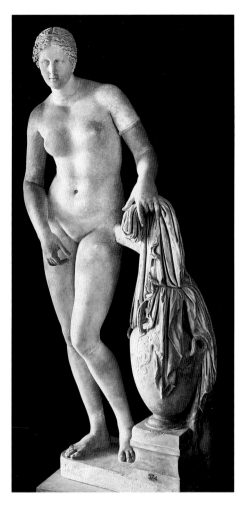

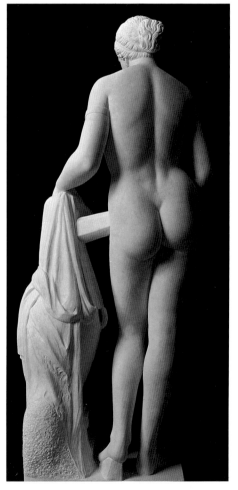

98.1–2 Aphrodite of Knidos. Copy of an original of mid-later 4th cent BC, by Praxiteles. (Vatican 812. H: 2.05 m). p. 79

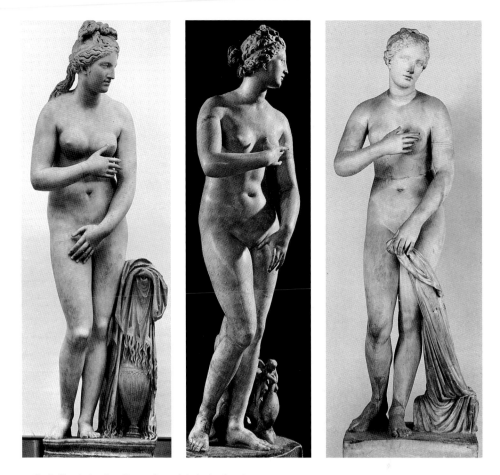

99 Capitoline Aphrodite. Copy of an original of 3rd–2nd cent BC. (Capitoline 409.
H: 1.93 m). p. 80

100 Medici Aphrodite. Copy or version of an original of 3rd–2nd cent BC. (Uffizi 224.
H: 1.53 m). p. 80

101 Aphrodite from the Troad. Copy of an original of 3rd–2nd cent BC. (Terme 75674.
H: 1.87 m). p. 80

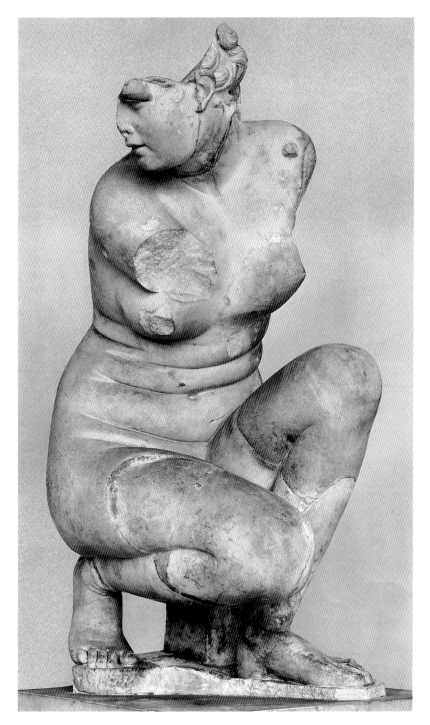

102 Crouching Aphrodite. Copy of an original of 3rd cent BC. (Terme 108597. H: 1.07 m). p. 80

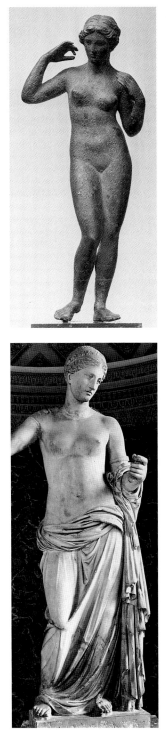

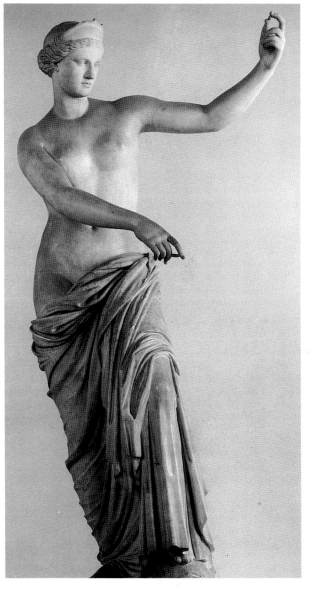

103 *(above left)* Aphrodite Anadyomene. Small bronze of 1st cent BC or
ᵗAD. (British Museum 1084. H: 26 cm). p. 81

104 *(left)* Aphrodite from Arles. Copy of an original of later 4th or 3rd
cent BC. (Louvre MA 439. Modern: right arm, left forearm. H: 1.94 m).
p. 81

105 *(above)* Aphrodite from Capua. Copy after an original of later 4th
or 3rd cent BC. Cf. *[305]*. (Naples 6017. Arms modern. H: 2.10 m).
p. 81

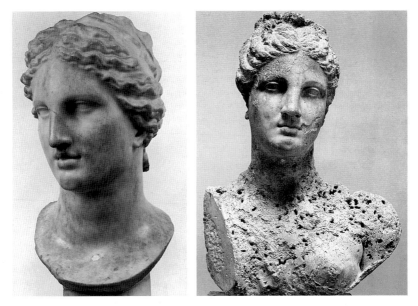

106 Leconfield head. Hellenistic or Roman-period version of a Praxitelean Aphrodite. (Petworth 73. H: 28 cm). p. 79

107 Aphrodite. From Mahdia shipwreck, 2nd cent BC. (Tunis, Bardo C 1183. H: 70 cm)

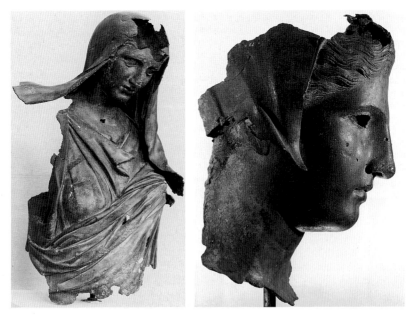

108 Lady from Sea. Bronze, 3rd cent BC. (Izmir 3544. H: 81 cm). p. 83

109 Ackland head. Bronze, 3rd cent BC. (Chapel Hill 67.24.1. H: 30 cm). p. 83

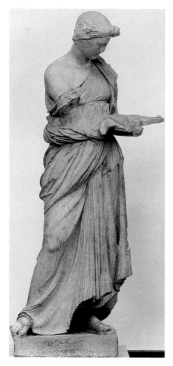

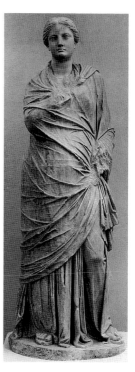

110 Antium Girl. Carries sacrificial tray.
Copy of an original of 3rd cent BC.
(Terme 50170. H: 1.80 m). p. 84

111 Nikeso from Priene. 3rd cent BC.
(E. Berlin 1928. H: 1.73 m). p. 85

112 Woman from Kos. Later 3rd or 2nd cent
BC. (Rhodes Mus. 13591. H: 1.97 m). p. 84

113 Kleopatra and Dioskourides. 138–7 BC.
(Delos. H: 1.67 m). p. 84

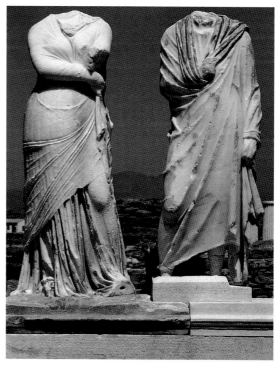

114 Diodora. 140–30 BC. (Delos). p. 86

115 Young girl with birds. 3rd cent BC. (Fethiye Mus. 862. H: 91 cm). p. 86

116.1–2 *(below)* Statues from Magnesia, of the family of L. Valerius Flaccus, governor of Roman Asia in *c.*99–8 BC or 62 BC. *(Left)* Baebia (mother). (Istanbul M 550. H: 2.30 m). *(Right)* Saufeia (wife). (Istanbul M 822. H: 2.13 m). pp. 86, 257

117 *(below right)* 'Tanagra' woman. Later 4th or 3rd cent BC. Painted terracotta. (E. Berlin TC 7674. H: 34 cm). p. 86

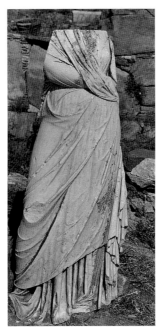

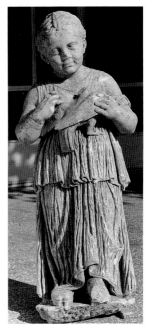

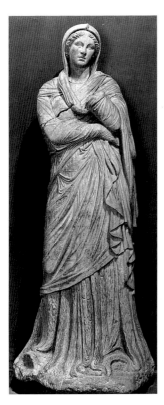

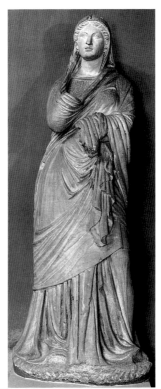

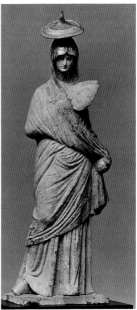

Chapter Seven

BAROQUE GROUPS: GAULS AND HEROES

Historical and mythological groups were a major new feature in Hellenistic sculpture, and without a small and precious series of copies we would know almost nothing about them. These groups were surely the major votive monuments of their day in which great names in sculpture gave the lead in formal and stylistic innovation. It was probably in the context of these groups that the Hellenistic baroque was evolved. The baroque was not an encompassing period style detectable in all sculptures, rather it was designed specifically to characterize the elevated, tumultuous world of epic heroes. We have good evidence only at Pergamon, but a general connection between the heroic groups and the kings seems very likely. Many were surely royal votives; and the baroque may have been in some sense a royal style, a grand manner for royal deeds and heroes.

Complex statue compositions had been little tried in the Classical period. State votive groups tended simply to multiply single standing figures in a line, like the Daochos Monument at Delphi [44], while myth groups usually comprised static unconnected figures. Action myth groups had been successfully designed for temple pediments, but in the Hellenistic period they became elaborate three-dimensional monuments in their own right. The external evidence is poor, but the formative period was most likely the third century. In the early period, before Pliny's caesura at 296, we hear of two major royal groups: Alexander's Granicus monument at Dion by Lysippos, which featured equestrian figures of thirty-five of the king's cavalry Companions who died in the Granicus battle; and Krateros' Lion-hunt monument at Delphi by Leochares and Lysippos, featuring Alexander, Krateros, and a lion. Both must have been impressive groups, but we have no precise idea of their appearance. Of the groups known in copies, we have external evidence for two, both Attalid.

Large and Small Gauls

Two series of copies representing Hellenistic Gauls, one of heroic scale, the other two-thirds lifesize, almost certainly reproduce figures from two votive groups set up by the Attalids of Pergamon. The two groups of copies are referred to as the Large and Small Gauls [118–132]. They represent our only major works of this kind attributable to a particular Hellenistic kingdom. One of the groups had

both historical and mythological figures, and it shows us how the two spheres could be connected.

Tribes of European Celts or Gauls invaded Greece in 279 BC. They were repulsed at Delphi and retreated. Three tribes crossed to Asia Minor in 278 BC, and eventually settled there in the interior. Culturally and ethnically different from the Greeks, they were not welcome. For more than a generation, their warriors terrified the coastal Greek cities, whether as wild pillagers and extractors of Danegeld or as Seleucid mercenaries. Attalos I of Pergamon defeated the Gauls in a series of battles in the 230's BC, battles that marked the accession of Pergamon to the Hellenistic world stage. The victories were commemorated by a great series of votive monuments dedicated on the acropolis at Pergamon itself and on the acropolis at Athens, as we know from inscribed bases at Pergamon and from literary sources. The copies must be connected with these lost dedications. The relevant literary texts may be given here for convenient reference in what follows:

1. Pliny, *NH* 43.84: 'Several artists made the battles of Attalos and Eumenes against the Gauls: Isigonos [= ?Epigonos], P(h)yromachos, Stratonikos, and Antigonos who wrote books about his art'.

2. Pliny, *NH* 34.88: 'Epigonos did most of these subjects (sc. philosophers, athletes, etc.) and excelled in his Trumpeter (*tubicen*) and his Infant miserably caressing its Dead Mother'.

3. Pausanias 1.25.2: 'By the south wall (of the Athenian Acropolis), Attalos dedicated (a) the legendary battle of the *Giants* . . ., (b) the battle of the Athenians against the *Amazons*, (c) the battle against the *Persians* at Marathon, (d) the destruction of the *Gauls* in Mysia – each figure being about two cubits [= three feet]'.

4. Plutarch, *M. Antonius* 60: 'At Athens the Dionysos in the Battle of the Giants was dislodged by the wind (in a storm) and thrown down into the theatre'.

5. Diodorus Siculus 5.28: 'The Gauls are tall in body, with rippling muscles . . . They are always washing their hair in limewater and pull it back from the forehead . . ., so that they look like Satyrs and Pans; the treatment of their hair makes it so heavy and coarse that it looks like the mane of a horse . . . Some of them shave the beard, but others let it grow a little. The nobles shave their cheeks but let the moustache grow until it covers the mouth.'

The Small Gauls are to be connected unequivocally with the Attalid dedication on the Athenian acropolis because of their highly unusual scale mentioned by Pausanias (3), and because they reproduce the four subjects he describes. The Large Gauls must be Attalid because one figure, the Dying Gaul /119/, is a precise mirror version of one of the Small Gauls /129/. This must constitute a

deliberate reference between the two groups. Also, since Pliny (1) envisages no other Gallic battle groups than Attalid ones, we should probably not expect others in copies. There was probably a further connection with Pliny's Epigonos, in text (2) and probably text (1) also. He was an Attalid court sculptor known from five signatures at Pergamon.

The centrepiece of the surviving Large Gauls is the great Ludovisi group /118/ representing the double suicide of a Gallic chieftain and his wife: they choose noble death before capture. It is a loose pyramidal composition that opens and closes from different viewpoints. The figures have a baroque intensity but are not overstated. The forms of heads, bodies, and draperies are kept quite simple, heroic expression coming more from posture, gesture, scale, and bold lines of composition. The Capitoline Dying Gaul /119/ came from the same collection in Rome as the Ludovisi group and clearly belongs with it in subject and style. The Gaul sits on his Gallic shield, in agony from a large wound in his right flank. On and around the shield lies a curved war trumpet. Although this instrument hardly seems the composition's main feature, it is quite possible that it identifies the figure as the Trumpeter of Epigonos mentioned by Pliny (2). Both of these Large Gauls wear moustaches with clean shaven cheeks which indicates they are nobles (see text 5). Some marked differences are used to define distinctions between them of age and status. The Dying Gaul is a thinner, more wiry figure with athletic muscle style and smaller head – he is younger. The Ludovisi Gaul is more heavily proportioned with wider shoulders and has a broader, more square face – he is clearly older, senior. The Dying Gaul wears a Celtic torque, but is otherwise completely naked. He has shorter hair brushed up in thick tufts, just as in Diodoros' comparison to a satyr's hair or horse's mane (5). The shorter hair and nakedness, like his 'younger' body style, are surely indications of junior status beside the chieftain, who has long hair and a (royal?) cloak. Such distinctions may or may not have been employed by real Gauls, but would be legible iconographic signs to a Greek viewer.

A few other pieces belong with the Large Gauls – in style, subject, and scale. A head in the Vatican /120/ shows an older Gaul with more unrestrained suffering. His overt anguish and unshaven beard indicate he is a subordinate Gaul. A head of a dying warrior in the Terme is usually said to be a 'Persian' because of his headgear, but may rather be a Gaul if it belongs. (To distinguish a Persian as a Seleucid mercenary from a Gaul seems too refined and pedantic a distinction for a group like this; and there is no other warrant for supposing a separate set of Persians, as in the Small Gauls.) A torso in Dresden is extremely close to the Dying Gaul and is probably a second copy of the same figure – the only duplicate among the copies. Most likely no Attalid victors were included in the monument. Its subject was the heroism of a defeated but noble enemy in which victors would be inappropriate. As often in Hellenistic groups, large parts of the subject were merely implied, left to be supplied by the viewer's imagination. In this group, the viewer was thereby tacitly invited to assume the role of victor.

The precise date and context of the monument which the Large Gauls copy are not known for certain, but it was most likely dedicated at Pergamon in the 220's BC. Pliny provides a general third-century context: all the sculptors he mentions in text (1) above were active in the middle or later third century (assuming, as we probably should, that the completely unknown 'Isigonos' is a textual error for the famous Epigonos). The inscribed bases of two monuments, called respectively the round base and the long base, in the sanctuary of Athena on the Pergamene acropolis, provide a more precise chronology and a possible setting. The round base /121/, known from fragments of its dedicatory inscription, was c. 3.10 m in diameter and was for a single victory over the Gallic tribe of the Tolistoagii at the source of the river Kaikos. It has usually been favoured as the setting for the Large Gauls. The long base /122/, set up in 226–223 BC, carried dedications from at least six earlier victories, divided by vertical lines on the front of the base. It has also been proposed as a setting for the statues. This is at first an attractive hypothesis because the long base is signed *EPIGONOU ERGA*, or 'Works of Epigonos', in large letters, running under the separate dedications. From this, one could then connect the long base with Pliny's mention of Epigonos' Trumpeter and so with the Dying Gaul. However, such a reconstruction is far from certain because the base is very narrow and decidedly ill-suited to the three-dimensional effect of the Ludovisi group. Although there is nothing decisive to connect the Large Gauls with either base, the round monument /121/ remains aesthetically the more effective setting of the two.

The Small Gauls /123–132/ are identified by their scale and the subjects specified by Pausanias (3). There is no single cycle of copies surviving. Small groups of single figures were excerpted from the monument for different (unknown) Roman contexts. We have no figure which is copied twice. Not all are agreed on which figures should be included: there are about thirty pieces in various collections of appropriate size and subject. The monument may have comprised more than fifty figures. Plutarch's reference (4) to a figure of Dionysos blown into the theatre at Athens by a storm indicates that the group was of bronze and set very close to the south wall of the Acropolis. We can only guess how the figures were arranged. The Plutarch passage also shows that the gods were included with the Giants, which need not imply, however, that the victors were present in the other groups. It seems unlikely, at least for the Gauls.

The monument's sculptors employed a subtle range of style, dress, and facial expression to characterize the different subjects. The Giants /123, 125/ have heavy, thick-set proportions, and brutish, bearded heads to show their older, primeval origin. They also have twirls of hair on chests and in armpits – a 'bestial' sign that recurs on some of the Giants of the Great Altar. Amazons /124/ were easily differentiated by their sex. Like the Ludovisi Gaul's wife, they have classically formed facial features – crumpled baroque agony was evidently deemed unsuitable for women. The Persians /126, 128/ are distinguished by

tight trousers (Aix), headdress, and physiognomy. Some of the Persians (Naples, Vatican) have thick lips and plainer, heavy features that characterize them as 'earlier', simple-looking barbarians, as compared to the later Gauls who have finer, more 'portrait-like' features indicating contemporary, real barbarians. The Gauls seem to have a much greater range of body and head styles than the other subjects. The Louvre Gaul [127] has more compact torso muscles, while the Venice Dead Gaul [132] has the more slender, wiry anatomy of the Capitoline Large Gaul. The Venice 'Falling' Gaul [131] not only has satyr-like hair, but his pinched, harassed young features also contain an allusion to satyr iconography: they express 'very youthful' Gaul. Fever pitch is reached in the superb anguished head of the Venice Kneeling Gaul [130], while the Venice Dead Gaul has smooth, classical features [132]. The use of varied formal styles here clearly has nothing to do with chronology: they simply express different things. Contorted, dynamic baroque forms are employed for older and for suffering figures [130] who have fallen but are still fighting. Smoother, plainer, classical styles are used for women and for the placid calm of death [132]. Variations of form and style create distinct ideal personae for Giants, for Persians, for different types of Gaul, and for different ages and states of mind. It is remarkable how easily we are still able to distinguish the participants in this group.

The purpose of the Small Gauls was clearly to set the Attalid victories in a long myth-historical perspective. The monument takes advantage of its Athenian context to raise the Attalid victories to the level of Athens' hallowed victories in the Persian Wars. Battles against Giants and Amazons had long been familiar as generalized allegories for Greek victories over barbarians, and by the third century Athens' Persian battles were perceived on the level of heroic myth. The Gallic victories are made equivalent, and Pergamon is cast as the new Athens, defender of Hellenism and the civilized world.

Pausanias, in the vital text 3 above, does not specify which Attalos dedicated the monument at Athens, and it has been endlessly debated on stylistic grounds whether it was Attalos I (241–197 BC) or Attalos II (160–139 BC). Prevailing opinion in many quarters is that the baroque style in some figures is so 'advanced' as to be impossible before the Great Altar, and so favours Attalos II. But there is nothing to show why the Small Gauls should be followers of the Great Altar style rather than its forerunners. In this period, a major votive group in the round was as likely, or more likely, to be stylistically innovative as an architectural frieze. Furthermore, it is possible, indeed probable, that the Great Altar does not coincide with the acme of the Hellenistic baroque but with its end (Chapter 9).

Stylistic arguments cannot decide the issue of the date of the Small Gauls. Historical circumstances, however, favour Attalos I and are rather against Attalos II. Attalos II fought no wars against the Gauls as king. He was involved in a Gallic victory only as general with his elder brother Eumenes II (in 166).

One would naturally expect the monument set up after such a victory to have been a joint dedication – family concord was a much-publicized Attalid virtue. Gallic wars were something new and vitally important under Attalos I, but by Attalos II's reign the Gauls had long since been settled and assimilated: they had cordial diplomatic relations with the Romans already in the 160's. We hear of no further Attalid fighting against the Gauls after 166. For cultural propaganda in Athens, Eumenes II and Attalos II had turned to dedicating expensive stoas. At Pergamon out of the many surviving inscribed dedications for Gallic victories, apart from one which honours both Eumenes and Attalos II, all were set up by Attalos I. Barbarian warrior Gauls and Gallic victories were generally connected in Greek historical memory with Attalos I, and it is more reasonable for us to suppose that Pausanias meant him.

Pasquino, Penthesilea, and Marsyas

Of the great Hellenistic mythological groups only three were regularly copied in Roman times: the Pasquino, the Achilles and Penthesilea, and the Hanging Marsyas. Parts of about ten copies of each survive. We have not a word of ancient testimony on any of them. The related Pasquino and Penthesilea should be discussed together.

Three major copies of the Pasquino (Loggia dei Lanzi, Palazzo Pitti, Palazzo Braschi) allowed a full and magnificent reconstruction by B. Schweitzer [133]. Later discoveries have confirmed its accuracy. An elder hero is lifting the dead body of a younger hero from the battlefield. Their ages are distinguished by head type and body style. The dead youth is softer and slighter, his rescuer, broader and heavily muscled. They form a powerful, highly compact pyramidal composition framed behind (in front view) by the large round shield. Bernini considered the ruined Braschi torso the finest ancient sculpture in Rome. For him, the group represented the wounded Alexander rescued by a soldier – an imaginative interpretation that reflects well its tenor of royal heroism. The subject, however, is certainly mythological and must come from Homeric epic, which contains several suitable recoveries of a hero's body – for example, Ajax' rescue of Achilles' body, so common in earlier Greek art.

The Pasquino, however, most likely represents Patroklos' body rescued by Menelaos, and it is interesting to see how the sculptor has included sufficient visual 'evidence' to allow the viewer to deduce this. First, hairstyles. The rescuing figure is bearded and long-haired: he is a senior member of the older generation of Homeric heroes, like Agamemnon, Odysseus and Menelaos. The dead hero cannot be Achilles (or Alexander) because he has shorter hair – one need only compare the Achilles in the Penthesilea group [134.3]. Paintings of Achilles with subordinate heroes show how a shorter hairstyle can indicate lesser heroic rank. The dead figure is thus both a young and a 'junior' hero. Second, dress. The rescuing hero wears helmet, tunic, baldric, and belt. He is thus both

armed and clothed, in contrast to the dead hero who is weaponless and completely naked. The nudity of the dead body then is not merely 'heroic', but seems to be iconographically motivated. It points most clearly to the body of Patroklos, stripped of Achilles' armour and rescued by Menelaos, a great episode recounted at length in the *Iliad* Bks 16–17. The subordinate hero Patroklos went out to fight on behalf of the sulking Achilles and was killed and stripped by Hektor. We see the subsequent recovery of the body. By equipping Menelaos with clothes and prominent armour (shield and helmet), the artist gave narrative meaning and identity to the conspicuously naked Patroklos.

The Achilles and Penthesilea group [134] is known in less complete copies. However, its effect can be appreciated in a new reconstruction by E. Berger, made in the light of recent discoveries. A major copy was found at Aphrodisias; the missing head types of both figures have been identified; and a miniature version (from Beirut) now gives the proper relationship of the two figures. The story of Penthesilea the Amazon Queen was told in the *Aithiopis* (a post-Homeric epic) and had long been popular in art. The Hellenistic group creates for the subject a new baroque narrative in the round. The group is clearly related closely to the Pasquino – in scale, theme, composition, and style. In both, heroes lean forward, legs apart, to lift up a 'beloved' corpse from which their heads turn away in order to confront imaginary opponents as well as the viewer. Both groups have pyramidal, multi-view compositions; their figures have a powerful, baroque muscle style; and the heads have an elevated intensity but are formally quite restrained. The drapery style of both is consciously simplified, with minimum elaboration. In theme, both groups reflect on the tragic errors of heroes. In the Pasquino, Patroklos' death was caused by Achilles' fatal error in lending Patroklos his armour. The Penthesilea group shows another fatal error: Achilles kills the queen with whom he had just fallen in love. The two groups seem to be of slightly different scales, so that they were probably not set up in the same context. However, the discovery of the fine but fragmentary copies of both groups decorating opposite sides of a tetrastyle pool in the Hadrianic baths at Aphrodisias shows they were conceptually linked at least in the Roman period.

The two groups have been dated from the third century to the late second or even first century. The middle or later third century is surely correct. The only valid and dated comparison is the Ludovisi Gallic group, probably of the 220's, to which they are obviously similar in composition, heroic manner, and stylistic detail. The Pasquino Menelaos [133] and the Ludovisi Gaul [118] are particularly close in muscle style, and all three groups share the 'economical' drapery style. The Gaul's head is different in style because he is a contemporary figure, not a Homeric hero. The two mythological groups could be before or after the Gauls. The Attalid Gauls should not be put first simply because they are dated. Pergamon was a late-comer to the forefront of Hellenistic sculpture, and there is no reason to think its artists were the innovators of the baroque, every reason to think they had some catching up to do.

A figure of the Hanging Marsyas [135] is known in more than twelve copies and versions. The copies are excerpts from a group whose approximate composition is given on a number of reliefs, sarcophagi, and coins of the Roman period. The group certainly included a crouching Scythian slave, the Knifegrinder, known in a single fine copy in Florence [136]. A seated Apollo with lyre may also have been included. The Marsyas is known in two 'editions': the Red Marsyas, in three copies of red-streaked marble (pavonazetto), and the White Marsyas, in ten or so white marble copies. The Red Marsyas attempts more realism and intensity, and seems to be a reworking of the White. The White copies are more consistent, more effective, more numerous, and doubtless reproduce the original figure more closely. The figures were probably arranged in an outdoor setting, in an open, disconnected group for which the reliefs and coins give only imprecise information.

The story of Marsyas and the pipes has two distinct parts. First, he picks up and learns to play the pipes, discarded by Athena as boorish. Second, he challenges Apollo to a musical contest with his life as forfeit. (A third 'genre' episode was later interposed, the musical instruction of his son Olympos.) The first part was the subject of a famous Classical group by Myron and the later contest was shown on the base of Apollo's statue at Mantinea by Praxiteles. The Hellenistic group shows the forfeit, a gruesome divine punishment of vanity and hubris. Marsyas is strung from a tree about to be flayed alive by the Scythian, who sharpens his knife for the task and looks up menacingly. Apollo, if present, sat by impassively, lyre in hand. The protagonists are superbly characterized. Marsyas' body is a brilliant anatomical study combining realism and the distinctive, sinewy forms of the satyr. His head mixes wild, sub-animal traits with a powerful, dignified pathos. The Scythian Knifegrinder is a compact crouching figure, with a genre 'portrait' head whose features were designed to express his 'low', slave origins. He has a moustache and whisps of beard on his chin and lower lip, indicating 'non-Greek'. He has flat, lank hair (heroes have full, curly hair) and an expanse of balding forehead which, combined with his raised and wrinkled brow, are probably meant to convey an air of sinister unthinking. In purely formal terms, Marsyas' head can be compared with the Giants from the Small Gallic group [123, 125]. The Knifegrinder's body and sharp characterization also recall some Small Gauls. The group was probably a monument of the middle or later third century.

Myron's Marsyas and Athena group may have contained topical, historical references to the superiority of cultured Athens over rustic, flute-playing Thebes (Plutarch, *Alcibiades* 2.5). Two interesting interpretations would make the Hellenistic Marsyas an allegory located in Seleucid Asia Minor. Although objections can be raised to both, they illustrate the kind of contemporary meaning such groups may have had. G. Lippold connected the Hanging Marsyas with a city called Kelainai in Phrygia, whose protecting hero was Marsyas. Their local river was named after him, and he defended the people

from the Gauls (Paus. 10.30.9). An obvious difficulty is that they could hardly have chosen a less favourable moment in Marsyas' career. Better is R. Fleischer's hypothesis that the group is an allegory of the savage punishment of the usurper Achaios by the young Seleucid Antiochos III. Achaios was captured at Sardis in 213 BC, and then mutilated, decapitated, and crucified, while his head was sewn up in the skin of a donkey (Polybios 8.21). Apollo was the patron deity of the Seleucids, young and beardless like the kings. Achaios, like Marsyas, was older and bearded, as we know from his coin portrait. They also have in common that they challenged their rightful masters and were grimly punished for it. Stupidity would be a connecting idea between Achaios' donkey and Marsyas. Victory over usurpers (Achaios was also related to Antiochos III), less suitable for a historical monument, could usefully be celebrated by a cautionary mythological allegory. The date would also be appropriate.

Other mythological groups

The multiple replicas of the Pasquino, Penthesilea, and Marsyas allow a good impression of the originals. There are other major groups, but none so clearly defined by copies. Each has its own problems of transmission, interpretation, or date. Works known in single versions are perhaps the most problematic, where inaccuracy, later adjustment, and later invention are always hidden possibilities. Several such groups, however, have strong internal coherence and seem convincing as works of the mid-Hellenistic period.

The winged Daidalos in Amman [137] must have been an impressive work. The figure is flying forwards, looking up with full baroque pathos, his arm raised to ward off the hot glare of the sungod Helios who has punished his presumption to fly by melting the waxed wings of his young son Ikaros. A fallen Ikaros was probably combined with the Daidalos in some way. In this work baroque art raises the lowly Cretan craftsman Daidalos to the realm of heroes. The provenance of the single copy, from Philadelphia in Jordan, has been thought, with insufficient reason, to indicate that the original was located in the Seleucid sphere. The Pitti Antaios and Herakles [138] is related to wrestler groups. The combination of athletic realism and mythological accuracy, in the lifting of Antaios from his mother Earth, is a typically 'learned' approach of a Hellenistic artist. The fragmentary Artemis and Iphigenia in Copenhagen [139] is closely related to the Penthesilea. Its more slender figures seem a little mannered, but this does not signify a difference of centuries. Fragments of a second version, in black and white marble, were identified recently on Samos and confirm its status as a major monument. In this technique, the draped parts in black marble are combined with flesh parts in white marble. The effect of such a copy must have been very arresting.

The Florence Niobids [140] formed an open group of probably sixteen figures (Niobe, fourteen children, and a paidagogos) in an arrangement as hard

to visualize as that of the Small Gauls. The main copies, in the Uffizi, are rendered in a rather florid, vapid style. Some of the figures are known in other versions that confirm broad compositional accuracy, and fragments of a set of copies, again in black and white marble, have been recognized at Hadrian's Villa at Tivoli. The famous Chiarmonti Niobid *[141]* is a striking and dynamic drapery essay, based on the pose of one figure excerpted from the group. It shows up the poor quality, but not the accuracy of its Florence counterpart. Pliny records a group of 'Dying children of Niobe' at the temple of Apollo Sosianus in Rome (*NH* 36.28), which the Florence Niobids may reproduce. Pliny adds that no one knew if the group was by Praxiteles or Skopas, which means of course that it was probably by neither. Our marbles probably copy a group of the late fourth or third century.

The Farnese Bull */142/* in Naples, from the Baths of Caracalla in Rome, is a grandiose pyramid of marble figures (much restored) within which lies a Hellenistic composition known in other media (gems, paintings, reliefs) which featured only Dirce, the bull, and two stepsons. This was doubtless the group by Apollonios and Tauriskos of Tralles, reported by Pliny (*NH* 36.34). A fragment of a small version in the Vatican confirms that the group was copied in the round elsewhere. The Farnese group is a clear and easily detected example of Roman elaboration of a Hellenistic composition.

The Farnese Bull features violence and death, and most of the groups we have been considering are concerned with death and suffering. In some, like Pasquino and in the Scylla and Polyphemos groups to be discussed shortly, the context is pure heroic epic. But in a much larger number of groups, death and suffering are part of a theme of divine punishment. Marsyas is punished by Apollo, Daidalos by Helios, Niobe by Artemis, and, we will see, Laocoön by Apollo. Dirce is also being punished and, in a sense, so is Achilles in the Penthesilea. Many of these themes are from Greek tragedy. They concern mortals struck down for their hubris, for fatal errors, but who achieve heroic status through being singled out for suffering. The sculptured groups are concerned not merely with heroism, but with heroic pathos – suffering that ennobled. The Hellenistic baroque was created specifically to express this idea.

Laocoön

The marble Laocoön group in the Vatican *[143]*, discovered in 1506 on the Esquiline hill in Rome, is one of the finest expressions of the full Hellenistic baroque. It represents the Trojan priest Laocoön and his two sons attacked at an altar by two large serpents. Since its discovery, it has been connected with the marble Laocoön group by three Rhodian sculptors, Hagesandros, Polydoros, and Athenadoros, seen, described, and lavishly praised by Pliny in the house of the (future) emperor Titus (*NH* 36.37). Although the Vatican group was not discovered in an imperial house, it is reasonable to suppose it was the one seen by

Pliny. (The group was found in a clearly later context, at the 'Sette Sale', the giant holding tanks for the baths of Trajan on the Esquiline.) There are no other versions of the group, and its precise art-historical context remains a matter of controversy. It was thought by some to be a Hellenistic original until it was found that the back of the altar was made with Italian (Luna or Carrara) marble which implies a date in the mid-first century B C or later. But what, if any, is the relation of the Vatican group to Hellenistic models? Is it a replica, adaptation, or new creation?

The Laocoön story was part of the epic cycle, and was treated in tragedy and Hellenistic poetry. Our only full, surviving literary version, however, is a famous passage in Virgil's *Aeneid* (2.199–233), and Virgil is in large part responsible for the Laocoön controversy: which, many have asked, came first, the *Aeneid* or the sculpture? Did the group inspire or did it illustrate Virgil? Without Virgil and Pliny, the Laocoön would simply have been classified as a copy or version of a mid-Hellenistic group. That Virgil knew and was impressed by a sculptured Laocoön is quite possible, but he must also have known the doubtless very evocative renderings of the story in tragedy and Hellenistic poetry. The dependence of the group on Virgil seems even less likely, for the following reason. In the *Aeneid*, Laocoön is an innocent priest of Neptune, whose death with his sons is not clearly or 'personally' motivated. He provides a brilliant and dramatic interruption of the Fall of Troy in Virgil's narrative. This episode would make in itself an inappropriate subject for a self-sufficient statue group. In the Vatican group, Laocoön is a classic suffering hero, and he should be undergoing punishment for some error or misdeed. In the tragic version (Sophokles), Laocoön was a priest of Apollo who should have been celibate and was punished for marrying, by the snake-inflicted death of his two sons. In this version he was not himself killed. In a Hellenistic version (Euphorion, in Servius) both Laocoön and his sons die. The Vatican group, then, goes most easily with the other Hellenistic punishment groups, as a baroque sculptural reworking of a theme from tragedy.

In composition and heightened theatrical pathos, the Laocoön is close to the Giant who opposes Athena on the east frieze of the Great Altar *[196.1]*. If there is a direct relation between them, it is more likely that the frieze echoes the statue than vice versa. This would place the composition in the later third or early second century, perhaps after both the Pasquino and the Marsyas. The composition is unlike the Pasquino and the Ludovisi Gallic group in being designed for a single viewpoint. This was no doubt simply a matter of the setting for which it was made, for example an exedra rather than a base set in an open space. A frontal viewpoint remained as valid an option for sculptural compositions in the mid-Hellenistic period as in any other.

Pliny is not clear about when the three Rhodians who made Titus' Laocoön were active. Their three names are so common among inscriptions and signatures on Rhodes that it was not possible to identify them until a signature

was discovered at Sperlonga which gives their patronymics. The evidence from Sperlonga suggests that they worked in the later first century BC or in the early imperial period. These finds cast much new light on the Vatican Laocoön and the sculptural business of the three Rhodians. They were 'copyists', but of a very special kind.

Sperlonga

In 1957 the fragments of four mythological groups were discovered in an elaborate cave-grotto at Sperlonga [144–47] on the coast south of Rome. The grotto was part of a villa used by the emperor Tiberius, and the groups may have been bought by him or by a previous owner. They are: 1, Pasquino; 2, Rape of the Palladion; 3, Blinding of Polyphemos; and 4, Scylla. The groups were probably part of one commission for the cave and probably from one workshop. A prominent signature on the ship in the Scylla group [147.3] gives the names of the same three Rhodians who made the Laocoön seen by Pliny. It was their workshop, then, that was probably responsible for all four groups. The lettering of the signature seems to be of the early to middle first century AD, while the sculptors' known family connections on Rhodes, traceable through their fathers' names, indicate a somewhat earlier date, in the later first century BC.

The Sperlonga Pasquino, to judge from its few and battered remains (Menelaos' head and Patroklos' legs), was a copy of the usual composition. The Rape of the Palladion [145] was an open, disconnected group featuring Diomedes, Odysseus, and the archaic Athena idol. It is also ill-preserved, but a Roman ash-urn (of a certain Megiste) in Athens seems to give its basic composition. The figure of Odysseus is known in two other, poor quality copies.

The Blinding of Polyphemos [146] was a colossal sculptural tableau set in a rocky alcove at the back of the main cave at Sperlonga. It must have been an astonishing work. It featured a vast drunken Polyphemos sprawled on his back, Odysseus behind with the wine cup, and two companions plunging the long pole with fiery end into the Cyclops' solitary eye. A third companion (the wineskin-carrier) in the foreground charges in dragging a wineskin. The carving is brilliant, the style a loud, full-blown baroque. The companions have powerful, lean bodies, and Odysseus' head is a bravura performance in itself. As in the Giants of the Great Altar [196], the carving of the Polyphemos combined meticulous delineation of details, like foothair and toenails, with great expanses of preternatural muscle. A relief in Catania gives the basic composition of the group and suggests it was not newly created at Sperlonga. Indeed, given the subject, one would expect a borrowed figure arrangement. At this scale and this level of complexity, one might also expect considerable freedom in the handling of details. This expectation, however, is confounded by another full-scale copy

of a part of the same group: a superb replica of the head of the wineskin carrier from Hadrian's Villa at Tivoli *[146.4]*. It is astonishingly close in style and detail to the Sperlonga head, and shows that both are highly accurate copies of a common model. These three groups then – Pasquino, Palladion, and Polyphemos – were high-quality replicas of earlier works.

The Scylla group *[147]* occupied the centre of the cave's pool and was clearly another tour de force. It showed the stern of Odysseus' ship with Scylla's monstrous form alongside, grabbing and devouring his companions with her tentacles and dogs. There are other Scylla compositions – small groups, reliefs, coins, and mosaics – some of which (notably, the contorniate coins) show a very similar arrangement of ship, helmsman, monster, and companions being devoured. The marble Scylla at Sperlonga must have been fantastically difficult to carve, and in quality of detail and finish it is somewhat inferior to the Polyphemos and Palladion groups. These factors might suggest less careful reproduction of models, that the Scylla is a more free or 'inventive' adaptation of a Hellenistic group. This could well be so, but without other full-size versions to compare, it would be unwise to conclude it was not intended as a replica like the others.

Sperlonga shows that the chief business of the three Rhodians was the high-class reproduction of Hellenistic mythological groups. Monumental baroque sculpture for Roman patrons was clearly a limited, specialized market. Princes and emperors were buyers. The villa at Sperlonga belonged to Tiberius; the Laocoön was in Titus' house; and at Tivoli, Hadrian possessed – among much else – fine examples of the Pasquino and the Polyphemos group. 'Copyists' is a modern pejorative term, but these sculptors were probably the best of their day. Free imitations and new creations were not necessarily regarded as 'better' than accurate marble copies. The real value and achievement of these groups lay in their translating highly complex and highly prized statue compositions, surely designed originally for bronze, into a far more difficult material. That Roman buyers particularly valued virtuoso statuary in marble is explicit in Pliny's high praise for complex sculptures (the Laocoön included) that were reportedly made 'from one block' (*ex uno lapide*). There is no evidence that at the top level of the statue market represented by these groups variation, adaptation, or invention were considered desirable artistic goals by either artists or patrons. Whether the Laocoön and Scylla are adaptations or replicas, we cannot say for certain without other versions. The evidence of groups that can be tested in multiple versions suggests only that the Laocoön and Scylla too would be intended as reproductions. Finally, Sperlonga shows that the Laocoön can no longer provide clear evidence for a Rhodian 'school' of baroque sculpture in the Hellenistic period. The origins of copyists give no necessary indication of the primary contexts of the works that they copied. We do not know where the Polyphemos and the Laocoön that the three Rhodians so brilliantly 'translated' into marble were originally dedicated.

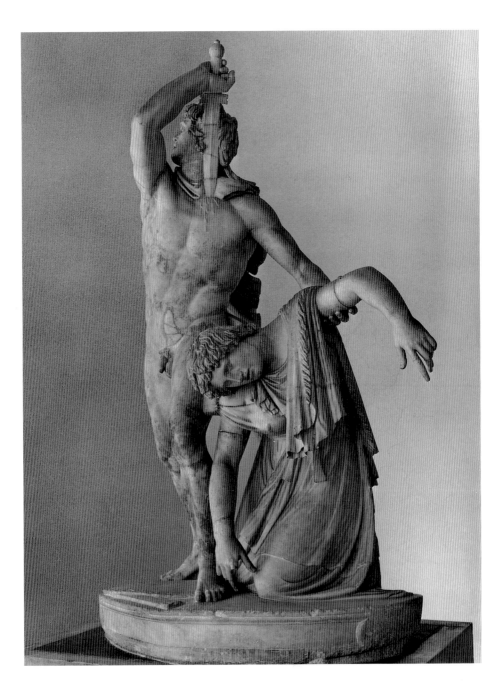

118–122 Large Gallic group. Copies of figures from a Gallic victory monument set up by Attalos I at Pergamon, probably in the 220's BC. pp. 99–102

118 *(above)* Ludovisi Gaul and Wife. Double suicide of Gallic chieftain and wife. (Terme 8608. Modern: both arms of chief, left arm of wife. H: 2.11 m)

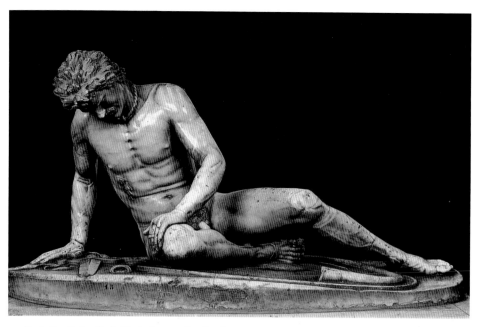

119 Capitoline Dying Gaul. (Capitoline 747. L: 1.85 m)

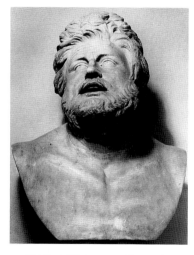

120 Old Gaul. (Vatican 1271. Bust modern. H: 35 cm)

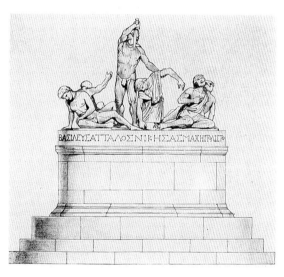

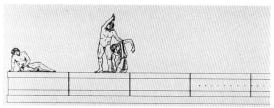

121 *(above right)* Round base at Pergamon. Restored with Large Gauls. (Reconstruction: H. Schober). p. 102

122 *(right)* Long base at Pergamon, signed 'Works of Epigonos'. Restored with Large Gauls. (Reconstruction: E. Künzl). p. 102.

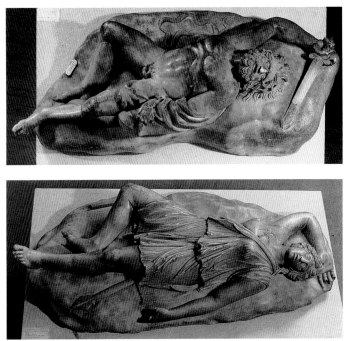

123 Dying Giant. (Naples 6013. L: 1.34 m)

124 Dying Amazon. (Naples 6012. L: 1.25 m)

Below

125 Giant. (Karlsruhe. H: 71 cm)

126 Persian. (Aix-en-Provence 246. H: 64 cm)

123–132 Small Gallic group. Copies of figures from a Gallic victory monument set up at Athens by Attalos I in the later 3rd cent BC (less likely by Attalos II in mid-2nd cent BC). pp. 102–3

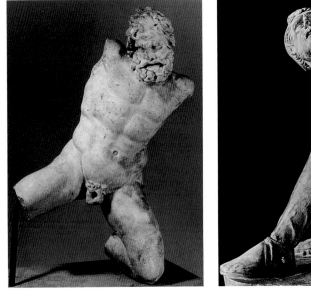

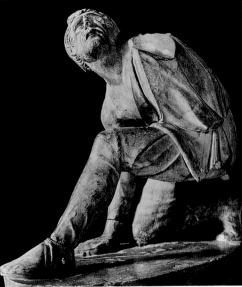

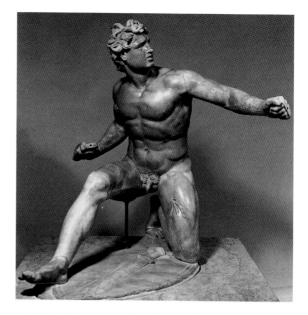

127 Gaul. (Louvre MA 324. H: 83 cm)

128 Persian. (Vatican 2794. H: 73 cm)

129 Gaul. (Naples 6015. H: 57 cm)

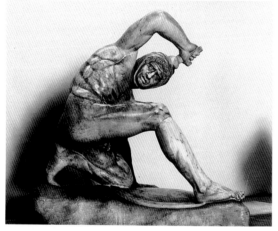

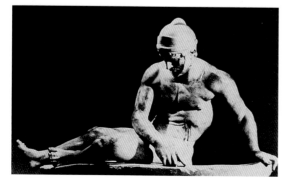

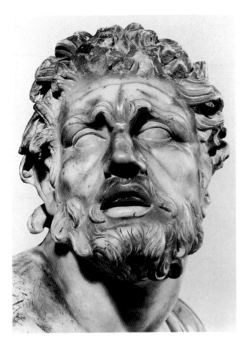

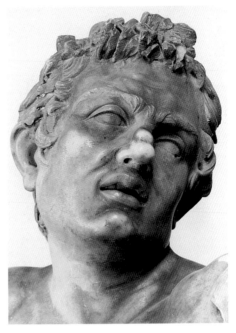

130 Small Gallic group. Kneeling Gaul.
(Venice 57. HdH 17 cm)

131 Small Gallic group. 'Falling' Gaul.
(Venice 55. HdH 16 cm)

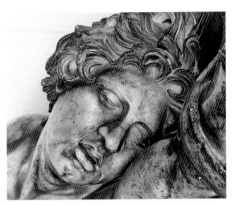

132.1–2 Small Gallic group. Dead Gaul.
(Venice 56. L: 1.37 cm)

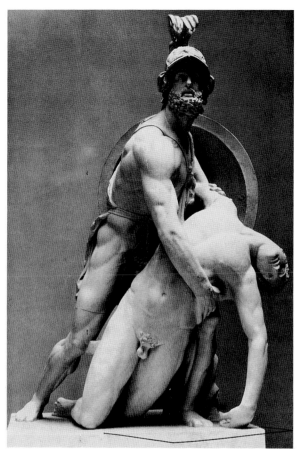

133.1–3 Pasquino. Menelaos with body of Patroklos. Copies of an original of c.250–200 BC. *(Left)* Cast reconstruction (Leipzig: B. Schweitzer). *(Below)* Menelaos head. (Vatican 694. H: 86 cm). pp. 104–5

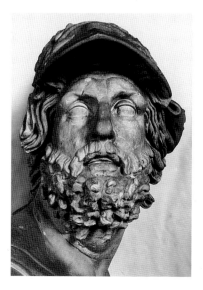

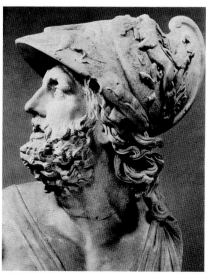

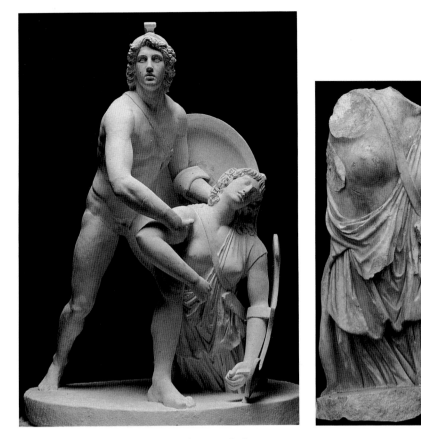

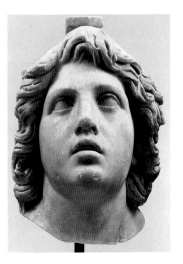

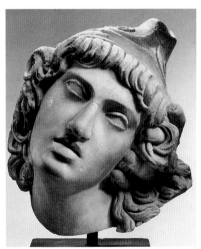

134.1-4 Achilles and Penthesilea. Copies of an original of c.250-200 BC.
1 Cast reconstruction (Basel: E.Berger). 2 Penthesilea torso (Aphrodisias).
3 Achilles. (Malibu 78.AA.62. H: 42cm). 4 Penthesilea. (Basel BS 214. H: 36cm). pp.104-5

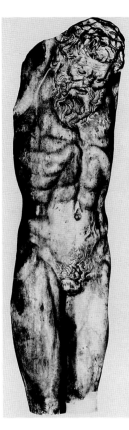

135.1–2 *(left)* Hanging Marsyas. Copies of an original of *c.*250–200 BC.
1 (Louvre 542. H: 2.56 m).
2 (Istanbul M 534. H: 1.31 m). p. 106

136 *(below)* Scythian Knifegrinder. Copy of original of *c.*250–200 BC, from same group as [135]. (Uffizi 230. H: 1.05 m). p. 106

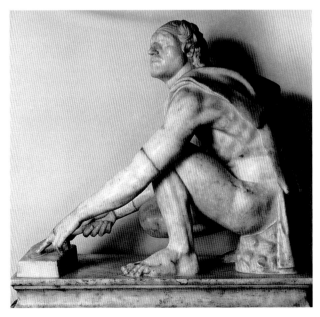

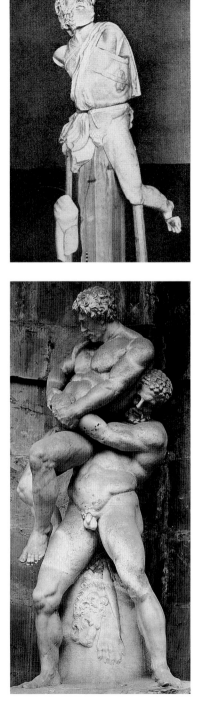

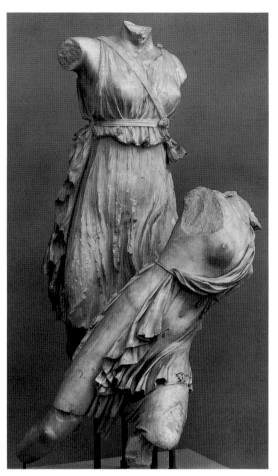

137 *(above left)* Daidalos from Philadelphia (Jordan). Copy after an original of 3rd–2nd cent BC. (Amman). p. 107

138 *(left)* Antaios and Herakles. Much restored copy after an original of 3rd–2nd cent BC. (Florence, Pitti Palace. Modern: heads, arms, lower legs. H: 2.90 m). p. 107

139 *(above)* Artemis and Iphigenia. Copy of an original of 3rd–2nd cent BC. (Copenhagen 481–482. H: 1.70 m). p. 107

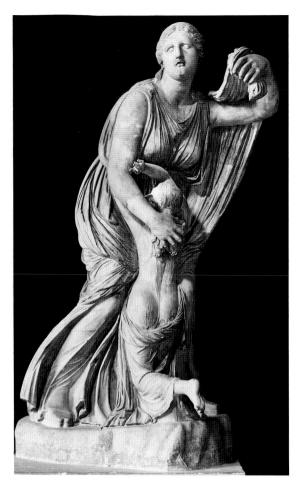

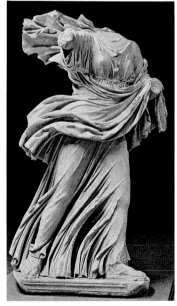

140 Niobe. Copy after an original of late 4th or 3rd cent BC. (Uffizi 294. H: 2.28 m). p. 107

141 Chiarmonti Niobid. Version of a statue from same group as [140]. (Vatican 1025. H: 1.76 m). p. 108

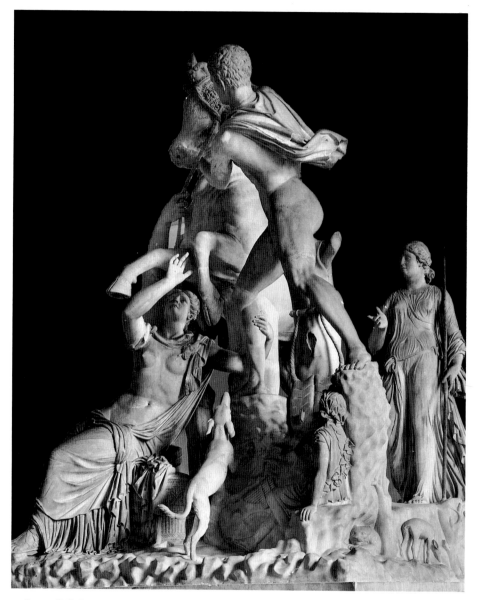

142 Farnese Bull. Dirce punished by Amphion and Zethos. Roman elaboration of a Hellenistic composition. (Naples 6002. Much restored. H: 3.70 m). p. 108

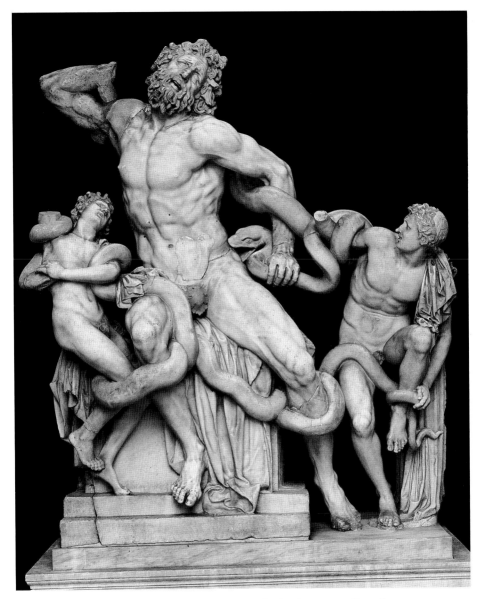

143 Laocoön. Trojan priest Laocoön and two sons attacked at altar by giant serpents. Copy after an original of *c*.200 BC. Copy made by same three Rhodians as *[147]*. (Vatican 1059, 1064, 1067. H: 1.84 m). pp. 108–10

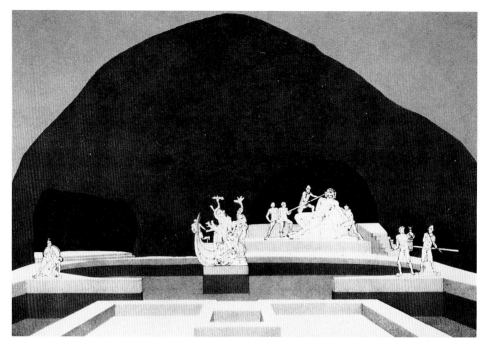

144 Reconstruction: B. Conticello

144–147 Sperlonga. Copies after Hellenistic baroque groups, made for cave-grotto of Roman seaside villa at Sperlonga. Later 1st cent BC or early 1st cent AD. (Sperlonga Mus.). pp. 110–11

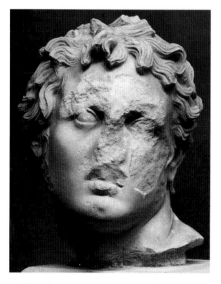

145.1–2 Diomedes with Palladion. Copy of an original group of 3rd–2nd cent BC. *(Above)* Diomedes. (H: 34 cm). *(Right)* Palladion. (H: 82 cm). p. 110

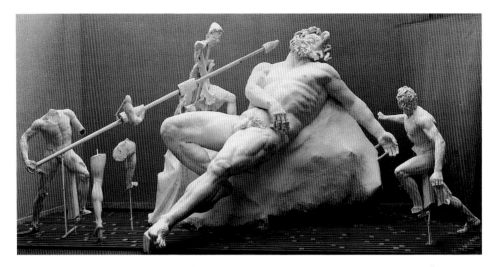

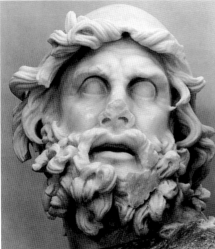

146.1–4. Blinding of Polyphemos. Copy of an original group of c.200 BC. 1 Reconstruction: B. Conticello. 2 (left) Odysseus (H: 64 cm). 3 (below) Wineskin-carrier (H: 2.21 m). 4 (below left) Head of wineskin-carrier. Copy from Tivoli. (British Museum 1860. H: 34 cm). p. 110

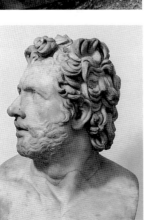

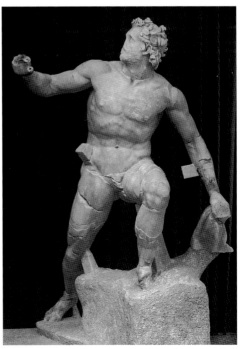

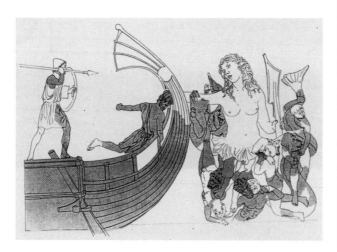

147.1–3 Sperlonga. Scylla attacks Odysseus' ship. Copy or version of an original group of *c*.200 BC. 1 Reconstruction (with ship folded back 90°): B. Andreae. 2 *(below)* Ship and Helmsman. (L: 2.90 m). 3 *(right)* Signature of the three Rhodians: 'Athanadoros son of Hagesandros, Hagesandros son of Paionios, and Polydoros son of Polydoros of Rhodes made it'. p. 111

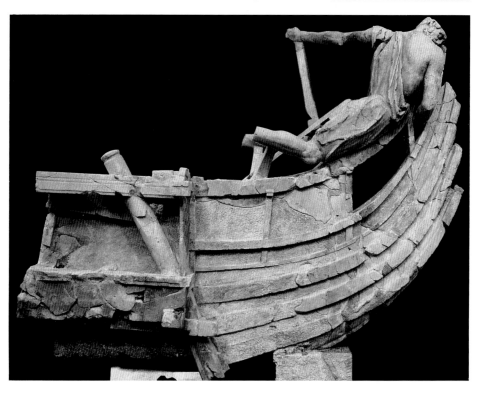

Chapter Eight

THE WORLD OF DIONYSOS

The realm of Dionysos was an ideal countryside populated by male satyrs and female bacchants. These were Dionysos' followers, his *thiasos* or 'festive band'. Their representation in statues was one of the most successful branches of Hellenistic sculpture. Their figures pervade private art of the Roman period and decorative art of the Renaissance and later. Their ebullient stylistic language is still easily read. The Hellenistic thiasos enlisted a progressively wider membership. New followers were added, like centaurs, nymphs, hermaphrodites, and Pan, who leave behind their own stories and are, as it were, mythologically disenfranchised in order to become part of the Dionysian realm. The full cast of the thiasos in action is best seen on the Dionysian sarcophagi of the second century A D *[332]*.

Dionysos was a particularly favoured Hellenistic deity. He was an 'international' god who answered needs at many levels of society. From a bearded Classical deity of seasonal agriculture and vintage, he became the soft Apolline youth of abundance. He was much favoured by the kings as a role model and putative ancestor, for several reasons: he was the conqueror and ruler of the East, a man who had become a god, and the master of royal *tryphē* – luxurious and magnificent living. His widest, most popular function, however, was as god of wine, laughter, and release. His agricultural aspects are replaced by the wider powers of a saviour god. Dionysos has little mythology. His only stories that are regularly represented are the Rescue of Ariadne and the Return from India, both of which provide space for the triumphant revelling thiasos. The thiasos has two essential features: it is impersonal and collective, and it inhabits the wild outdoors. It translates easily into real terms as an alternative, cohesive society, offering happy escape from the cares of city life. The thiasos in art was a parallel or simple allegory of the well-being secured by Dionysian worshippers in real life: their associations, naturally, were called thiasoi. Ideal Dionysian order was often a reversal of the normal order: civilized men became wild, women ran free, sex roles were reversed, and masks submerged identity. Dionysos had a darker, destructive side, as portrayed in Euripides' *Bacchae*, but it was reserved for opponents like Pentheus. Dionysian statues, the votives of worshippers, naturally represent the positive, beneficent side of the god. They are concerned with the joy, delight, happiness with which the god can suffuse the simple pleasures of song and dance. They represent Dionysian forces as tamed, benevolent, made safe.

The long description in Athenaeus (5.197–203) of a grand festival procession at Alexandria in the early third century BC shows well the close connections that existed between Dionysian art, life, and religion. Among much else, he describes floats with statues of Dionysos and sculptural tableaux of the Rescue of Ariadne and the Return from India, which are accompanied by hundreds of 'real' satyrs and maenads dressed as his soldiers and attendants. Statues of the kings were also carried, and royal abundance was clearly a central aspect of the procession: the king's beneficence to his subjects is like that of Dionysos to his followers. The procession is a vivid illustration of Dionysian art in action.

Great quantities of Roman marbles represent figures from the Hellenistic thiasos. They were used to make Roman villa gardens into parts of an ideal Hellenistic countryside, for which there was often no intention, indeed no need, to make recognizable replicas of particular statues. Subjects and motifs could be copied, adapted, and recast in endless variations. This is especially true of small-scale figures. A clear line between Hellenistic creations and their continuing decorative evolution at Rome becomes apparent, however, if we concentrate on major works known in multiple replicas in which an intention to copy can be judged. Except for a few references in Pliny before his caesura in 296 BC, this category of statues is almost wholly undocumented.

Satyrs, maenads, nymphs

Young satyrs and old Silenos figures had been with Dionysos since the Archaic and Classical periods and are familiar in vase painting. They were wild, drunken, and lustful. They soon lost their goat legs but retained animal ears, tail, and snub face. Myron's Marsyas, part of a fifth-century narrative group, was the first major statue of a satyr. Praxiteles, in the later fourth century, made at least two 'self-sufficient' satyr statues, that is, devoid of narrative context. They were the earliest 'genre' satyrs, and both were well known. One, called by Pliny the 'Periboetos', roughly 'World-Famous' (*NH* 34.69), is probably to be recognized in the Leaning Satyr type [*148*]. Its replication in more than fifty full-size copies (and many small versions) was no doubt due to the opportune conjunction in one statue of famous art work and appropriate villa ornament. The Leaning Satyr is a refined, cultivated being with soft, sinuous pose, and is recognizable as not human chiefly by his animal-skin garment. His ears are concealed, and his face is only slightly satyr-like. Praxiteles' satyr is important because it provides a fixed point at which to place the beginning of the rapid evolution of Hellenistic satyrs.

Hellenistic sculpture adds a whole range of satyr types and styles, from vigorous, beast-like youths to more reflective older figures. Many are portrayed in a light and elegant style (*lēptos, glaphyros*), which expresses Dionysian playfulness and merriment. Others deploy formal language from the Hellenistic baroque which signifies a more 'serious', dignified, or even grand tone (*semnos,*

axiōmatikos, megaloprepēs). These are not so much opposed styles as different aspects of a formal range designed to represent the various characters and moods of these ideal creatures.

The classic older 'humane' satyr is the Silenos with Baby Dionysos [149], a major work, probably early Hellenistic, known in fine replicas. The crossed-leg, leaning pose recalls the Leaning Herakles, but this can hardly demonstrate an attribution to Lysippos. The Borghese Satyr [150], a statue known in several copies, is also older and 'serious' but very different in expression. It is a brilliantly poised, spiral figure, with a pensive, distinctly 'Socratic' head, which is concentrating on playing the double flute. The subject is perhaps Marsyas, the most intelligent and human of satyrs. Similar dancing satyrs are quite common in small bronzes, both Hellenistic and Roman, for example a fine statuette from Nikomedia [151] and the famous Dancing Faun from Pompeii. They are free essays on a familiar motif.

Praxiteles' Leaning Satyr [148] was soft, plump, and precociously human. For young satyrs, Hellenistic sculptors created a new and distinctive style of body and head. The body is tall, slender, wiry, and the head has thick, sprouting hair and round grinning face, with prominent goat-ears. The face is clearly non-human and the sinewy muscle-style of the body, though derived from athletes, also has an uncanny animal effect, hard to define, but recognizable even in headless torsos as 'satyr', not 'athlete'. Fine, major examples are the types of the Capitoline Fauno Rosso [152] and the Aphrodisias Satyr with Baby Dionysos [154]. The older Satyr with a Wineskin [156] is similar, but in deliberate contrast to these taut youngsters he has a flaccid body spreading at the waist. He reclines drunkenly, right hand raised snapping his fingers to the music of the (unseen) thiasos. His face has a scrappy beard, but he laughs, showing his teeth: a sign of Dionysian *hilaritas*, the happy laugh of the carefree. None of these satyrs is externally dated, and there are no dated comparanda after Praxiteles. In anatomical style they seem later than Lysippos: third or second century. Their formative period should be placed in the third century when we have evidence for greatly intensified Dionysian activity under royal patronage, most notably at Alexandria.

Of the female followers of Dionysos, we have much less. There was a Classical cycle of maenad reliefs, but statues are attested only from the mid–later fourth century. A rhetorical description (*ekphrasis*) by one Kallistratos (third century AD) describes a raving maenad by Skopas at this date, and Pliny records a drunken flute-girl by Lysippos (*NH* 34.63: *temulenta tibicina*). This last is probably identical with a statue type, known in good copies, of a lightly clad girl, dancing with one breast bare [155]. The subject, 'flute-girl', sounds an unlikely genre subject for a major fourth-century statue, and it is easier to take the subject, both in the Pliny passage and the statue, as a drunken maenad. In style and tone, the statue fits well as a female counterpart to the Borghese Satyr [150]. A well-known small figure of a dancing maenad in Dresden carries the

torsion of the pose further. Although it is over-optimistic to see here Skopas' maenad (there are no precise connections to the description and no other copies), it may reflect a statue composition of the late fourth or third century.

Dionysian females are best seen in three major satyr groups, all in the 'light' Dionysian style: the Invitation to the Dance, the Satyr and Nymph, and the Satyr and Hermaphrodite [157–159].

The Invitation to the Dance [157] was reconstructed and named by W. Klein who formed round it the idea of 'Hellenistic Rococo'. From a group featured on coins of Cyzicus, Klein recognized that the figures of a satyr and a seated nymph, known separately in copies, belong together in an open group like the Hanging Marsyas. ('Nymph' in this context means simply an ideal female of the Dionysian outdoors, a non-wild bacchant.) The satyr stamps time with a footclapper and snaps his fingers at the bare-chested coquettish nymph seated on a rock who is adjusting her sandal. He is a fine example of satyr style: tightly knit musculature and stringy, slightly bowlegged proportions. She has a slender, sub-Aphrodite body and a remarkable head [157.4] that defines a new ideal for the Dionysian female. The expressionless features of the Classical maenad are here replaced by a subtle, femine edition of a laughing young satyr: round face, dimpled cheeks, over-high cheekbones, pointed chin, and smiling teeth. Not a girl, not a satyr, but a new-style bacchant. Although the satyr retains his lustful potential, she has no trace of wildness. The raving, flesh-eating maenad of Euripides has become an elegant Arcadian dance-partner. This is a Hellenistic sculptural *fête champêtre*.

The Satyr and Nymph group [158], known in many copies, is smaller in scale and even lighter in treatment than the Invitation. It shows the Invitation's inevitable consequence: the satyr's sexual attack on the nymph. In Dionysian art, satyrs are usually condemned to eternal frustration. They stalk, court, and assault the bacchants, but rarely achieve their goal, because of course it belongs to the imagination of the viewer. In the Satyr and Nymph group, pose and style convert rape into play. The satyr's seated position is hardly effective, hardly 'serious', and he is made unthreatening by extreme youth and playful expression. The powerful satyr from the Invitation group deployed here might have made a different story. The nymph too, is very young. Her pose recalls the Crouching Aphrodite [102] and her head is closely related to that of the nymph in the Invitation. The composition is compact but with limited viewpoints.

The Satyr and Hermaphrodite group [159], also known in many copies, is altogether different. It is a remarkably daring composition to be viewed all round, and the intertwined poses and the identity of the figures have to be explored in order to be understood. It is an explosive, momentary design. The moment represented is just after that in the Satyr and Nymph group: the Hermaphrodite, struggling to escape from between the satyr's legs, thrusts its hand in the satyr's face, and the latter falls back off-balance. Both figures are slender and elegant. The action and the victim's body-forms would lead the

viewer to expect a nymph or maenad, and only exploration reveals it to be a hermaphrodite. Its head is related to those of the smiling nymphs in the two previous groups and shows that, despite the vigour of the action, we are still in a trouble-free, Arcadian world, where attempted rape is Dionysian play. The group demands an outdoor, scenic context. It is reproduced in a Pompeiian painting in an open landscape setting, and a good marble copy of the group was found recently by the great tree-lined pool of the Roman villa at Oplontis. It is obvious this composition was designed first as a sculptural group, not as a painting, and this is surely true for other groups known in both sculpture and painting. The painting shows the piquant contrast of white hermaphrodite and dark-skinned satyr, and it is conceivable such an effect would have been attempted in the original, either with a combination of materials or more likely of dark and light patinated bronzes.

All three satyr groups just discussed are known in many close copies and were clearly major Hellenistic works. Their date within the Hellenistic period is impossible to determine with any precision. Erotic groups like these were called *symplegmata*, 'entanglements' or 'figures entwined', and two general references in Pliny (*NH* 36. 24 and 35) provide dates in the early third and later second centuries: Kephisodotos the son of Praxiteles (active *c.* 290 BC) was known for a highly realistic *symplegma*, and one Heliodoros made a *symplegma* of 'Pan and Olympos'. Heliodoros was the father of a sculptor known to have been active in the early first century and so himself worked in the later second century.

A major group of Pan teaching Daphnis the pipes [160], known in copies, may allow us to visualize Heliodoros' work more precisely. The 'Pan and Olympos' attributed to him by Pliny is a mythological *non sequitur*, since Olympos was the son and musical pupil of Marsyas; so he is perhaps an error for the shepherd boy Daphnis, Pan's more usual pupil. Pan was the lustful goat-god of the countryside. He enjoyed a strong cult as an independent deity in rural Macedonia under Antigonid patronage, but during the Hellenistic period he was also subsumed into the Dionysian realm. In form he was often closely related to satyrs, and it is possible Pan was intended as the assailant in the Hermaphrodite group [159]. However, his canonical Hellenistic form, as seen in the Daphnis group, is with strong goat-legs and a remarkable man-goat synthesis for his head. His normal Dionysian role was pure, single-minded lust, a quality well captured in this extraordinary 'goatish' portrait. The ostensible music instruction of Daphnis thus has strong erotic overtones.

Centaurs

A famous Classical painting of a centaur family by Zeuxis included old, young, and female centaurs, and prepared the way for the Hellenistic centaur. Enabled by Zeuxis to reproduce themselves in a family community, the centaurs foreswore their old Classical ways of wild rape and violence, and joined the

Dionysian thiasos as harmless chariot teams and carousing partners for satyrs [332].

Fine black marble copies of a Young and an Old Centaur [162, 163] were found together in Hadrian's villa at Tivoli and show that they formed a pair. The colour of the copies and the thin equine legs suggest the originals were of bronze. This pair combined, in the one group, the two Dionysian stylistic modes, the light and the serious (*lēptos* and *semnos*). Although Dionysian in context, the group was also a mildly allegorical study in the contrasting natures of youth and old age. The animal iconography and satyr style ensure that the allegory, while obvious, is not transparent. Other versions show that both centaurs had small figures of Eros on their backs [161] to which they are shown reacting very differently. The Young Centaur, probably goaded by an arrow (as seen on gems), raises one arm in a vigorous, 'free' gesture and laughs in delight at the jabs of Eros. The Old Centaur, by contrast, has his hands tied behind by Eros, and his old bearded head responds to the god of desire with the full pathos of a baroque hero. Their bodies too make use of subtle contrasts. The Young Centaur has thick, tightly-knit muscles and a springing step which indicates the compressed energy of lustful youth. Beside him, the Old Centaur is unsure, a little tired. Light Dionysian style here expresses carefree youth, while the baroque shows the suffering of age, here allegorized as the torment of physical desire.

Pliny records in the *Saepta* or Voting Enclosure at Rome two Hellenistic groups, clearly a pair, of disputed authorship: 'No less is it argued who made the Olympus and Pan, and the Chiron with Achilles in the Saepta' (*nec minor quaestio est in Saeptis, Olympum et Pana, Chironem cum Achille qui fecerint, . . : NH* 36.29). The Chiron group must obviously have represented the old centaur Chiron instructing Achilles. There are numerous reflections in painting of such a group – surely this one. The best, a large picture from Herculaneum, shows that the Chiron was a serious and noble old creature. A large and exceptionally fine centaur head in the Conservatori [164], though clearly not from this group, may allow us to envisage the powerful effect of the Chiron. This head has a tremendous baroque strength in which an intense vigour replaces the suffering of the Old Centaur [163]. Its ferocious glance also sets it apart from the paternal centaur of the group seen in the Herculaneum painting. These older centaur images reveal a surprising range of expression within the more 'serious' Dionysian style – what we may call the 'Dionysian baroque'.

The other group in the Saepta also represented mythological instruction. Pliny again illogically calls it 'Olympos and Pan'. He might mean '*Daphnis* and Pan', which some would then see in the Naples Pan and Daphnis group [160] discussed above. However, neither the homoerotic subject nor the light manner of the Naples group would accord well with the evidently dignified tone of the Chiron and Achilles. It is better to suppose Pliny meant 'Olympos and *Marsyas*', a more suitable and comparable theme of sober, paternal instruction. It could

well then be this group which is reflected in the fine painting of Olympos and Marsyas that was paired with the Chiron and Achilles picture at Herculaneum. The painting shows an older, seated Marsyas, with heavy, powerful musculature, and a young Olympos standing by. If one wants to visualize a sculptured version of such a Marsyas, the Belvedere Torso [165] might serve well. The famous Torso is seated, not on a lion-skin of Herakles, but on a panther-skin, the regular animal wear of satyrs. It sits on a rocky base which indicates a figure of the outdoors, and it has a hole in the small of its back that can be explained as a dowel hole for the addition of the short stub of a satyr's tail. The signature on the base of an Athenian sculptor, one Apollonios son of Nestor, is that of a high-grade copyist, like those on the Borghese Warrior [54] and the Sperlonga Scylla [147]. The panther-skin shows the Torso must belong in the realm of Dionysos, and it was no doubt, like the Old Centaur, a copy after a great work of the Dionysian baroque, perhaps, given its heroic scale and style, a Marsyas. Another heroic torso [167] shows that satyrs were certainly a fit subject for such grand and intense body studies.

Sleeping Hermaphrodite

There remain two remarkable works from the world of Dionysos in which we can trace a high level of artistic thought: the Barberini Faun, from a stylistic environment similar to that just discussed, and the rather different Sleeping Hermaphrodite.

The Satyr and Hermaphrodite group [159], we saw, used the Hermaphrodite's bisexuality as a surprise within an overtly erotic composition. The figure of the Sleeping Hermaphrodite [169] is concerned with the subject's bisexuality in itself. Hermaphrodite, born of Hermes and Aphrodite, was a minor deity worshipped from the fourth century BC. Some idea of a 'straightforward' cult figure of this god may be had from a large statue from Pergamon [187]. Hermaphrodite also had an aetiological myth which traced its bisexuality to an obsessive union with a nymph Salmacis (Ovid, Met 4.285). The statue of the Sleeping Hermaphrodite is clearly separate from both these aspects. It is neither a cult nor a mythological figure. It is a figure of Dionysian art, taken as the subject of a self-contained 'study', like the pair of centaurs.

The Hermaphrodite is a lying figure composed in a long spiral posture. The back view is the more effective and clearly the principal one. This was no doubt programmed in some way in its original setting. The proportions and forms from behind are clearly female; only exploration round the figure revealed its bisexuality. This is more than the playful surprise of the Satyr and Hermaphrodite group, because the viewer has been more thoroughly prepared to expect a female – a sleeping nymph, for example. There is however a further, more precise visual reference. The back view of the Hermaphrodite seems to be a loose quotation from a late Classical painting (known in good copies from

Pompeii) of the sleeping Ariadne about to be rescued by Dionysos. Thus the viewer is conditioned to expect in the statue not just a sleeping bacchant or nymph, but a sculptured version of the sleeping Ariadne, a familiar and seductive image of the naked heroine. The head, also visible from behind, reinforces this expectation. It is not one of the new Hellenistic 'girl-satyr' heads, like those of the Hermaphrodite and nymphs in the satyr groups discussed earlier [157–159], but a refined and ideal Classical female head. It both arouses the expectation of a heroine and raises the 'level' of the Hermaphrodite once discovered.

The figure is certainly asleep, and the raised lower leg must be rightly interpreted as 'troubled sleep', the obvious meaning it has for the figure of Ariadne in the painting. The only thing the solitary Hermaphrodite can be troubled by is its sexuality. As we saw in the context of naked Aphrodites (Chapter 6), the relative merits of a male versus female erotic ideal were vigorously debated by the ancients. 'Technical' arguments from physical form were very important, and as objects of male desire only boys or women qualified. It was natural then that the Hermaphrodite, which at one level represented a Utopian amalgam of the sexes, should have a female body with male genitals. A man's body with female sex parts would have held no interest, would have 'lost' on all counts. The perceived physical advantages of female form had to be weighed against the accepted moral advantages of male sex (intellect, morality, culture). The Sleeping Hermaphrodite made the 'erotic' issue of boy versus woman its subject. The (male) viewer was invited to respond to the female back view and was then asked to consider a different response after going around the figure. The statue's purpose then was a part serious, part playful engagement of the viewer's ideas of eroticism.

Only one Hermaphrodite is recorded in Pliny, a *hermaphroditus nobilis*, by a sculptor called Polykles (*NH* 34.80). *Nobilis* here probably has the sense, common in Pliny, of 'renowned' or 'famed', although 'dignified' would also be possible. The sleeping figure is the only major Hermaphrodite known in copies, and so could well be that referred to by Pliny. It is a sufficiently striking and original work to be 'famed' and sufficiently serious to be 'dignified'. Polykles was a common name in a well-known family of Athenian sculptors, and we cannot be sure which one Pliny meant. The context in which he is mentioned is an alphabetical listing of mostly Classical and early Hellenistic sculptors. This may exclude the two sculptors called Polykles known to have lived in the second century, who are normally the favoured candidates – but only because we happen to know more about them. The sculptor of the *hermaphroditus nobilis* mentioned by Pliny was more likely an early Hellenistic or third-century Polykles.

Barberini Faun

The Barberini Faun *[168]* is also a sleeping figure that requires examination to discover its identity. It represents, at first glance, a youth asleep in a provocative posture, but who turns out to be a satyr, recognizable only close-up by his ears and animal-skin rug. He is lying in a rocky setting, and we are to suppose he had fallen asleep drunk in the woods. He could not be more different from the Sleeping Hermaphrodite. The Hermaphrodite is all elegance, art, classic form, complexity, concealment. The Faun's slumped, sprawling body, on the other hand, aims to look relaxed, natural, open, straightforward. The Hermaphrodite is ostensibly heteroerotic (but is not), while the Faun, also with the male viewer in mind, is overtly homoerotic. The sleeping motif gives the 'sex-appealing' posture innocence, and the satyr format removes it a small but essential distance from reality – it provides the pretext for rendering such a pose in a monumental statue.

The apparent naturalness of the Faun and the artistic management of its 'ungainly' pose make it a most striking work. The pose has distant echoes in the Sperlonga Polyphemos, and the body is in an unusual style for the subject. Instead of the distinctive satyr musculature of, for example, the Invitation Satyr *[157]*, it prefers a heavier baroque musculature more like an epic hero. The style elevates the figure, makes it a more 'serious' work. The head also has little overt satyr iconography. It retains some faint animal traces, like the tuft of hair on the forehead, and has slight non-human adjustments in the physiognomy. The features, however, are strongly characterized, individualized in a way reminiscent of the Scythian Knifegrinder *[136]*, but with a very different expression. This is a brilliant 'portrait' study of a satyr.

The idea of a sleeping satyr was intentionally something of a paradox or role reversal. In the world of Dionysian art, naked Ariadnes, bacchants, and Hermaphrodites sleep in order to be found, looked at, spied on, by satyrs, Pans, and us the viewers. Satyrs, on the other hand, are meant to be active, dancing, drinking, lusting, making music – eternally awake. The sleeping Faun reverses the natural order, and the viewer here spies, not on a female, but on a sexually provocative male. The Sleeping Eros *[84]* embodied a similar reversal, since the young god's defining role was to awaken desire: Eros asleep is no Eros at all. There, however, the ostensible subject was simply the innocent sleep of infants.

The Faun was discovered in Rome in the early 17th century, reportedly at the Castel Sant'Angelo. Like the Laocoön, it has no other copies or versions, but is thoroughly and convincingly Hellenistic in style and effect. And, as with the great Conservatori centaur head *[164]*, it is not obvious whether it is of Hellenistic workmanship or a superb marble translation made later. The baroque-style body and the relation of the head to the Knifegrinder suggest a mid-Hellenistic date for the design.

Genre and peasants

Part also of the Dionysian countryside is an impressive series of old labourers, derelict women, and peasant boys. Many carry explicit badges of Dionysian membership, like ivy wreaths, and most should be seen as part of his realm. They have in common with satyrs and nymphs that they are figures of the outdoors and are without true personal identity. Only a thin iconographic line separates the Sleeping Faun from pure genre. Genre studies of everyday and low-life subjects for their own sakes were something new in major statues. Sculptors evolved new statues and styles for human subjects for which there were no existing art types. It is sometimes said that the major genre figures are later than the Hellenistic period, that the whole phenomenon is Roman. Both literature and copies, however, show that genre statues were a part, probably a small part, of the Hellenistic repertoire. We hear of clearly genre statues of 'an old man' and of 'a little boy strangling a goose' in a third-century temple (Herodas 4.30–1). Pliny attributes to different artists 'a drunk old woman', another 'boy strangling a goose', and unspecified 'old women' (NH 34.84 and 86; 36.32). There are copies of statues with similar subjects which have clear formal connections to certainly Hellenistic works. There can be no serious doubt that the major genre statue types were created in the Hellenistic period.

A group of a Boy Strangling a Goose *[170]*, known in several good replicas, is genre only in subject. The boy is formally close to the Sleeping Eros in both head and body, and the elaborate pyramidal composition seems to echo heroic groups. This is an anecdotal subject treated in the ideal manner. We do not know whether the group is the one mentioned by Herodas (4.31) and/or the one attributed by Pliny to a Boethos (NH 34.84), whose date and further identity are unknown. Herodas is useful in giving a third-century date for this kind of subject and a context for this kind of statue: a votive in a temple of Asklepios. Such a group may have been a parent's thank-offering for a successful healing of their child by the god, but it could also have been dedicated for other reasons, not necessarily relevant to its subject.

Two other works representing young boys, the Biter group *[173]* and the Spinario or Thorn-puller *[171]*, are by contrast pure genre. The Biter, known in a single incomplete but fine copy, showed two youths fighting over a game of knuckle-bones. The subject is recorded in major ideal statuary of the Classical period: Pliny (NH 34.55) records nude knuckle-bone players, *astragalizontes*, by Polykleitos. Our group gives a Hellenistic low-life version. The main surviving figure in the copy is vigorously biting his opponent's arm. The pose and the thick leathery cloth of his tunic are highly realistic; the short tunic is peasant-wear; and the boy's head is excellently characterized as 'low' and 'rustic' by his lean, hungry features and tall brow. This is a genre 'portrait' in the tradition of the Scythian Knifegrinder *[136]*, here in an adolescent edition.

The Spinario, a seated boy pulling a thorn from his foot, is an attractive

lifesize figure known in a variety of versions. The thorn-in-foot motif was popular for satyr and Pan figures, and connects the Spinario to the Dionysian world. Thorns are a hazard only in the countryside and only to the genuinely barefoot. The thorn motif both places the boy in the country and draws attention to the reality of his nakedness. The figure was popular and may have had more than one authoritative edition or prototype. It was later variously reproduced and with different heads. Several close marbles, however, clearly aim to copy more than the pose and motif. One of these, in the British Museum [171], preserves its head, which is an interesting and convincing genre study of a country boy, with clear relations to the generic Artemision Jockey [58]. This figure is clearly a good copy of a single Hellenistic work.

A small terracotta Spinario from a house in Priene [172] gives a caricatured interpretation of the figure. It can make several points for us. First, it wears a real peasant cap and tunic and thus shows up the large ideal component in the full-scale Spinario. Second, it has ugly, caricatured features and an enlarged phallus which place it in the realm of grotesques and caricatures that exist only at this scale and for a very different (private, apotropaic) function from that of the lifesize figures. And third, its context in a Hellenistic house at Priene assures a Hellenistic date both for the Spinario composition and for the beginning of such grotesques. The comparison of the major and minor Spinarios reveals the unspoken limit placed on genre realism in statues. The more awful human afflictions – disease and deformity – were confined to figurines, designed primarily to scare off the evil eye. Poverty and old age, however, were acceptable subjects for statues, because they were in some ways redeemable.

There are three major genre figures known in multiple replicas (a Drunk Old Woman and two Old Fishermen), while several other important figures and heads are known in single versions. A significant number of these figures were made at the unusual scale of about two-thirds lifesize. No doubt, small scale expressed the low status of the subjects. Smaller size might assuage any sense of impropriety at the representation of such lowly subjects in fine statues.

The Drunk Old Woman [174] was a full-scale work, evidently of some importance. There are two good copies (Munich, Conservatori) and numerous reflections of it in the minor arts (statuettes, figure vases). It represents an old woman sitting on the ground clutching a wine jar and looking up at the viewer. The apparent naturalism and realism are achieved, as often, with much artifice in the drapery and structures of body and head. The jar is a well-known Hellenistic type, and clearly recognizable as a wine container by the Dionysian ivy on its shoulder. The woman is clearly meant to be drunk, but to see her as a genre study of aged alcoholism would reflect a modern perspective. She is, rather, a laughing figure, in the care of the wine god. She bares her teeth like trouble-free satyrs and maenads: she is *hilara* – merry or exhilarated. Her body is ruined by age, emphasized by her exposed bony shoulder. Her dress has slipped, in drunkenness perhaps, but also as an ironical or mock-coquettish reference to

her vanished sexual attraction. The figure is both a study of old age and a statement of Dionysos' powers. He can make an old hag laugh at her fate and at the passing viewer. The wine jar she clutches may be of a type called a *lagynos*, and we know of a particularly drunken Dionysian festival at Alexandria, called the *Lagynophoria*, established in the later third century by Ptolemy IV, a great devotee of Dionysos and of this festival. The statue might then have been a votive connected with such a festival, and the jar, if correctly identified, would be used as a visual reference to it. Pliny records a 'drunken old woman' in marble by Myron, evidently meaning the famous fifth-century sculptor (*NH* 36.32). This is clearly a misattribution, but it does reflect a perception of such statues as part of the highest artistic endeavour.

Two other old women, known in a single version each, are closely connected to the Drunk Old Woman and also overtly part of the Dionysian world: the head of a Laughing Old Hag in Dresden [176] and the New York Old Market Woman [*Frontispiece, 175*]. Both wear ivy wreaths. The New York Woman also wears a fine dress and delicate sandals, clearly her best, not for the farmyard. She is walking, on her way to a Dionysos festival at which the Dresden woman has already arrived.

The old peasant men are close in style and themes to the women. The Conservatori Old Fisherman [178], known in two copies, has the same walking and carrying theme as the Market Woman. Her basket contains poultry; his is full of fish, and, like her, he is probably on his way to a festival, not just to market. He wears a rather grand, full cloak which can hardly be his everyday fishing wear. The body, carefully copied in the two replicas, is a fine study of lean old age, hardened by work. The bearded head (wearing peasant cap) has formal analogues with portraits like the fictional Blind Homer [35] which should indicate a late third-century or broadly mid-Hellenistic date.

An extreme limit in realistic genre is represented by the 'Seneca' Fisherman type [179], a full-scale figure known, extraordinarily, in about seventeen copies. The exaggerated black marble version in the Louvre, once taken for the Stoic Seneca in his suicide bath, gives the type its name and suggests the original was bronze. In conception, he is very different from the Conservatori Fisherman. The figure wears only a peasant's loin cloth and stands still, stooping, with a basket and probably a fishing rod in his hands. He is not on his way to a festival but at work in his everyday wading wear. His body is bowed by age, and his head uncompromisingly 'realistic'. The face with short scrappy beard, thick lips and high level of pathos has clear connections with the fictional Pseudo-Seneca portrait [36]. If this portrait type (also once taken as Seneca) represents Hesiod, as is very possible, the connection with the fisherman makes clear sense, since Hesiod was the poet of rustic labour.

Major genre statues, like most others, were the dedications of a wealthy élite. Real fishermen obviously could not afford them – their votives were fishing tackle, epigrams tell us. Any statue was a suitable votive for a god. Pliny the

Younger explains in a letter (*Letters* 3.6) that he is thinking of dedicating a genre bronze of an old man that he has recently acquired in the local temple of Jupiter: it is a fitting dedication simply because it is a fine work. Votives may have relevance to the god, but need not. The old women, we saw, were most likely Dionysian votives. The old peasants and fishermen are less obviously 'cult-directed': Dionysos or another god would be appropriate. Since other kinds of statues would have been equally suitable, we may ask why some of the urban élite chose to commission derelict rustics as votives. What were statues of old fishermen meant to express?

Although we may reasonably detect a patronizing, élitist cast of mind in these statues – for example, an innate brutish lack of self-control in peasants and slaves is an essential premise of the Biter group *[173]* – it can hardly have been the statues' primary purpose to express this. The statues are to be seen rather as objective, neutral portrayals of poverty and old age. They were not designed to make moral or class statements, either negative or positive. That is, they expressed neither a sneering attitude to the lower classes nor a concern to idealize the life of labour – they are not studies in the dignity of human toil. For ancient men of high status, hard work was something horrible, the result of being given poverty as one's lot by the gods. The theme is sounded from Hesiod to Theokritos. As in literature, the statues aim to make a telling contrast of subject and medium. Theokritos wrote of shepherds and whores in recondite Doric hexameters, and fine, technically exquisite bronze statues represented derelict fishermen. If the baroque groups dealt with Homeric man and nobility through suffering, the genre statues are concerned with Hesiodic man and rustic toil. Their themes are those of Hesiod's *Works and Days*: poverty requires incessant labour which makes you old and feeble. As one fisherman says to another in his cabin in Theokritos' *Idyll* 21: 'poverty is the true teacher of labour'. The statues are about human mortality, but of a particular kind that was new to major sculpture. Heroes combat mortality by glorious deaths, philosophers by intellectual insight, but peasants can only labour and die.

Dionysian and genre statues could be dedicated in traditional temples and sanctuaries like any other statues. The viewer would mentally supply any setting the figures required. In Roman villas we know copies of these statues were displayed in quasi-naturalistic outdoor settings: satyrs among bushes and trees, fishermen by pools. It is very probable that such displays had precedents in Hellenistic royal gardens, like those in the palace area at Alexandria, and in Hellenistic parks attached to sanctuaries, like those of Apollo at Daphne near Antioch or the extended park on the acropolis at Rhodes. A variety of evidence attests a new interest in the Hellenistic period in an appropriate landscape setting for statues. The Nike of Samothrace *[97]* and the Scylla group *[147]* both required water settings, the Polyphemos group a cave *[146]*. The display of the groups at Sperlonga may owe something to an original setting in grotto-parks like those which have been found on Rhodes. We hear of a statue of the poet

Philitas set under a tree (Athenaeus 13.598e), and a tree was an integral part of the composition in the Hanging Marsyas *[135]*. On Delos and at Kamiros on Rhodes, statue bases for Hellenistic bronzes have been found carved in the form of a naturalistic rock mass. These would lend a rustic reference to statues set up in fully 'urbanized' sanctuaries. Natural rock bases are preserved with copies of the Spinario *[171]* and Invitation Nymph *[157]*, with the Barberini Faun *[168]* and the Belvedere Torso *[165]*, and were no doubt part of their original compositions. Other figures like the Sleeping Hermaphrodite *[169]*, Sleeping Eros *[84]*, and the Satyr with Wineskin *[156]* must also have had 'natural' bases.

The best evidence for the function and variety of major genre statues that would have been encountered in a typical Hellenistic sanctuary is Herodas' *Mime* 4. It is a short genre depiction of the visit of two middle-class women and their slave-girl to a temple of Asklepios (perhaps on Kos) in the mid-third century. They make a prayer, sacrifice a cock, set up a tablet recording it, and then review the more prestigious votives on display. They see a votive statue of Hygieia by the sons of Praxiteles, a portrait statue of a prominent local woman, no doubt of the usual draped type *[112]*, and what are clearly genre statues of a 'girl looking up at an apple', an 'old man', and a 'boy strangling a goose'. The women also discuss a relief and a painting of a sacrifice scene. This text illustrates vividly the easy mixture of subjects and categories of votive statues in a typical third-century temple.

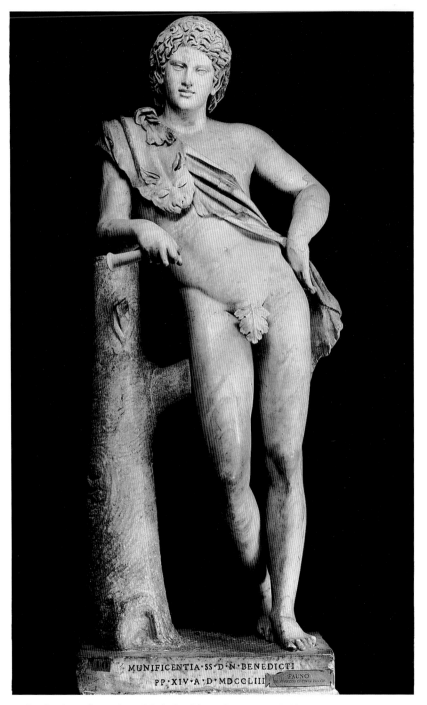

148 Leaning Satyr. Copy of an original of mid-later 4th cent BC, probably by Praxiteles. (Capitoline 739. H: 1.71 m). p. 128

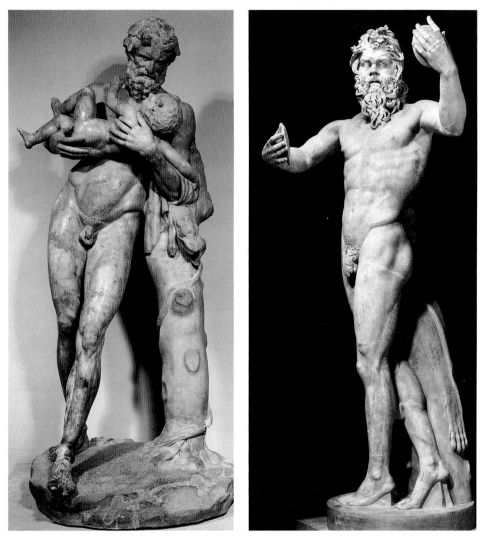

149 Silenos with Baby Dionysos. Copy of an original of *c*.300 BC. (Louvre MA 922. H: 1.90 m). p. 129

150 Borghese Satyr (Marysas?). Copy of an original of *c*.300 BC. (Borghese 802. H: 2.05 m). p. 129

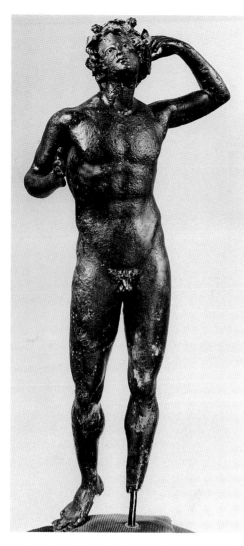

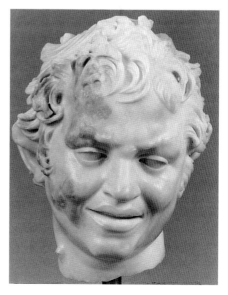

151 Satyr from Nikomedia. Bronze, 3rd cent BC. (Istanbul 5985. H: 61 cm). p. 129

152 Fauno Rosso. Red marble, from Hadrian's Villa. Copy of an original of 3rd–2nd cent BC. (Capitoline 657. H: 1.68 m). p. 129

153 Satyr (Fauno col Macchia). Copy after an original of 3rd–2nd cent BC. (Munich 222. H: 25 cm). p. 25

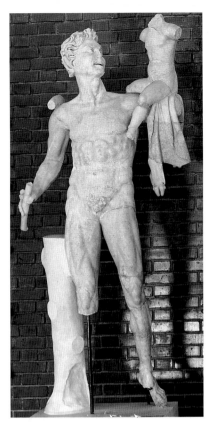

154 *(left)* Satyr with Baby Dionysos. Sinewy youthful style. Copy (from Aphrodisias) of an original of 3rd–2nd cent BC. (Aphrodisias Mus. H: *c.*1.75 m). p. 129

155 *(above)* Dancing Bacchant. Copy of an original of the late 4th cent BC, probably identical with the Drunken Flute-Girl by Lysippos. (Berlin 208. H: 1.18 m). p. 129

156 Satyr with Wineskin. Snaps fingers of right hand. Older flabby figure. Copy of an original of 3rd–2nd cent BC. (Naples 5628. L: 1.37 m). p. 129

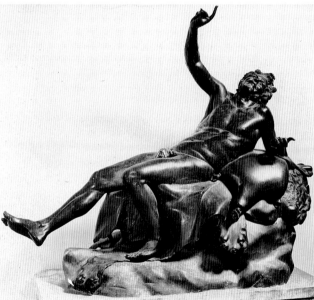

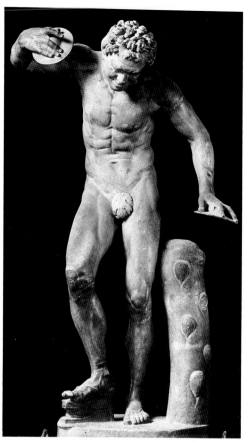

157.1–4 Invitation to the Dance. Satyr beats time with cymbals and foot-clapper, while seated nymph removes sandals: Hellenistic fête champêtre. Composition known from coins of Cyzicus. Copies of an original of 3rd–2nd cent BC. 1 Coin of Cyzicus (c.AD 200). 2 Satyr. (Uffizi 220. H: 1.43 m). 3 Nymph. (Brussels. H: 80 cm). 4 Nymph. (Venice 63. H: 46 cm). p. 130

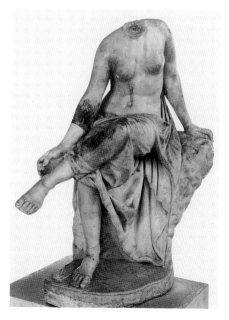

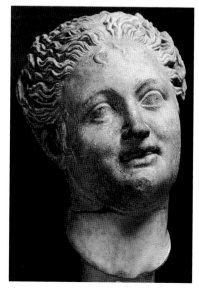

158 Satyr and Nymph. Copy of
an original of 3rd–2nd cent BC.
(Conservatori 1729. H: 60 cm).
p. 130

159 *(below)* Satyr and
Hermaphrodite. Copy of an
original of 3rd–2nd cent BC.
(Dresden. H: 91 cm). p. 130

160 *(opposite)* Pan and Daphnis.
Lustful man-goat Pan gives
shepherd Daphnis musical lesson.
Copy of an original of 3rd–2nd
cent BC. (Naples 6329. H: 1.58 m).
p. 131

161–3 Old and Young Centaurs. Copies of originals of late
3rd or early 2nd cent BC. p. 132

161 Old Centaur. Eros torments old man-horse. (Louvre MA 562. H: 1.47 m)

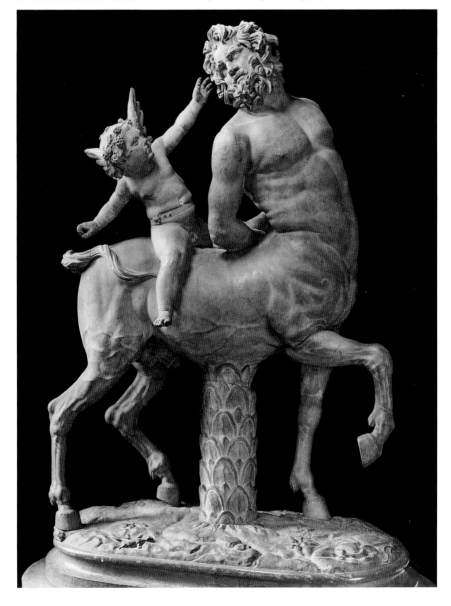

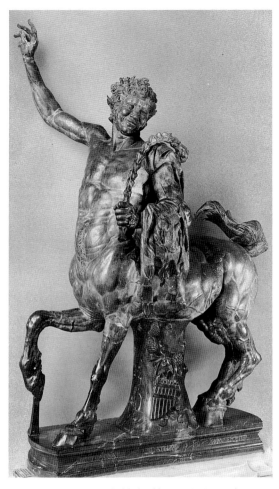

162 *Young Centaur.* Youth delighted by (missing) Eros. Grey-black marble copy from Hadrian's Villa. Signed by Aristeas and Papias of Aphrodisias, 2nd cent AD. (Capitoline 656. H: 1.56 m)

163 *(above right)* Old Centaur. Grey-black marble pair of /162/. (Capitoline 658)

164 *(right)* Centaur. Glowering heroism. Copy after an original of c.200 BC. (Conservatori 1137. H: 41 cm). p. 132

165 *(left)* Belvedere Torso. Figure of Dionysian baroque, seated on panther-skin, perhaps Marsyas. Copy after an original of *c*.200 BC. Copy signed by Apollonios son of Nestor of Athens, 1st cent BC. (Vatican 1192. H: 1.59 m). pp. 54, 133, 261

166 *(below left)* Satyr (Gaddi Torso). Copy after an original of 3rd–2nd cent BC. (Uffizi 335. H: 85 cm)

167 *(above)* Satyr. Heroic scale and style. Copy after an original of 3rd–2nd cent BC. (Naples). p. 133

Opposite

168 *(above)* Barberini Faun. Sleeping Satyr. Copy after an original of *c*.200 BC. (Munich 218. Modern: right leg, left forearm. H: 2.15 m). p. 135

169.1–2 *(below)* Sleeping Hermaphrodite. Ambivalent sexuality concealed: looks from behind like a sleeping Ariadne. Copy of an original of 3rd–2nd cent BC. (Terme 593. L: 1.47 m). pp. 133–4

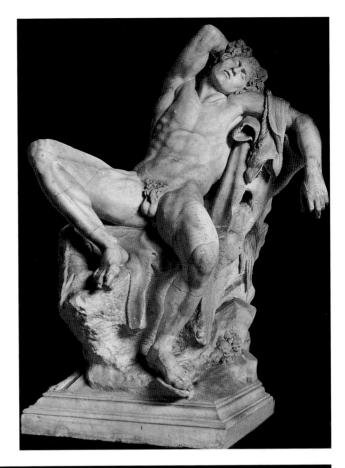

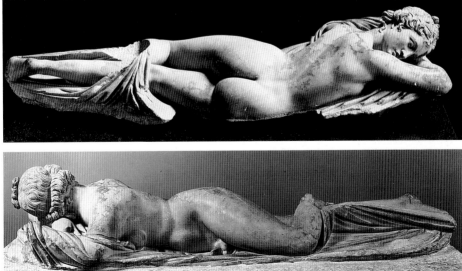

170 Boy strangling Goose. Mock-heroic genre. Copy of an original of later 3rd cent BC. (Munich 268. H: 84 cm). p. 136

171 Spinario. Peasant boy extracts thorn from foot. Copy of an original of 3rd cent BC. (British Museum 1755. H: 73 cm). pp. 136–7

172 (right) Spinario from Priene. Small 'grotesque' version of [171]. Terracotta, 2nd cent BC. (Berlin TC 8626. H: 17 cm). p. 137

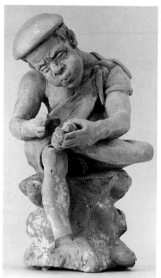

173 Biter Group. Rustics dispute over knuckle-bones. Copy after an original of 3rd–2nd cent BC. (British Museum 1756. Modern: most of base and limbs. H: 69 cm). p. 136

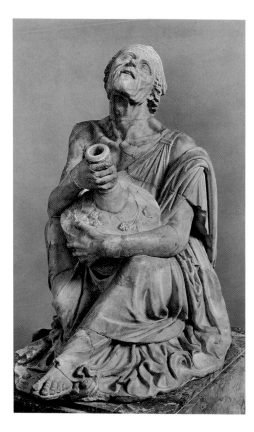

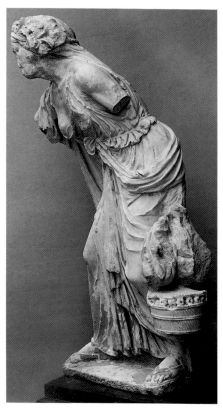

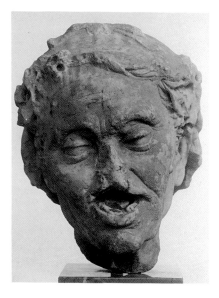

174 Drunk Old Woman. Clutches ivy-wreathed wine jar (lagynos) and laughs. Copy of an original of late 3rd cent BC. (Munich 437. H: 92 cm). p. 137

175 Old Market Woman. Carries poultry basket, and wears ivy wreath, best dress and fine shoes – for a festival. Copy after an original of 3rd–2nd cent BC. (New York 9.39. H: 1.26 m). p. 138 and see Frontispiece

176 Laughing Old Hag. Ivy wreath. Copy after an original of 3rd–2nd cent BC. (Dresden 475. H: 22 cm). p. 138

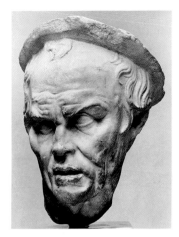

177 *(right)* Peasant. Rustic cap. Copy after an original of 3rd–2nd cent BC. (Dresden 98. H: 23 cm)

178 *(below)* Old Fisherman. Carries basket of fish. Copy of an original of c.200 BC. (Conservatori 1112. H: 1.20 m). p. 138

179 *(below right)* 'Seneca' Fisherman. Cf. *[36]*. Copy of an original of c.200 BC. (Vatican 2684. H: 1.61 m). p. 138

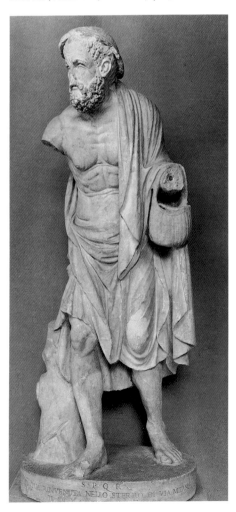

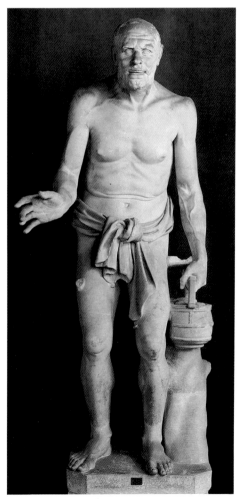

PART II · SCULPTURE IN THE HELLENISTIC KINGDOMS

Chapter Nine

PERGAMON AND THE GREAT ALTAR

Pergamon occupies a central position in the contemporary evidence for Hellenistic sculpture. It is the only one of the royal capitals to have been systematically excavated and provides a good series of originals with which to compare and complement the record of the copies. It also provides a quite exceptional monument: the colossal baroque frieze of the Great Altar. The two Gallic groups, known in copies (Chapter 7), and the Great Altar are fixed points against which it is usual to assess and date other Hellenistic sculpture. It is important, however, to stress that Pergamon was a relative latecomer. The material is mostly of the late third and second century: it provides for us a broadly dated cross-section of mid-Hellenistic sculpture.

In the early Hellenistic period, Pergamon was simply a fortress city governed by a local dynast Philetairos (d. 263 BC), on behalf of major Macedonian kings, first Lysimachos, then the Seleucids. Eumenes I (263–241 BC) achieved a precarious independence, and it was not until Attalos I (241–197 BC), who defeated both Gauls and Seleucids in the 230's, that the dynasty achieved any real political standing. Attalos I was the first to take the royal title. Compared to the great Macedonian dynasties, the Attalids seemed parvenu kings, and to combat this appearance Eumenes II (197–159 BC) and Attalos II (159–139 BC) spent lavishly on culture, buildings, and art, in imitation of Athens and Alexandria. They bought old statues, bought books for their library, patronized Delphi, and funded scholarship. They presented the image of a model royal dynasty, making a great show of their family cohesion. Special reverence was shown to the queen mother, Apollonis, wife of Attalos I. Pergamon was thus an aspiring Hellenistic kingdom and one which came late to art and cultural politics. The last king Attalos III (139–133 BC) died without an heir, willing the kingdom to Rome, so that the dynasty constituted a royal centre for only one century (230's–133 BC). Its period of greatest influence was in the second century when the kings profited greatly by alliance with Rome. The Romans' defeat of the Seleucids at Magnesia (190 BC) and the subsequent Peace of Apamea (188 BC) gave Pergamon control of much of Asia Minor. Success by alliance with Rome earned the Attalids lasting opprobrium in Greek eyes, which made them only more insistent to be seen as the standard-bearers of Hellenism, as founders of a new Athens. This insistence lies at the heart of the Great Altar Gigantomachy.

Original statues

The regular output of statues at Pergamon may be reconstructed from inscribed bases and surviving marbles. The inscriptions reveal that the major works on the Pergamene acropolis were large Gallic dedications (Chapter 7) and royal portraits, that is, statues of the kings, their immediate family and top royal officials, such as generals and priests. Attalid cultural pretentions are revealed in the bases for works signed by famous sculptors and for the portraits of great cultural figures of the past – for example, the historian Herodotos and the lyric poet Alkaios. If we compare the surviving marbles with the categories of statues discussed in the preceding chapters, we see that the originals partly overlap with and partly supplement the copies. From royal statues, we have several diademed heads and a fine ruler torso [181]. The most important of the portraits is one of Attalos I [180] that was reworked to receive an added wreath of royal hair and a diadem, no doubt when Attalos took the royal title in the early 230's. Philosophers were important to philhellenic kings, but they were not important enough to have received statues on the royal acropolis. Of ephebes and athletes, there are several possible heads and a small torso from the gymnasium [182] that might be athletic or royal. Poets and thinkers were represented in the royal library, but they were all Classical figures.

The Attalids fostered major cults of a variety of gods: Athena, Zeus, Dionysos, Demeter, Asklepios, Kybele. Among surviving divine statues, only the impressive colossal Zeus [63], from the temple of Hera, is clearly a cult statue. A headless and dull Kybele could also have been a cult figure. A more interesting trousered Attis [186] must belong in Kybele's environment – he was her youthful, self-mutilating, oriental devotee. This statue, however, presents him as a reserved and solemn figure of Greek cult. Related in tone and function is a large statue of Hermaphrodite [187]. This is not a playful genre figure of Dionysian art, but a powerful static image of a particular deity. Athena is represented by a colossal figure from the library [185], a free version of the Athena Parthenos at Athens. The figure is reproduced as a recognized cultural symbol, not as a precise copy of a Pheidian art-work. Particularly in the treatment of the face, it has many contemporary Hellenistic traits. Another Athena, with a crossed aegis, and a draped 'Hera', both in a more consistent fifth-century style (and once heavily painted) are often said to show that the copying of old master statues began at Pergamon. However, neither statue has other surviving copies which would be surprising for a major fifth-century Athena, and both are more easily taken as convincing essays in the high Classical manner or simply as fifth-century originals, purchased, for example, at the contemporary sales of war booty in Greece.

Draped female statues in contemporary style are extremely well represented. More than forty over-lifesized figures [183, 184] were found on or near the Great Altar terrace, of which unfortunately only one or two preserve their

heads. The figures are all different in drapery scheme, but relatively homogeneous in scale and style. A few are seated, and only one /184/ carries a distinctive attribute (a sword). The surviving heads are of indeterminate ideal form, equally appropriate for goddesses, personifications, or mortals. These figures, and especially their sheer quantity, are hard to interpret. One hypothesis, that they decorated the external colonnades of the Great Altar, would explain their great number.

Mythological groups were probably rare, prestige dedications, and most of them would have been of bronze. This category is represented among the originals only by two small marble groups: a poor version of a Leda and Swan group, and a fine open group of Prometheus freed by Herakles /188/, which must have been placed in some kind of landscape setting. Individual major baroque figures, however, are well represented by the fine head of the 'Wild Man' from the Asklepieion /189/ and two vigorous seated torsos, one surely a hero /191/ and perhaps from a group, the other a colossal deity /190/ from Elaia, Pergamon's port on the Aegean coast. From the Dionysian realm, excavation has turned up one or two satyr bronzes from private houses and a group of several galloping centaurs /192/. The centaurs were found (in 1960) in the foundation filling for the later east stoa of the Asklepieion, together with material suggesting a date before the mid-second century BC. They are a little under lifesize and do not have the detail or power of the Capitoline Centaurs /162/, but are important for their dated context. They are centaurs from the mid-range of sculpture production. (A terracotta from Priene provides a centaur from the lower levels.)

As discussed earlier, Roman copies supply us with great quantities of philsopher portraits, naked Aphrodites, and Dionysian figures, but few Olympians and draped women. The Pergamene originals correct the balance with more gods and many more draped females. Generally, philosopher statues were probably rare compared to those of kings and athletes, and naked Aphrodites were probably less frequent compared to other deities and draped women. Taken together the remains of original statuary from Pergamon seem broadly typical of other centres. There are no great innovations and no consistent stylizations or technical preferences informing a majority of the pieces that one would not readily find elsewhere. Against this background, the two friezes of the Great Altar stand out as quite extraordinary, each in different ways.

The Great Altar

The Great Altar was discovered by C. Humann in 1871, and its main parts were excavated and taken to Berlin by 1886. The Altar /193/ consisted of a monumental platform set on a massive podium with projecting wings, between which a great stairway led up to an enclosed court. The sacrificial altar proper

would have been within this enclosed court. The outside of the podium was decorated with the Gigantomachy frieze [195], the inside of the altar-court with a smaller frieze [197] recounting the life of Telephos, the mythological founder of the Attalid dynasty. There were also various small figures placed on the roof of the colonnades: tritons, griffins, lions, horses. Although these acroteria were installed, the work as a whole was never quite completed. Some parts of the upper colonnades and parts of the Telephos frieze are unfinished. The small fragments of the architrave dedication do not preserve the name(s) of the god(s) to whom the altar was dedicated: perhaps Zeus, or Zeus and Athena. The Great Altar, one of the most impressive sculptural projects of its (and any) period, receives only one certain mention in ancient literature: a brief description in a late Roman account of the wonders of the world, by one L. Ampelius. It adds little or nothing to our knowledge of the monument.

The project is usually dated early in the reign of Eumenes II (197–159), after the Peace of Apamea (188 BC) which secured Attalid power. A later date, after a Gallic war in 168–66, has been proposed on the doubtful evidence of some scraps of pottery from the foundations. Such chronological fine tuning is less important for us than a more basic question: how do we know the Altar was made in the second rather than the third century (as was once argued)? The answer may be found in the inscribed architrave dedication, of which only two small fragments survive [194]. One preserves part of the word *AGATH(A)*, that is, the 'successes' or 'benefits' in return for which the altar was vowed. This does not help. The other fragment, however, though very battered, clearly preserves the remains of *BASILISS(A)* or 'queen'. This can only be the first Attalid queen Apollonis, here mentioned certainly not as co-dedicator with Attalos I (he is not known to have made any dedications with her), but as queen mother of Eumenes II and/or Attalos II, his brother, who regularly called themselves 'sons of King Attalos and Queen Apollonis'. This gives virtual proof of dedication after 197. The latest possible date of dedication is 139, the death of Attalos II. Within that period 197–139 BC, the only strong historical argument is for the period after Apamea (188 BC). We do not know how long the work took or why parts are unfinished. The Gigantomachy, which is perfectly finished and has a strong unity of style, was executed first and perhaps in a shorter space of time. The subsequent work on the upper colonnades and the Telephos frieze must have dragged on longer. One obvious external cause for lack of completion would have been the end of the dynasty in 133 BC.

The Gigantomachy

The battle of the gods and Giants was a time-honoured theme in earlier Greek art. The Giants were the sons of Ge (Earth) who had been accidently fertilized by Ouranos when Kronos castrated him. They were an older generation of malformed, beast-like and philistine primordials, who sought to oust the ruling

gods. These Olympians, on the other hand, were fully anthropomorphic, cultured beings – the gods of the Greeks. Told that victory would be theirs only with mortal help, the gods recruited Herakles. The struggle and victory of the Olympians was a basic aetiology for the Greek order of things and would be widely understood as an implicit allegory of any historical defence of that order. On the Great Altar, generalized allegory of Attalid defeat of Gauls is no doubt present but probably the strongest symbolic value of the subject lay in its having been sanctified by Classical Athens as representing the defence of civilization.

The frieze was in many ways the *raison d'être* of the Altar. It dominated its elevation and was the largest, most elaborate, and most expensive element of the whole. It was also the first part to be executed. The frieze was 2.30 m high and 110 m long. It was carved in narrow panels of varying width (70–100 cm), about 30 per side and about 120 panels in all. The panels were originally blocks about 50 cm deep of which 30 cm is used for the depth of the relief, enabling the sculptors to make the figures stand out as though independent of the background. The frieze originally comprised some 100 figures in all, in addition to various animals. The panels were of varying width so as to accommodate (roughly) the body of one main figure per panel, although in practice the dynamic diagonals of the composition often made this impossible. Such a division of the composition into panels of different widths implies very careful planning. There must have been first a detailed scale drawing of the whole which was then divided to give the most rational arrangement of the figures on the slabs within a practical maximum and minimum width for each slab. The implication of an elaborately planned programme is born out by the inscriptions. Every god and Giant in the frieze had a name. The gods' names were inscribed on the cornice above in large letters, and the names of the Giants were engraved below, on the moulded course on which the panels stood, in smaller letters.

Unusually for architectural sculpture, the frieze was signed by the master-sculptors responsible for each section. Their names were inscribed below those of the Giants. Fragments of sixteen signatures were found, in the form: 'Orestes, son of Orestes of Pergamon, made (this)'. At least three were the joint signatures of a pair of sculptors. One sculptor came from Athens and three from Pergamon. The names of five survive: Dionysiades and Menekrates (a pair), Melanippos, Orestes, Theorrhetos. A signature can be matched with the frieze in only one place, the inner side of the south projection, where the signature had to be transferred to the cornice due to the steps. This 7 m stretch was executed by Theorrhetos and one other sculptor. If this were a typical division of the work (about three panels each), the frieze would have employed about forty signing sculptors. This figure is possible but seems high. Alternatively, it might be supposed that some or all the sculptors worked on more than one part of the frieze. The signing masters would each have had their own small team of assistants and slaves, and would in turn have been directed by the overseeing

designer/architect. The latter would have been responsible for the detailed drawings or cartoon of the whole frieze from which the signing sculptors surely worked. We have no evidence as to who the designer(s) may have been. We may be sure that he worked in close consultation with his royal patrons.

It has been disputed whether the frieze was carved before or after the slabs were set into position. The answer must be: some parts before, but mostly after. The layout of the figures must have been drawn on the blocks, arranged to make up the right length of each side. The lowest portions, where feet, snake-legs and drapery meet the ground, would have to be carved before setting because they could not be carved in position without damaging the course on which they stood. The uppermost parts, on the other hand, were certainly carved in position, since the lifting slots for the blocks (lewis holes) have either been carved away or have been rendered useless by subsequent carving of the figures (as, for example, on the Okeanos panel). It would make sense to carve the bulk of the figures in position due to the frequent slab divisions and continuous overlapping. Although thought was given to keeping the body of each figure in the middle of the slab, the vigorous action left few natural breaks. The frieze would have to be substantially complete before the upper cornice was put in position and the rest of the building could proceed. No doubt wooden boarding from cornice to base protected the frieze during construction of the superstructure.

About seventy-five per cent of the frieze survives, and for the most part the correct order of the extant panels is secure. Joining figures and preserved corners assure the arrangement of long sections – for example, the east half of the north frieze. Other panels are situated by the cornice blocks, which have continuously numbered setting marks; when preserved, these blocks can always be put in their correct position. The cornice blocks also have the names of the gods and can thus secure the position of those panels which feature recognizable gods, even though there are no adjacent joins (for example, Poseidon and Ares). Most panels are positioned by a combination of joins, identifications, inscriptions, and architectural features like corners and steps. Recent research has added several important pieces: in the south frieze, a junior god fighting the bull-Giant (Worksop relief), and in the north frieze, the head of Aphrodite and the inverted body of a defeated Giant (Fawley Court relief).

In composition and format, the frieze follows two principles of Classical frieze narratives: the figures occupy the full height of the frieze, and the entire frieze represents only one moment in the action. The best known precedent for extending one subject at one moment over four long sides of a building was the Parthenon frieze. In most other respects, the relief treatment is thoroughly unclassical. The figures are carved in high relief and twist and turn with little reference to the background, and there are many frontal, projecting figures. Such high relief had been common for Classical metopes but not Classical friezes in which the figures generally pass along the relief in profile. The frontal effect

with a 'submerged' background is most like, and was perhaps inspired by, Classical pediments, especially the Parthenon's. The background is confined to irregular pockets of shadow by the compressed battle composition. This method of heightening the dramatic effect would have been greatly assisted by dark background paint.

The figures have a powerful combination of grand design and refined detail. They have massive body forms and sweeping drapery, but all the details of attributes and equipment (for example, footwear and harness) are painstakingly carved. Usually in architectural sculpture, such details would simply be added in paint. The Gigantomachy sculptors represented an extraordinary and skilful variety of surface textures, such as animal-skins, fish-skins, and bird-feathers. This kind of detailing, usual in large bronzes, is here self-consciously reproduced in marble as a display of virtuosity. The high-pitched baroque style of the figures is employed to express the superhuman: the tremendous power of the conquering Olympians and the tumultuous struggle of the attacking Giants. It takes to an extreme the manner we saw pioneered in the Small Gauls [123–132]. The frieze is in an epic style – lofty in tone, massive in scale, simple in theme, endlessly varied, and complexly composed. The baroque figures also try to enter and threaten the world of the viewer. The massive Zeus seems to burst out of the east frieze; some of the frontal Giants threaten to sieze the viewer; and 'real' Giants crawl out on to the altar steps.

The frieze was designed to portray primordial chaos which is being mastered only with difficulty by the gods, and indeed it would appear irregular and chaotic when experienced on the building from close up. Studied on paper, however, the composition can be seen to contain careful correspondences, repetitions, and mirror inversions of individual figures and groups. Some such devices were designed simply to provide compositional accents within each side; some were used to unite thematic groups; and some connected groups and figures from different sides. For example, on the west side, the groups on the front of the two projections clearly echo each other: Triton and his mother Amphitrite on the north projection, Dionysos and his mother Semele on the south. Or again Phoibe, on the south, clearly 'repeats' her grand-daughter Hekate on the east. The formal repetition links the family of Phoibe and Leto across the southeast corner.

As well as internal correspondences, the frieze also employs echoes and reminiscences of earlier works. Some are accidental or were not intended for any but the most learned – like a particular quotation from the Parthenon frieze in the chariot group of Helios on the south frieze. Others must have been obvious, like the clear reference to the Parthenon west pediment in the Zeus and Athena of the east frieze. There are also more recent echoes: Athena's opponent recalls the Laocoön in its pose and snake-attack theme. And there seem to be implicit references to fallen Gallic figures in some of the defeated Giants – for example Triton's opponent. The Parthenon references have an obvious

meaning for Pergamon as the new Athens, defender of Hellenism. The Laocoön evokes the theme of tragic punishment, and Gallic reminiscences make quiet reference to Attalid deeds.

The designers elaborated for both the gods and Giants an extraordinarily rich iconography. Apart from distinctions of age, sex, and their usual attributes, the Olympians have greatly varied styles of dress and undress. They are also aided by a variety of animals: three hunting dogs (with Hekate, Artemis and Asterie), three lions (for Semele, Keto, Rhea), three eagles (with Zeus and at the tops of the steps), many horses including three chariot-teams (of Hera, Ares, Helios), a team of sea centaurs (Poseidon's), and a huge fish (with Keto). The Giants are single-sex (male) and not sufficiently civilized to wear drapery. They are varied chiefly by age and leg type. Mostly, but not exclusively, younger Giants have human legs, while older (= bearded) Giants are snake-legged. Snakes were the regular animal symbol for the subterranean and are attached to Giants to evoke their origin as sons of Ge (Earth). Ge appears herself in order to plead for her sons on the east side, as usually in Greek art, sunk up to her waist in the ground. A few Giants have helmets and proper weapons, but mostly they fight with clubs, rocks, and their hands and snake-legs. They protect themselves with a variety of animal-skins (goat, lion, bear). A few Giants have special anatomical forms: Leto's opponent on the east has wings and bird-claw hands, and on the south side, one Giant is bull-headed, another lion-headed. These probably illustrate very specific parts of a Gigantomachy whose mythology is lost to us. Several Giants on the north side have clear fish elements in their snake-legs, and we may guess the mythology used by the frieze incorporated a Giant attack from the depths of the sea as well as the earth.

At the lower, less literate levels of society, the frieze could be understood as an endlessly varied battle between the gods and Giants. The defeated are easily distinguished, and many individual gods are immediately recognizable by their familiar attributes. At another level, those familiar with the appropriate mythology and literature could read from a combination of the iconography and the inscribed names that the whole frieze was constructed with an easily comprehensible programme, divided according to the four sides and by the different kinds of gods participating. The gods are not arranged by strict genealogy, but rather by their most familiar associations (family or sphere of action). This broad programme and the identities of most of the gods are still easily read – except in one long stretch, in the north frieze.

The east frieze, which was encountered first by the visitor, was also the 'easiest'. It featured the main Olympians: (from right to left) Ares, Athena, Zeus, Herakles, Hera, and then Apollo, Leto, Artemis, and their family. Family and love connections overlap the corners: Ares' lover Aphrodite, with her mother Dione, is next to him at the corner of the north frieze, and Leto's mother and sister (Phoibe and Asterie) are the first on the south frieze. Phoibe and Asterie mean 'Bright' and 'Starry', and they set a clear theme of gods of light and

the heavens for the south side. Thus follow on the south: Selene, Helios, Eos. The west side, the front of the altar, has clear divine groups which wrap around the three sides of each projection. The south projection features Dionysos, his attendants, his mother Semele, and the Asiatic Great Mother Kybele (identified by the Greeks with Rhea). The north projection has sea gods: Poseidon, Amphitrite and family. The entire middle section of the north frieze, between Poseidon and Dione, is uncertainly interpreted due not so much to missing parts as to a lack of inscriptions and genuinely 'difficult' or unfamiliar iconography. The sea theme continues after Poseidon for a distance with the large fish and Keto(?) – the sea-woman, daughter of Pontos (Sea) and mother of the Chimaera, who would be the lion next to her. Beyond this, identities are controversial. Attractive recent interpretations see here various dark forces – Erinyes (Furies), Moirai (Fates), and the Graiai – who would make up themes of blood revenge, fate, and destiny, which were of course all useful and familiar elements in the Olympian armoury.

The arrangement of the gods thus deliberately flowed over the corners of the building in order to unite the frieze's subject. This is especially clear at the projections, where thematic continuity was most likely to disintegrate. This fluid division of the gods also allowed room for complementary, geographic divisions. The east side must be clearly the assault on Olympos itself. The south projection must be situated in Asia, the domain of Dionysos and Kybele, and so firmly on land, while the ocean and sea are the clear locale of the opposite projection. Asia, obviously, was in the East, and Ocean was most commonly conceived as being to the West. Since the themes and subjects of the two projections clearly wrap round on to their respective long sides, the north and south friezes may also have been conceived with broadly contrasting programmes. The south side may have had the multiple theme of land, East, light, the heavens, while the north side featured Ocean, the West, and the forces of darkness. This would suit the orientation of the building since it is of course the north side that would be most in shadow during the day.

Difficulties in interpreting the frieze as fully and precisely as its details seem to demand suggest that we are missing some key, surely a literary text on which it was based. The frieze is impressively learned, and that text would most easily be a Hellenistic epic, perhaps an Attalid court epic. The fifty or so gods could have been taken from Hesiod's *Theogony*, the original source of most Greek divine genealogy. But Hesiod was not concerned with Gigantomachy. Indeed, the Giants are important evidence for the nature of the frieze's source. The surviving blocks of the footing course preserve seventeen inscribed Giants' names, whole or in part (these blocks do not have setting marks and cannot be positioned so as to identify any of the Giants). They are as follows:

Allektos	Molodros	Palamneus	[Char]adreus
Bro[nteas]	Obrimos	Peloreus	Chthonophylos
Erysichthon	Olyktor	[Sthe]naros	
Eurybias	Oudaios	[Stu]phelos	
Mimas	Octhaios	[Pha]rrangeus	

The names are for the most part unfamiliar, even exotic, and only one, Mimas, is found in our fullest surviving literary account of the Gigantomachy (Apollodoros 1.6). This strongly suggests an independent source now lost almost without echo. This would suit very well an Attalid court Gigantomachy epic. Behind the stunning frieze may lie a quite unmemorable poem. The 'abnormal' nature of the Giants' names also indicates that it is vain to attach names from the Apollodoran Gigantomachy to unnamed Giants in the frieze.

A court epic might also have provided the key for an extra, upper level of meaning in which were embedded various topical references to royal deeds. Some gods could refer to particular localities or Pergamene cults. Some Giants' names or attributes might be cryptograms for particular royal enemies. Unusual weapons, attributes, and animals could have anecdotal or punning references to particular events, people or places. This more precise, topical level of allegory, if it existed, now escapes us. We should be content with the role of the minimally informed viewer who could grasp the broad programme of the four sides and some of their internal correspondences and external echoes.

The Telephos Frieze

After the unrelieved clamour of the Gigantomachy, the visitor would have experienced in the Telephos frieze [197] a pervading mood of calm. It is concerned with the heroic mythological origins of Attalid Pergamon and its connection to the venerable tradition surrounding Troy. The frieze ran round the inner walls of the altar-court [198] and was designed to have been seen behind the columns of a colonnade, like paintings in a stoa. (The planned colonnade, however, seems never to have been built.) The frieze was 1.58 m high and originally about 80–90 m long. It was carved from slabs 75–95 cm wide and 35–40 cm deep. The slab divisions pay little attention to the composition. This and the position of the lewis holes show that it was carved mostly *in situ*. What survives is very fragmentary and makes up only about one third of the whole.

The designers made striking departures in both setting and narrative from the normal format of a sculptured frieze. Innovations in the rendering of place and time were no doubt borrowed from painting. The actions of all previous friezes that we know, including the Gigantomachy, occur in a placeless, timeless moment. The action of the Telephos frieze, however, takes place at different

times and in different locations. Indications of setting and time-narrative are twin parts of a new frieze conception. Outdoor settings and sanctuaries are indicated by trees, rocks, and hills. Pillars, seats, and beds indicate indoors and palaces. Divine statues (Apollo, Athena) and different kinds of trees (laurel, plane, oak) specify particular sanctuaries. Ships refer to the shore and landings. The figures occupy only a half or two-thirds of the frieze height, leaving free space above for background setting or empty 'sky' – clearly a borrowing from painting. The figures thus inhabit a real space rather than an abstract frieze space. They are also frequently grouped in depth. (Previous friezes preferred basically paratactic figure compositions, with infinite or no depth behind.) Setting and spatial depth required flexible relief height: foreground figures are thus sometimes in almost full high relief, while figures behind and background settings are in varied levels of lower relief.

The narrative time of the frieze was complex. It was both 'continuous' and episodic. That is, it not only portrays stretches of more or less continuous time in which loosely divided scenes followed consecutively, with the same protagonist appearing in adjacent scenes, but it also makes large jumps forward and backward in time in order to narrate concurrent and widely spaced parts of the story. In theme and narrative technique, the Telephos frieze is very much in the manner of Homer's *Odyssey*. It has the same variety of picturesque settings, the same abrupt changes of time and place, and the same rapid succession of events and concurrent narratives. Like the frieze, the *Odyssey* depicts man in his real environment: indoors, outdoors, at sea. The *Iliad*, on the other hand, makes use of a unified theme (battle) with man operating on a greatly elevated stage. The Gigantomachy frieze is Iliadic epic, the Telephos frieze is Odyssean epic.

Like the other dynasties, the Attalids required heroic ancestors. Telephos was made to fit admirably. He was a son of Herakles, from Arcadia, therefore properly Hellenic, but he also became king of Mysia, the region of Pergamon. He was also connected with the prestigious Trojan story. His history had several quite separate strands represented in different authors. His part in the Trojan epic – the Greeks, who could not find their way, were guided by him to Troy – was told in the *Cypria*, and his earlier life was dealt with by Attic tragedians. The frieze gave an extraordinarily detailed treatment of all parts of his life, from conception to death. It brings together disparate elements not found in any one author we know and includes whole sections of narrative not attested elsewhere. The treatment of the story is as learned and in some ways even more complex than the Gigantomachy – the surviving one third of the Telephos frieze has over ninety figures. Even more clearly we have here to hypothesize a court epic on Telephos which synthesized his story and added parts related to the foundation of Pergamon and its cults.

The story in outline is as follows. Aleos of Arcadia, warned by an oracle against a grandson, makes his daughter Auge a nun-priestess. None the less, she is seduced by Herakles, and Telephos is duly born. He is exposed, and Auge is set

adrift in a small boat. She lands in Mysia where the local king Teuthras adopts her. Telephos meanwhile, suckled in the wilds by a hind, is discovered by Herakles, grows up, and goes to look for his mother in Mysia where he is eventually made king and marries the Amazon queen Hiera. He fights and routs the Greeks on their first aborted Trojan campaign – they had landed by mistake in Mysia – but is wounded by Achilles at the instigation of Dionysos. Told the wound will only be healed by that which inflicted it, Telephos seeks council in Argos at the court of Agamemnon. He takes little Orestes hostage and is finally cured by the rust from Achilles' spear, and in return guides the Greeks to Troy.

Most of the major episodes are easily recognized in surviving parts of the frieze: Aleos' oracle, the building of Auge's boat [199.1], the finding of Telephos [199.3], the long battle scene, the Argive conference [199.5], Orestes taken hostage. However, the frieze is much fuller than our surviving literary accounts. It expands the story, adding episodes often unknown to us, especially of Telephos' later career, for example his death-bed scene or the building of an altar [199.6]. The latter no doubt represented the founding of a major Pergamene cult. The longest continuous surviving sections are made up of three joining panels. Of the episodes thus preserved, one is the Argive conference [199.5], one is an expanded greeting and arming scene [199.4], and the last is an unknown scene with satyrs and a priest in a rocky landscape, perhaps at the founding of a cult of Dionysos. The surviving panels are mostly quite badly worn, and unfinished parts are obvious only in the boat-building and cult-of-Athena scenes [199.2]. Most of the frieze was probably fully finished, and its originally superb quality can be appreciated in a few unweathered parts, like the altar-building panel [199.6].

The Gigantomachy has great variety and complexity in its details and composition, but it could always be understood at the basic level of a single battle narrative. It maintains the same thundering baroque tone throughout. The complexity of the Telephos frieze is different. It has a rapidly evolving narrative structure and represents a very wide variety of locations and moods – pastoral, urban, military, civilian, forensic, domestic. The frieze can be understood only at one level: the viewer has to follow carefully the story and the abrupt changes of place and time or he is soon lost. Its extraordinarily rich narrative makes it much harder to read than the Gigantomachy. No inscribed names for the frieze were found, and its position within the altar-court may imply a more restricted public.

The Great Altar was a stupendous sculptural monument from a category and in a style of which we otherwise catch only fleeting or reflected glimpses. The Telephos frieze incorporated innovations in narrative technique of astonishing complexity, seen nowhere before, and in the Gigantomachy the Hellenistic baroque reached its highest extreme – a more exaggerated, rhetorical, and emotional style than that of the free-standing groups discussed earlier (Chapter 7).

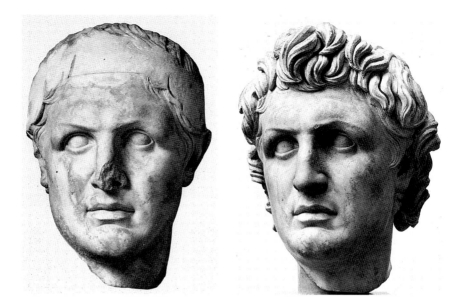

180.1–2 Pergamon. Attalos I (241–197 BC). (E. Berlin P 130. H: 39.5 cm). *(Left)* Attalos I as undiademed dynast, *c.*240 BC. *(Right)* Attalos I as king, with added hair and diadem, *c.*240–230 BC. p. 156

181 Pergamon. Ruler. Later 3rd or 2nd cent BC. (E. Berlin 1486). p. 156

182 Pergamon. Ruler or athlete, from the gymnasium. Later 3rd or 2nd cent BC. (Izmir). p. 156

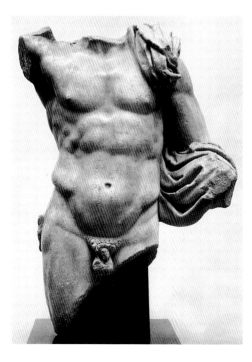

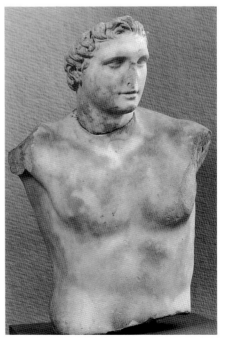

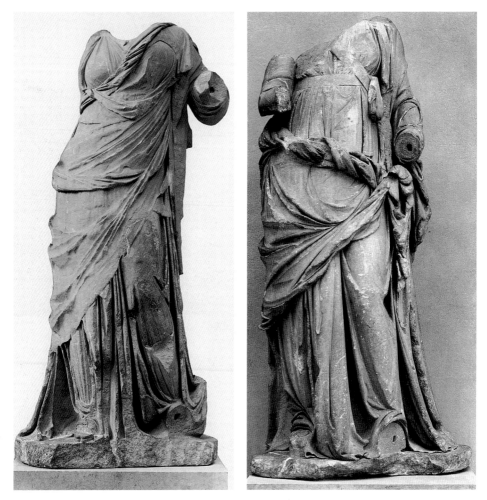

183 Pergamon. Woman, from Great Altar terrace. About 200–150 BC. (E. Berlin P 54. H: 1.90 m). p. 156

184 Pergamon. Woman with Sword, from Great Altar terrace. About 200–150 BC. (E. Berlin P 47. H: 1.80 m). p. 156

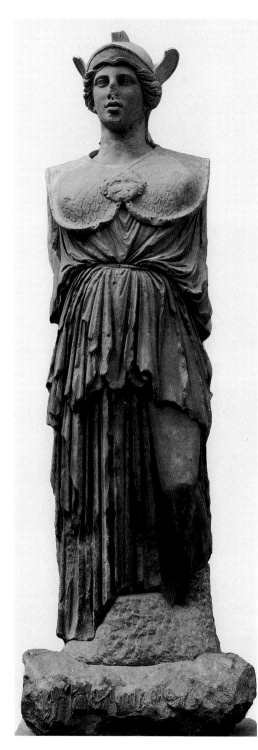

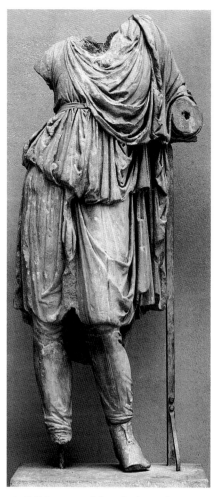

185 *(left)* Pergamon. Athena Parthenos, from library. About 200–150 BC. Free version of Pheidias' statue. (E. Berlin P 24. H: 3.10 m). p. 156

186 *(above)* Pergamon. Attis. Later 3rd or 2nd cent BC. (E. Berlin P 116. H: 1.50 m). p. 156

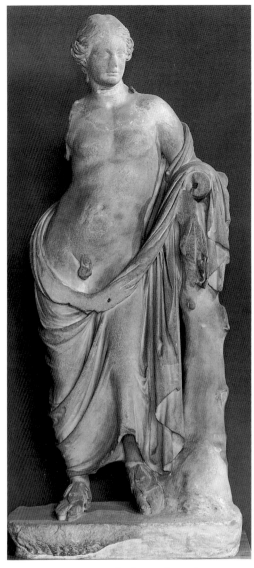

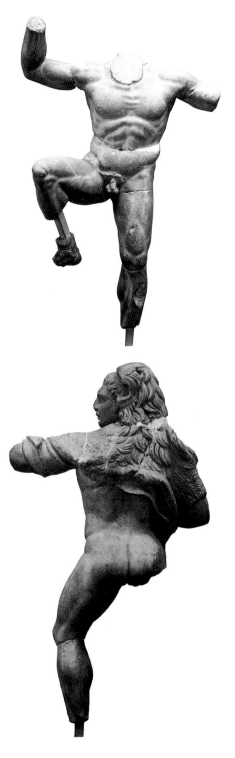

187 Pergamon. Hermaphrodite. Later 3rd or 2nd cent BC.
(Istanbul M 624. H: 1.87 m). p. 156

188.1–2 Pergamon. Prometheus freed by Herakles. Late 2nd
or early 1st cent BC. (E. Berlin P 168. H: 73 & 63 cm). p. 157

189 Pergamon. 'Wild Man' (Marsyas?), from road to Asklepieion. About 200–150 BC. (Bergama. H: 48.5 cm). p. 157

190 Elaia. Colossal seated god. 2nd cent BC. (British Museum 1522). p. 157

191 Pergamon. Seated hero(?) Later 3rd or early 2nd cent BC. (E. Berlin P 122. H: c.1.70 m). p. 157

192 Pergamon. Centaur, from the Asklepieion. Before 150 BC. (Bergama. H: 72 cm). p. 157

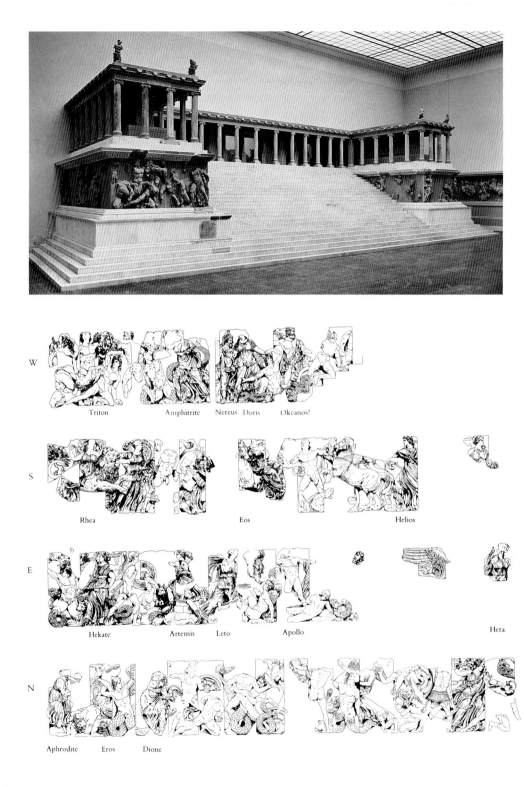

W

Triton Amphitrite Nereus Doris Okeanos?

S

Rhea Eos Helios

E

Hekate Artemis Leto Apollo Hera

N

Aphrodite Eros Dione

193 *(opposite)* Pergamon. Great Altar, *c.*190–150 BC. (E. Berlin). pp. 157–66

194 *(above)* Great Altar. Two fragments of architrave dedication. The mention of 'Queen' (*basilissa*) implies a date after 197 BC. p. 158

195 *(below)* Great Altar. Gigantomachy frieze (H: 2.30 m). Reconstruction

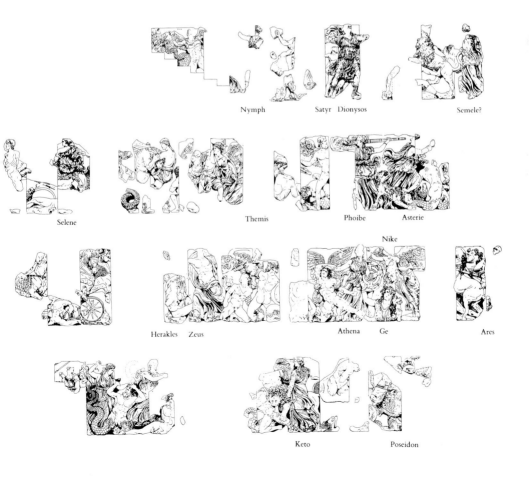

Nymph Satyr Dionysos Semele?

Selene Themis Phoibe Asterie

Nike

Herakles Zeus Athena Ge Ares

Keto Poseidon

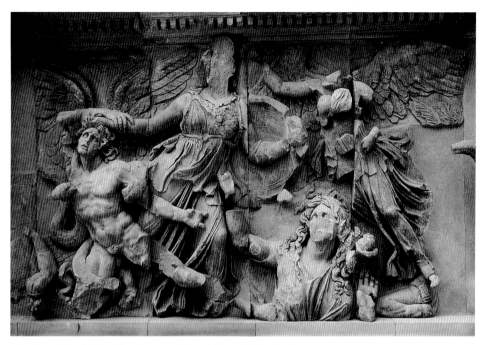

196.1 Great Altar. E. frieze, L to R: young Giant, Athena, Ge (Earth), Nike

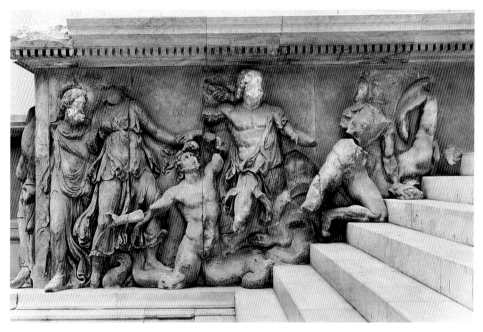

196.2 Great Altar. N. projection. Sea-gods: Nereus and Okeanos

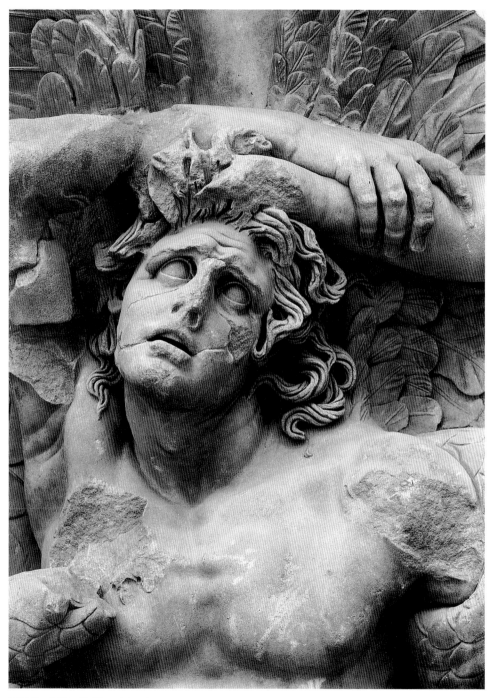

196.3 Great Altar. E. frieze. Athena's opponent

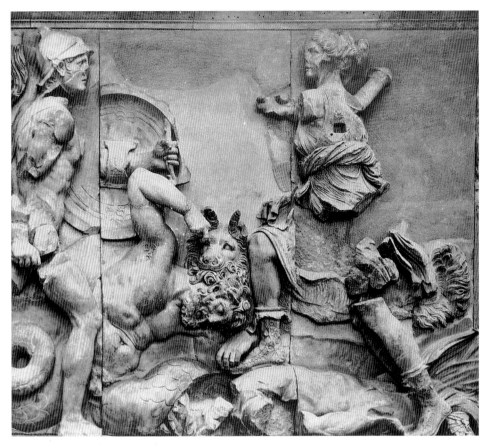

196.4 Great Altar. E. frieze. Two Giants and Artemis with Dogs

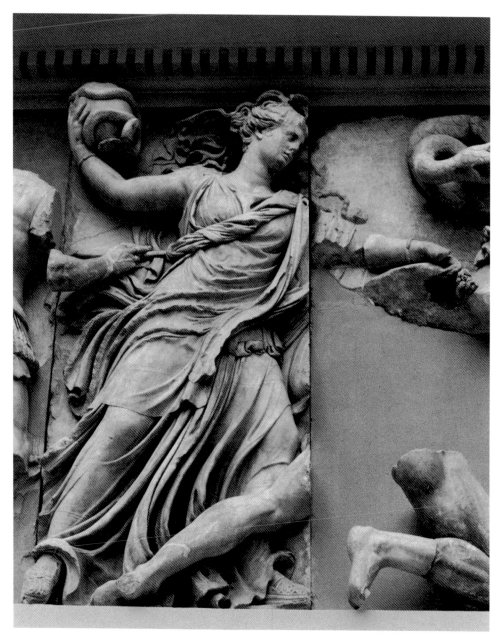

196.5 Great Altar. N. frieze. Goddess with Snake-pot ('Nyx')

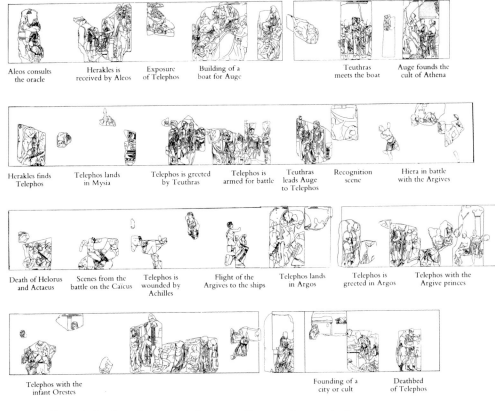

Aleos consults the oracle · Herakles is received by Aleos · Exposure of Telephos · Building of a boat for Auge · Teuthras meets the boat · Auge founds the cult of Athena

Herakles finds Telephos · Telephos lands in Mysia · Telephos is greeted by Teuthras · Telephos is armed for battle · Teuthras leads Auge to Telephos · Recognition scene · Hiera in battle with the Argives

Death of Helorus and Actaeus · Scenes from the battle on the Caïcus · Telephos is wounded by Achilles · Flight of the Argives to the ships · Telephos lands in Argos · Telephos is greeted in Argos · Telephos with the Argive princes

Telephos with the infant Orestes · Founding of a city or cult · Deathbed of Telephos

197 Great Altar. Telephos frieze (H: 1.58 m), before 133 BC. Reconstruction. pp. 164–6

198 Great Altar. Section through altar-court showing position of Telephos frieze (H. Schrader)

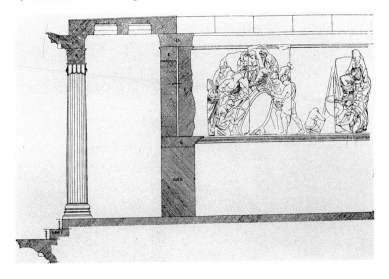

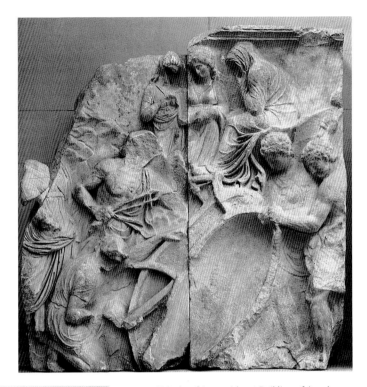

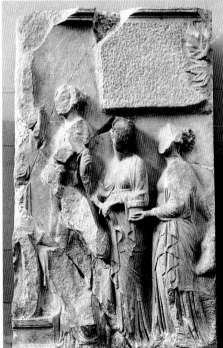

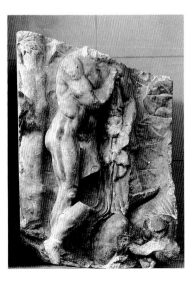

199.1–3 Telephos frieze. 1 *(above)* Building of Auge's boat (5–6). 2 *(left)* Offering to Athena idol (11: unfinished). 3 *(below)* Herakles finds Telephos (12)

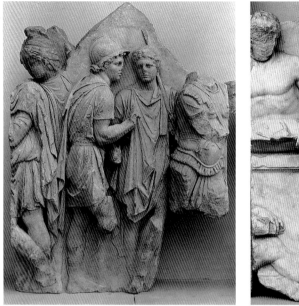

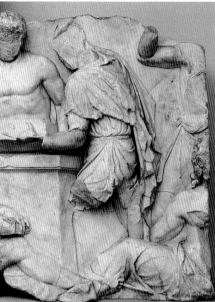

199.4–6 Telephos frieze. 4 *(above)* Telephos' soldiers (16). 5 *(below)* Argive conference, R to L: servant, Telephos, Odysseus, Achilles with spear (standing), Nestor(?), Agamemnon and Menelaos, servant (38–40). 6 *(above right)* Telephos builds an altar (50)

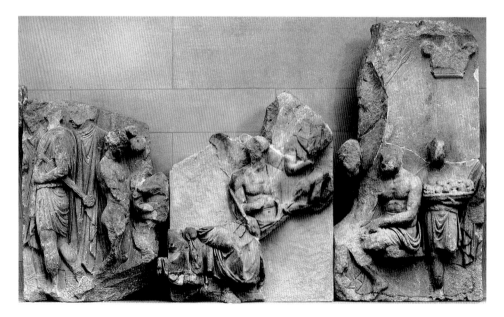

Chapter Ten

RELIEFS: FRIEZES AND STELAI

Leaving aside the extraordinary friezes of the Great Altar at Pergamon (Chapter 9), the format and functions of Hellenistic relief sculpture changed little from the Classical period. Figured reliefs (mainly friezes) were used to decorate temples and tombs, and independent free-standing reliefs (stelai) continued to function as votives and grave-markers. Much interesting material survives from both contexts. Generally, however, relief sculpture did not receive the same level of attention as it had in the Classical period. This is most obvious in architectural sculpture.

Architectural sculpture and friezes

Much of the lavish sculptural decoration of Classical temples could not be properly appreciated from ground level. Hellenistic temple-designers rational-ized the use of architectural figure-carving, subordinating it to the role of decorating the building. Hellenistic temple sculpture thus carries much less iconographic and artistic weight. The surviving monuments are mainly from Aegean Greece and Asia Minor and cover quite evenly the third and second centuries. The first century BC was a war-bound, chaotic period, not conducive to major building projects. The main monuments can be broadly dated and provide important chronological evidence for this level of work. In the third century we have, principally, the temple of Athena at Ilion [201], the Belevi Tomb [203], and the Tarentine tombs [204]. The second century is covered by the three great temples at Magnesia, Teos, and Lagina [205–207]. And many other friezes are attested in more fragmentary state.

Most kinds of sculptural decoration on tombs and temples were already familiar. Monumental altars with columnar screens were new – the Great Altar is the biggest of this type. They could have large high-relief figures set between or behind the columns. The late Classical altar in front of the temple of Artemis at Ephesos may have had figures of this kind, and they are found later on altars at Magnesia, Kos, Priene, and perhaps Lagina. Their exact position in the architectural reconstructions, however, is often far from clear. It is possible the Great Altar had free-standing figures in its outer colonnade, above the frieze. New Doric temples were rare until a partial revival in the second century, when they were often entirely without sculptural decoration (Kos, Lykosoura).

Sculptured metopes were employed for the Athena temple at Ilion [201], and are attested by stray examples at Limyra and Thera. Pedimental figures and figured acroteria, a notable feature of many earlier Doric temples, were decidedly rare. The Hieron at Samothrace [210] unusually had both. Sculptured coffers were an impractical rarity, inspired by the Mausoleum and the temple of Athena at Priene [202]. They are found on the Belevi Tomb [203] and the propylon of the temenos at Samothrace. Sculptured column drums (*columnae caelatae*), an extravagant Ephesian device, are found later only on the temple of Apollo Smintheus in the Troad, there placed certainly at the top of the columns, in two types: figured, or with bucrania and paterae. The favoured form of figured decoration for Ionic temples and other buildings was the continuous frieze. Many Hellenistic temples had sculpted friezes in their external order: temples of Dionysos(?) on Knidos and Kos, the Smintheion in the Troad, the temple of Apollo at Alabanda, and the temples at Magnesia, Teos, and Lagina. All were Ionic except Lagina, which was Corinthian. Figured friezes were also used on two 'secular' buildings on Delos (the Monument of Bulls and the 'Keraton') and on tombs in Macedonia (Leucadia) and South Italy (Tarentum). A colossal frieze of relief figures in stucco (now very fragmentary) decorated some rooms of the governor's palace at Ai Khanoum [267].

The themes of these architectural reliefs (and others no longer associated with their buildings) are mostly from a limited repertoire already well known in the Classical period. Gigantomachy appears in the Priene coffers, the Ilion metopes (east), and friezes at Pergamon and Lagina (west) – in that chronological order. Amazonomachy in the Mausoleum tradition was as popular as ever, and is featured in the frieze of the temple at Magnesia and in stray frieze blocks at Alabanda, Mylasa, and Athens (Kerameikos). Centauromachy also remained popular, and is found among the Belevi coffers, the metopes at Ilion, Limyra and Thera, and the frieze at Mylasa. The Limyra metopes give this old theme a particularly vigorous and 'modern' handling. New are temple friezes featuring the Dionysian thiasos, at Teos, Knidos, and perhaps Kos. At Teos we see centaurs explicitly removed from their Classical context (Thessalian war) to the realm of Dionysos where they will remain. Heroic-looking battle friezes, not further specified, are used on the Leucadia tomb, Tarentine tombs, and unattached frieze blocks at Alinda and elsewhere. Dancing females (nymphs) are the subject of a large frieze from Sagalassos and of the archaistic frieze of the propylon of the temenos at Samothrace. The latter, of the later fourth century, is a rare attestation of neo-archaic style before the late Hellenistic and Roman period. (Most examples of certainly Hellenistic date seem to be representations of old images.) Friezes with more particular or specific subject-matter include a battered marine frieze from the Monument of Bulls and a possible Theseid (very battered) from the 'Keraton', both on Delos. Most unusual is the overtly historical subject of a fine, unattached battle frieze from Ephesos [208]: it shows a battle against Gauls. Generally, however, the iconographic repertoire was

simple and familiar, and reveals by contrast the truly extraordinary complexity of the royal friezes at Pergamon, especially the Telephos frieze.

We may look, in chronological order, at some of the better preserved monuments. The Lysikrates Monument at Athens *[200]*, built for a theatre victory in 335–34, is a small, round, and elaborate Corinthian structure, with a low frieze showing Dionysos attacked by the pirates. The monument is highly precocious in several respects: its use of the Corinthian order on the *outside* of a building (our first example), the Dionysian subject matter of the frieze, and its subordination of the figured frieze to the architectural order. More sculptural attention was paid to the roof finial and the elaborate, innovative capitals than to the frieze. The figures are widely spaced, simple, and easily legible.

The Doric temple of Athena at Ilion *[201]*, probably built under Lysimachos (d. 281; cf. Strabo 13.1.26), had sixty-four small metopes, but not necessarily all of them were carved. The division of subjects by side seems to have followed that of the Parthenon metopes: Giants on the east, Sack of Troy on the north, and Centaurs on the south. The presence of Amazons on the west is purely hypothetical. Some of the gods and Giants are well preserved, the rest very fragmentary. Some similarities of motif with the Great Altar Gigantomachy do not reverse the chronology of these two monuments: they merely show that the Pergamenes started from an existing iconographic tradition.

The Belevi Tomb near Ephesos was a grand monument, modelled on the Mausoleum. It was partly rock-cut and partly built. The character of its mouldings and Corinthian capitals suggest a date *c.* 300–250 BC, and the probable occupant was either Lysimachos, re-founder of Ephesos, or Antiochos II, who died at Ephesos in 246. Though Greek in execution throughout, the sculpture has some oriental elements, for example, heraldic griffins on the roof, a robed reclining figure on the *kline* (couch) in the tomb chamber, and his trousered 'attendant'. The sculptured coffers *[203]*, however, are purely Greek. Half of them feature a vigorous centauromachy, and half have athletic or gymnasium scenes. Like the Ilion metopes, the Belevi coffers employ a mainly late Classical figure style, with some hints of baroque musculature and expression. Tarentum shows much more.

Tarentum was a vigorous centre in the mainstream of Hellenistic culture, as witnessed, for example, by its fine terracottas and jewellery. The city was at the height of its power in the late fourth and third centuries. It was at the forefront in the wars of Pyrrhos (280–275 BC) and was still the leading city in South Italy when it declared support for Hannibal in 213 and was sacked by Rome in 209. Though not systematically excavated, the city has produced extensive remains of small-scale limestone sculpture that once decorated the distinctive *naiskos* type of tomb *[204]* – a small columnar shrine, sheltering a statue of the deceased, as frequently pictured on South Italian vases. The tombs are roughly but certainly dated, by associated pottery and on historical grounds, to the later fourth and third centuries. There are small metopes and pediments, but most

common are low friezes. Some of the sculptors clearly knew of developments in Greece and the eastern centres. Many of the figures in both mythological and battle scenes [204.2] have a baroque character and strong overtones of 'Gallic' iconography. Pergamon was evidently not the first in this field – there were major Gallic wars and monuments from 279. Although the Tarentine reliefs are not grandiose art works, they show that baroque figure sculpture was current by the early-to-middle third century, indicating that this style did not originate in the Attalid monuments and the Great Altar, but culminated in them.

The two major Ionic temples at Magnesia and Teos were designed by the famous second-century architect Hermogenes of Alabanda, and each had a long, single-theme frieze. The larger of the two, the temple of Artemis at Magnesia, had a 175 m frieze taken up entirely with an Amazonomachy [205] of which no less than 135 m survives (now in East Berlin, Istanbul, Paris). The one mythologically specific figure, Herakles, is lost in the surrounding generalized Amazonomachy. The extant portions have 347 figures: 162 Greeks, 185 Amazons. Many figures have 'lumpy', baroque-style muscles, ill-suited both to the scale of the figures and their manner of execution, and one figure seems to quote the 'Hyperion' of the south frieze of the Great Altar. These references to 'modern' style and prestigious iconography are, like the Herakles, gratuitous. The frieze is poorly executed throughout, with frequently awkward and incompetent figures in repetitious groupings. However, this consistent lack of quality may not be due simply to incompetence – it was probably planned. On the building, c. 17 m above the ground, the frieze carving would have been sufficiently effective. Its stocky figures are well spaced and stand out at a distance. Better quality would have been to no purpose. The frieze (H. 80 cm) is treated merely as one course of the entablature (H. c. 3.00 m), not much different in emphasis from the other elements. Even more than in the Lysikrates Monument, figured relief functions here simply as architectural enrichment. The frieze is not much more than a large figured moulding.

The temple of Dionysos at Teos seems to have been rebuilt after an earthquake, probably in the early Imperial period. Original and late elements may be detected, but the restoration clearly aimed to reproduce the second-century building. The frieze [206] is similar in all principal aspects – composition, style, quality – to the Magnesia frieze. It is a little smaller, and features the thiasos of Dionysos instead of an Amazonomachy. It is essentially a large Dionysian moulding.

The frieze of the Corinthian temple of Hekate at Lagina [207] is much more ambitious. Lagina was the religious centre for Carian Stratonikeia. The temple plan is related to those of Hermogenes, and first-century inscriptions on the temple walls imply an earlier date: probably the later second century. More precise dates have been sought from a supposed historical reference in the 'alliance' scene [207.2] in the north frieze, which however cannot be sustained. The Corinthian order was still rare for major temples – there are only two other

examples in the second-century: the temples of Zeus at Athens and Olbia. Its use at Lagina accords well with the more pretentious frieze. The frieze was part of the outer order and, though only a little taller (H. 93 cm) than those at Magnesia and Teos, it attempts both a much higher level of execution and a complex, 'relevant' iconographic programme; relevant, that is, to the goddess of the temple. This was difficult since Hekate was (elsewhere) a lesser deity, with little mythology and less iconography. Each of the four sides had a different subject, of which only the west is now clearly legible. It features a Gigantomachy, composed with liberal quotations from the Great Altar. Artemis, for example, on slab 7 [207.1] appeared in the same scheme as Hekate on the Great Altar. The east had a complicated scene of divine birth, probably that of Zeus from Rhea in which Hekate played a part (she took a stone wrapped in swaddling clothes to Kronos to prevent him from swallowing the infant Zeus). The long north and south sides seem to have had local stories, now quite unclear in meaning. An assembly of gods, Olympians and others, is recognizable on the south among other unknown figures. The subject of the north frieze [207.2], often interpreted as the making of a treaty between the personified figures of Rome and Stratonikeia, is in fact highly obscure. It shows draped women and Greek soldiers (1–8), a divine assembly (9), the 'alliance' scene (handshake: 11), and Greeks and Amazons, standing not fighting (13–21). The subject was surely mythological.

The sad lesson of the Parthenon – that good friezes high up are wasted – was ignored at Lagina. The ambitious subjects of the frieze seem to have been conceived by a temple committee. A professional designer, like the rationalist Hermogenes, would probably have eschewed such a complex programme. The result is (and probably was) much obscurity and illegibility. Basic comprehension would have required an explanatory booklet and unusually powerful eyesight.

The frieze from the equestrian monument of Aemilius Paullus at Delphi [209] survives almost complete and is precisely dated to the months immediately after the battle of Pydna in 168 BC (Plutarch, *Aem.Paul.* 28). The monument was a tall rectangular pillar, intended originally to carry a bronze equestrian statue of the Macedonian king Perseus, but was commandeered by Paullus after his defeat of Perseus. The high-quality frieze decorated the top of the pillar and represented Romans fighting Macedonians. The two armies are carefully distinguished by equipment, but the battle is generalized in traditional Greek frieze style, with widely spaced, 'heroic' figures. The subject, however, was intended to be precisely historical: it is clearly indicated as Pydna by the inclusion of a runaway horse, an anecdotal reference to the start of the fighting. A combination of Hellenistic execution and Roman subject, the frieze stands at the beginning of a long series of historical reliefs made for Romans by Greek sculptors. Hellenistic patrons preferred to represent history and victories in paintings or statue groups. The only earlier historical reliefs are those on

the Alexander Sarcophagus, also a 'foreign' commission (discussed at the end of this chapter) and the small Gallic battle frieze from an unknown context at Ephesos [208].

Votive reliefs

Reliefs were one option within a great variety of figured artefacts that could be offered to a god as a prayer or thank offering. Typical Hellenistic examples differ little in form or iconography from their Classical predecessors. They generally show small worshippers, usually in profile, approaching a tall god or gods (gods are usually about twice mortal size). The god is often frontal, but is still understood as the god in person, rather than his image. There is usually some indication of the act of cult – an altar and/or a victim – and sometimes of setting. The amount of space and emphasis given respectively to gods and worshippers can vary greatly, indeed worshippers can be elided altogether. The narrative iconography usually dictated a panel longer than it was tall, and the reliefs were generally made with an architectural frame or would be inserted in one made separately. They were intended to be self-sufficient monuments, and would be set up in sanctuaries, for the most part probably on free-standing pillars at about eye-level. Mostly the reliefs were 'middle-level' votives: more prestigious than terracottas and small bronzes, but less so than statues. Their cost was probably about equivalent to a small marble figure or a small bronze. Instead of a plain image of the god or donor, they offered a narrative of the act of cult. In some cases they may have been conceived as visual records of a real sacrifice. A sacrificial victim plus relief may have been for some a more pious alternative to a votive statue.

Strong continuity in these reliefs is shown by the great difficulty encountered in distinguishing fourth and third century examples, and is well illustrated, for example, by the Attic series dedicated to Pan and the Nymphs. For the less well-off, there were summarily executed reliefs with a single deity and no indication of sacrifice, no worshippers, and without any frame. More complex, high-quality pieces, like the Venice Kybele relief [213] and the Munich sacrifice relief [214], are also small, but were clearly expensive, prestigious gifts. The Venice relief is more Classical in composition: the gods fill almost the full height, and setting is reduced to a half-open door. Its Hellenistic date is assured by the drapery and naturalistic scale-relation of the worshippers, clearly a mother and daughter. The Munich relief, on the other hand, has a lavish outdoor setting, in a sanctuary, with a large tree, a hanging drape (for privacy), and two statues on a pillar. The two 'real' gods are approached by a family household of eight, filing in front of the tree and behind the large altar. The figures are small and set into a natural picture space in a manner similar to the Telephos frieze.

Two votive reliefs, both roughly dated by their inscriptions, are of quite exceptional pretension: a relief signed by one Archelaos of Priene (late third or

second century), and a large relief dedicated by one Lakreitides at Eleusis (early first century).

The Archelaos relief [216] employs the normal small-scale figures, but is unusually elaborate in iconography and composition. It has twenty-seven figures, arranged in four tiers. It was dedicated, no doubt by a victorious poet, to an unusual deity, namely Homer. Two figures, 'World' and 'Time', who stand behind Homer in the lowest register, seem to be cryptoportraits of Arsinoe III and Ptolemy IV (222–205). We know that this Ptolemy founded a temple to Homer at Alexandria, and although the relief was found in Italy it surely comes from an Alexandrian context. The lowest register takes the outward form of a normal family sacrifice in the manner of the Munich relief. The throned god at left receives sacrifice at an altar from an allegorical family of literary personifications, their names all inscribed below: Myth, History, Poetry, Tragedy, Comedy. The sacrifice takes place in a sanctuary interior, in front of a colonnade blocked by a long drape, probably intended as the temple of Homer. In the three registers above, Apollo and the nine Muses are shown in a separate, mountain setting, with Zeus and Mnemosyne, the parents of the Muses, at the very top. Apollo stands in a cave beside the Delphic omphalos, and the mountain is probably Parnassos. Delphi and Parnassos are probably evoked simply as points of Apolline and poetic reference, not necessarily because the relief commemorated a victory at Delphi. A statue of the victorious poet with tripod stands at right, unintegrated with the rest of the action. The relief thus combines a Muses landscape and a votive scene that has been transformed into a rather pedantic allegory. It reflects well the scholarly milieu of Alexandrian literature and its elaborate homages to the past.

The Lakreitides relief [215] is a colossal votive to the gods of Eleusis, dedicated by a priest Lakreitides on behalf of himself, his two sons, and his wife. Normally if one could afford such a monument, a statue would be preferred. The only precedent for a votive relief of this scale is a fifth-century relief, also from Eleusis and dedicated to the same gods. Lakreitides was probably making a genuflection to the 'old days'. The figures are arranged in an ambitious, unconventional composition that integrates the gods and the worshippers in an unspecified 'narrative' setting. However, perhaps in deliberate reference to the earlier relief, the individual figures and the drapery are treated in a self-conscious Parthenonian style.

Grave stelai

Our understanding of late Classical grave reliefs is dominated by the large stelai of fourth-century Athens. Smaller stelai and marble vases were also used in Athens, but family tombs tended to be marked by large reliefs, often set in *naiskoi* and featuring generic, often touching domestic scenes of ambiguous greeting-farewell. These continue into the early Hellenistic period, until

funerary legislation of the pro-Macedonian autocrat Demetrios of Phaleron (317–307 BC) forbade as grave-marker anything other than a three-cubit column, a table, or a basin (Cicero, *De Legibus* 2.66). Some of the largest and finest family reliefs belong near the end of the series, when they are joined by a few that reflect new social and artistic concerns. The Aristonautes stele [217], for example, shows a dynamic, early Hellenistic warrior, probably a mercenary of the type encountered in New Comedy who has made his fortune in the wars abroad. His tomb reflects his wealth and how he acquired it. Why the Attic stelai do not resume after the fall of Demetrios in 307 is not clear. The small-column markers prescribed in his legislation have been found in some quantity in the Kerameikos.

Sometime during the third century, a new, smaller and distinctive type of grave stele emerged in Asia Minor and Aegean Greece and dominated production into the Roman period [218–222]. They are generally carved in one piece and constitute a self-sufficient 'architectural' monument in which the relief figures occupy a much smaller proportion of the whole than in Classical stelai. They are often elaborate and pretentious, but the best are always considerably smaller than the major Classical stelai. The relief figures stand in a *naiskos* which is flanked by pilasters or columns, set on a podium-base, and surmounted by a moulded entablature, pediment and floral acroteria. An attic zone is often inserted between the pediment and cornice; this can be decorated with honorific wreaths and/or carry an inscription. The base also provides a field for longer inscriptions or epigrams than were normal on Classical reliefs. The attic zone has no architectural logic in a stele and was probably borrowed from the prestigious architecture of Macedonian tombs (where it served to conceal the barrel vault). The new stelai thus combined representation of an imaginary tomb façade with the traditional image of the deceased. They generally have taller proportions than Classical stelai, partly due to their architectural format and partly to more 'vertical' iconography, that is, they tend to represent fewer main figures, who also usually stand. The smaller scale of the stelai is often countered by greater elaboration, but they can be remarkably uniform in the series of a given city (for example, Smyrna). The similarities of scale and treatment may be attributed to a combination of powerful social norms, cemetery regulations, and workshop conventions.

The iconography of the deceased has marked differences from the old stelai. The new reliefs mostly abandon the intimate family emphasis – the seated women, the children in laps, the handshakes, the narrative interaction of the figures, and their longing looks. Instead, the figures tend to stand in the frontal posture of public statues, without interconnection. The stelai may represent a family, rarely more than three figures, often a couple or siblings, and often single figures: a child, a youth, a man, a girl, a woman [219–222]. Women can appear alone and in their own right [220, 222], that is, without primary definition as a wife or mother. Children, if they are not the deceased [221], are

accorded 'miniature' status and are often indistinguishable from slaves. The public posture of the deceased adults, dressed in their city best, is often reinforced by attributes symbolic of the person's main role and virtues in the eyes of Hellenistic society. These symbols, which would otherwise float awkwardly in the field, are shown resting on 'shelves' or pillars in the background. The widest range defines the qualities of the desirable wife. Women are finely dressed, attractively shaped, and may have in addition attributes that signify one or more of the following: wealth (jewel box or cornucopia), domestic virtue (spindle, wool basket), education/intelligence (book), office of priestess (wreath). Men were generally felt to have more self-sufficient virtue that required fewer explanatory symbols. Younger men may be dressed in military costume [218], while youths usually pose as naked athletes in the gymnasium which is indicated by a herm [219]. Mature men may appear in cosmopolitan 'Aischines' style, with tunic and himation, or as intellectually cultivated in the Demosthenes-philosopher style, with himation only. Older men tend more to the 'thoughtful' image, drawing on the well recognized virtue-made-visible of the philosopher portraits. Tools of a trade, so common on Roman-period stelai, are mostly absent – standing acquired by artisan work was not yet a matter of celebration among the city bourgeoisie. The frontal posture and essentially public expression exclude any of the sepulchral sentiment explicit in Classical stelai. Such sentiment and reflections on death are expressed (if at all) in the accompanying epigrams. These attest more widespread literacy in the Hellenistic period.

A modest stele of a young woman Menophila from Sardis [222] well illustrates both the use of symbols to express a moral biography and the transfer of sentiment to the inscription. The image, the attributes, and the sepulchral thought are standard. What is unusual is the explicit reading of the iconography provided in the epigram. The attributes are as follows: a wool basket and bundle of book scrolls at the upper left, a flower (lily) on the right, a wreath in the pediment, and an alpha (= the number 1) inscribed on the background at the left. The inscription explains:

This gracious stone shows a fine woman. Who is she? The letters of the Muses inform us: Menophila. Why then is this white lily and the 'one' (alpha) carved on the stele? Why the book, wool basket, and wreath above?

The book is for her intelligence. The wreath tells of her public office (as priestess), the 'one' tells she is an only child. The basket is the sign of her well-ordered virtue. The flower is for the bloom that a daimon stole away.

Lightly do I the dust lie upon you. Many are they to whom you have left tears – dead without husband or parents.

A quite distinct class of stelai [223] features with few variations the following elements: the deceased man naked, a horse, a tree, and a snake – a servant is optional. Snakes here are symbols of the subterranean living, that is, heroes,

with whom horses are also often associated. These stelai were probably then for the heroized dead, that is, youthful males dead before their time who were, with increasing freedom, regarded as heroes. In epitaphs of the later Hellenistic and Roman periods, 'hero' came to mean little more than the 'late beloved'. These hero and horse stelai remained popular into the Roman period. A related but quite distinct class, the *Totenmahl* or 'funerary-meal' reliefs *[224, 225]*, was even more popular. Its iconography is applied to reliefs of widely varying scale, quality, and date. In later Hellenistic and Roman times they represent perhaps a quarter of the total surviving grave reliefs from the Greek East. Unlike the 'normal' Hellenistic stelai, they have overt sepulchral reference. At first glance they may appear to be a retrospective representation of the dead at a symposium, but it is clear from the presence of the family, wife and children, that this is not a symposium nor indeed an ordinary family meal. The stereotyped iconography represents, rather, the funerary banquet held at the tomb of the deceased. On the day of the funeral and later on his birthday, the family would gather at the tomb to eat, laying out a couch and food for the dead person, who in the reliefs is the reclining protagonist – usually male and young. Weapons, a horse's head, and a snake often appear in the background and provide a link with the 'hero and horse' reliefs. Again, the attributes indicate that the deceased has departed to the realm of the heroized dead.

The Alexander Sarcophagus

The Alexander Sarcophagus *[226]*, named after its iconography, not its occupant, is the finest monument of Hellenistic relief sculpture after the Great Altar. Its two long friezes give us two major royal narratives, a battle and a hunt, and it is also externally dated by historical circumstances, in the early Hellenistic period, before c. 300 BC. It is, however, in many ways an anomaly. Its context is funerary, but the iconography is historical. The style and format are Hellenistic, but the patron and context were Phoenician. The medium is Greek, but rarely used for such subjects – paintings and statue groups were the usual media for celebrating historical events. Inhumation had been employed by Greeks before, but the coffins were never of marble nor were they sumptuously decorated. Macedonian kings had sumptuous tombs but chose to be cremated. The Alexander Sarcophagus represents the convergence of Greek architectural carving, Macedonian narrative, and a Phoenician patron.

The Sarcophagus was found in the underground tomb complex of the rulers of Sidon in a suburb of modern Sidon in 1887. It was one of a series of finely worked marble sarcophagi in the tomb (three others have figured reliefs) ranging in date from the fifth to fourth centuries. The Alexander Sarcophagus is the most richly decorated and one of the last. It has an extraordinary wealth of ornament and colour which gives it the jewel-box splendour of an archaic treasury and the air of excess of a tomb like the Nereid Monument at Xanthos or

the Mausoleum at Halikarnassos. The subsidiary figural decoration of the sarcophagus lid – the Siren masks on the ridge-pole, the superb corner lions, and the animal-head gutters – is as elaborate and careful as the main panels. The mouldings are carved with metallic precision and constitute a textbook collection of late Classical Greek ornament, but deployed in lavish, un-Classical profusion.

The relief figures fill all four sides of the chest and both pediments of the lid. They are carved in very high relief, projecting beyond the surrounding panel frame. The figures are small, and their detailed carving gives a precise, almost miniaturist effect – there seems to be too much detail for their scale. Further detail was supplied by a wealth of metal attachments, for reins, bridles, bows, spears, and swords, that are now detected only by their fastening holes. The figures and ornament were also very elaborately painted, and much of the colour survives: blue, yellow, red, violet. Indeed, this sarcophagus is the single best testimony to the possible effects of ancient sculptural polychromy. The colour adds great richness and depth, articulates the composition, clarifies dress and drapery, and picks out details of eyes, hair, and attributes. The full extent of possible elaboration in paint is illustrated by the decorated interior of one of the Orientals' shields. It featured a drawing of a Persian audience scene in a convincing pseudo-Achaemenid style.

The Sarcophagus was most likely the coffin of one Abdalonymos, who was made king of Sidon by Alexander in 332 B C. It is not known when he died. The reliefs are best interpreted as showing the most important events of his reign and his relationship to Alexander. The battle frieze is a fine version of an Alexander battle against Orientals, and surely represents the great battle of Issos in 333 B C, fought just to the north of Sidon. It was the battle that gave Alexander Phoenicia and Abdalonymos his throne. The hunt frieze represents Greeks and Orientals hunting together, and the Phoenician ruler is shown prominently alongside Alexander. There was a famous royal hunting park at Sidon which is no doubt the intended setting. The Krateros dedication at Delphi had employed the theme of a famous lion-hunt (probably one at Sidon too) in a similar way, to express a special relationship to Alexander.

The battle frieze [226] is a vigorous, compact composition and has strong echoes in the pictorial tradition of Alexander battles (notably the Alexander Mosaic), from which it probably borrowed directly. It is a highly effective representation of the chaotic turmoil of battle. The hunt frieze, on the other hand, is less well integrated. It falls a little awkwardly into a central scene and two flanking groups, and, unlike the battle frieze, the wall of figures is punctuated by large gaps that distract from the desired effect of submerging the background in shadow. Elements may have been borrowed from Alexander hunt pictures, but since the protagonist of the frieze is Abdalonymos, it was no doubt freshly composed for him.

The Alexander Sarcophagus and the Pergamene Great Altar are both

extraordinary monuments. None of the other relief sculpture reviewed in this chapter comes close to their quality of design and carving. The styles, subjects, and artistic sophistication of the Sarcophagus and Great Altar friezes, however, were probably typical at the highest levels of Hellenistic art. They are merely unusual in applying them to marble relief sculpture – a decision of the patrons who commissioned them. These two monuments, then, are most useful for us in illuminating not the world of Hellenistic relief, which was dominated by purposefully mediocre friezes and bourgeois grave stelai, but the brilliance and elaboration of style and technique that characterized the royal art of the Hellenistic courts.

200 Athens. Frieze of Lysikrates Monument. Satyrs and pirates. 335–34
BC. (Cast: British Museum. H: 25 cm). p. 183

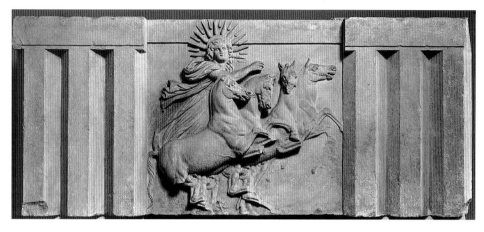

201 *(above)* Ilion. Temple metope. Helios. Early 3rd cent BC.
(E. Berlin. H: 86 cm). p. 183

202 *(left)* Priene. Temple coffer. Cybele on lion. Late 4th cent BC.
(British Museum 1170. H: 66 cm). p. 183

203 Belevi. Tomb coffer. Centaur (W 4).
About 300–250 BC. (Izmir. H: 1.13 m).
p. 183

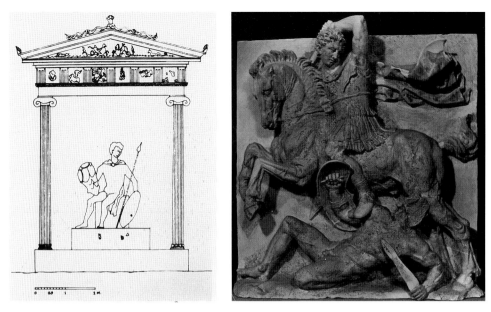

204.1–2 Tarentum. Tomb reliefs. About 300–250 BC. *(Left)* Tomb reconstruction (J. Carter).
(Right) Battle metope (Taranto 113768. H: 51.5 cm). pp. 183–4

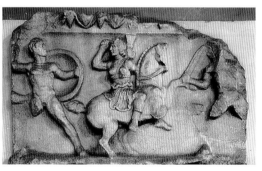

205.1–2 Magnesia. Temple frieze. Amazonomachy. 2nd cent
BC. *(Left*, E. Berlin. H: *c.*3.00 m). (*Above*, Istanbul M 154.
H: 80 cm). p. 184

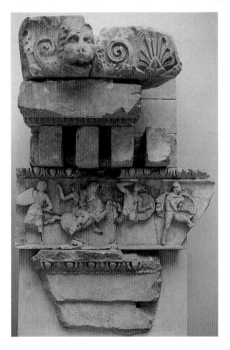

206 *(right)* Teos. Temple frieze. Dionysian thiasos:
maenads and centaurs. 2nd cent BC. (Izmir 175.
H: 66 cm). p. 184

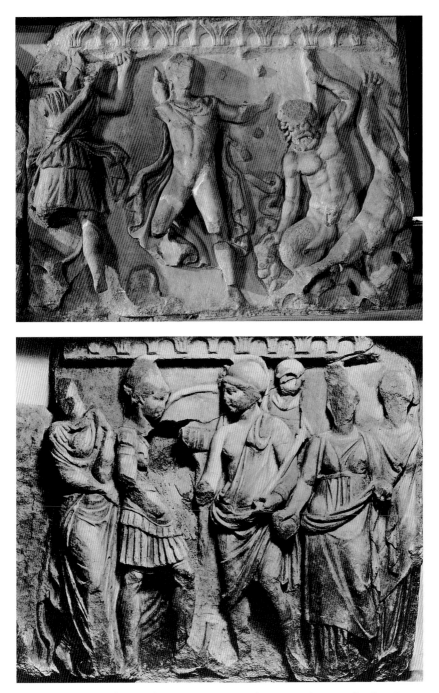

207.1–2 Lagina. Temple frieze. 2nd cent BC. (H: 93 cm). 1 *(above)* (W 8). Gigantomachy: Artemis, Apollo, and Giants. (Istanbul M 229). 2 *(below)* (N 11). 'Alliance'. (Istanbul M 223). pp. 184–5

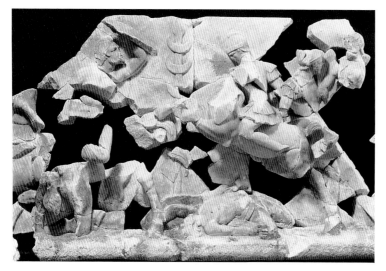

208 Ephesos. Gallic battle frieze. 3rd or early 2nd cent BC. (Vienna I 814, I 1740 A-C. H: 99 cm). p. 186

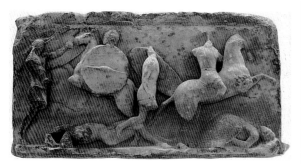

209 Delphi. Monument of Aemilius Paullus. Frieze: Romans fight Macedonians. 168 BC. (Delphi Mus. H: 45 cm). p. 185

210 Samothrace. Nike acroterion from Hieron. 2nd cent BC. (Samothrace Mus. H: 1.43 m). p. 182

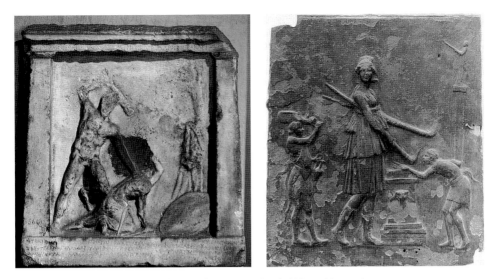

211 Cyzicus. Votive relief: Herakles clubs a Gaul. 277–76 BC. (Istanbul M 858. H: 70 cm)

212 Delos. Votive relief: Artemis and two satyrs at altar. Bronze, 3rd cent BC. (Delos Mus. A 1719)

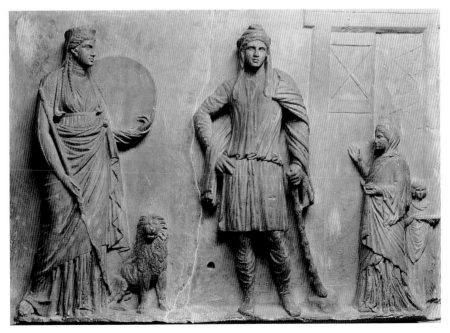

213 Votive relief: Kybele, Attis, worshippers. 3rd cent BC. (Venice 118. H: 57 cm). p. 186

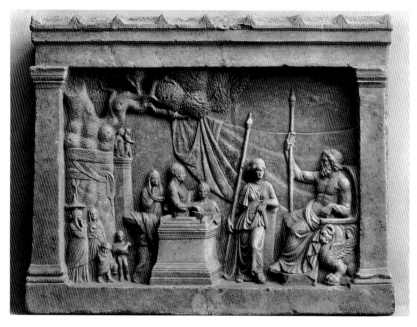

214 Votive relief: family sacrifice. 3rd cent BC. (Munich 206. H: 61 cm). p. 186

215 Eleusis. Votive relief of Lakreitides. Priest Lakreitides (head at upper left) with his family, Triptolemos, and gods of underworld. Early 1st cent BC. (Eleusis Mus. 5079. H: 1.50 m). p. 187

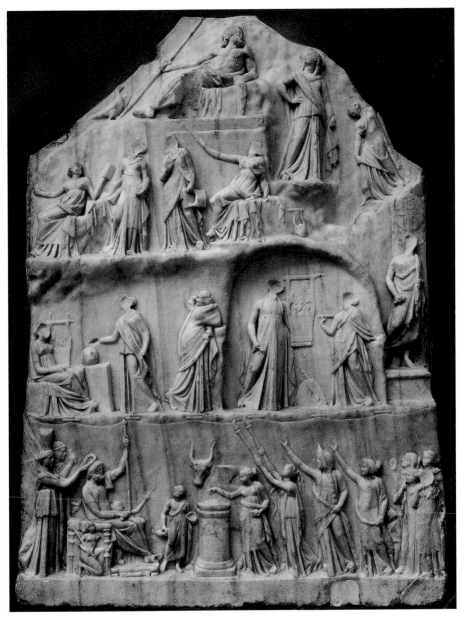

216 Archelaos Relief. Learned dedication of a poet to the Muses (above), with an allegorical 'votive'
scene to Homer enthroned (below). Inscribed in lowest register (L to R): *Oikoumene* and *Chronos*
(behind Homer), *Iliad* and *Odyssey* (crouching by throne), *Myth* (boy in front of altar), *History*, *Poetry*,
Tragedy, and *Comedy* (approaching altar), and *Physis*, *Arete*, *Mneme*, *Pistis*, *Sophia* (group at right).
Signed by Archelaos of Priene. Found at Bovillae in central Italy. Late 3rd or 2nd cent BC. (British
Museum 2191. H: 1.18 m). p. 187

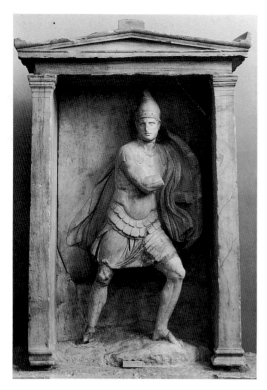

217 Athens. Grave monument of Aristonautes. Late 4th cent
BC. (Athens, NM 738. Figure H: 2.00 m). p. 188

218 Rhodes. Grave relief of young soldier. Early 3rd cent
BC. (Rhodes Mus. H: 92 cm). pp. 188–9

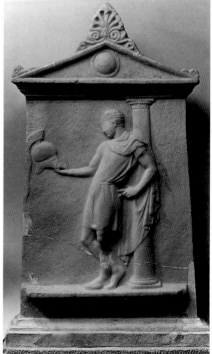

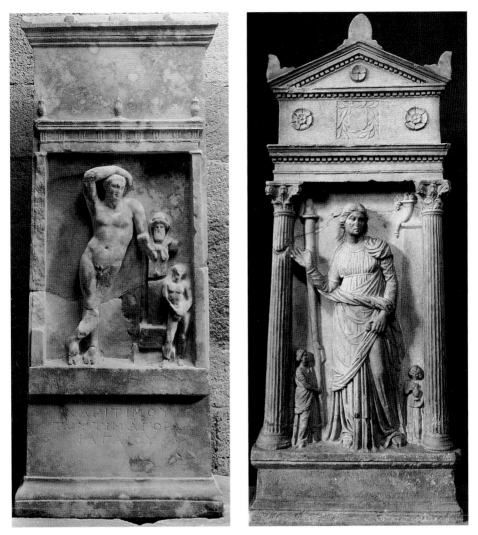

219 Rhodes. Grave relief of young athlete (Charitimos). Herm locates scene in gymnasium. Early 3rd cent BC. (Rhodes Mus. H: 1.23 m). pp. 188–9

220 Smyrna. Grave relief of priestess. 2nd cent BC. (E. Berlin Sk 767. H: 1.54 m). pp. 188–9

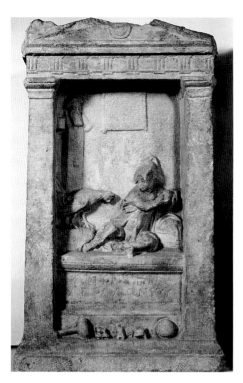

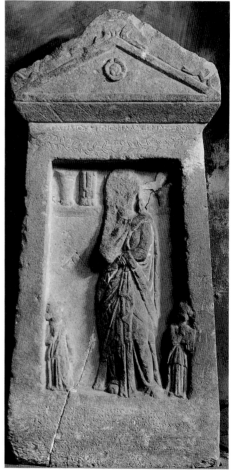

221 Smyrna. Grave relief of young child (Amyntes).
Cock and basket of food. Toys below: rattle,
knucklebones, ball. 3rd–2nd cent BC. (Louvre.
H: 56 cm). pp. 188–9

222 Sardis. Grave relief of Menophila. 2nd cent BC.
(Istanbul I 4033. H: 1.07 m). pp. 188–9

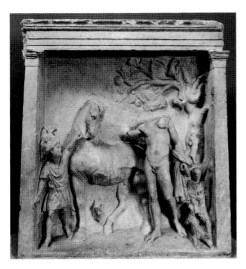

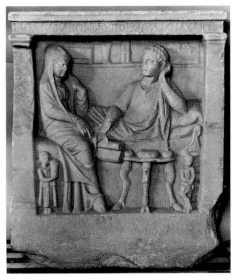

223 Smyrna. Grave relief of youth as hero, with horse, servant, and dogs. Later 3rd or 2nd cent BC. (E. Berlin Sk 809. H: 88 cm). p. 189

224 Byzantium. Grave relief of Polla Pakonia. Later 2nd or 1st cent BC. (Istanbul, Hagia Sophia 388. H: 61.5 cm). p. 190

225 Samos. Grave relief. Sacrifice (L) and funerary meal (R). Later 3rd or 2nd cent BC. (Samos, Tigani 307. H: 56 cm). p. 190

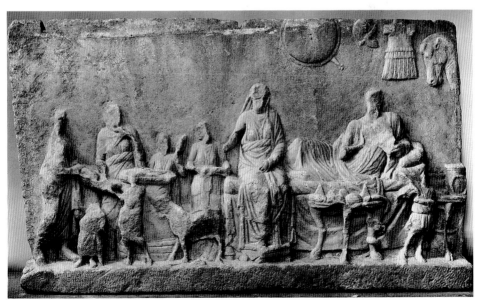

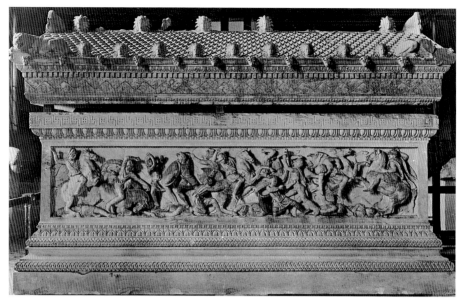

226.1–2 Sidon. Alexander Sarcophagus. 330–300 BC. Battle of Macedonians and Persians.
(Istanbul M 68. H: 1.95 m. Frieze H: 69 cm). pp. 190–92

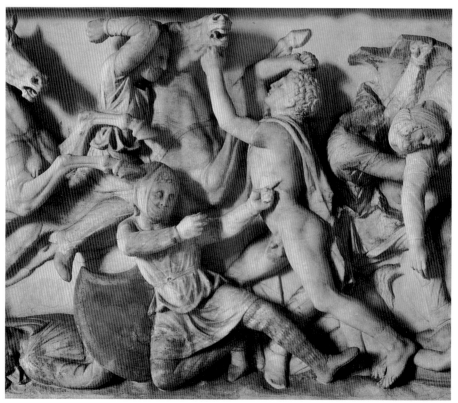

Chapter Eleven

THE PTOLEMIES AND ALEXANDRIA

The following three chapters look at the surviving original sculpture from the major Macedonian kingdoms. Of the three main kingdoms, the Antigonid was unlike the other two in being a traditional monarchy based in the Macedonian 'home' country, while the Seleucids and Ptolemies formed new kingdoms abroad in which Greek and Macedonian settlers were outnumbered by native populations. The purely Greek style with which they continued to represent their gods and themselves was an important expression of the settlers' cultural identity.

Alexander took Egypt in 332 and founded the city of Alexandria in 331. After his death Ptolemy I Soter held Egypt with a consistent separatist policy, making himself king in 305. During his reign (305–282) and that of his son Ptolemy II Philadelphos (282–246), the resources of Egypt were harnessed in a distinctive royal economy controlled centrally from Alexandria. The kingdom had two distinct parts: the Macedonian-Greek royal capital at Alexandria and the Egyptian countryside (chora). Unlike the Seleucids, who were great city founders, the Ptolemies did not attempt to plant city-states in the traditionally non-urban Nile valley. Alexandria was the home of the king, the court, and the royal administration, and to the Ptolemies the city was not on the edge of their kingdom, but at its pivotal centre. Alexandria looked both towards Egypt, its source of wealth, and overseas to its maritime empire among the Greek cities of the Aegean and Asia. The Ptolemaic golden age was the third century. The second century saw decline, and in the first century the kingdom became a third-rate power.

Alexandria was a famous cultural centre, noted for the intellectual and scientific life of its Museum and Library, and modern scholars once laboured hard to detect a distinctive artistic contribution of Alexandria to match that of its literature. Major trends and innovations in sculpture were discerned, such as a tendency towards soft Praxitelean modelling, an emphasis on classicizing forms, and the creation of genre and grotesque realism. There is, however, little to show that these things were more favoured at Alexandria than elsewhere. Most of the surviving sculpture suggests a plainer truth: Alexandria was one of many centres which propagated the Hellenistic koine, the common artistic language of Greeks in the Hellenistic East. Innovations there no doubt were, but what they may have been and in what categories of sculpture we mostly lack the evidence

to tell. The royal image, on coins and in good sculptures, has some distinctive qualities, and the literary evidence adds clear indications that, at the top level, the Ptolemies provided patronage for a diverse range of sculptural products. From this we may surmise that Alexandria was a leading centre of Hellenistic sculpture, but the idea of an 'Alexandrian style' we may doubt.

The literary evidence consists of detailed descriptions of three Ptolemaic spectacles (Athenaeus 5.196–206): the festival Pavilion and Grand Procession of Ptolemy II, and the luxury River Yacht of Ptolemy IV. The Grand Procession featured statues of gods, kings, and allegories, several complex groups or sculptural tableaux, symbolic items like tripods and gilded palm trees, and various gilded animal statues. The splendid array of Dionysian figures suggests Alexandria was at least one centre for this category of sculpture (Chapter 8). The Pavilion featured, among much else, a hundred marble statues by 'the foremost artists', and the River Yacht included a shrine with marble portraits of the royal family, a round temple with a marble statue of Aphrodite, and a 'Corinthian' *oecus* (cabin) decorated with a frieze of ivory figures on a gold background. The frieze was one and half feet high. The 'Egyptian' cabin on the Yacht had columns with alternating black and white drums and Egyptian floral capitals. As the surviving evidence corroborates, it is only in such architectural and ornamental contexts that Egyptian elements were borrowed for Greek artefacts, and then only on a highly selective basis. Egyptian stylisations are not found in Hellenistic marble statues at Alexandria.

It is striking how much marble sculpture has been recovered at Alexandria, even though the city had to import all its marble and has never been systematically excavated. Some major pieces survive – a few gods and a number of kings and queens. A head of a Gaul from Gizeh [229], no doubt made in Alexandria, is a rarity, but important because it shows that this stylistic strand also existed in the Ptolemaic kingdom. The remainder consists of small-scale sculpture of marble, bronze, terracotta, wood, and faience, representing a full range of familiar subjects. The two new major deities promoted in the Hellenistic pantheon through Alexandria, Isis and Serapis, are known mainly in later versions. Serapis is reproduced in the form of his original seated cult statue by Bryaxis [82], and Isis appears in a multitude of forms [90, 251]. Her iconography is pervasive in the portraits of priestesses and later queens [239, 240].

Although there is no all-embracing Alexandrian style in sculpture, the use of various marble-saving techniques can give much of the sculpture a distinctive appearance. One method was 'piecing', that is, adding parts in separate pieces of marble. This was common elsewhere, but at Alexandria a single head could be composed of separate pieces [228]. Another method was to use stucco to complete hair, the backs of heads, and beards. Acrolithic figures, with wooden body and marble head and limbs, were probably quite common, but are now hard to detect. The best marble pieces often have a distinctive treatment of the

surface: rubbed to a near-polish that exposes the crystal structure of the marble. In the heads of gods and kings, this technique is often combined with a rather formless or simplified treatment of the face and features. A good illustration of these characteristics is provided by three fine heads from the Serapeion at Alexandria, representing Serapis, a king, and a queen [227]. They must be from a royal cult group which probably featured a seated Serapis flanked by the standing king and queen. A pair of statuettes allows us to visualize the full statues of the royal couple [230]. The heads of all three figures were completed in stucco. The Serapis is identifiable mainly from its context in the Serapeion. Despite the high quality of its execution, the head has a surprising lack of detail which contrasts strongly with the sharp articulation of Roman versions of Bryaxis' great cult statue of Serapis [81]. We do not need to suppose the cult statue was very different from its later versions, only that the contemporary marble head employs a different stylistic option. It favours a smooth, elevated, generalized appearance over iconographic specificity.

The head of the king from this group is an excellent example of an ideal royal style which implicitly suggests godlike qualities while remaining separate from familiar divine images. The queen is even more purely ideal, but is still clearly not a goddess. Both king and queen have an elevated 'pathos' not seen in the images of gods, which was designed to express, not suffering, but the striving concern of the rulers for their subjects, their *philanthropia* – a prized royal virtue. The two portraits cannot be precisely identified. Like many other Ptolemaic heads, they prefer an ideal presentation to precise identity. Context or inscriptions would have told the viewer which particular king and queen they were. The heads concentrate simply on expressing their godlike nature. Many Ptolemaic portraits show a similar lack of concern for identity. Their homogeneity was meant to indicate the kind of dynastic stability which was expressed in the repeated use of the name 'Ptolemy' for each and every king. The other Macedonian dynasties alternated between two or more names (Antigonos and Demetrios in Macedonia, and Seleukos and Antiochos in Syria).

Alongside the many generalized portraits, there are others which reproduce enough particulars of a defined portrait type known from coins or seals for them to be identifiable. We may review some of the more important examples.

There survive two rather different marble portraits of Ptolemy I. He achieved royal power late in life, aged about sixty, and died aged over eighty. He therefore employed a more mature image than did his successors. A head in Copenhagen is unusual in its detailed naturalistic treatment of the portrait type seen on his coins, while the Louvre head [233] gives a much more typically Ptolemaic treatment: stiff, cold, sharply and simply modelled. Both heads have the distinctive Ptolemaic bulging round eyes.

The third-century Ptolemies present a subtly but clearly different royal image from that of the other main Macedonian kingdoms. The contrast is seen best on coins. Whereas the Seleucid image [259, 260] is energetic, longer-haired, heroic,

and charismatic, the Ptolemies [232] are restrained, sober, short-haired, and plump-faced. The Boston Ptolemy IV [234] provides a typical third-century Ptolemaic portrait in marble: it is bland, plain, calm, and worked in an essentially Classical format. (The head was later cut down for the addition of a beard and was originally fuller in the face.)

The Ptolemies were also unusual in giving a high public prominence to their queens, who appear more regularly on coins and in statues than did the queens of any other kingdom. The Ptolemaic king and queen were regularly presented as a royal pair: in the royal cult, in document headings, and in statues. Ptolemaic queens probably set female royal style for the other kingdoms and provided a model for non-royal women. Most female royal portraits in the third century and later are highly ideal compositions which were designed to reflect the passive beauty of the good royal wife. A sharp-profiled and lean-faced portrait was created for Arsinoe II [231]. It is both ideal and highly distinctive in appearance. Berenike II employed a fuller-faced, Aphrodite-like ideal that was more widely imitated. This female style is reflected, for example, in the Serapeion head [227.2] and a fine head in Kassel [236]. Arsinoe III, paired with her husband Ptolemy IV in the two Boston heads [235], is given a restrained, Victorian-looking expression and, for a queen, a rare individuality that permits independent identification by her coins. The head aims to express a stern female virtue. The same kind of virtue is also reported of Arsinoe III in an anecdote in which the great scientist Eratosthenes describes the queen's revulsion at one of her husband's drinking parties.

Alongside the passive, goddess-like style of the earlier queens, which continued, there appeared in the second century another female royal option: a stronger, more mature, even 'masculinizing' ideal. These queens, of which a head in the Louvre [239] is a good representative, are usually portrayed with the long 'corkscrew' locks of hair worn by Isis. The second century saw a series of Ptolemaic queens (Kleopatras I–III) who exercised real power on behalf of weak or boy-kings, and this portrait style surely expresses a new ideal of royal women with executive power: not merely beautiful, but active and energetic. A good male counterpart to the Louvre queen in the second century is provided by a head of Ptolemy VI in Alexandria [237]. It continues in the earlier tradition but with a strong injection of dynamism, which in reality the kings no longer exhibited. It is a good example of the use of ideal form to create a portrait type. The surface is smooth and even, with very sparing physiognomic detail, but the posture, long face, and prominent chin lend the work a strongly individual effect.

Another development in the second century was the increasing use of Alexandrian portrait models by the native Egyptian workshops which made the hardstone royal statues for the Egyptian temples. These were usually more or less purely pharaonic in statue type, royal insignia, and formal style, but sometimes naturalistic portrait features and hair in Greek style were added to the

head. Such heads were often based on portrait models from Alexandria, as can be demonstrated in a number of cases where we have both an Alexandrian marble version and an Egyptian 'translation' in hardstone of the same royal portrait type [237–242]. The Egyptian sculptors tended to simplify the Greek models and in some cases [240] mismanaged or misunderstood them. Significantly, this borrowing was not reciprocal: Alexandrian sculptors of the Hellenistic period generally did not incorporate Egyptian stylizations in marble statues. Egyptian sculptors also drew on their new acquaintance with Alexandrian sculpture in the remarkable hardstone portraits of Egyptian priests and others [254, 255] in which Greek portrait realism is transformed into a biting new verism.

A number of royal portraits can be grouped around the kings of the late second and early first centuries BC (Ptolemies VIII–XI). This was a period of fraternal dynastic strife, and precise identification of royal heads is made difficult because many were clearly reworked to represent the next king who seized power. Most of these portraits use a stronger, more aggressive royal style than that of the earlier Ptolemies. In a time of dynastic upheaval, these kings wanted to express a strength and vigour which in reality they lacked. Fine heads in Boston, Malibu, New Haven, and Alexandria all belong here [241–245]. There is also a rare complete statue [246] from this context, a poor limestone work from the lower end of the market. It comes from Aphroditopolis in middle Egypt and was probably a local dedication of, for example, an army-unit stationed there. The body is miserably handled, but the head, for which the sculptor clearly had a central model, is quite vigorous.

The famous Kleopatra (VII), the last Ptolemaic monarch, had two main portrait images. Her first portrait type, well known on coins [247] and in two or three marble heads, presents her in the youthful, ideal manner of the third-century queens: it recalls the passive beauty of Berenike II. Kleopatra was in fact one of the most personally dynamic of the Ptolemaic queens, but it was not the business of royal portraits to reflect real personality. This portrait appears on her coins at Alexandria all through her reign, and it was evidently designed for home consumption. Kleopatra also had another political identity, as the partner and client of the Roman triumvir M. Antony. For this role, she had a second image type: an older, hook-nosed, thin-necked, unflattering portrait, whose purpose was to show her in the style of her Roman patron. This 'Romanized' Kleopatra is seen primarily on coins minted outside Egypt [248] and was evidently for external consumption. We have, unfortunately, no sculptured versions of this portrait. There is no reason to imagine that one of Kleopatra's portrait types is more 'accurate' than the other. The types were meant to express two different roles: one a traditional Macedonian queen at Alexandria, the other a Roman client-ruler in the new territories abroad she had acquired from M. Antony. She had of course, like all her predecessors, a third and separate role as Egyptian queen inside Egypt for which she had a standard pharaonic image.

There is an interesting range of small-scale sculpture from Alexandria. In terracotta there is a considerable variety of grotesques and a good selection of Tanagra-style figurines [253]. The latter represent elegant urban women, standing with veil and fan, seated and talking, or sometimes dancing or making music. They are women from the middle class and the demi-monde, both well illustrated in Theokritos. There is also a large number of small marble Aphrodites [252], variations of famous Hellenistic types like the Capitoline Aphrodite and the Anadyomene. They attest the popularity of the naked goddess beyond the few well-known cult statues. The same marble workshops also turned out large quantities of small royal figures. These were probably personal votives offered to the divine rulers in pious hope of, for example, a swift promotion in the royal bureaucracy. These can be divided easily into two basic kinds. One shows the god Alexander [249], the founder of the city who was worshipped in his own central cult. The others are Ptolemaic heads [250], very difficult to tell one from the other, that signify simply 'Ptolemy the King', but none in particular.

The surviving material allows no generalizations about the invention of or specialization in particular styles or subjects, still less about an all-encompassing 'Alexandrian style'. Nothing can be inferred about missing categories such as heroic groups or intellectual portraits. The literary evidence suggests Dionysian statues may have been important, but they are almost entirely absent from the surviving record. Such categories were represented in major bronzes, and what survives is only what was regularly made in marble or terracotta. It is probably not an accident that the kings dominate the sculptural record of Alexandria. There were probably more royal statues than any other kind. What survives of other categories, at the middle and lower levels of society – small marbles, grave reliefs, terracottas – suggests that Alexandria was broadly in the same mainstream as the great cities of Asia Minor. We may conclude, then, that Alexandrian sculpture had a distinct manner in so far as the Ptolemies were a distinctive dynasty – in their style of patronage and of self-representation. Royal patronage produced a festival art whose daring and novelty we can just glimpse in literature, and in their portrait images we can see clearly that the Ptolemies stand apart from Macedonian kings elsewhere both in royal style and in the prominence of their queens. Indeed, Ptolemaic queens evolved for themselves a range of female portrait styles wider than anywhere else in the Hellenistic world. In the Nile valley, the indigenous tradition of hardstone Egyptian statues of gods and kings in pharaonic style continued with only sporadic borrowing from Alexandrian models for the royal image. The veristic hardstone portrait heads of native priests [254, 255] combine Hellenistic and Egyptian traditions to make something quite new: they exploit Greek realism to create an aggressively 'non-Hellenic' image. At Alexandria, the general lack of interaction between Greek and Egyptian sculpture is most striking. It reflects a certain exclusivity between Greek and native culture in the Ptolemaic period –

at least as far as the images of men and gods represented in public statues were concerned.

Cyprus

Cyprus was part of the Ptolemaic overseas empire. Apart from a brief period of Antigonid domination (306–294 BC), the island was ruled for almost the entire period by the Ptolemies. Its sanctuaries have produced large quantities of limestone statuary [256–258] which provide an interesting combination of local and Alexandrian currents. We see how an indigenous sculptural tradition was re-shaped by the new styles of the day.

In the Classical period, when Cyprus had been ruled by quasi-Hellenized native kings, sculptors had made use of both the local sub-Archaic styles and the imported Classical style. In the Hellenistic period, Classical types, which had by that time become the conservative norm, continued alongside the more up-to-date, Hellenistic manner. The statues range widely in scale and quality. A few are divine figures, but they consist mostly of generic votaries: ideal portrait-like images of the wreathed donor. The men are usually clean-shaven, wear tunic and himation, and carry small branches. The heads seem portrait-like, but in fact repeat a few basic types. Older men have sterner, more Classical features; younger men employ a 'modern', third-century portrait style. The short hair, placid features, and plain treatment recall Ptolemaic portraits, and some make more particular borrowings from Alexandrian court style. The full-faced, almost fat, youthful image, often with fashionable sideburns, is popular [256.2], and was clearly borrowed from the well-fed images of third-century Ptolemies [232, 250]. The women [257, 258] wear the impressive bulky clothes of good Hellenistic matrons. Their ideal portraits range in effect from the crude and provincial to the refined and sensitive. Some are simply modulated, mortal versions of Aphrodite types. Others are clearly influenced by the new female royal ideals of Arsinoe II and Berenike II. None of the surviving limestone portraits, however, represent kings or queens. They are the images of the local Cypriot bourgeoisie, anxious to appear Hellenic and Alexandrian, prosperous and cultivated.

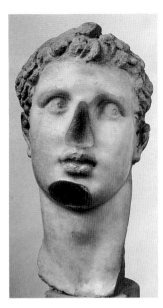

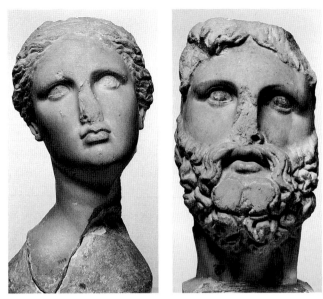

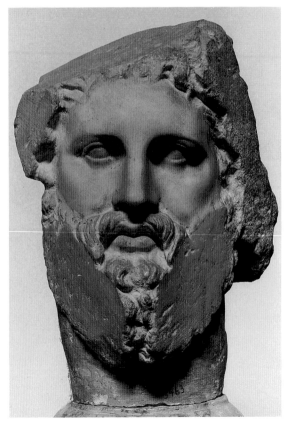

227.1–3 *(above)* Alexandria. Royal group from the Serapeion. Later 3rd or 2nd cent BC. 1 King. (Louvre MA 3168. H: 45 cm). 2 Queen. (Alexandria 3908. H: 46 cm). 3 Serapis. (Alexandria 3912. H: 53 cm). p. 207

228 *(left)* Alexandria. Bearded god. 3rd–2nd cent BC. (Alexandria 3463). p. 206

Opposite

229.1–2 *(above)* Gizeh. Gaul. 3rd cent BC. (Cairo CG 27475. H: 37.5 cm). p. 206

230.1–2 *(below)* Alexandria. Ptolemy II and Arsinoe II (282–246 BC): queen with double cornucopia, king with club, elephant scalp, and Dionysian boots. Bronze, mid-3rd cent BC. (British Museum 38442. H: 39 cm). p. 207

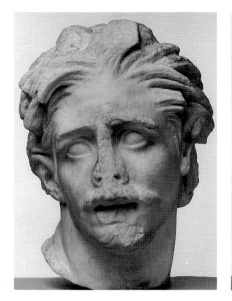
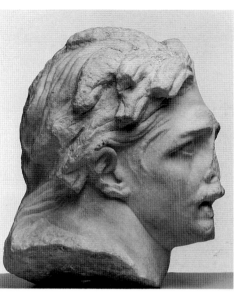

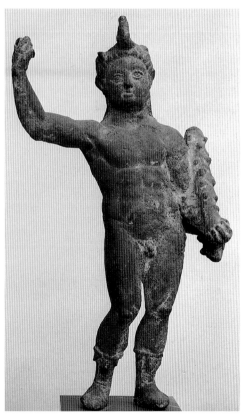

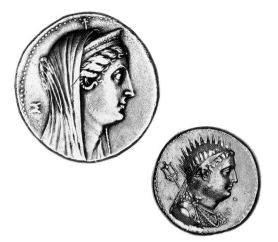

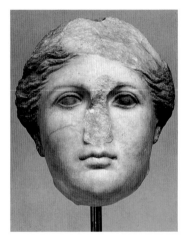

231 Alexandria. Arsinoe II, with ram's horn of Ammon. Silver decadrachm, mid–3rd cent BC. p. 208

232 Alexandria. Ptolemy III (246–222 BC), with radiate diadem, aegis-cloak, and trident-sceptre. Gold octodrachm, c.220 BC. p. 208

233 *(right)* Alexandria. Ptolemy I (305–282 BC). (Louvre MA 849. H: 24 cm, excluding restored neck and bust). p. 207

Below

234 Alexandria. Ptolemy IV (222–205 BC). (Boston 01.8208. H: 27.5 cm). p. 208

235 Alexandria. Arsinoe III. A pair with *[234]* (Boston 01.8207. H: 23.5 cm). p. 208

236 Alexandria. Ptolemaic queen. 3rd–2nd cent BC. (Kassel SK 115. H: 38.0 cm). p. 208

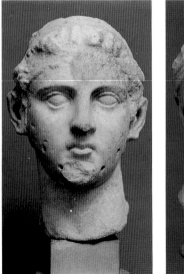

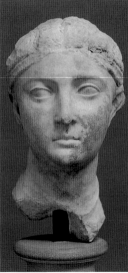

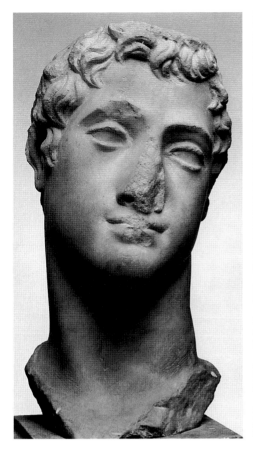

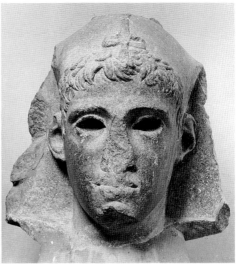

237 *(left)* Alexandria. Ptolemy VI (180–145 BC). (Alexandria 24092. H: 41 cm). p. 208

238 *(above)* Canopus. Ptolemy VI. Egyptian version of same portrait type as *[237]*. Granite, mid–2nd cent BC. (Alexandria 3357. H: 61 cm). p. 209

239 *(below left)* Alexandria. Ptolemaic queen (Kleopatra I–III), with Isis hairstyle. 2nd cent BC. (Louvre MA 3546. H: 37 cm). p. 208

240 *(below)* Egypt. Ptolemaic queen. Egyptian version (somewhat mishandled) of an Alexandrian portrait similar to *[239]*. Black stone, 2nd cent BC. (Vienna 406). p. 209

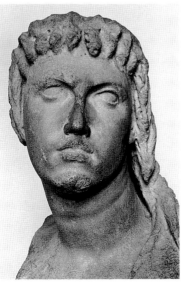

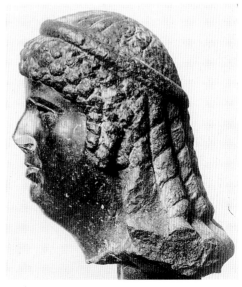

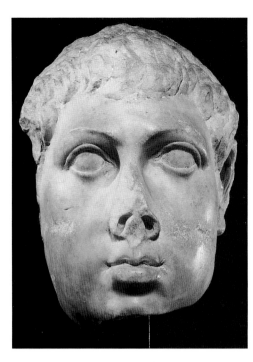

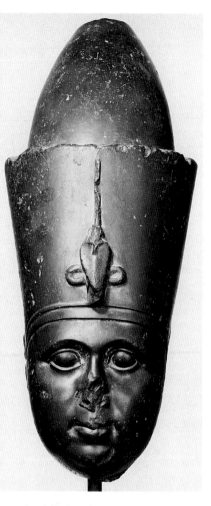

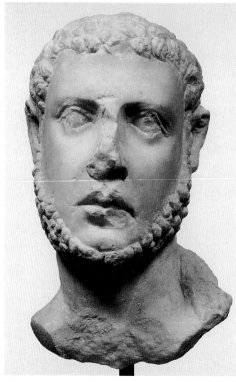

241 *(above left)* Alexandria. Late Ptolemy (IX or X) Later 2nd or early 1st cent BC. (New Haven. H: 23.5 cm). p. 209

242 *(above)* Egypt. Ptolemy VIII Physkon (the Fat), 145–116 BC. Egyptian copy of an Alexandrian portrait type. Diorite. (Brussels E 1839. H: 51 cm). p. 209

243 *(left)* Alexandria. Late Ptolemy (IX or X). Late 2nd or early 1st cent BC. (Malibu 83.AA.330. H: 34 cm). p. 209

244 *(opposite)* Alexandria. Late Ptolemy (IX or X). Late 2nd or early 1st cent BC. (Boston 5951. H: 64 cm). p. 209

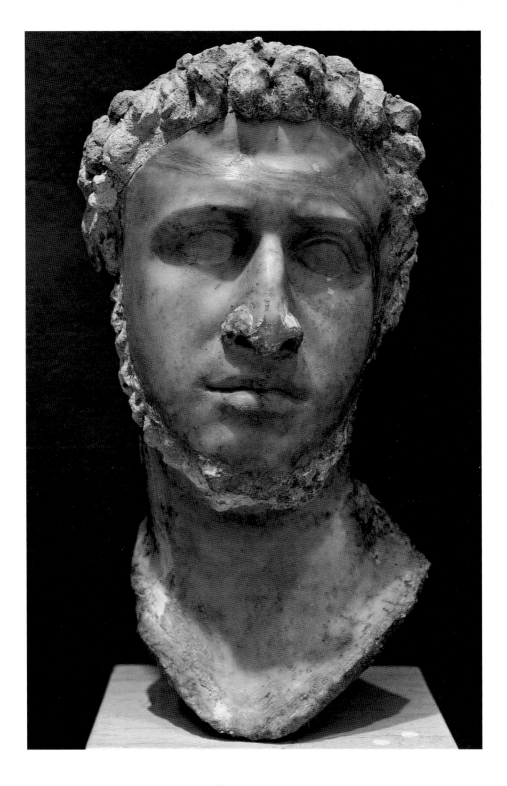

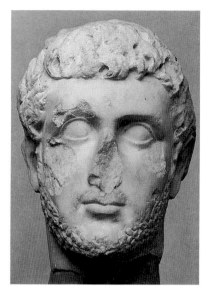

245 Paraitonion. Late Ptolemy (IX or X). Late 2nd or early 1st cent BC. (Alexandria 24.660. H: 38 cm). p. 209

Below

247 Kleopatra VII (51–30 BC). Alexandrian or 'Hellenistic' portrait type. Silver tetradrachm of Askalon, 39–38 BC. p. 209

248 Kleopatra VII (51–30 BC). 'Romanized' portrait type. Silver tetradrachm, *c.*37 BC. p. 209

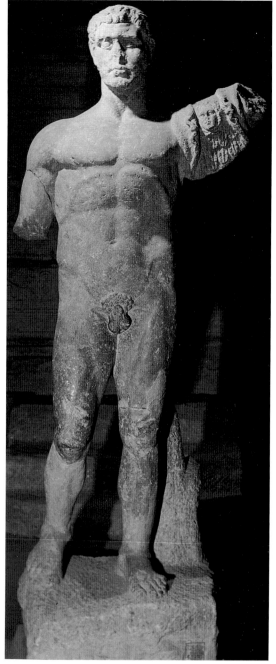

246 Aphroditopolis. Late Ptolemy (IX or X). Late 2nd or early 1st cent BC. Wears aegis. Limestone. (Cairo JE 42891. H: 2.05 m). p. 209

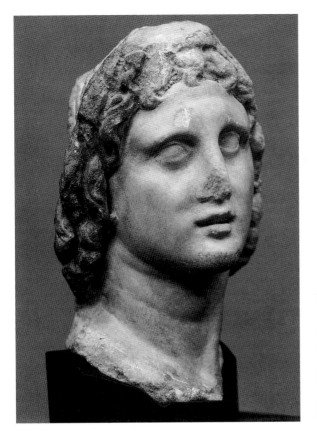

249 Alexandria. Alexander. 2nd cent BC. (Cleveland 27.209. H: 29.4 cm). p. 210

250 Alexandria. Ptolemaic king. 3rd cent BC. (Louvre MA 3261. H: 23.5 cm). p. 210

251 Thmuis. Isis. 2nd cent BC. (Cairo JE 39517. H: 19 cm). pp. 76, 206

252 Thmuis. Aphrodite. 2nd cent BC. (Cairo JE 39518. H: 22 cm). p. 210

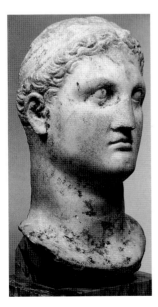

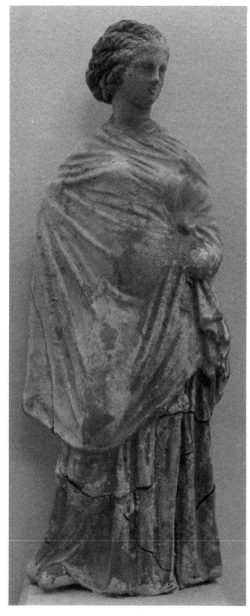

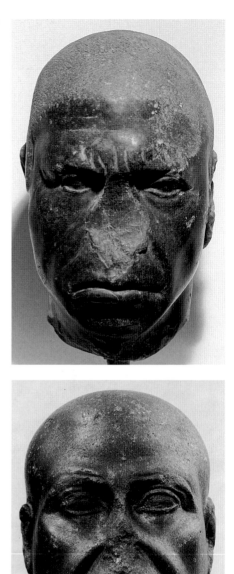

253 Alexandria. Terracotta statuette, coloured in broad bands of pale blue and pink. (Alexandria Mus.) p. 210

254 Egypt. Priest(?) 2nd–1st cent BC. Basalt. (Venice 64. H: 17 cm). p. 210

255 Egypt. Priest(?) 2nd–1st cent BC. Diorite. (Detroit 40.47. H: 20 cm). p. 210

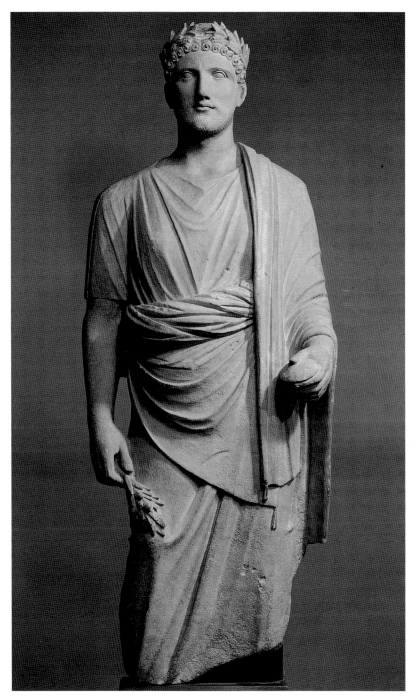

256.1 Cyprus. Wreathed worshipper, with laurel branch and incense(?) box. From Golgoi. Limestone, 3rd cent BC. (New York 74.51.2465. H: 1.62 m). p. 211

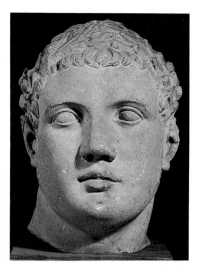

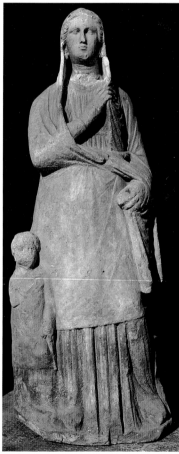

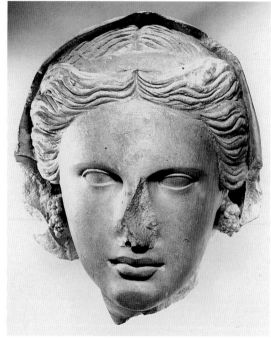

256.2 (*above left*) Cyprus. Wreathed male portrait. From Golgoi. Limestone, 3rd cent BC. (New York 74.51.2817. H: 27 cm). p. 211

257 (*left*) Cyprus. Woman with child or servant. Limestone, 2nd cent BC. (Nicosia E 524. H: *c.*1.95 m). p. 211

258 (*above*) Cyprus. Woman with earrings. From Arsos. Limestone, 3rd cent BC. (Nicosia D 272. H: 32 cm). p. 211

Chapter Twelve

THE SELEUCIDS AND THE EAST

In the wars of the Successors, Seleukos I Nikator the founder of the Seleucid dynasty seized, eventually, the largest part of Alexander's empire. In 281, his kingdom stretched from western Asia Minor to northwest India. It was centred on northern Syria with the capital at Antioch on the Orontes and secondary capitals at Sardis in the west and Seleucia on the Tigris in the east. Seleucid history was dominated by a struggle against territorial fragmentation; and separatist kingdoms were already established by the mid-third century – minor dynasties in Asia Minor (Pergamon, Bithynia, Pontus, Cappadocia) and a major kingdom in Bactria. In the second century, Asia Minor was lost to Pergamon and the east beyond the Euphrates to Parthia. After a period of dynastic chaos, the kingdom was brought to an end by Rome in 64 BC.

The Seleucids founded many cities throughout their empire. The bold Hellenistic colonization of the area from Iraq to Afghanistan was relatively short-lived and has been little explored archaeologically. The extent and character of its material achievements in the third century remain for the most part obscure. Recent excavations, however, in Babylonia (Seleucia), in the Persian Gulf (Failaka), and especially Bactria (Ai Khanoum) have shed some light. It was to describe a 'mixed' culture produced by Greek and Oriental in Asia that G. Droysen originally coined the term 'Hellenistic'; but excavation has not shown fusion and interaction to have been this culture's leading characteristics. The new cities had both Greek and native populations, but they remained separate. Dominant institutions, culture, and art, were Greek. The best working theory is that the Hellenistic artistic and sculptural *koine* flourished wherever and in so far as its patrons did. And in the third and second centuries, its patrons were mainly the Greek and Macedonian settlers. From the second century, they were joined by some Hellenised Iranians and some Parthian kings, who commissioned Greek art works to decorate the cultural life of their courts.

Syria

At the Seleucid centre, no coherent picture emerges for any category of sculpture: Hellenistic Antioch is almost entirely lost. There are a few disconnected pieces and a few works known from copies and on royal coins. Some major Seleucid cult statues can be glimpsed: the revolutionary Tyche of

Antioch in small versions [91], the Apollo Kitharoidos of Daphne and a major Zeus on coins of Antiochos IV. Apollo was the patron god of the Seleucids, and he appears as a soft lithe youth, seated with a bow, on the regular royal coinage. Some idea of such as Apollo in 'modern' style may be mentally reconstructed from the fine Tralles Apollo [76]. The draped Apollo Kitharoidos at Daphne, which can be approximately visualized in various later marbles, was clearly more conservative. Typical cult statues among the minor kingdoms of Asia Minor may be imagined from the Zeus on Bithynian royal coins [65] and from the headless Zeus from Pergamon [63]. Of the mythological groups, we saw that the Hanging Marsyas [135] has been interpreted as a Seleucid allegory. In addition, the only extant version of the baroque Daidalos [137] comes from the Seleucid sphere. Apollo-Helios was the (unseen) punishing deity in both these groups.

Coins provide an excellent series of royal portraits from the Founder to the last king [259, 260], but there is no coherent body of sculptured portraits as at Alexandria. Two portrait types, of Seleukos I and Antiochos III, are known both from coins and fine sculptured copies: the Papyri Seleukos [12] and Louvre Antiochos [18]. Both are unusual, though in rather different ways. The Seleukos combines an older face with ideal royal hair and dynamic pose. The Antiochos has short hair and a sharp, lean, highly individualized face. The effect here of pragmatic soldier-king as opposed to youthful god-king is accentuated in the sculpture. Most Seleucid coins present the king as younger, more ideal, more heroic. Three original royal heads have appeared recently. A head in Berlin (without documented provenance) may represent Antiochos IV [263]. And two high-quality portraits from near Antioch are both late Hellenistic. One is a lifesize diademed head of a living, ruling king, probably Antiochos IX [262]. He has long sideburns and underchin beard; this feature and the style are reminiscent of some late Ptolemies [243]. Late Seleucids on coins are normally more dynamic. The other Antioch head [261] is well over lifesize and wore long, separately attached bull's horns. Its unusual 'pathos' and un-portrait-like divinity indicate that it is a posthumous portrait, probably of the founder Seleukos whose images commonly wore bull's horns [259]. A colossal head from Skythopolis [264], perhaps from a cult statue, seems Hellenistic in date but it is hard to tell if it represents a god, Alexander, or a Seleucid king – it combines elements of all three. A similar conception underlies royal cult titles which can combine the names of a god and a king, for example, 'Antiochos Apollo Soter'.

Ai Khanoum and Bactria

To the east, the Hellenistic sculptural *koine* is found at a few widely spaced sites, of which Ai Khanoum is the most important. Ai Khanoum has done much to clarify the nature of Hellenism in further Asia. It is the site of a Greek city on the river Oxus in north east Afghanistan, discovered in 1964 and excavated between

1965 and 1979. The city was founded in the later fourth century (330–300 BC) and destroyed by invaders from the north in the later second century (c. 130 BC). Its material is thus externally dated to the early and middle Hellenistic period. During the first half-century of its history the city was Seleucid, and thereafter it was part of Bactria, a powerful Greek kingdom which seceded from the Seleucids c. 255 BC. Bactrian coins provide some impressive images of gods and an astonishing series of royal portraits [265, 266]. The kings are shown as more mature, military, and realistic-looking than in other dynasties. Ai Khanoum fills out this picture with its heterogeneous sculptural finds.

Most of the sculpture from Ai Khanoum – like the inscriptions, mosaics, and gems – is purely Hellenistic in style and content. There are only a few items clearly made for native consumption (for example, small bone figurines of a naked fertility goddess). The architecture is more mixed: it employs both Greek and Oriental ground plans, local materials (brick and limestone), but mainly Greek forms for elevations and orders. Marble was available only in small quantities, and the fragments of colossal reliefs in the governor's palace were made of painted and gilded clay and stucco – a native medium found elsewhere in the East. Some portrait heads survive from one of these reliefs [267]; and from another, fragments of a colossal equestrian group were recovered. A large temple of Oriental design contained a colossal acrolithic cult statue (Zeus?) of which one impressive sandaled foot in purely Greek style has survived [268]. A small limestone statue of a draped woman [269] from the same temple is in Hellenistic format but somewhat stiff and provincial in handling (reminiscent, of course quite unconsciously, of Cypriot figures). The large Greek gymnasium has produced an inscription to the athletic gods Hermes and Herakles and an interesting Herakles herm [270], of a type common, for example, in the gymnasium on Delos. Also in excellent *koine* style are a vigorous marble statuette of a naked athletic male [272] and an attractive limestone grave relief of a dead youth [273]. Lower levels are represented by a rather gauche bronze statuette of Herakles [271].

A Hellenistic palace complex was also recently discovered in northern Bactria, on the Oxus river at Takhti-Sangiz. According to an inscribed altar, the complex was dedicated to the river Oxus. The finds include votives of earlier and later periods. Among the Hellenistic artefacts are a small painted clay head of a ruler or hero and a small alabaster head of a bearded Iranian. The coexistence of Hellenistic and Parthian ruler styles is also seen on coins in many places in second-century Iran. In the first century, with the collapse of the Seleucids and Bactrians, the Parthian style [279, 280] comes to predominate, at least for dynasts.

Shami, Failaka, Seleucia

Hellenistic and Parthian are seen together in sculptural finds at three important sites. At Shami, a small sanctuary in Susiana of the later Hellenistic and early

Parthian period, remains of about twenty statues and statuettes, mostly fragmentary bronzes, were found. The fine head of a Seleucid king *[275]* had been deliberately broken. Several small pieces and one large statue represent Iranians *[274]*, no doubt local Parthian clients who replaced the Seleucid rulers in this area. A small marble head in standard *koine* style was perhaps from an Aphrodite. Excavation of a Seleucid fortress-sanctuary on the island of Failaka (Hellenistic Ikaros) in the Persian Gulf has produced an interesting selection of terracottas: Hellenistic males and females *[277, 278]* in *koine* style, some Babylonian frontal female idols for native consumption, and one or two figures of Iranians *[276]* wearing trousers and 'satrapal' headgear – these no doubt reflect a change to Parthian overlordship of the sanctuary. Excavations at Seleucia on the Tigris, the Greek capital of Babylonia, have revealed a similar range of terracottas but in greater quantity and over a longer period. There are Hellenistic figures for Greek consumption and frontal female idols for native consumption. Under Parthian rule from the mid-second century BC, the Greek populace of Seleucia continued an essentially Greek cultural existence well into the second century AD. In the later period, the terracottas are complemented by a series of remarkable painted alabaster figures, some naked goddesses but mostly draped women – the urban middle class of the Parthian period. The longevity of the Hellenistic *koine* at Seleucia has been recently demonstrated by the discovery of a bronze Leaning Herakles of early Hellenistic type and style, inscribed with the date AD 150/1. The inscription is secondary, but how much earlier the statue was made is not clear.

Parthian kings and barons presented themselves on coins and in statues as stiff, implacable Oriental rulers wearing native costume, hairstyle, and headgear *[279]*. However, the sculptural finds from the Parthian capital at Old Nisa show that the Parthian élite also commissioned Greek *koine* art which conveyed a sense of culture. From Nisa come ideal marble figures and fine ivory drinking horns, decorated with figured friezes, Greek in style and workmanship. The Parthian court spoke and wrote Greek, and listened to recitals of Euripides (Plutarch, *Crassus* 33). Other Greek sculptures of the Parthian period, for example, some bronze statuettes from Nihawand or a marble head of a Tyche from Susa *[281]*, which is signed prominently by a Greek sculptor on the front of her mural crown, could have been made either for Parthian or Greek clients.

Kommagene and Antiochos I (*c.* 70–30 BC)

As we have seen, the sculpture of the Hellenistic East shows little evidence of Greco-Iranian interaction. There is, however, one group of monuments, in Kommagene *[282, 283]*, which makes a clear attempt at a stylistic mixture, in highly particular circumstances.

Antiochos I was the hereditary local ruler of Kommagene, a small but rich kingdom in eastern Anatolia, between the Taurus mountains and the upper

Euphrates. Like others, he was a Hellenised Iranian, with some Seleucid blood in his veins (his father had married a Seleucid princess). Upon the dissolution of Armenian and Seleucid power in this region by the Romans in 64 BC, Antiochos was left as a Roman client king, a buffer between Asia Minor and the Parthians. Unusually, Antiochos chose to present a mixed Greek-Iranian image. He grandly conceived of his kingship as combining the best of Hellenic and Persian traditions, and instituted the worship of himself and an assembly of mixed Greco-Oriental gods at sanctuaries throughout his kingdom. The sanctuaries were furnished with large sculptured monuments and verbose cult inscriptions which tell in exalted style of his theocratic programme. He begins thus: 'The Great King Antiochos, God Just and Manifest, Friend of the Romans, Friend of the Greeks . . . inscribed on consecrated bases with inviolable letters the deeds of his personal grace, for eternal time'. His royal cult was to be judiciously half-Greek and half-Persian, reflecting his supposed dual descent from both Macedonian and Achaemenid royalty. And his sculptured images were to be made in mixed style 'according to the ancient manner (*palaios logos*) of the Persians and the Hellenes – most blessed roots of my family', as he commands explicitly in one of his inscriptions. The nature and expression of Antiochos' theocratic pretensions are unique in this period, and perhaps reveal serious delusions of the mind.

Antiochos instituted both grand tomb-sanctuaries (*hierothesia*), where members of the royal family were buried, and lesser sanctuaries (*temene*). We have sculptures and inscriptions from over ten such sites. The most elaborate were the *hierothesia* for his father Mithradates at Arsameia and for himself on Nemrud Dagh, a lofty peak in the Taurus range. Nemrud Dagh is the best preserved sanctuary. It consisted of a steep tumulus and two terraces on opposite sides where nearly identical sets of reliefs and colossal statues were displayed. On each terrace the reliefs were arranged in two lines, representing his Macedonian and Persian ancestors. The best preserved ancestor relief shows a Persian king (Darius) wearing a tiara and a curious garment resembling a dressing-gown. Like Antiochos' claimed descent from Darius, its 'Achaemenid' style and costume are purely fictional. The colossal seated statues [282] are cubic frontal figures, built in uneven courses of hard limestone blocks. They represent Antiochos himself and the four syncretic gods of his pantheon, and wear Oriental costumes and headgear, no doubt intended to be Achaemenid. The Hellenic element is here confined to the basically Classical formal structure of the heads.

Dexiosis reliefs, showing the king shaking hands with a god, have been found at all the sanctuaries. They illustrated the king's equality of divine status with the Olympians. The finest and largest is that from Arsameia [283] and shows the king with a naked Artagnes-Herakles. The figure of the king is drawn according to the official royal model, with Oriental costume and clean-shaven Greek face. In the Herakles, one sees the problems caused by the royal directive for a mixed

style. The sculptors were clearly capable of carving naked male figures in good *koine* or naturalistic style, as seen elsewhere in the kingdom; but here, in accordance with the king's stylistic instructions, they make a vigorous effort to introduce '*un*-Greek' components, by artificially barbarizing the anatomical scheme. There could be no genuine Achaemenid element in such figures, because nudity and naked images had always been anathema to Iranians. The artificiality is shown by the lack of consistent schemata between different reliefs. Another nude Herakles, from Nemrud Dagh, is also 'un-Greek' but quite different from that at Arsameia.

Antiochos' monuments probably do not reflect any wider stylistic trends in the Seleucid East. The syncretic gods were his own creation, with apparently no existence outside the royal cult. The synthetic style of the sculptures has a certain hollowness that well expresses Antiochos' dynastic vision. The monuments of Kommagene were probably the atypical products of a troubled time and a troubled mind.

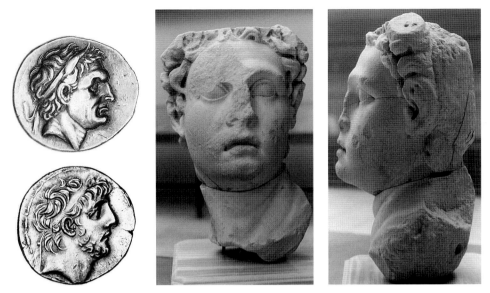

259 Seleukos I (311–281 BC), with bull's horn. Silver tetradrachm of Sardis, c.270's BC. p. 224

260 Antiochos IX (115–95 BC). Silver tetradrachm of Antioch. p. 224

261.1–2 N. Syria. Seleukos I, with bull's horns added separately. From Iskenderum, 2nd cent BC. (Antakya 14319. H: 53.5 cm). p. 224

262.1–2 N. Syria. Antiochos IX. From Iskenderum, c.100 BC. (Antakya 14318. H: 43 cm). p. 224

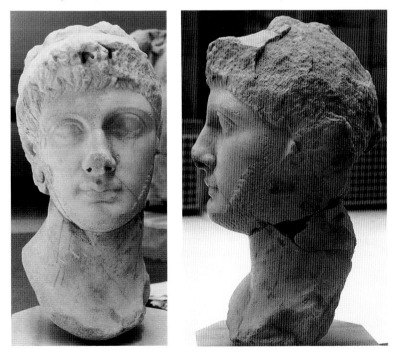

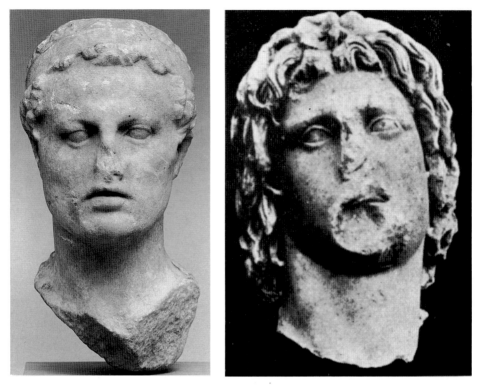

263 Diademed king: Antiochos IV(?) Mid–2nd cent BC. (W. Berlin 1975.5. H: 24.5 cm). p. 224

264 Skythopolis. Divinized king(?) 2nd cent BC. (Jerusalem Arch Mus. H: 42 cm). p. 224

265 Antimachos of Bactria. King with 'accessible' smile, wearing Macedonian kausia. Silver tetradrachm, c.180 BC. p. 225

266 Eukratidas of Bactria. King as general, wearing horned helmet. 20-stater gold piece, c.160 BC. p. 225

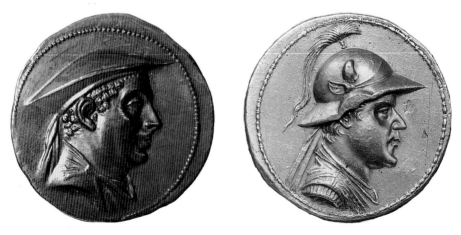

267 *(above)* Ai Khanoum. Portrait head from clay and stucco relief, originally painted and gilded. *c.*250–150 BC. (Kabul. H: 22 cm). p. 225

268 *(below)* Ai Khanoum. Foot of cult-statue. Marble, *c.*250–150 BC. (Kabul. L: 27 cm). p. 225

269 *(right)* Ai Khanoum. Draped woman. Limestone, *c.*250–150 BC. (Kabul. H: *c.*1.00 m). p. 225

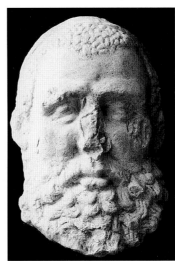

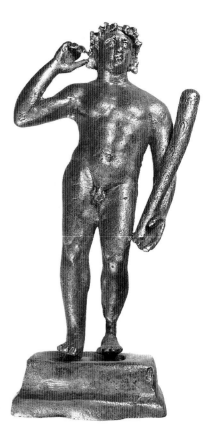

270.1–2 *(above)* Ai Khanoum. Herakles herm, from the gymnasium. Limestone, *c.*250–150 BC. (Kabul. H: 77 cm, HdH: 20 cm). p. 225

271 *(right)* Ai Khanoum. Statuette of Herakles. Bronze, *c.*250–150 BC. (Kabul. H: 16 cm). p. 225

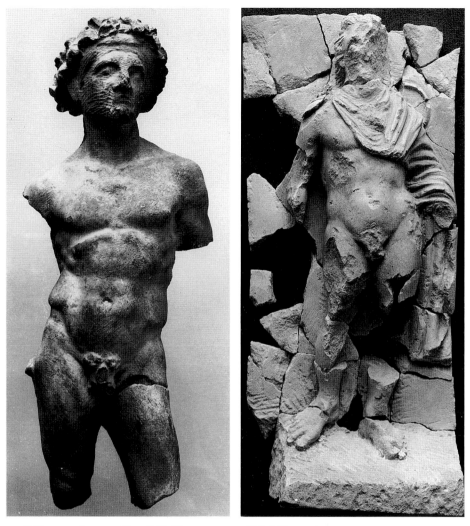

272 Ai Khanoum. Statuette of hero(?) Marble, c.250–150 BC. (Kabul. H: 35 cm). p. 225

273 Ai Khanoum. Grave relief of youth in chlamys. Limestone, c.250–150 BC. (Kabul. H: 57 cm). p. 225

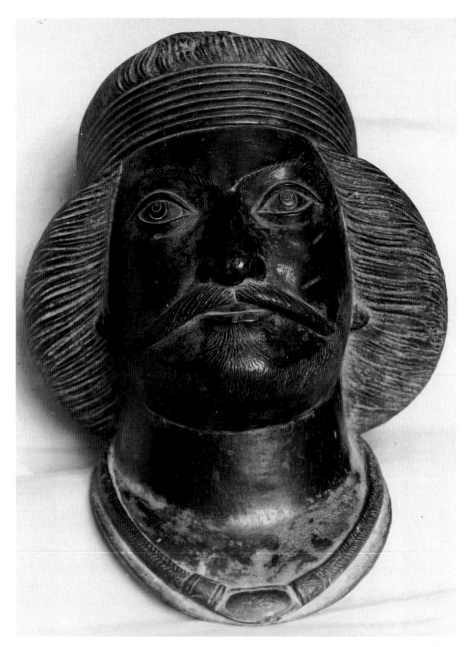

274 Shami. Local ruler or satrap. Bronze, 2nd–1st cent BC. (Tehran 2401. H: 25 cm). p. 226

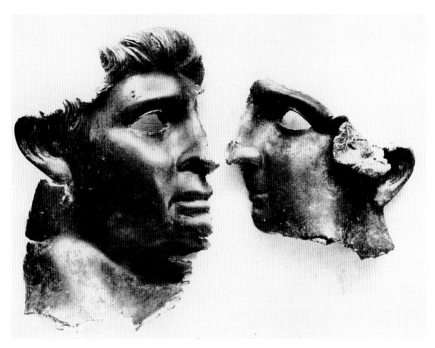

275 Shami. Seleucid king: Antiochos VII(?) Bronze, *c*.130 BC. (Tehran 2477. H: 27 cm). p. 226

276 *(below left)* Failaka. Parthian-style ruler. Terracotta, late 2nd cent BC. (Kuwait Nat Mus. H: 25 cm). p. 226

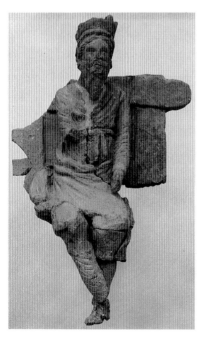

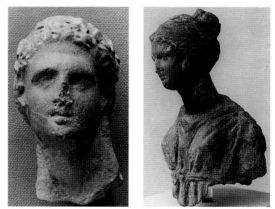

277 Failaka. Terracotta, 3rd cent BC. (Kuwait Nat Mus. H: 8 cm). p. 226

278 Failaka. Terracotta, 3rd cent BC. (Kuwait Nat Mus. H: 11 cm). p. 226

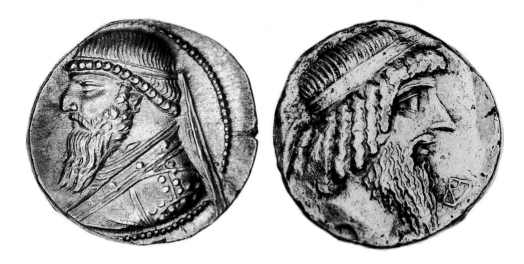

279 Mithradates II of Parthia (123–87 BC). Silver tetradrachm of Seleucia on the Tigris, c.115 BC. p. 226

280 Attambelos I of Characene (47–27 BC). Silver tetradrachm, 46–45 BC. p. 225

281 Susa. Head of Tyche. Signed on crown by Antiochos son of Dryas. 2nd–1st cent BC. (Tehran 2452. H: 40 cm). p. 226

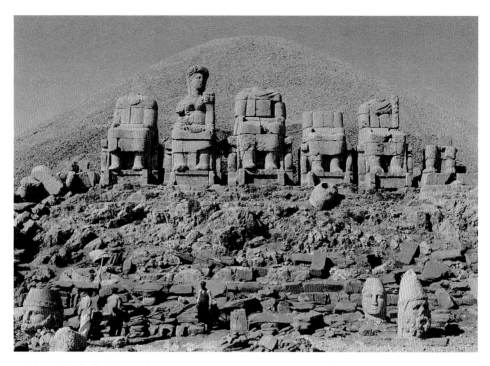

282 Nemrud Dagh. Antiochos I of
Kommagene (c.70–30 BC) and his gods. L–R:
Antiochos, Kommagene, Zeus–Oromasdes,
Apollo–Helios–Mithras, Artagnes–Herakles–
Ares. Limestone, mid-1st cent BC. (In situ.
H: 8.50 m). p. 227

283 Arsameia. Antiochos I with Artagnes–
Herakles. Limestone relief, mid-1st cent BC.
(In situ. H: 2.26 m). p. 227

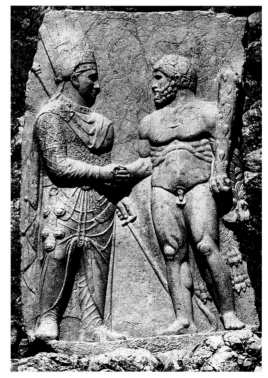

Chapter Thirteen

MACEDONIA AND GREECE

Macedonia was the power base of Philip and Alexander and the point of origin of the major Successor dynasties. After a long struggle, the kingdom was eventually secured by the Antigonids who ruled until their abrupt removal in 168 BC by the Romans, after the battle of Pydna. At their most powerful, in the middle and later third century, the Antigonids controlled much of mainland Greece and the Aegean. Until the 1970's, Macedonia itself was as obscure archaeologically as Seleucid Syria. Recent excavations at Vergina, the old capital Aigai, and at Pella, the new capital, have revealed rich houses and tombs, decorated with fine paintings, mosaics, ivories, and precious metalware. The royal economy was driven by the gold mines of Mt. Pangaios, and the finds of goldwork from the same moulds in Vergina and the Thracian interior show that Macedonia was a leading metalworking centre from the later fourth century on. Already in the later fifth century, when Euripides moved to Pella, the city was clearly no cultural backwater. Due no doubt to accidents of survival, the sculptural finds from Pella and Vergina are not abundant, but combined with pieces from other sites in the kingdom, they offer the outlines of a coherent picture.

In Macedonia, kingship was traditional, and there seems to have been no dynastic royal cult, no need for a focus of organized loyalty to the king. Antigonid coinage is conservative in generally not using the successive kings' portraits; and we have coin portraits of only three rulers: Demetrios Poliorketes *[284]*, Philip V, and Perseus *[285]*. Demetrios' portrait is also known in a fine marble copy from Herculaneum *[10]*. A good original Alexander head *[288]*, found at Pella, has the typical posthumous ideal 'pathos' and is probably third-century. Impressive gods are featured on the royal coinage *[286, 287]*. Otherwise divine images survive only in small figures: a small bronze Poseidon, a terracotta Athena, and a young Pan in marble *[289]* – all were important deities in the kingdom. The Nike of Samothrace *[97]*, we saw, may well have been a monument of a third-century Macedonian naval victory (Chapter 6).

A considerable body of figured ivories has been found recently in tombs at Vergina: an Achilles and Penthesilea group on a ceremonial shield, a fine appliqué Dionysian group from a piece of furniture *[291]*, and a series of small heads from a frieze decorating a couch or chest *[292]*. These heads no doubt had bodies of painted and gilded wood, in high relief. Their impassioned style

indicates that they were probably part of a battle frieze, in the manner of the Alexander Sarcophagus [226]. The battle seems to have been between clean-shaven Macedonians and bearded barbarians. The Vergina ivories are dated with the tombs, in the later fourth century. From a later tomb at Leucadia (third century) comes a similar series of dynamic ivory heads from a high-relief battle frieze – here preserved with limbs in action and strips of a decorative frame. The élite context and once opulent effect of these ivory compositions recall the elaborate frieze of ivory figures on a gold background that decorated one of the dining cabins of Ptolemy IV's River Yacht (Athenaeus 5.205c). The middle levels of sculpture are represented for us by some marble grave reliefs [293, 294] from towns away from the main centres. They are plainer, more conservative than the stelai of Asia Minor. And from the lower levels, we have a good range of terracottas from graves at Pella [290], of the standard 'Tanagra' repertoire.

From mainland Greece and the Aegean area we have a large amount of original marble statuary from all levels, some of which is also well documented. This material provides good examples of the normal commissions, civic and family, in the cities and sanctuaries of old Greece. There are many large pieces of good quality, from a traditional polis milieu. There are, for example, no baroque groups, no big centaurs. Instead we have much divine statuary, cult and votive, and many civic portraits. These must always have constituted the regular work for the workshops of locally-based sculptors: statues of city gods and the city élites.

Athens

Athens remained a political and cultural centre of the greatest prestige. It was the capital of Hellenistic philosophy, and was much courted by the kings. Athens is the only city for which we can reconstruct a fairly complete profile of its statuary output in the Hellenistic period. A few royal heads [20] survive out of the many statues of kings known to have been set up. The philosopher portraits, Athens' greatest contribution to Hellenistic sculpture, we would have missed entirely if we had relied on marble originals alone. From literature and marble copies we are well informed about the statues of some of the city's leaders and many of its resident philosophers (Chapter 3). Our only major originals in this category, from anywhere in Greece, are a very fine bronze head from Antikythera [298] and a statue at Delphi [295]. There must also have been athletic statues at Athens in some quantity. The Acropolis base with athletic figures [45] and the Artemision Jockey [58] are their best-quality surviving representatives.

The figures best represented are gods and goddesses. From the early third century, there are two dull and conservative figures: the Themis of Rhamnous [296] and the seated Dionysos from the choregic monument of Thrasyllos [297] above the theatre. Later in date is the Asklepios of Mounychia [67], in more

'modern' style. And probably from the later second century, we have a large Athena head and a torso of another goddess ('Nike') from the Kerameikos, both frequently attributed (wrongly) to the sculptor Euboulides on the basis of a misreading of Pausanias (1.2.5). Both are in a strongly Classical manner, the interpretation of which will be discussed below.

The Peloponnese and Damophon

From a combination of archaeology and Pausanias, we are particularly well informed about a series of cult statues made in the Peloponnese in the second century BC. They are mostly colossal, acrolithic figures, elaborately pieced, with heads and limbs hollowed out behind. At Aigeira in Achaia, Pausanias (7.26.4) saw in a temple of Zeus a cult statue by Eukleides of Athens. Its head *|299|* and right arm were recovered in excavations. The impressive head captures the awesome grandeur of the chief Olympian; he is not a naturally sympathetic father-figure, like the Mounychia Asklepios *|67|*, but powerful and detached. The surface is hard, the eyes and lips sharply cut in a Classical manner. The head, however, is no monument of neo-Classicism, that is, the use of fifth-century style as a self-conscious aesthetic reference. Rather the head employs the normal ideal language of a Hellenistic Zeus. Most Zeus heads drew on Pheidian prototypes for their identifying features, but the treatment here is fully 'up-to-date': enlarged eyes, thick lips, and a tall brow with bulging middle, articulated by strong modulations at the temples. The forked beard is carved in a sketchy impressionistic manner, and the hair was brushed up from the forehead in upright curling locks, added separately. The head of a cult statue found recently at Pheneos *|300|*, probably of Hygieia, provides a female counterpart to Eukleides' Zeus. It is similar in style and rather daunting in effect. Its unusual impact is due to the preservation of its separately inset eyes and bronze lashes. The inscribed base of the statue was also recovered, and gives the signature of the sculptor, one Attalos of Athens.

Of Damophon of Messene, we know more than any other Hellenistic sculptor. He made cult statues in the Peloponnese for Lykosoura, Messene, and Megalopolis, as reported by Pausanias, and he is honoured in a series of eight inscriptions at those sites. He was also chosen to carry out a restoration of Pheidias' Zeus of Olympia. His dates are not known precisely: the first half of the second century is most likely. He was clearly the best known sculptor of his day in southern Greece, perhaps a specialist in cult statues. His reputation, however, was purely local. We know of no works by him outside the Peloponnese. No other writer apart from Pausanias mentions him, and his name appears nowhere in Pliny. This probably means Damophon was not in Hellenistic art history as such.

Pausanias (8.37.1–6) describes in detail a marble group made by Damophon for the temple of Despoina (= Persephone) at Lykosoura in Arcadia. The heads

of the four figures and other substantial parts were excavated on the site in 1889, and the group can be broadly reconstructed on paper [301.1]. The veiled Despoina and her mother Demeter sat on a wide double throne, flanked by Artemis on one side and a local hero Anytos on the other. The figures were built and pieced in various techniques and materials. The heavy marble heads and other large parts were hollowed out behind to reduce weight for transport. Like most cult statues they were meant to be seen from the front only. Like the Pheneos head, the females are rather formless essays on fourth-century goddess types, with 'modern' melon hairstyles carved impressionistically. The Artemis [301.3] is quite vigorous. Like Eukleides' Zeus, the Anytos [301.2] combines Classical facial forms with a modern hairstyle. The irregular dynamic locks of his beard and hair are modelled in baroque style as if from soft clay. The effect of the Anytos, beside the tautly composed Zeus of Eukleides, is somewhat vapid, even sluggish. Damophon also made a statue of Apollo for his home town of Messene which Pausanias (4.31.10) saw. A large Apollo head [302], in clear 'Damophonian' style, has been found at Messene and must surely come from this statue. In formal handling, it is closely related to the goddesses at Lykosoura, but is of much better quality. It provides a good Apollo counterpart to the Lykosoura Artemis.

Many scholars have emphasized the Classical components in Damophon's work, noting that he must have been very familiar with Pheidias' style from his restoration work on the Zeus at Olympia. He has therefore been identified as a prime innovator in the neo-Classicism of the late Hellenistic period. For some, Lykosoura is the 'first document of neo-Classical style' (A.F. Stewart). There is, however, in Damophon's work no close reproduction of fifth-century schemata as a stylistic device, as a conscious reference to the past. The cult statues of Damophon and other Hellenistic sculptors no doubt attempted a Pheidian grandeur, but there is no deliberate quotation of Pheidian style. Damophon was not a revivalist reinventing a style that had since disappeared. This manner of representing the gods had never been absent, as third-century works like the Themis of Rhamnous [296] and Thrasyllos' Dionysos [297] show. It was simply the continuing sculptural manner for cult statues in mainland Greece. The real importance of Lykosoura lies not in the sphere of neo-Classicism, which is a different, self-conscious phenomenon, but in the detailed picture it gives of a typical, major cult group of the middle Hellenistic period.

The Islands and the Aegean

Some of the island sanctuaries, like Delos and Samothrace, experienced their greatest prosperity from Hellenistic royal patronage. The sanctuaries were often the context for the most prestigious royal dedications – imposing portrait statues, and victory monuments. The Nike of Samothrace [97] is a rare survival from this level. What mostly survives of statuary from the islands is similar in

241

outline to what we saw on the mainland: large marble gods and, increasingly, civic portraits. The largest concentrations of typical material are from Delos, Kos, Rhodes, Samos, and Thasos.

The most important surviving divine figures are a Dionysos and Muses from Thasos, a fine Helios head from Rhodes [303], and the Poseidon and Aphrodite statues from Melos [304, 305]. Such pieces fill out the standard Hellenistic repertoire of divine statues, poorly represented in the copies. The differences between them are not essentially of date or stylistic direction (they are all third to second century), but of divine character and its appropriate sculptural expression. For example, the contrast between the dynamic Rhodian Helios and the stolid Melian Poseidon expresses on the one hand the energy and mobility of the young, chariot-driving sun god, and the stable power of a senior Olympian on the other.

Surviving marble portrait statues seem to be fewer in the third century and become more common from the second century. The islands have produced great quantities of standing draped women [112–114] – men, for whatever reason, are much less common in marble. Some were no doubt public honorific statues, but increasingly they were family commemorative and funerary commissions. Figures with their heads intact are, unfortunately, rare. Probably typical are a female statue ('Nikokleia') from Knidos [306] and a large bearded male statue from Kos [307]. Youthful male counterparts to these elders are provided by two figures, also from Kos. One, a statue [308], is in full civic attire of himation and tunic. The other, a large relief figure [311], is of an athletic victor. Such figures continued as a constant of statue production into the Roman period. A series from the Odeion on Kos, for example, shows a full range of women, men, and youths, of various dates, from the middle Hellenistic period well into the early empire.

Of all the islands, Delos provides the richest cross-section of surviving marble sculpture. The material also has an approximate external lower date, 88–67 BC, when the island lost much of its commercial importance due to two sacks in those years. A few pieces are also dated more precisely [113, 114]. There are good examples from most of the major categories: divine statues, for example of Isis [312]; several royal heads [309, 310]; a heroic Gallic figure; fine civic portrait statues, like those of Kleopatra and her husband Dioskourides [113]; and some Dionysian sculpture [313], including a famously disliked erotic group of Aphrodite and Pan [314]. Only philosophers (predictably) are missing. There is also a mass of small-scale sculptures: small votive figures, and many herms from the gymnasium. These complete the sculptural profile of a thriving Hellenistic city-sanctuary. Besides its abundant evidence for the Hellenistic sculptural mainstream, Delos is perhaps most important for the early dated evidence it provides for two central new phenomena of the late Hellenistic period to be discussed in the next chapter: a new style in portraiture, and the copying of older works.

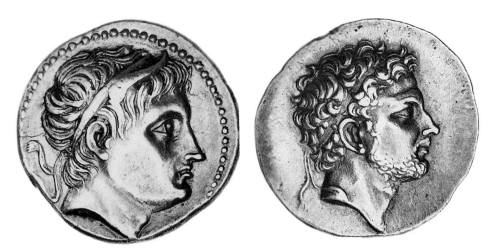

284 Demetrios Poliorketes (306–283 BC) Silver tetradrachm. p. 238

285 Perseus of Macedonia (179–168 BC). Silver tetradrachm. p. 238

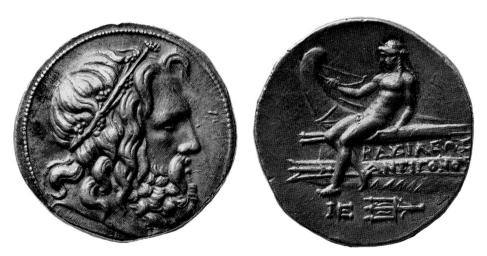

286 Poseidon. Silver tetradrachm of Antigonos Doson (229–221 BC). p. 238

287 Apollo on warship. Silver tetradrachm of Antigonos Doson (229–221 BC). p. 238

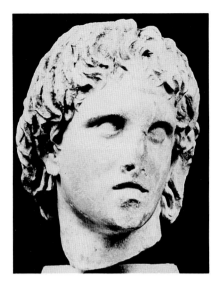

288 Pella. Alexander. 3rd cent BC. (Pella Mus. GL 15.
H: 30 cm). p. 238

289 Pella. Young Pan. 3rd cent BC. (Pella Mus. GL 13.
H: 38 cm). p. 238

290 Pella. Woman. Painted terracotta, 3rd cent BC. (Pella
Mus. 1976.271. H: 28 cm). p. 239

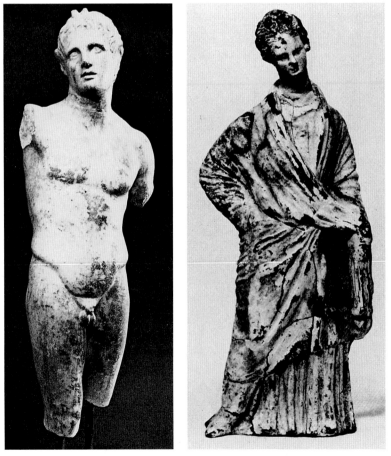

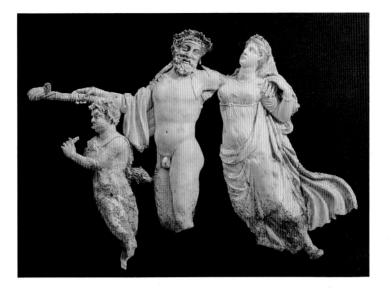

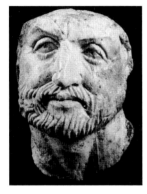

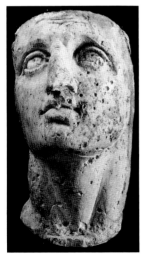

291 *(above)* Vergina. Satyrs, Dionysos, Maenad. Ivory appliqué relief, late 4th cent BC. (Thessaloniki). p. 238

292.1–2 *(left)* Vergina. 1 *(above)* Bearded warrior from Tomb II. Ivory, late 4th cent BC. (Thessaloniki 11. H: 3.2 cm). 2 *(below)* Warrior. Ivory, late 4th cent BC. (Thessaloniki 12. H: 3.4 cm). p. 238

293 *(below)* Macedonia. Grave relief from Aiane: man and family. For kausia (hat), cf. [265]. 3rd cent BC. (Louvre MA 804. H: 1.03 m). p. 239

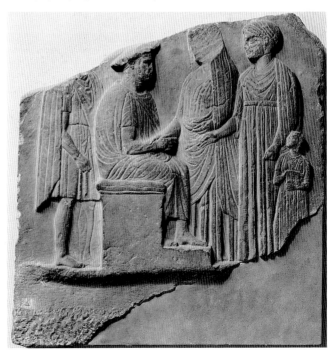

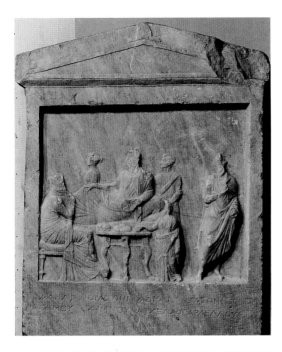

294 Macedonia. Grave relief of two children, Adea and Thrason (at right), with their grandparents, also named Adea and Thrason (at left). 2nd cent BC. (Louvre MA 817. H: 1.31 m). p. 239

Below

295 Delphi. Philosopher. 3rd cent BC. (Delphi Mus. H: 2.07 m). p. 239

296 Rhamnous. Themis. Signed by Chairestratos, early 3rd cent BC. (Athens NM 231. H: 2.22 m). p. 239

297 Athens. Dionysos from the monument of Thrasyllos (320–19 BC). Statue of 3rd cent BC, added to monument later. (British Museum 432. H: 1.91 m). p. 239

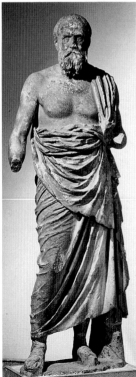

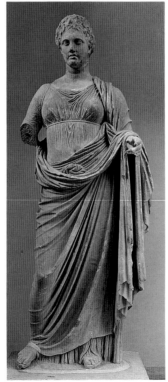

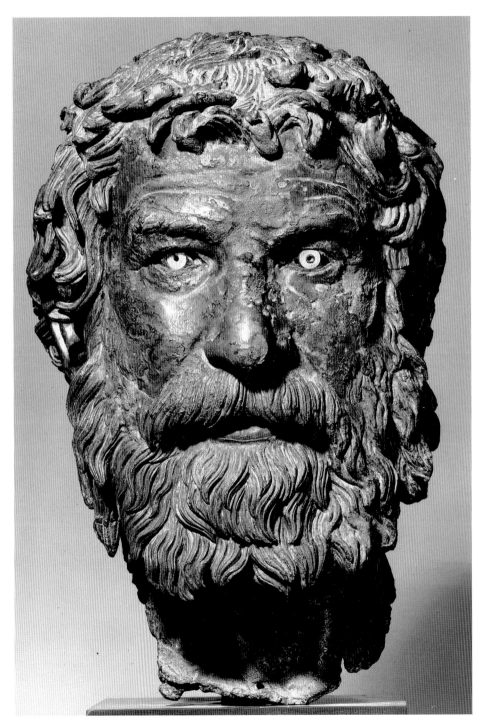

298 Attica(?) Philosopher from Antikythera. Bronze, 3rd cent BC. (Athens NM Br 13400. H: 29 cm). p. 239

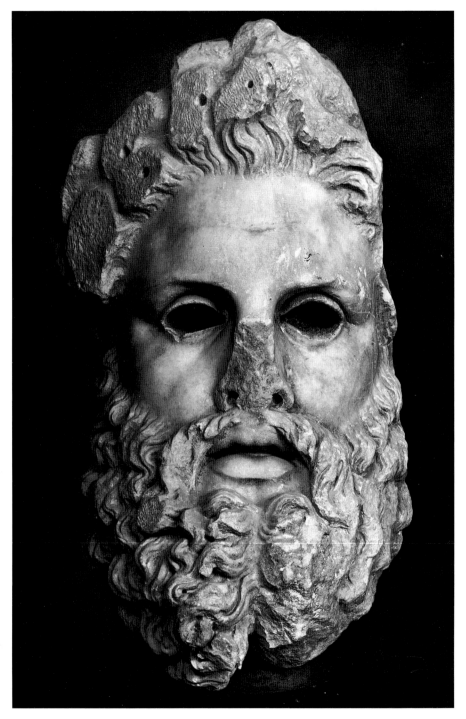

299 Aigeira. Zeus. By Eukleides of Athens, 2nd cent BC. (Athens NM 3377. H: 87 cm). p. 240

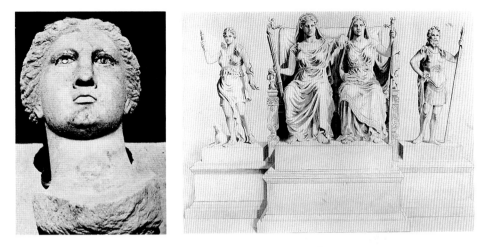

300 Pheneos. Hygieia. Signed by Attalos of Athens, 2nd cent BC. (Pheneos. H: 80 cm). p. 240

301.1–3 Lykosoura. Cult group by Damophon of Messene, 200–150 BC. 1 *(above right)* L–R: Artemis, Despoina, Demeter, Anytos. (Reconstruction: G. Dickens). 2 *(below left)* Anytos. (Athens NM 1736. H: 74 cm). 3 *(below right)* Artemis. (Lykosora Mus. & Athens NM 1735. H: 1.33 m). p. 241

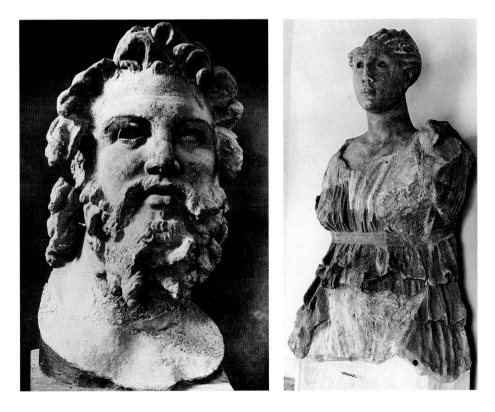

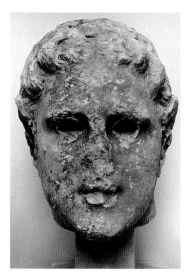

302 Messene. Apollo. By Damophon of Messene, 200–150 BC. (Mavromati Mus. H: 33 cm). p. 241

303 Rhodes. Helios. 3rd cent BC. (Rhodes Mus. H: 55 cm). p. 242

304 Melos. Poseidon. 2nd cent BC. (Athens NM 235. H: 2.17 cm). pp. 64, 242

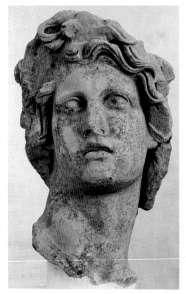

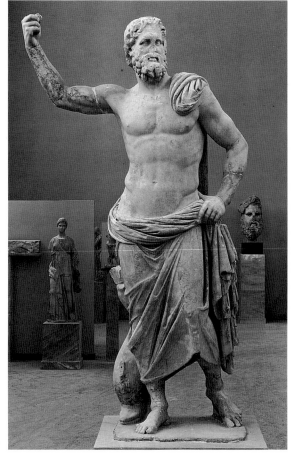

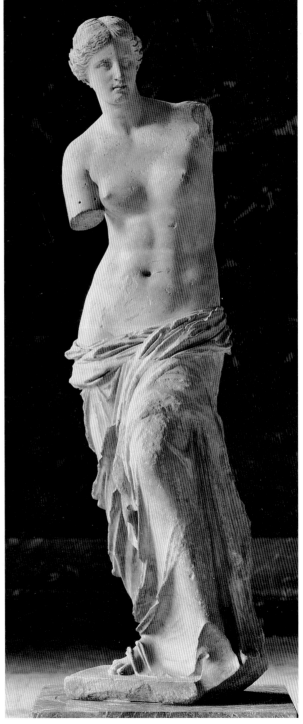

305.1–2 Melos. Aphrodite. Free version
of same type as *[105]*. 2nd cent BC.
(Louvre 399/400. H: 2.04 m).
(Below) Signed base:
'[Alex?]andros son of Menides from
Antioch-on-the-Meander made it'.
(Lost). pp. 65, 81, 242

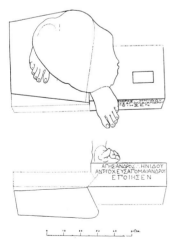

306 Knidos. Woman from sanctuary of Demeter ('Nikokleia'). 2nd cent BC. (British Museum 1301. H: 1.57 m). p. 242

307 Kos. Man in himation. 3rd–2nd cent BC. (Kos Mus. 32. H: 1.97 m). p. 242

308 Kos. Youth in himation. 3rd–2nd cent BC. (Rhodes Mus. 13578. H: 2.30 m). p. 242

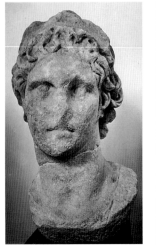
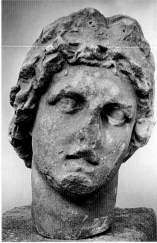

309 Delos. King with diadem. Late 2nd or early 1st cent BC. (Athens NM 429. H: 55 cm). p. 242

310 Delos. King with diadem; goat's horns were attached separately over forehead. 2nd cent BC. (Delos A 4184. H: 54 cm). p. 242

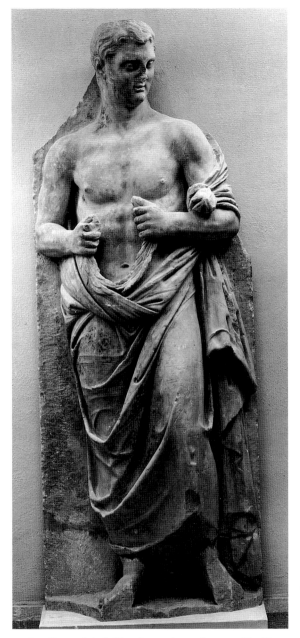

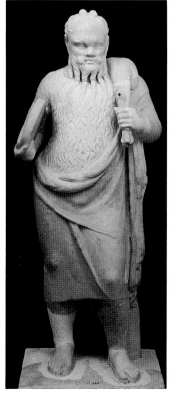

311 Kos. Grave relief of athlete. Later 3rd or 2nd cent BC. (Kos Mus. H: 2.26 m). p. 242

312 Delos. Isis. Dedicated by the Athenians in 128–27 BC. (In situ. H: 2.00 m). p. 242

313 Delos. Silenos. 2nd cent BC. (Delos Mus. A 4122. H: 1.20 m). p. 242

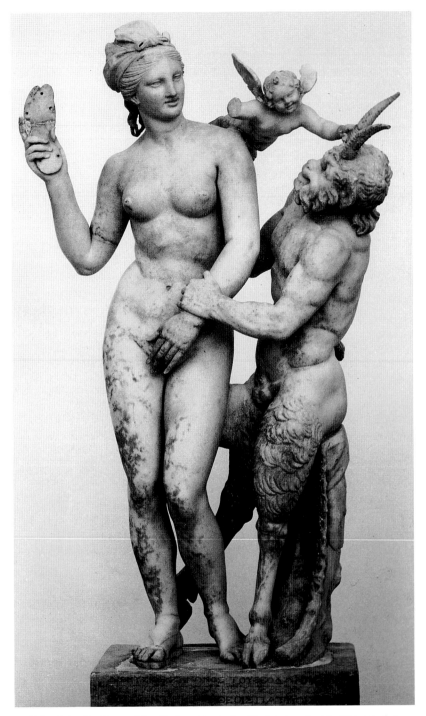

314 Delos. Aphrodite, Eros, and Pan. Dedicated by the Poseidoniasts (merchants) of Beirut in their Delian club-house. Late 2nd cent BC. (Athens NM 3335. H: 1.29 m). p. 242

Chapter Fourteen

LATE HELLENISTIC: DELOS TO ROME

The preceding chapters have concentrated on the sculpture made for Hellenistic kings and cities in the third and second centuries BC. The period from the later second century to the victory of Augustus in 31 BC was a distinct period in political terms during which the fate of the Hellenistic world was caught up with that of Rome. From a Greek or Hellenistic perspective, the period is late Hellenistic; from a Roman perspective, late Republican. The major political trends in the Greek East were the decline and disappearance of the kings, the rise of the city élites to fill the vacuum, and the presence of Rome. The Romans were the key new factor. They dismembered the kingdoms, firmly established the city aristocracies in power, and appropriated the wealth and culture of the Hellenistic world.

Since civic life in the Greek cities continued much as before, the usual statues and sculpture continued to be made: divine statues, civic portraits, grave stelai, terracottas. The period also saw some striking innovations. We may single out two major phenomena: *1*, a strident new kind of portrait realism; and *2*, copying and neo-Classicism. The first was a radical change in portraiture which reflected deep-seated changes of self-image and self-presentation in real life. The second represented the turning of Greek art back on itself to reproduce the works and styles of earlier periods. Neither were inevitable developments. They were clearly choices, and both were in some way connected with the Romans. A partial key to understanding both is provided by Delos.

Delos and the new portraiture

Delos was made a free port under Athenian control by the Romans in 166 BC. It was sacked by Mithridates VI in 88 BC and again in 67 BC by pirates. Between 166 and 67 it was a thriving commercial centre, inhabited by an international population of both Greeks and Romans. The Romans had their own monumental market square (the Agora of the Italians). For them, Delos was particularly important as the clearing house for the slave trade from the East to Italy. Inscriptions show commercial primacy was lost after 67, so that the latest sculpture from the island is a broadly dated body of material of the first importance for assessing the late Hellenistic period. Coincidently, it provides our first dated sample of statues commissioned by Romans.

The new portrait mode appears within the category of civic statues. Its external features are easily recognized: middle-aged, short-cropped hair, and a hard, objective, realistic-looking style. The short hair, often receding over the temples, encourages non-ideal representation of shapes of head and of protruding ears. The portraits have a strong effect of apparent realism, of a particular mortal individual 'as he really was', as though unimproved by art. This was something quite new. According to a client's preference, objective realism cold be heightened to a complacent mundanity, reduced by covert ideal elements (eyes, lips), muted by 'pathos', or combined with other portrait effects, like dynamic posture. In other words, the external formulae – middle-age, short hair, 'real' physiognomic structure – became a basic portrait mode capable of variety and a range of expression within itself. In the first century BC, this new portrait style had astonishing success, and, although some still chose older styles, it eventually became the dominant portrait manner in the cities of the Mediterranean from Syria to Rome.

The 'origins' and interpretation of the new portrait style are controversial, due to the lack of secure evidence on where, when, and for whom such portraits were first made. The importance of Delos is that it provides the first externally dated examples which survive *[315–318]*. Some think that such portraits were first made for the Greek bourgeoisie, which were then imitated and adapted by Romans. However, there is no reason to think the Delian examples were either the first of their kind or predominantly commissioned by Greeks. Inscriptions show that of about seventy 'private' or non-royal statues set up in the later second and early first century, close to one half were of Romans and Italians (merchants and others). And of about twenty-four surviving portraits from Delos, about half are in the new manner. For three of these, we have some external evidence, and they are known to be of Romans: a fine head from Agora of the Italians *[317]*, and two superb busts from a house by the harbour known from its archive sealings to have belonged to a Roman trading family. All three are impressively aggressive in their worldly, middle-aged particularity. For the others, there is no external evidence whether they are of Greeks or Romans. Most have instinctively felt, however, that the famous Pseudo-Athlete *[315]*, for example, is a Roman by virtue of his distinctive manner of self-presentation.

The strongest, 'purest', most astringent examples of the new portrait manner were commissioned by Romans in Italy *[319, 320]*. Among surviving portraits of late Republican dynasts, there are several that could well date before Delos *[320]*. On this view, the new portrait, and the self-image which lies behind it in real life, first emerged during the second century at Rome. There, Hellenistic sculptors were enlisted to produce portraits that would embody the Roman aristocrat's ideas of his defining qualities: his sternness, honesty, gravity, experience, and hardened military courage. The new portrait manner was the product of Roman self-presentation and was probably seen from the beginning as a 'Roman' style. Thus the formal modulations and altered expressions that

sometimes differentiate Italian and Eastern portraits of this kind are to be explained, not so much in terms of Roman reception of a Hellenistic bourgeois portrait, but more in terms of Greek adoption and adjustment of an aristocratic Roman portrait manner.

The reasons for the adoption of a 'Roman' style by some elements of Greek society in this period can be illuminated by some particular cases. In the first century BC some minor kings in the Greek East, known from coins and in sculptured heads [321–323], chose this style as opposed to the prevailing, highly idealized royal norms [19, 20, 261, 262]. These kings, it turns out, were all client rulers who owed their thrones to Rome, and for them this portrait manner clearly signified their 'Roman' loyalty. It was the visual expression of the title Philorhomaios or 'Friend of the Romans' which many of them adopted. The coins of Ariobarzanes I Philorhomaios [321] and a royal head in Adana [323] found recently, are good examples of this older mundane royal style that contrasts so strongly with the dynamic divinizing style of Rome's enemies like Mithradates VI [19]. Among non-royal portraits in this manner, the most important is a head from Pergamon, probably of one Diodoros Pasparos [324]. He was one of the new kind of city dynasts who held sway with the support of Rome in the vacuum left by the removal of the kings. His portrait is a good example of softening and modulation within the objective, short-haired portrait manner.

This portrait style is seen in many undocumented marble heads from the Greek East, from Athens [326] to Antioch and Alexandria [325]. They are mostly of the first century BC, and it is usually not possible to tell whether a given portrait head is of a Roman abroad or a local Greek. The upper-classes of the Greek cities were Rome's allies, and our inability to distinguish within this category of portraits is an index of the degree to which the Greek élites accommodated themselves to and emulated their new rulers. The new portrait manner was quickly normalized, but, as for the Philorhomaios kings, such portraits signalled, in a quiet way, a basic political choice. Earlier portrait modes continued – overtly sympathetic portraits of polis elders, youthful ephebic images, philosopher portraits, and extravagant and emotional royal portraits [19, 20]. The crossing of elements drawn from these portrait traditions with the new objective realism produced some of the most interesting late Hellenistic heads.

Most portraits of late Hellenistic women continued to employ a purely ideal vocabulary [327.2], as did those of some Roman women in the Greek East, such as Baebia and Saufeia at Magnesia [116]. The new manner, however, was soon also favoured by some women (or their husbands) for female portraits. Our earliest example is a fine head from Delos [318] – probably the first objective-looking portrait of a woman from the ancient world. Instinctively, one would guess that she was someone like the wife of the Pseudo-Athlete [315]. (The head does in fact come from the same house.) The new mode became especially

popular for elder women in Rome, there signifying the moral severity they espoused with their husbands, but it was never popular for women in the Greek East, even under the Empire [336].

The Pseudo-Athlete [315] and a naked torso of one C. Ofellius Ferus [316] are of great importance in the history of portrait statues. The Ferus statue is a version or adaptation of a known late Classical Hermes type [69] and the Pseudo-Athlete's body employs a recognizably older Classical style. They are the first examples of a (to us) curious practice, common in Roman statues later, of dividing the figure between 'real' portrait head and an overtly 'unreal' body borrowed from earlier ideal statuary. The head specifies the individual portrayed, leaving the statue to symbolize high qualities not necessarily visible in the sitter's real person. Although quite different in terms of context and meaning, the production of such Classical and pseudo-Classical body types for portraits became, in terms of manufacture, simply a part, indeed a major branch, of the copying industry.

Copies and classicism at Rome

Since the second century, top Greek artists had been available at Rome to provide the very best in marble and bronze sculpture – in the finest technique and in any style that a Roman buyer might want. For public contexts, Romans commissioned portrait statues of their leaders [319], new cult statues of their gods [73], victory monuments, and occasional historical reliefs. They also began to commission, mostly for private contexts, large quantities of Classical Greek statuary in the form of marble copies.

In public life and in portrait statues, the Roman aristocrat was a senator of austere Italian values. In private, he was a cultured and refined man of Hellenic taste and education. The Roman villa was his palace of Hellenism, and Greek statues were one of its essential components. The available supply of original Greek sculpture was limited, and demand was met instead by contemporary workshops supplying marble copies and neo-Classical works on a near-industrial basis. The products of this industry make up the bulk of Greek-looking sculpture in our museums today. Any major Roman villa would have had a range of these sculptures. Their main categories were as follows: 1, nobilia opera, that is, copies and versions of famous works by famous artists reproduced more or less as 'fine art'; 2, imagines illustrium or portraits of famous Greek writers and thinkers, the great cultural heroes of Hellas; and 3, ornamenta, that is, decorative sculpture, including everything from Dionysian statuary to marble vases, urns, basins, well-heads, tables, altars, and other sculptural bric-a-brac. Decorative pieces and portraits copied works from all periods of Greek art. The repertoire of nobilia opera, however, was almost exclusively from the Classical period, from Myron and Polykleitos to Lysippos and Praxiteles. Copies of major Hellenistic works, we have seen, were decidedly rare. Within the nobilia

opera, the distinctions between replicas, versions, and new creations are readily observable to the trained modern scholar and may often have been recognized by buyers, but they were probably not of the first importance from a Roman perspective. Close copies of Classical works and new works in the Classical style were indicative of a single cultural choice. Their strict separation reflects modern judgement about the relative values of 'copy' and 'new creation' not felt by the ancients. For the discerning Roman buyer, accurate reproductions were probably as prized as newly invented pseudo-Classical compositions – probably more so.

It is sometimes argued that Roman choices regarding Classical art merely reflected a new aesthetic prevailing in the Hellenistic East in the second century BC: the baroque was already exhausted, and Greek patrons and sculptors had already turned back to the Classical past. Romans, on this view, merely picked up the latest significant trend in Hellenistic sculpture, they simply continued the late Hellenistic legacy. Pergamon is cited for the commissioning of Classical copies, and Damophon as an example of a classicizing sculptor. However, the 'copies' at Pergamon and elsewhere in the second century are merely Hellenistic essays on well-known Classical statues. The Pergamene Athena Parthenos *[185]*, for example, has many later stylistic components, and functioned as a cultural symbol, not as 'fine art' reproduction. And in mid-second century Pergamon, the baroque was, of course, still a fully valid option, as seen on the Great Altar. The works assignable to Damophon *[301, 302]*, we have seen (Chapter 13), employ a Classical mode for divinities that had never disappeared during the third century. There are in fact no precise copies of particular Classical statues, no strict imitations of fifth-century style intended to be recognized as such, until the late second and early first century. All the abundant evidence for such copies and classicism comes from Roman contexts. This was a phenomenon of Roman patronage for which the literary as well as the material sources are surprisingly good.

Some of the surviving material evidence is well dated: we have copies from Delos and from two important shipwrecks, at Mahdia and Antikythera. The earliest surviving replica of a particular Classical statue is the marble copy of Polykleitos' Diadoumenos *[328]* from Delos of *c.* 100 BC. It was found in the same house as the Pseudo-Athlete *[315]* and the 'Romanizing' female portrait head *[318]*, and was therefore in all probability made for a Roman buyer. No earlier statue attempts the precise, stylistically consistent scale-reproduction of a well known old-master work that we see in the Delian Diadoumenos. The Mahdia shipwreck (also *c.* 100 BC) gives a typical cross-section of originals *[50]*, copies *[107]*, and *ornamenta*, on their way from Athens to Italy to outfit a Roman villa. The Antikythera ship was carrying a much greater proportion of copies, this time from the eastern Aegean, some time in the mid-first century BC. And the Roman market for such sculptural cargoes is vividly illustrated at precisely this period by Cicero's earliest letters to Atticus, in the 60's BC.

Literary sources tell us about some of the new figures involved in the sculpture industry that supplied the Roman market in the first century BC. A leading figure undoubtedly was Pasiteles, a sculptor-writer-critic from South Italy working in Rome in about 70–50 BC. He made a cult statue there and wrote five volumes, significantly entitled *Nobilia Opera* or 'Masterpieces', no doubt dealing with Classical works. It probably functioned as something like a high-class trade catalogue of works available in copies for the Roman market. He is cited as a source by Pliny in all his books on art, and, as a Greek sculptor-critic in Roman service at this period, he was perhaps the original source of the polemical dismissal of Hellenistic sculpture between 296 and 156 BC that we find in Pliny – his famous *cessavit-revixit* statement (see Chapter 1). A figure of similar status was probably the sculptor Arkesilaos who made the cult statue of Venus Genetrix for Caesar's Forum in 46 BC and who provided, we hear, plaster models for other artists to work from (Pliny, *NH* 35.155). We also hear of sculpture dealers, such as C. Avianius Evander and Damasippos, again in Cicero's letters. Cicero's early correspondence, mentioned above, gives a detailed insight, from the point of view of the Roman buyer, into the bulk ordering of statues and *ornamenta* from Greece through intermediaries, shippers, and dealers.

The manufacture of copies was no doubt located in several centres. A series of signed works enable us to visualize in some detail the neo-Classical output of two, clearly prestigious sources supplying the Roman market in the first century BC: the workshop of Pasiteles, and the 'neo-Attic' workshops of Athens. Pasiteles is the only famous artist in this area that we can connect with surviving works. There survives a classicizing athlete signed by one 'Stephanos, pupil (*mathētēs*) of Pasiteles'. It is a type known in so many other versions and so often combined in pseudo-mythological groups *[330]* that it may have been an original design of the master himself. There is also a most singular neo-Classical group *[331]* signed by a sculptor Menelaos, who calls himself *mathētēs* of Stephanos. The designation 'pupil of' is most unusual, and probably indicates both that Stephanos and Menelaos were of servile origin (they have no patronymic) and at the same time some sense of a prestigious sculptural dynasty among Pasiteles' followers. Sculptors' signatures normally give their father's name and, increasingly in this period, their city of origin, which, in the case of Athenian sculptors, was clearly meant as a badge of quality.

The 'neo-Attic' products of these Athenians are recognized by signatures ending *Athenaios* and by designs that copy or adapt known Classical Athenian monuments. They produced both *nobilia opera* and a whole range of decorative reliefs and marble vases with figured decoration. Pheidian and late fifth-century designs were much favoured – for example, the Amazonomachy reliefs on the shield of the Athena Parthenos. The Athenian workshops were probably also responsible both for the copies of thinker portraits (the originals of which were mostly in Athens) and for much of the marble bric-à-brac (candelabra, table

supports, etc) found in Roman villas. They could also make the occasional baroque work for any client with more particular tastes. The Belvedere Torso *[165]*, for example, is the product (surely a copy) of a neo-Attic sculptor. In short, these sculptors could supply any statue or sculptural artefact that a client might want reproduced in marble. It was these same sculptors, the 'copyists', who also made for the Romans their portrait statues, the cult images of their gods, and their historical reliefs – men like Pasiteles, Arkesilaos, and the 'Athenians'.

In the first century B C, then, Rome became in many senses the new capital of the Hellenistic world, but the transfer of the Hellenistic cultural heritage was by no means a smooth or straightforward process. In the sculpture reviewed in this chapter we have seen two quite abrupt changes wrought by Roman patronage of Hellenistic sculptors: firstly, the new 'Roman' manner of self-representation in portraiture, which was immensely influential in the Hellenistic East; and secondly, the extraordinary and quite separate phenomenon of mass replication in marble of older works, which was, for the time being, confined to the Roman villa market in central Italy.

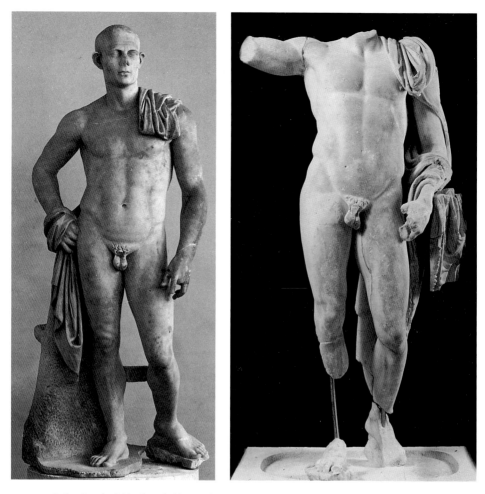

315 Delos. 'Pseudo-Athlete'. Probably an Italian *negotiator* (businessman). From House of the Diadoumenos. About 100 BC. (Athens NM 1828. H: 2.25 m). pp. 256–8

316 Delos. C. Ofellius Ferus. Signed by Polykles and Timarchides of Athens. From Agora of the Italians. About 100 BC. (Delos A 4340. H: 2.80 m). p. 258

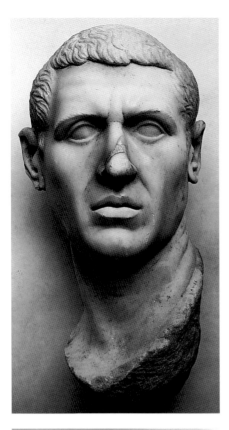

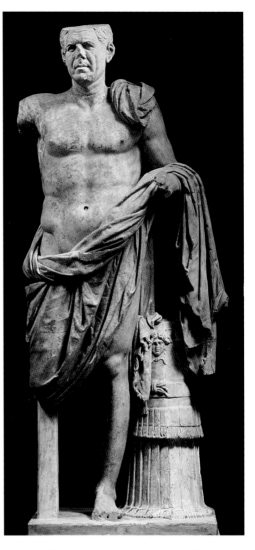

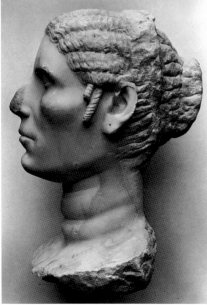

317 *(above left)* Delos. Male portrait head, probably of an Italian businessman. From Agora of the Italians. About 100 BC. (Delos A 4186. H: 49 cm). p. 256

318 *(left)* Delos. Female portrait. From House of the Diadoumenos. About 100 BC. (Delos A 4196. H: 36.5 cm). p. 257

319 *(above)* Tivoli. Roman general. From temple of Hercules, early 1st cent BC. (Terme 106513. H: 1.94 m). p. 256

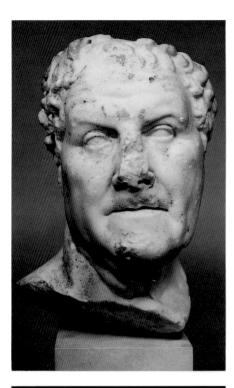

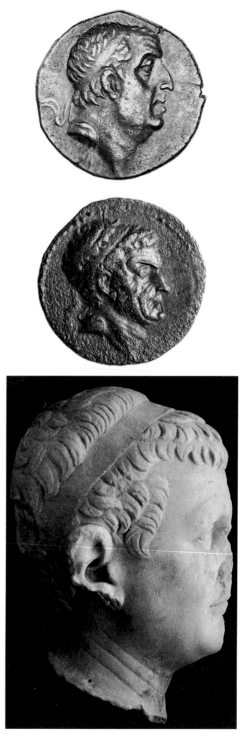

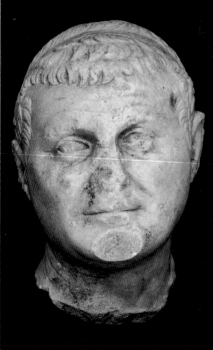

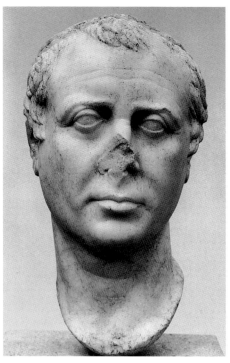

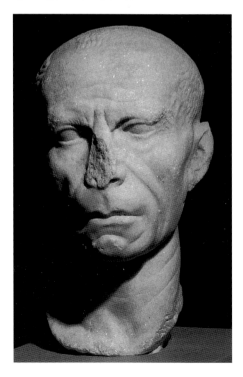

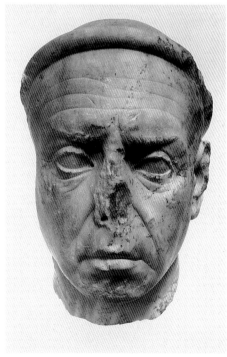

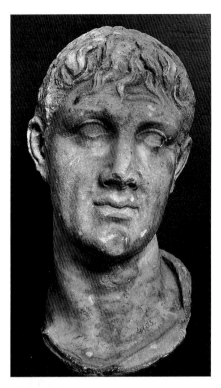

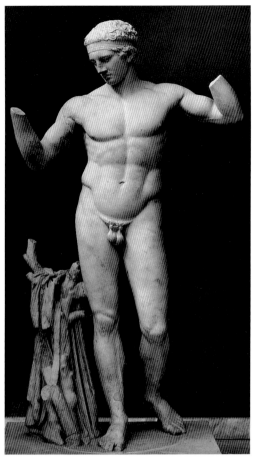

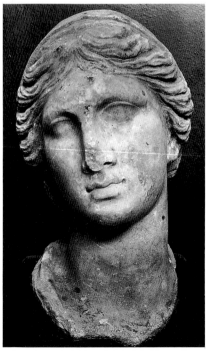

327.1–2 *(left)* Smyrna. Male portrait. Later 2nd or 1st cent BC. (Athens NM 362. H: 44 cm). Female portrait. Later 2nd or 1st cent BC. (Athens NM 363. H: 45 cm). p. 257

328 *(above)* Delos. Copy of Diadoumenos by Polykleitos. Quiver added on supporting stump lends local Apolline flavour. About 100 BC. (Athens NM 1826. H: 1.95 m). p. 259

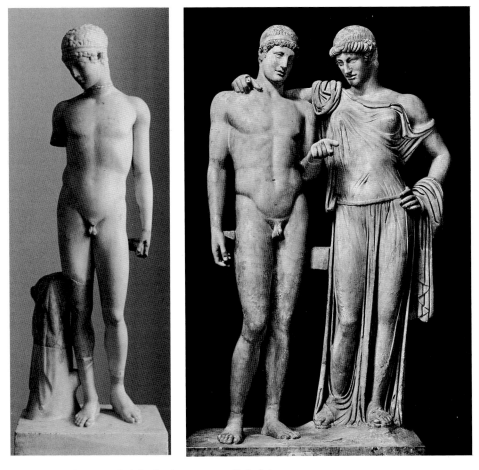

329 Athlete, in classicizing 'Pasitelean' style. 1st cent BC. (E. Berlin)

330 Rome. Pasitelean group. Two statue types combined to form mythological pair of uncertain identity ('Orestes and Electra'). Later 1st cent BC. (Naples 6006. H: 1.50 m). p. 260

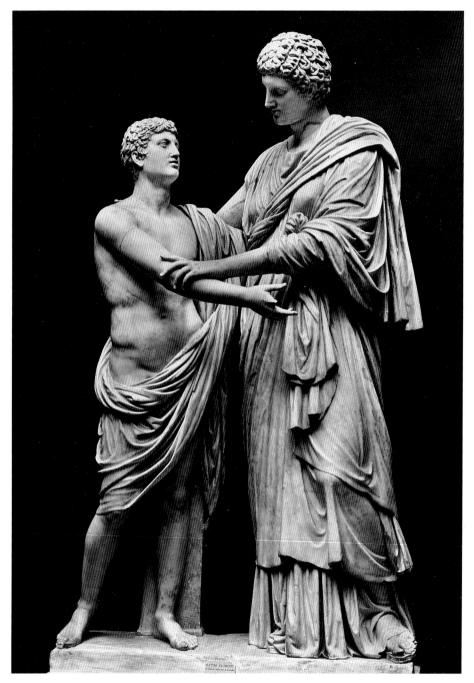

331 Rome. Menelaos group. Heroic youth and woman with cropped hair meet at a grave(?) Stele-support signed: 'Menelaos pupil of Stephanos made it'. Later 1st cent BC. (Terme 8064. Forearms restored. H: 1.92 m). p. 260

Chapter Fifteen

CONCLUSION: CHRONOLOGY

A lack of clear chronological development in Hellenistic sculpture is often lamented. This is misplaced because autonomous stylistic development as such probably did not occur. Neither the evidence nor historical probability supports the hypothesis that Hellenistic sculpture underwent a consistent, measurable, organic development – either in a continuous line or consecutive phases. We have seen, rather, that the category of subject and the level of production to which a statue belonged were more decisive in determining its appearance. What is important is the subject represented and the level of sculptural quality the patron could afford. A model that better fits the evidence and the historical conditions is a broadly static one, to which subjects and styles are added as and when required. Not all categories were evenly supplemented, nor was the additive process regular. Chronology must be first looked at within each subject category for, if there was any progression, it consisted of an increasing plurality of forms. This, we have seen, better reflects the historical circumstances of the Hellenistic world. What we tend to see rather simply as 'development' were in reality the vivid reflections of a complex historical process – of society's changing perceptions of the various kinds of gods, heroes, and men that were important to it.

It is useful to contrast the Classical period. In the fifth century, Athens produced a more circumscribed and coherent range of subjects and styles in its major statues. The body and head types of gods and mortals had a narrow range of variation (what we call the Classical ideal) which defined and expressed the norms of a more homogeneous society. Scholars still debate, for example, whether a particular statue by Polykleitos (the Doryphoros) represented Achilles or an athlete. Since fewer subjects are represented and in styles and forms that vary less, documented sculptures can provide good chronological indications for a much larger number of works. In the Hellenistic period, by contrast, society's expanded horizons are reflected in the greatly increased range of its major statues: divine kings, old philosophers, superhuman heroes, and ultrahuman peasants. Statues were made to speak distinct languages that separated athletes from heroes. They could borrow each other's formal vocabulary (for example, peasants from philosophers, kings from heroes), but there is no necessary chronological connection between them. It is the creation and sharp visual definition of these separate subject categories in Hellenistic

statues that is most striking. The subjects are described by a rich new language of styles for drapery, muscles, physiognomy, and hair that allows the viewer to read and understand immediately a wide variety of sculptured figures. The significant differences between Hellenistic statues are the result, not so much of their various dates or places of manufacture, as of their separate character definition and expressive purposes.

If we review each subject category in its own terms we see that the difficulties of chronology are not always due to a lack of dated monuments – in total there are many more dated works than in the Classical period. In some categories there are plenty of externally documented works. In others, however, few or none.

For kings, there are dated and identified portraits in both copies and originals from Alexander [6] to Mithridates VI [19]. The philosophers and writers are excellently documented in identified copies from the late fourth century to the end of the third, from Aristotle [27] to Chrysippos [33]. Among the athletic statues, we have only Lysippos' Apoxyomenos [47] and the Daochos Monument at Delphi [44]; nothing else is dated. For gods there is almost nothing documented between versions of Bryaxis' Serapis [81] and the loosely dated works of Damophon [301, 302]. Draped goddesses and women have a good series of dated statues covering all three centuries, from Eutychides' Tyche [91] in c. 300 BC to the Magnesia women of the early first century [116]. For naked Aphrodites, there is the Knidia [98] in the later fourth century, after which there is nothing documented. Of the baroque groups, only the large Attalid Gauls [118, 119] are externally dated. The world of Dionysos and genre is almost entirely devoid of externally fixed chronological points: we have Praxiteles' Leaning Satyr [148], then little except the Pergamene centaurs of before c. 150 BC [192]. Architectural friezes have plenty of dates in the third and second centuries, while grave and votive stelai have fewer [211], but their generally static chronology is not problematic.

There is no need for exasperation, for chronological *aporia*. There are enough dates to show broadly what was going on in sculpture in the third and second centuries. The evidence for some categories allows more precision than in others, but there are no serious black holes. The overall picture is merely more complex than some have expected. In categories with plenty of dated works, for example kings or philosophers, a line of inner growth is not their most obvious feature. Among the kings, there is no single discernible line of formal development. Different kings and dynasties make choices within broad limits of proper royal appearance. Some formal evolution can be seen in the philosophers and writers, but mainly between late Classical and third-century. Within the third century, the factors of philosophical school, literary 'allegiance', and posthumous reception are as important in determining the different expressive styles of the portrait images. For undated works, the earliest possible date can usually be determined with confidence. The latest possible date, however, often

cannot be closely fixed. This reflects important levels of continuity in some parts of society over long periods of time, mostly the middle and lower levels of the Hellenistic cities. The main lines of innovation at the upper levels are relatively clear.

Three of the most striking and enduring innovations of Hellenistic sculpture may be singled out: *1*, Individualized portrait statues that give a powerful impression of a real person and which at the same time carry a highly charged expression of a public role external to personal psychology; *2*, Heroic groups and the baroque style, representing a lofty world inhabited by Homeric and tragic heroes ennobled by epic struggles and crushing divine punishments; and *3*, The Dionysian realm of satyrs and centaurs, a carefree landscape of ideal well-being in which the outwardly less fortunate figures of genre also find a place – fishermen, peasants, proletarian hags. All three areas of innovation were probably fully evolved in the third century when they coexisted with the continuing subjects and stylistic modes of late Classical sculpture. The portrait statues, we saw above, are very well documented through the third century. Dionysian statues go back to the later fourth century and are documented in literature at Alexandria in the early third century. Their evolved formal style (the 'satyr' style) is a modulated or 'reverse' version of the baroque, that is, Dionysian style is a counterpart to the heroic style – its figures use similar formal language to express a different character and meaning. The baroque is documented chiefly at Pergamon, by the Large Gauls in the late third and by the Great Altar in the mid-second century. Pergamon, however, was a latecomer to cultural and artistic eminence; the baroque had no doubt emerged much earlier in other kingdoms. This is supported by the strong reflections of baroque style in reliefs from Ilion *[201]*, Belevi *[203]*, and Tarentum *[204]*, all dated to the first half of the third century. Early royal interest in a more elevated, more dynamic stylistic mode is also reflected in the battle frieze of the Alexander Sarcophagus *[226]*.

Good external evidence for this 'early' chronology, especially for the baroque, is provided by Pliny's rejection of Hellenistic sculpture between 296 and 156 BC. The more fully articulated rejection of Hellenistic rhetoric as an 'Asiatic sewer', for example by Dionysios of Halicarnassos, makes it clear that it was precisely the (filthy Asiatic) baroque that could not be tolerated by these neo-Classical critics at Rome. Pliny was following such a critic, a specialist in the visual arts (perhaps, we saw, Pasiteles), and the dates of his 'caesura' give excellent evidence for the rise and floruit of the baroque, that is, the third and early second centuries. Pliny's militant condemnation of sculpture from 296 to 156 BC is thus an important reason to place its main innovations in that period.

The emergence of Rome as a new capital of Hellenistic culture during the second century brought two major innovations in sculpture. The Romans commissioned from the Hellenistic sculptors at their disposal firstly the strident (and widely imitated) portrait manner which defined them as 'Roman' and

secondly copies and versions of old, Classical statues. With the latter, Greek art began to recycle itself (Pliny's *revixit*). Copying and neo-classicism were not part of an internal trend in the evolution of Hellenistic sculpture, rather they were part of an external Roman cultural choice.

Hellenistic sculpture under the Empire

Under the Empire, most of the major innovative contributions of Hellenistic sculpture remained largely ignored. At Rome, an 'authentic', high-quality baroque lived on in specialized workshops, like that of the three Rhodians in the first century AD and that of the emigré Aphrodisians in the second, catering for a discerning private élite. They produced top-grade marble translations of works like the Laocoön *[143]*, the Polyphemos *[146]*, and the Capitoline Centaurs *[162]*. Their clients were emperors: Tiberius, Titus, Hadrian. Hellenistic philosopher portraits were reproduced in marble in massive quantities for Academy-like porticoes in the villas of the élite. Dionysian figures and selected genre statues were also mass-produced for the gardens of the aristocracy and bourgeoisie alike. The marriage of Hellenistic formal technique and Roman self-perception that produced the late Republican portrait was abandoned in the statues and state reliefs of Augustus' regime in favour of a more exalted classicism, but a modulated objective realism remained alive in portraits in other sectors of Roman society. A new and striking combination of Hellenistic style and Roman subject was later forged in the Great Trajanic Frieze, the most powerful of all Roman state reliefs and the nearest that imperial Rome came to answering the Pergamene Gigantomachy. A similar marriage of Hellenistic form and contemporary subject underlay the increasing subtlety and complexity of marble portraiture in the second century AD *[333]*, both private and Imperial. At Rome in the second and third centuries AD, Hellenistic sculpture had its strongest afterlife in the great series of mythological and Dionysian sarcophagi *[332]* – a living medium that constantly reinvented the Hellenistic repertoire.

In the Greek East under the Empire, some sculptors, most notably at Aphrodisias, continued to make for the home market superb marble versions of Hellenistic *nobilia opera [134, 154]* and lively new versions of ideal subjects in pure Hellenistic style *[335]*. Many civic donors, however, now preferred to decorate their public façades and fountains in the Roman manner, with copies of Classical statues, as, for example, at Side and Perge in southern Asia Minor. Hellenistic-style civic statuary continued, in increased quantity and with an optional accommodation to contemporary Roman portrait styles. That is, a local Greek aristocrat, according to preference and cultural standpoint, might imitate the styles, dress, and coiffure fashionable at Rome. Alternatively, he or she might prefer a purely traditional, Hellenistic self-presentation *[336]*.

Hellenistic sculpture remained part of the inherited culture of the Greek East,

and it was natural for sculptors to use its formal language wherever it was deemed appropriate – for example, for the unusual commissions of imperial reliefs that decorated buildings dedicated to the emperor at Aphrodisias and later at Ephesos. The image of the Hellenistic philosopher also remained a potent force. The highly self-conscious Greek literary renaissance of the second century A D known as the Second Sophistic claimed direct intellectual descent from the great orator Aischines [38], and it was natural for its leading exponents at Ephesos or Athens [334] to reject the prevailing norms set by the imperial image, in favour of the portrait styles of early Hellenistic thinkers. Sculptured portraits in this area continued to borrow from Hellenistic types into the fifth century A D, when the advanced techniques of figure sculpture were finally lost. The legacy of Hellenistic sculpture was a repertoire of highly varied, adaptable, and seductively 'real' images. Ultimately, it survived longest in its place of origin, the Greek cities of Asia Minor.

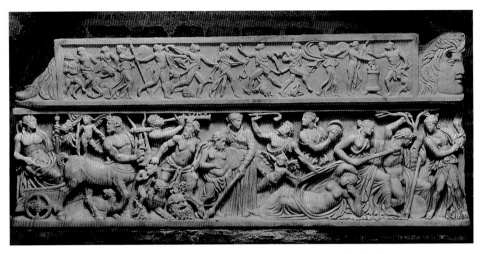

332 Rome. Dionysian sarcophagus. Dionysos comes to sleeping Ariadne, accompanied by his thiasos: centaurs, putti, Pan, Silenus, satyrs, and bacchants. 2nd cent AD. (Rome, St. Peter's. L: 1.95 m). pp. 127, 272

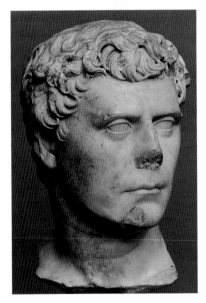

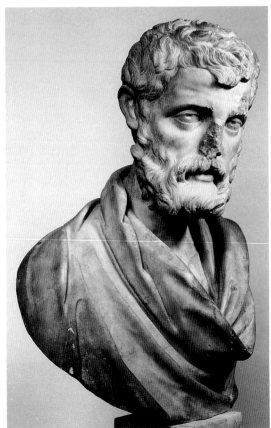

333 Rome. Male portrait. About AD 130. (Copenhagen 658. H: 37 cm). p. 272

334 Attica. Herodes Atticus, Athenian sophist (d. AD 177). Found at Probalinthos, near Marathon. (Louvre MA 1164. H: 60 cm). p. 273

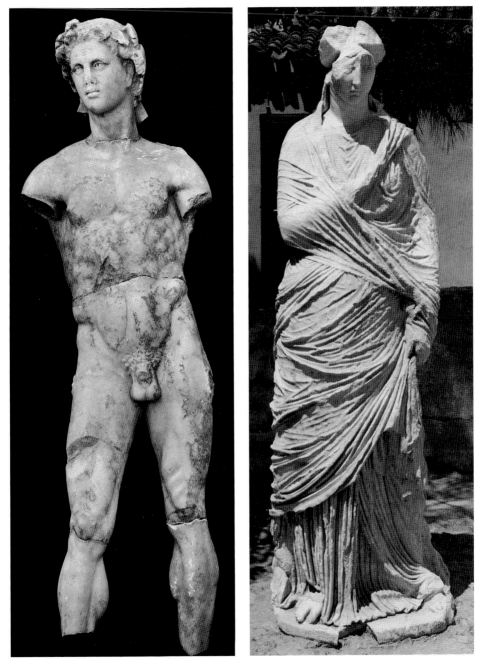

335 Aphrodisias. Wreathed athletic Herakles(?) 2nd cent AD. (Aphrodisias Mus. H: 1.40 m). p. 272

336 Aphrodisias. Draped woman. Signed by Menodotos son of Menodotos, 1st cent AD.
(Aphrodisias. H: 2.00 m). p. 272

ABBREVIATIONS

AA	*Archäologischer Anzeiger*	*JHS*	*Journal of Hellenic Studies*
AAA	*Athens Annals of Archaeology*	*JRS*	*Journal of Roman Studies*
AJA	*American Journal of Archaeology*	Künzl	E. Künzl, *Frühhellenistiche Gruppen* (1968)
Akurgal-Hirmer	E. Akurgal, M. Hirmer, *Griechische und römische Kunst in der Türkei* (1987)	*LIMC*	*Lexicon Iconographicum Mythologiae Classicae*
AM	*Athenische Mitteilungen*	Lippold	G. Lippold, *Die griechische Plastik* (1950)
AntK	*Antike Kunst*		
AntPlast	*Antike Plastik*	*MAAR*	*Memoirs of the American Academy at Rome*
AvP	*Altertümer von Pergamon*	Mansuelli	G.A. Mansuelli, *Galleria degli Uffizi: le sculture* I (1958)
BABesch	*Bulletin antieke beschaving*		
BCH	*Bulletin de correspondance hellénique*	*ÖJh*	*Jahreshefte des Österreichischen archäologischen Instituts in Wien*
Bieber	M. Bieber, *The Sculpture of the Hellenistic Age* (2nd ed., 1961)	Pollitt	J.J. Pollitt, *Art in the Hellenistic Age* (1986)
BSA	*Annual of the British School at Athens*	Richter, POG	G.M.A. Richter, *Portraits of the Greeks* (1965)
GettyMusJ	*J. Paul Getty Museum Journal*	*RM*	*Römische Mitteilungen*
Giuliano	A. Giuliano (ed), *Museo Nazionale Romano: le sculture* I.1 (1979)	Robertson	M. Robertson, *A History of Greek Art* (1975)
Helbig	W. Helbig, *Führer durch die öffentliche Sammlungen klassischer Altertümer in Rom* I–IV (4th ed., H. Speier 1963–72)	Smith, HRP	R.R.R. Smith, *Hellenistic Royal Portraits* (1988)
		Stewart, Attika	A.F. Stewart, *Attika: Studies in Athenian Sculpture of the Hellenistic Age* (1979)
IstMitt	*Istanbuler Mitteilungen*		
JdI	*Jahrbuch des deutschen Archäologischen Institut*	*ZPE*	*Zeitschrift für Papyrologie und Epigraphik*

NOTES AND BIBLIOGRAPHY

The best general accounts of Hellenistic sculpture are M. Bieber, *The Sculpture of the Hellenistic Age* (2nd ed. 1961), M. Robertson, *A History of Greek Art* (1975) chs. 7–8, and J.J. Pollitt, *Art in the Hellenistic Age* (1986). G. Lippold, *Die griechische Plastik* (1950) is still useful; A.W. Lawrence, *Later Greek Sculpture and its influence on East and West* (1927) still stimulating. R. Lullies, M. Hirmer, *Griechische Plastik* (4th ed. 1979) has the best illustrations. Some wider aspects are well discussed in T.B.L. Webster, *Hellenistic Poetry and Art* (1964) and J. Onians, *Art and Thought in the Hellenistic Age* (1979). Two major works appeared recently: B.S. Ridgway, *Hellenistic Sculpture I: The Styles of ca. 331–200 BC* (1989), and A.F. Stewart, *Greek Sculpture: An Exploration* (1990) 2 vols.

1. INTRODUCTION

History and culture: W.W. Tarn, *Hellenistic Civilisation* (3rd ed. 1952); M.M. Austin, *The Hellenistic World: Sources in Translation* (1981); W. Walbank, *The Hellenistic World* (1981).
Pliny's 'caesura': F. Preisshofen, in *Le classicisme à Rome* (Entretiens Fondation Hardt 25, 1979) 270–3.
Functions of statues: R. Smith, *Omnibus* 8 (1984) 1–4. Votive: W.H.D. Rouse, *Greek Votive Offerings* (1902). Honorific: M.K. Welsh, *BSA* 11 (1904–5) 32–49; A.S. Henry, *Honours and Privileges in Athenian Decrees* (1983) 294 f. Status of sculptors: Stewart, *Attika*, 101–26. Telesinos: *Inscr.Graec.* XI.4.514.
Literary evidence: J. Overbeck, *Die antiken Schriftquellen* (1868); J.J. Pollitt, *The Art of Greece: Sources and Documents* (1965). Xenokrates, Antigonos, Pliny: E. Sellers, *The Elder Pliny's Chapters on the History of Art* (1896) xxxvi–lxvii; B. Schweitzer, *Xenokrates von Athen* (1932). Pausanias: C. Habicht, *Pausanias' Guide to Ancient Greece* (1985).
Bases, inscriptions, signatures: E. Löwy, *Inschriften griechischer Bildhauer* (1885); J. Marcadé, *Receuil de signatures de sculpteurs grecs* I–II (1953–57); H.B. Siedentopf, *Das hellenistische Reiterdenkmal* (1968); M. Jacob-Felsch, *Die Entwicklung griechischer Statuenbasen* (1969); V. Goodlet, *Collaboration in Greek Sculpture* (Diss. New York 1989).
Copies at Rome: G. Lippold, *Kopien und Umbildungen griechischer Statuen* (1923); H. Lauter, *Zur Chronologie römische Kopien* (1966); C.C. Vermeule, *Greek sculpture and Roman taste* (1977); P. Zanker, in *Le classicisme à Rome* (1979) 283–306 and *Klassizistische Statuen* (1974); M. Bieber, *Ancient Copies* (1977); B.S. Ridgway, *Roman Copies of Greek*

Sculpture (1984); C. Landwehr, *Die antiken Gipsabgüsse aus Baiae* (1985); R. Neudecker, *Die Skulpturenausstattung römischer Villen in Italien* (1988). Later reception and restoration: F. Haskell, N. Penny, *Taste and the Antique* (1981); C. Picon, B. Cavaceppi: 18th-Century Restorations of Ancient Marble Sculpture* (1983).

2. ALEXANDER AND THE KINGS

Richter, *POG* III; Robertson, 513–6, 520–3; H. Kyrieleis, *Bildnisse der Ptolemäer* (1975); Pollitt, 19–37; Smith, *HRP*.
Olympia monument *[1]*: W. Hoepfner, *Zwei Ptolemäerbauten* (1971) 11–51. Terme Ruler *[3]*: N. Himmelmann, *Herrscher und Athlet* (Exhib. Bonn 1989) 126–49. Naples bronze *[4]*: H.P. Laubscher, *AM* 10 (1985) 336–7.
Alexander *[6–9]*: M. Bieber, *Alexander the Great in Greek and Roman Art* (1964); T. Hölscher, *Ideal und Wirklichkeit in den Bildnissen Alexanders* (1971); E. Schwarzenberg, in *Alexandre Le Grand (Ent.Fond. Hardt 22, 1975) 223–78; A.F. Stewart, *Alexander the Great and Companions in the J.P. Getty Museum* (forthcoming).
Villa of Papyri rulers *[10–17]*: R.M. Wojcik, *La villa dei Papiri ad Ercolano* (1986); Smith, *HRP* ch. 7. Antiochos III, Mithradates VI, Athens 'Ariarathes' *[18–20]*: ibid nos. 30, 83 and 85.

3. PHILOSOPHERS, ORATORS, POETS

K. Schefold, *Die Bildnisse der antiken Dichter, Redner, und Denker* (1943); Richter, *POG* I–II; G.M.A. Richter, *Portraits of the Greeks* (Abr. R. Smith, 1984); Pollitt, ch. 3; K. Fittschen (ed), *Griechische Porträts* (1988).
Philosophy and Athens: W.S. Ferguson, *Hellenistic Athens* (1911); J. Lynch, *Aristotle's School* (1972); A.A. Long, *Hellenistic Philosophy* (1974); C. Habicht, *Hellenistic Athens and Her Philosophers* (David Magie Lecture 1988).
Epikouros *[29]*: B. Frischer, *The Sculpted Word* (1982); H. Wrede, *AM* 97 (1982) 235–45; B. Schmalz, *Marb.Winck.Prog.* (1985) 17–56. Stoics *[32]*: H.J. Kruse, *AA* (1966) 386–95. Antisthenes *[34]*: F. Zevi, *Rend.Pont.Accad.* 43 (1969–70) 110–114; Helbig IV.3388; Richter, *AJA* 75 (1971) 434–5; Stewart, *Attika*, 7–12; B. Andreae, *Eikones: Fest.H. Jucker* (1980) 40–8, dating too late.
Aischines *[38]*: W. Wrede, *Städel Jhb* 3 (1971) 68–77. Demosthenes *[39]*: J. Balty, *Bull.Mus.Royaux d'Art* 50 (1978) 49–74. Menander *[42]*: K. Fittschen,

Katalog der antiken Skulpturen in Schloss Erbach (1977) 25–9. Poseidippos *[43]*: H. von Heintze, *RM* 68 (1961) 80–92.

4. ATHLETES

D. Arnold, *Die Polykletnachfolge* (1969); J. Chamay, J.L. Maier (eds), *Lysippe et son influence* (1987); *Mind and Body: Athletic Contests in Ancient Greece* (Exhib. Athens 1989).
Daochos' monument *[44]*: *BCH* 21 (1897) 592–8, the inscriptions; E.M. Gardiner, K.K. Smith, *AJA* 13 (1909) 447–76; T. Dohrn, *AntPlast* 8 (1968) 33–51. Apoxyomenos *[47]*: Helbig I.254; Robertson, 463–6; J. Inan, *AntPlast* 12 (1973) 69–79; Stewart, *AJA* 82 (1978) 169–71. Poulydamas base *[46]*: G. Treu, *Olympia* III (1897) 209–12; J. Marcadé, *Lysippe et son influence*, 113–24. Acropolis base *[45]*: Robertson, 466; M. Brouskari, *The Acropolis Museum* (1974) 18–19.
Ephesos Scraper *[48]*: Lattimore, *AJA* 76 (1972) 13–16. Getty *[49]*: J. Frel, *The Getty Bronze* (1982). Agon *[50]*: W. Fuchs, *Der Schiffsfund von Mahdia* (1963) no. 1. Tralles boy *[51]*: H. Sichtermann, *AntPlast* 4 (1965) 71–84; H. von Steuben, *IstMitt* 22 (1972) 133–40; Robertson, 524.
Dresden athletes *[52]*: P. Johnson, *Lysippos* (1968) 239–40. Conservatori athlete *[53]*: Helbig II.1585. Wrestler groups *[55–7]*: Künzl, 49–69; Mansuelli, 61.
Artemision Jockey *[58]*: V.G. Kallipolitis, *AAA* 5 (1972) 419–26; R. Wünsche, *JdI* 94 (1979) 105–7, pottery date (later 2nd to 1st cent. BC). Horse and groom *[59]*: W.H. Schuchhardt, *AntPlast* 17 (1978) 75–97. Bodrum boy *[60]*: C.M. Havelock, *Hellenistic Art* (1971) no. 133; Akurgal-Hirmer, pls. 36, 190–1.
Kyme Runner *[61]*; Akurgal-Hirmer, pls. 37, 227–9. Terme Boxer *[62]*: Helbig III. 2272; Himmelmann, *Herrscher und Athlet*, 150–84.

5. GODS

R.L. Gordon, 'The Real and the Imaginary: Production and Religion in the Graeco-Roman World', *Art History* 2 (1979) 5–34; W. Burkert, *Greek Religion* (1985).
Pergamon Zeus *[63]*: Akurgal-Hirmer, pl. 186; W. Radt, *Pergamon* (1988) 215–6, as Attalos II. Otricoli head *[64]*: Bieber, 180; Helbig I.33. Aigeira Zeus and Melos Poseidon: Ch. 13. Asklepios from Mounychia *[67]*: P. Walters, *AM* 17 (1892) 1–15; Stewart, *Attika*, 48–50; *LIMC* 346. Melos head *[68]*: B. Ashmole, *BSA* 46 (1951) 2–6; *LIMC* 345. Farnese-Andros Hermes *[69]*: Helbig I.246. Sandalbinder *[70]*: B.S. Ridgway, *AJA* 68 (1964) 113–28, dating too late. M. Edip Özgür, *Skulpturen des Museum von Antalya* I (1987) no. 6 – copy from Perge. Leaning Herakles *[71–2]*: D. Krull, *Der*

Herakles vom Typ Farnese (1985). Alba Fucens *[73]*: F. de Visscher, *Heracles Epitrapezios* (1962). Civitavecchia Apollo *[74]*: E. Simon, *JdI* 93 (1978) 224–5; *LIMC* Apollon/Apollo 59. Cyrene *[75]*: *LIMC* Apollon 222. Tralles *[76]*: *LIMC* Apollon 595; Akurgal-Hirmer, pls. 182–3.
Basel Dionysos *[77]*: E. Pochmarski, *AntK* 17 (1972) 73–5 and *Das Bild des Dionysos* (1974); *LIMC* Dionysos 120 (Woburn Abbey type). Athens *[78]*: C. Rolley, *Greek Bronzes* (1986) pl. 178. Heads *[79, 80]*: *LIMC* Dionysos 205 (Delphi), 206 (Thasos). Serapis *[81–2]*: W. Hornbostel, *Serapis* (1973); V. Tran Tamm Tinh, *Sérapis debout* (1983). Eros *[83]*: H. Dohl, *Der Eros des Lysipp* (Diss. Göttingen 1968); *LIMC* Eros 352. Sleeping *[84]*: Richter, *AJA* 47 (1943) 365–78; *LIMC* Eros 780a. Kairos *[85]*: A.F. Stewart, *AJA* 82 (1978) 163–71.

6. GODDESSES AND WOMEN

DRAPED GODDESSES

Piraeus Athena *[86]*: G. Waywell, *BSA* 66 (1971) 373–82; *LIMC* Athena 254. Artemis Leptis-Versailles: *LIMC* Artemis 250–65. Herculaneum *[88–9]*: M. Bieber, *Proc.Amer.Phil.Soc.* 106 (1962) 111–34 and *Ancient Copies* (1977) 148–57.
Isis *[90]*: R.E. Witt, *Isis in the Graeco-Roman World* (1971). Tyche *[91]*: T. Dohrn, *Die Tyche von Antiochia* (1960). Conservatori girl *[92]*: Helbig II.1480. Aphrodite of Aphrodisias *[94]*: F. Squarciapino, in *Aphrodisias de Carie* (Colloq. Lille, 1987) 65–71; *LIMC* Aphrodite (Aphrodisiensis) 1–41. Muses *[95]*: D. Pinkwart, *Das Relief des Archelaos und die Musen des Philiskos* (1965).
Nike of Samothrace *[97]*: A. Conze, *Samothrake* II (1880) 55–88; H. Thiersch, *Nach.Gesell.Göttingen* (1931); J. Charbonneaux, *Hesperia* 21 (1952) 44–6, the r. hand; K. & P.W. Lehmann, *Samothracian Reflections* (1973) 180–99.

APHRODITE

K. Clark, *The Nude* (1956) Ch. 1; Bieber, 19–21; Robertson, 390–4, 548–57; D.M. Brinkerhoff, *Hellenistic Statues of Aphrodite* (1978); W. Neumer-Pfau, *Studien zur Ikonographie und gesellschaftlichen Funktion hellenistischer Aphrodite-Statuen* (1982); H.H. von Prittwitz und Gaffron, *Der Wandel der Aphrodite* (1988).
Knidia *[98]*: C. Blinkenberg, *Knidia* (1933); L. Closuit, *L'Aphrodite de Cnide* (1978); *LIMC* Aphrodite 391. Capitoline *[99]*: Helbig II.1277; B.M. Felletti Maj, *Archeologia Classica* 3 (1951) 33–65; *LIMC* Aphrodite 409. Medici *[100]*: Mansuelli, 45; *LIMC* Aphrodite 419. Troad *[101]*: Giuliano, 81; *LIMC* Aphrodite 422.
Crouching *[102]*: Giuliano, 100. Doidalsas: A. Linfert, *AM* 84 (1969) 158–64. Sandal-binding and Anadyomene *[103]*: *LIMC* Aphrodite 423–54 and 462-74. Arles *[104]*: Ridgway, *AJA* 80 (1976) 147–

54; *LIMC* Aphrodite 526. Capua [*105*]: Hölscher, *AntPlast*. 10 (1970) 67–80; Bieber, *Ancient Copies* (1977) 43–6; *LIMC* Aphrodite 627. Leconfield [*106*]: H.G. Oehler, *Foto + Skulptur* (1980) no. 82. Male sexuality and status of women: K. Dover, *Greek Homosexuality* (1978) and in *Women in the Ancient World: The Arethusa Papers* (1984); S.B. Pomeroy, *Goddesses, Whores, Wives, and Slaves* (1975) ch. 7 and *Women in Hellenistic Egypt* (1984) chs. 1–2; M. Foucault, *History of Sexuality* II–III (1985–6). Pseudo-Lucian on sex: Foucault, III. 211–32.

DRAPED WOMEN

R. Horn, *Stehende weibliche Gewandstatuen* (1931); Bieber, 129–33; A. Linfert, *Kunstzentren hellenistischer Zeit* (1976).
Ackland head [*109*]: Smith, *HRP* no. 42. Lady from Sea [*108*]: Ridgway, *AJA* 71 (1967) 329–34; Robertson, 480.
Antium [*110*]: Helbig III.2270; H. Lauter, *AM* 86 (1971) 147–61; A. Borbein, *JdI* 88 (1973) 134–7; Giuliano, 121. Kos [*112*]: R. Kabus-Preisshofen, *Die hellenistische Plastik der Insel Kos* (1989) no. 56. Kleopatra and Diodora [*113, 114*]: J. Marcadé, *Au Musée de Délos* (1969) 131–4, pl. 66. Fethiye [*115*]: R. Özgan, *Marb.Winck.Prog.* (1979) 39–45; H. Rühfel, *Das Kind in der griechischen Kunst* (1984).
Magnesia [*116*]: Pinkwart, *AntPlast* 12 (1973) 149–58; F. Coarelli, in *Epigrafie e ordine senatorio* I.4 (1981) 439, for *c.* 100, instead of 63 BC. Tanagras [*117*]: G. Kleiner, *Tanagrafiguren* (1942); R. Higgins, *Greek Terracottas* (1967) 96–133 and *Tanagra and the Figurines* (1986).

7. BAROQUE GROUPS: GAULS AND HEROES

Bieber, 73–82; Robertson, 527–46; Pollitt, chs. 4–5.

GAULS

Large Gauls [*118–22*]: A. Schober, *JdI* 53 (1938) 126–49; E. Künzl, *Die Kelten des Epigonos* (1971); R. Wenning, *Die Galateanatheme Attalos I* (1978); F. Coarelli, in *I Galli e l'Italia* (1978) 231–58; M. Mattei, *Il Galata Capitolino* (1987). Small Gauls [*123–32*]: Stewart, *Attika* 19–23; B. Palma, *Xenia* 1–2 (1981) 45–84.

HEROES

Pasquino [*133*]: B. Schweitzer, *Die Antike* 14 (1938) 43–72; B. Andreae, *AntPlast* 14 (1974) 87–95; A. Nitsche, *AA* (1981) 76–85, on date. Penthesilea [*134*]: G. Lugli, *Boll.d'Arte* 6 (1926–7) 193–217 and ibid 9 (1920–30) 207–225; E. Berger, *Gestalt und Geschichte: Fest. K. Schefold* (1967) 61–5.
Marsyas [*135*]: G. Lippold, *JdI* 70 (1955) 81–4; R. Fleischer, *ÖJh* 50 (1972–75) Beibl. 103–22; A.H. Borbein, *Marb.Winck.Prog.* (1973) 37–52; H.

Meyer, *Der weisse und der rote Marsyas* (1987). Daidalos [*137*]: J. Iliffe, *Studies D.M. Robinson* I (1951) 705–12; H. Möbius, *JdI* 68 (1953) 96–101. Antaios [*138*]: H. Möbius, *AntPlast* 10 (1970) 39–47. Artemis & Iphigenia [*139*]: F. Studniczka, *Abh. Sächs.Akad.* 37.5 (1926); Bieber, 77–8; *LIMC* Artemis/Diana 337 (E. Simon); B. Freyer-Schauenberg, in *Fest. E. Akurgal* (forthcoming), coloured fragments from Samos. Niobids [*140*]: Mansuelli, 70–82; A.F. Stewart, *Skopas* (1977) 118–20; W.A. Geominy, *Die Florentiner Niobiden* (1984). Farnese Bull [*142*]: Robertson, 608; C. Börker, *ZPE* 64 (1986) 41–9, on the sculptors; V. Lambrounidakis, *Fest. N. Himmelmann* (1989) 341–50, a new cuirass relief from Naxos.
Laocoön [*143*]: F. Magi, *Pontificia Accademia Romana di Archeologia: Memorie* 9 (1960); P.H. von Blanckenhagen, *AA* (1969) 256–75; E. Simon, *AA* (1984) 643–72; E.E. Rice, *BSA* 81 (1986) 233–50; B. Andreae, *Laokoon und die Gründung Roms* (1988). Sperlonga [*144–7*]: B. Conticello, B. Andreae, *AntPlast* 14 (1974); P.H. von Blanckenhagen, *AJA* 77 (1973) 456–60 and *AJA* 80 (1976) 99–104; A.F. Stewart, *JRS* 67 (1977) 76–90.

8. THE WORLD OF DIONYSOS

W. Klein, *Vom antiken Rokoko* (1921); Bieber, ch. 10; Pollitt, ch. 6.
Dionysian religion: E.R. Dodds, *The Greeks and the Irrational* (1971) 270–82; P.M. Fraser, *Ptolemaic Alexandria* (1972) 201–6. Athenaeus: E.E. Rice, *The Grand Procession of Ptolemy Philadelphus* (1983).

SATYRS AND CENTAURS

Leaning satyr [*148*]: Helbig II.1429; P. Gercke, *Die Satyrn des Praxiteles* (1968). Silenos with Dionysos [*149*]: Lippold, 282; Künzl, 23–5; *LIMC* Dionysos 688. Borghese Satyr [*150*]: Helbig II.1995. Nikomedia bronze [*151*]: H. Philipp, *AA* (1987) 131–43. Fauno Rosso [*152*]: Helbig II.1420. Satyr with Dionysos [*154*]: K.T. Erim, *Mélanges A.M. Mansel* (1974) 767–75; *LIMC* Dionysos 693a. Dresden Maenad: Stewart, *Skopas*, 91–3. Fluteplayer [*155*]: K. Schapiro, *AJA* 92 (1988) 509–27. Invitation group [*157*]: W. Klein, *Zeit.bild.Kunst* 20 (1909) 101–8; Mansuelli, 51–2. Satyr and nymph [*158*]: Helbig II.1716. Satyr and Hermaphrodite [*159*]: Bieber, 146–7. Pan and Daphnis [*160*]: Mansuelli, 101 (Uffizi); Haskell-Penny, no. 70 (Terme).
Centaurs [*161–3*]: Helbig II.1398; Blanckenhagen, *Monsters and Demons: Papers E. Porada* (1987) 86–7. Conservatori head [*164*]: Helbig II.1483. Belvedere Torso [*165*]: R. Carpenter, *MAAR* 18 (1941) 84–91; A. Andren, *Opusc.Arch.* 7 (1952) 1–45; Helbig I.245; G. Säflund, *Opusc.Rom.* 11 (1976) 63–84; W. Raeck, *JdI* 103 (1988) 155–67. Gaddi Torso [*166*]: Mansuelli, 126.

Barberini Faun *[168]*: *Burlington* 114 (1972) 435, restored leg; Robertson, 534–5; Blanckenhagen, *Wandlungen: Studien E. Homann-Wedeking* (1975) 193–201; Haskell-Penny, no. 33. Hermaphrodite *[169]*: Giuliano, no. 89. Ariadne painting: J. Charbonneaux, *Hellenistic Art* (1973) fig. 147.

GENRE

N. Himmelmann, *Über Hirten-Genre in der antiken Kunst* (1980); H.P. Laubscher, *Fischer und Landlaute: Studien zur hellenistischen Genreplastik* (1982); E. Bayer, *Fischerbilder in der hellenistischen Plastik* (1983); Pollitt, 241–6; P. Zanker, *Die Trunkene Alte: Das Lachen der Verhöhnten* (1989).
Goose-strangler *[170]*: Künzl, 77–81. Spinario *[171]*: P. Zanker, *Klass.Statuen* (1974) 71–83. Grotesques: L. Giuliani, *AA* (1987) 701–21. Biter *[173]*: A. Herrmann, *Studies P.H. von Blanckenhagen* (1979) 163–73. Drunk Old Woman *[174]*: Zanker, *Die Trunkene Alte*. New York Market Woman *[175]*: Richter, *Cat..Greek Sculptures* (1954) no. 221; Laubscher, no. 38. Conservatori fisherman *[178]*: Helbig II.1479; Laubscher, no. 3. Seneca fisherman *[179]*: Laubscher, no. 1.
Setting for sculpture: Ridgway, *Hesperia* 40 (1971) 336–56; Lauter, *AntK* 15 (1972) 49–58. Herodas: A. Bulloch, *Camb.Hist.Classical Lit.* I (1985) 611–13.

9. PERGAMON AND THE GREAT ALTAR

A. Schober, *Die Kunst von Pergamon* (1951); E.V. Hansen, *The Attalids of Pergamon* (1971); *Pergamon Ausstellung* (Ingelheim am Rhein, 1972); H.-J. Schalles, *Untersuchungen zur Kulturpolitik der pergamenischer Herrscher im 3 Jhd.v.Chr.* (1985); W. Radt, *Pergamon: Geschichte und Bauten* (1988).

STATUES

Inscribed bases: H. Fraenkel, *AvP* VIII.1 (1890). All sculptures in F. Winter, *AvP* VII (1908), except the following. 'Wild Man' *[189]*: *AA* (1966) 466–7; E. Künzl, *Arch.Korrespondenzblatt* 6 (1976) 35–7, Marsyas. Elaia torso *[190]*: *JHS* 11 (1891) 192. Centaurs *[192]*: J. Schäfer, *Pergamenische Forschungen* I (1972) 164–92.

GREAT ALTAR AND GIGANTOMACHY

H. Winnfeld, *AvP* III.2 (1910); H. Kähler, *Der grosse Fries von Pergamon* (1948); E.M. Schmidt, *Der grosse Altar zu Pergamon* (1961); E. Simon, *Pergamon und Hesiod* (1975); M. Pfanner, *AA* (1979) 46–57; Robertson, 537–41; E. Rhode, *Pergamon: Burgberg und Altar* (1982); Pollitt, 97–110; H.-J. Schalles, *Der Pergamonaltar: Zwischen Bewertung und Verwertbarkeit* (1986).
Pottery date: P. Callaghan, *Bull.Inst.Class.Studies* 28 (1981) 115–21. Dedication *[194]*: *AvP* VIII. 69. Signatures: *AvP* VIII.70–85. Additions to frieze: H. Luschey, *Funde zu dem grossen Fries von Pergamon*

(1962), head of Aphrodite; D. Haynes, *Jhb.Berliner Museen* 5 (1963) 1–13, Worksop giant, and *AA* (1972) 737–42, Fawley Court giant; W. Radt, *AA* (1981) 583–96, Istanbul Alexander(?); M. Vickers, *AJA* 89 (1985) 516–9, speculative thunderbolt. Giants' names: *AvP* VIII. 112–28. Erinyes: M. Fuchs, *JdI* 99 (1984) 215–53.
Telephos Frieze: H. Schrader, *JdI* 15 (1900) 97–135; K. Stähler, *Das Unklassische im Telephosfries* (1966); Hansen, 338–47; Pollitt, 198–205; H. von Hesberg, *JdI* 103 (1988) 342–3, 355–7; H. Froning, *JdI* 103 (1988) 174–7.

10. RELIEFS: FRIEZES AND STELAI

ARCHITECTURAL

R. Demangel, *La frise ionique* (1932) 326 ff; S. Şahin, *Die Entwicklung der griechischen Monumentalältare* (1972); H. Lauter, *Die Architektur des Hellenismus* (1986).
Lysikrates *[200]*: *Inscr.Graec.* II².3042; J. Stuart, N. Revett, *The Antiquities of Athens* I (1762) 27–34; J. Travlos, *Pictorial Dictionary of Ancient Athens* (1971) 348. Ilion *[201]*: B.M. Holden, *The Metopes of the Temple of Athena at Ilion* (1964). Priene coffers *[202]*: J.C. Carter, *The Sculpture from the Sanctuary of Athena Polias at Priene* (1983) 44–180. Belevi *[203]*: C. Praschniker et al, *Forsch.Ephesos* VI (1979). Tarentum *[204]*: J.C. Carter, *The Sculpture of Taras* (1975).
Hermogenes: Vitruvius, 3.2.6 and 8; 4.3.1; 7 praef 12. Magnesia *[205]*: A. Yaylali, *Der Fries des Artemisions von Magnesia* (1976); A. Davesne, *La Frise du tempe d'Artemis à Magnesie* (1982). Teos *[206]*: W. Hahland, *ÖJh* 38 (1950) 66–109. Lagina *[207]*: A. Schober, *Der Fries des Hekateion von Lagina* (1933); U. Junghölter, *Zur Komposition der Lagina Fries* (1989).
Ephesos Gallic frieze *[208]*: W. Oberleitner, *Jhb.Kunstsammlungen Wien* 77 (1981) 57–104. Delphi *[209]*: H. Kähler, *Der Fries vom Reiterdenkmal des Aemilius Paullus* (1965); O. von Vacano, *Bathron: Fest. H. Drerup* (1988) 375–86. Samothrace *[210]*: P.W. Lehmann, *Samothrace* III.1 (1969) 237–387, Hieron, and *ibid* V (1982) 148–266, temenos propylon; cf. M.A. Zagdoun, *La sculpture archaisante* (1989) 163–5.

VOTIVE RELIEFS

F.T. van Straten, *BABesch* 49 (1974) 159–89 and *BABesch* 51 (1976) 1–27; G. Neumann, *Probleme des griechischen Weihreliefs* (1979); C. Edwards, *Greek Votive Reliefs to Pan and the Nymphs* (Diss. New York 1985) ch. 3. Lakreitides *[215]*: *LIMC* s.v. Eubouleus 2. Archelaos *[216]*: D. Pinkwart, *Das Relief des Archelaos* (1965).

GRAVE RELIEFS

E. Pfuhl, H. Möbius, *Die ostgriechischen Grabreliefs*

I–II (1977–79), essential; G.M.A. Hanfmann, *From Croesus to Constantine* (1975) 59–62; P. Zanker, in *Images and Ideologies: Self-Definition in the Hellenistic World* (Berkeley, forthcoming) – case-study of Smyrna. Menophila *[222]*: Pfuhl-Möbius, no. 418; N. Ramage, *Sculpture from Sardis* (1977) no. 245.

ALEXANDER SARCOPHAGUS

K. Schefold, *Der Alexander-Sarkophag* (1968); V. von Graeve, *Der Alexandersarkophag* (1970); T. Hölscher, *Griechische Historienbilder* (1973) 189–96; Robertson, 481–2.

11. THE PTOLEMIES AND ALEXANDRIA

P.M. Fraser, *Ptolemaic Alexandria* (1972); H. Maehler, V.M. Strocka (eds), *Das ptolemäische Ägypten* (1978); A.K. Bowman, *Egypt after the Pharaohs* (1986); R.S. Bianchi, et al, *Cleopatra's Egypt: Age of the Ptolemies* (Exhib. Brooklyn, 1988). Sculpture at Alexandria: A.W. Lawrence, *Journal of Egyptian Archaeology* 11 (1925) 179–90; A. Adriani, *Testimonianze e monumenti di scultura alessandrina* (1948) and *Repertorio d'arte dell' egitto greco-romano* A II (1961); Bieber, ch. 6; Pollitt; ch. 12.
Ptolemy II's Procession: E.E. Rice, *The Grand Procession* (1983). The Pavilion: F. Studnizcka, *Das Symposion Ptolemaios II* (1914). Ptolemy IV's Yacht: F. Caspari, *JdI* 31 (1916) 1–24.
Serapeion group *[227]*: H. Kyrieleis, *Stele: Fest.N. Kontoleontos* (1981) 383–7. Gizeh Gaul *[229]*: G. Grimm, *Kunst der Ptolemäer und Römerzeit im Ägyptischen Museum Kairo* (1975) no. 7.
Royal portraits *[230–48]*: H. Kyrieleis, *Bildnisse der Ptolemäer* (1975); Smith, *HRP* ch. 9, cat. 46–82. Late Ptolemies *[241–6]*: K. Parlasca, *JdI* 82 (1967) 167–94; R. Smith, *GettyMusJ* 14 (1986) 64–78. Kleopatra coins *[247–8]*: H.R. Baldus, *Jhb Numismatik und Geldgeschichte* 23 (1973) 18–43.
Small Alexanders *[249]*: K. Gebauer, *AM* 63–4 (1938–9) 1–106. Small Aphrodites *[252]*: Adriani, *Repertorio* A II (1961) nos. 73–111. Alexandrian terracottas *[253]*: R.A. Higgins, *Greek Terracottas* (1967) 129–33 and 157; N. Himmelmann, *Proc. Brit.Acad.* 67 (1981) 193–207.
Egyptian hardstone sculpture *[254–5]*: B. Bothmer, *Egyptian Sculpture of the Late Period* (1960); A. Adriani, *RM* 77 (1970) 72–109. Cyprus *[256–8]*: J.B. Connelly, *Votive Sculpture of Hellenistic Cyprus* (1988).

12. THE SELEUCIDS AND THE EAST

W.W. Tarn, *Greeks in Bactria and India* (3rd ed. F.L. Holt, 1984); A.K. Narain, *The Indo-Greeks* (1957); D. Schlumberger, *L'orient hellenisé* (1970).

ANTIOCH AND SYRIA

Statues on coins: L. Lacroix, *Les réproductions des statues sur les monnaies grecques* (1949). Marsyas and Daidalos groups: Ch. 7. Antakya heads *[261–2]*: A. Houghton, *AntK* 27 (1984) 123–8 and *AntK* 29 (1986) 52–611; E. La Rocca, *BullComm* 90.1 (1985) 26–35; Smith, *HRP* nos. 93–4. Berlin Antiochos IV *[263]*: H. Kyrieleis, *Ein Bildnis Antiochos IV* (1980). Skythopolis head *[264]*: R. Wenning, *Boreas* 6 (1983) 108–11.

BACTRIA AND AI KHANOUM

Bactrian coins *[265–6]*: C. Kraay, N. Davis, *The Hellenistic Kingdoms: Portrait Coins and History* (1973) figs. 129–79; M. Mitchiner, *Indo-Greek and Indo-Scythian Coinage* (1975) I.
Ai Khanoum *[267–73]*: P. Bernard, *Proc.Brit.Acad.* 53 (1967) 71–95 and annual reports in *Compt. Rend.Acad.Inscr.* 1965–1980; *Fouilles d'Ai Khanoum* I– (1973–); F.R. Allchin, N. Hammond (eds), *The Archaeology of Afghanistan* (1977) ch. 4.
Oxus sanctuary: B.A. Litvinskiy, I.R. Pichikiyan, *Journal of the Royal Asiatic Society* (1981) 133–67. Shami *[274–5]*: A. Stein, *Old Routes of Western Iran* (1940) 130–34, 141–59. Failaka–Ikaros *[276–8]*: H. Mathiesen, *Ikaros: The Hellenistic Settlements I: The Terracotta Figurines* (1982). Seleucia: W. van Ingen, *Figurines from Seleucia on the Tigris* (1939). Bronze Herakles: *International Magazine of Arab Culture* 4 (1985) 36; *LIMC* Herakles 731. Parthians *[279–81]*: M.A.R. Colledge, *Parthian Art* (1977).
Kommagene *[282–3]*: K. Humann, O. Puchstein, *Reisen in Kleinasien und Nordsyrien* (1890) 209–372; J.H. Young, in F.K. Dörner, T. Goell, *Arsameia am Nymphaios* I (1963) 197–227 and *AJA* 68 (1974) 29–34; W. Hoepfner, *Arsameia am Nymphaios* II (1983). Antiochos' inscriptions: H. Waldmann, *Die kommagenischen Kultreformen . . Antiochos I* (1973), with English translation, F.C. Grant, *Hellenistic Religions* (1953) 20–5.

13. MACEDONIA AND GREECE

MACEDONIA

N.G.L. Hammond, G.T. Griffith, *A History of Macedonia* I–III (1972–88); *The Search for Alexander* (Exhib.Cat. 1980); B. Barr-Sharrar, E.N. Borza (eds), *Macedonia and Greece in Late Classical and Hellenistic Times* (*Stud.Hist.Art:* Washington 10, 1982).
Pella *[288–90]*: M. Andronicos, *The Greek Museums: Pella Museum* (1975); *Search* Cat. 147–155. Vergina *[291–2]*: M. Andronicos, *Vergina: The Royal Tombs* (1984). Leucadia ivories: K. Rhomioupoulou, *AAA* 6.1 (1973) 87–92. Grave reliefs: *Search* Cat. 49–50; E. Voutiras, *Fest. N. Himmelmann* (1989) 355–60.

ATHENS

W.S. Ferguson, *Hellenistic Athens* (1911); G. Becatti, *Rivista di Archeologia* 7 (1940) 7–116 =

Kosmos: *Studi sul mondo classico* (1987) 305–414; Stewart, *Attika*, 34–55.
Philosophers: Ch. 3. Antikythera philosopher *[298]*: P.C. Bol, *Die Skulpturen..Antikythera* (1972) 24–27. Delphi *[295]*: Lullies-Hirmer, pl. 249. Rhamnous *[296]*: Lullies-Hirmer, pl. 244; E.B. Harrison, *Fest. F. Brommer* (1977) 157. Thrasyllos *[297]*: Travlos, *Pict.Dict..Athens* (1971) 562–5; *LIMC* Dionysos 147.

THE PELOPONNESE AND DAMOPHON

Aigeira Zeus *[299]*: O. Walter, *ÖJh* 19–20 (1919) 1–14 and *ÖJh* 27 (1932) 146–52, the arm. Pheneos head *[300]*: *BCH* 83 (1959) 625; *AJA* 63 (1959) 280–1; E. Protonotariou, *Arch.Delt.* 17 B (1961–2) 57–61. Damophon and Lykosoura *[301]*: G. Dickins, *BSA* 12 (1905–6) 109–36 and *BSA* 13 (1906–7) 357–84; C. Habicht, *Pausanias' Guide to Ancient Greece* (1985) 36–57. Messene head *[302]*: A.K. Orlandos, *Praktika* 1962 (1966) 99–101; G. Despinis, *AA* (1966) 378–85.

THE ISLANDS

Rhodes *[303]*: G. Merker, *The Hellenistic Sculpture of Rhodes* (1973). Melos Poseidon *[304]*: G. Schäfer, *AntPlast* 8 (1968) 55–67. Melos Aphrodite *[305]*: A. Furtwängler, *Masterpieces of Greek Sculpture* (1895) 367–401; A. Pasquier, *La Vénus de Milo* (1985); *LIMC* Aphrodite 643.
Thasos: P. Devambez, *Mon.Piot* 38 (1941) 93–116; P. Bernard, F. Salviat, *BCH* 83 (1959) 288–335; *Guide de Thasos* (1968) 130–7. Kos *[307–8, 311]*: R. Kabus-Preisshofen, *Die hellenistische Plastik der Insel Kos* (1989). Delos *[309–10, 312–14]*: J. Marcadé, *Au Musée de Délos* (1969).

14. LATE HELLENISTIC: DELOS TO ROME

E.S. Gruen, *The Hellenistic World and the Coming of Rome* (1984); M. Beard, M. Crawford, *Rome in the Late Republic* (1985).

PORTRAITS AND DELOS

P. Zanker, in *Hellenismus in Mittelitalien* (1976) II, 581–609; Smith, *HRP* ch. 13. Delos *[315–18]*: C. Michalowski, *Les portraits hellénistiques et romains* (*Délos* XIII, 1932). Rome *[319–20]*: B. Schweitzer, *Die Bildniskunst der römischen Republik* (1948), w. review, P.H. von Blanckenhagen, *Gnomon* 22 (1950) 321–35; L. Giuliani, *Bildnis und Botschaft* (1986), w. review, R. Smith, *Gnomon* 103 (1988) 761–3.
Philorhomaioi *[321–2]*: Smith, *HRP* 130–2. Add head in Adana *[323]*: R. Özgan, *JdI* 103 (1988) 367–80. Pasparos(?) *[324]*: G. Hübner, *AvP* XV.1 (1986) 127–45, with C.P. Jones, *Chiron* 4 (1974) 183–205, for chronology. Other heads from Greek East: G. Hafner, *Späthellenistische Bildnisplastik* (1954). Athens *[326]*: E.B. Harrison, *Agora* I (1954) no. 3.

Smyrna *[327]*: L. Laurenzi, *Ritratti greci* (1941) nos. 90–2.

COPIES AND NEO-CLASSICISM AT ROME

Hellenistic sculptors in Rome: G. Richter, *Three Critical Periods in Greek Sculpture* (1951) ch. 3; F. Coarelli, *Dial.d'Arch.* 2 (1968) 302–68, *Stud.Misc.* 15 (1970) 77–83, and *Dial.d'Arch.* 4–5 (1970–1) 241–65; Pollitt, ch. 7.
Cult statues: H.G. Martin, *Römische Tempelkultbilder* (1987). Villa sculpture and copies: see bibliog. Ch. 1. Hellenistic 'copying': M. Gernand, *AM* 90 (1975) 1–47; J.P. Niemeier, *Kopien und Nachahmungen im Hellenismus* (1985).
Shipwrecks: W. Fuchs, *Der Schiffsfund von Mahdia* (1963); P.C. Bol, *Die Skulpturen des Schiffsfundes von Antikythera* (1972). Cicero: Neudecker, 8–18. Pasitelean *[330–1]*: M. Borda, *La scuola di Pasitele* (1953); Zanker, *Klass.Stat.* 49–68; E. Simon, *JdI* 102 (1987) 291–304; K. Tancke, K. Yfantidis, *AA* (1989) 243–9. Neo-Attic: W. Fuchs, *Die Vorbilder der neuattischen Reliefs* (1959) and *Enc.Art.Ant.* s.v. 'neoatticismo'; H. Froning, *Marmor-Schmuckreliefs..im 1 Jh.v.Chr.* (1981). Marble bric-à-brac: H.U. Cain, *Römische Marmorkandelaber* (1985).

15. CONCLUSION: CHRONOLOGY

Development: cf. M. Robertson, *Between Archaeology and Art-History* (1963). Chronology: cf. Pfuhl-Möbius, 42–4; Pollitt, App I, 265–71; B. Andreae, *Fest.N. Himmelmann* (1989) 237–44, an optimistic list of 50 dated sculptures.

SCULPTURE UNDER THE EMPIRE: ROME

Three Rhodians: above Ch. 7. Trajanic Frieze: A.M. Touati, *The Great Trajanic Frieze* (1987). Portraits *[333]*: V. Poulsen, *Les portraits romains* II (1974) no. 60; K. Fittschen, P. Zanker, *Kat. der römischen Porträts in den Capitolinischen Museen* I, III (1983–5). Sarcophagi: H. Sichtermann, G. Koch, *Römische Sarkophage* (1982). Dionysian *[332]*: F. Matz, *Die Dionysischen Sarkophage: Die antiken Sarkophagreliefs* IV.2 (1975) no. 159.

SCULPTURE UNDER THE EMPIRE: THE GREEK EAST

C.C. Vermeule, *Roman Imperial Art in Greece and Asia Minor* (1968); G.M.A. Hanfmann, *From Croesus to Constantine* (1975) chs. 3–4.
Herodes *[334]*: Richter, *POG* 186. Aphrodisias *[335–6]*: M.F. Squarciapino, *La scuola di Afrodisia* (1943) and *Archeologia Classica* 35 (1983) 74–87; K.T. Erim, *Aphrodisias: City of Venus-Aphrodite* (1986). Ephesos: W. Oberleitner, *Funde aus Ephesos* (1978). Side: J. Inan, *Roman Sculpture from Side* (1975). Portraits: J. Inan, E. Alföldi-Rosenbaum, *Roman and Early Byzantine Portrait Sculpture in Asia Minor* (1966) and *Römische und frühbyzantinische Porträtplastik aus der Türkei: Neue Funde* (1979).

ACKNOWLEDGEMENTS

The publisher and author are grateful to the museums and collections named in many of the captions for photographs and permission to use them. Other important sources of illustration have been:

Alinari 23, 26, 28, 36, 38, 140, 150, 152, 156, 157.2, 157.4, 160–161, 169.1, 330, 331
American Numismatic Society, New York 231–232, 259–260, 279–280, 284–285, 321
American School of Classical Studies at Athens, Agora Excavations 326
Austrian Excavations, Ephesos 203
Cabinet des Médailles, Paris 266
Department of Coins and Medals, British Museum 265, 322
Danish Excavations, Failaka 276–278
Fitzwilliam Museum, Cambridge 248
French Archaeological Delegation in Afghanistan 267–273
French School, Athens 80, 114, 209, 212, 295, 301.2–3, 308–316
German Archaeological Institute, Athens 8, 20, 44.2, 45–46, 58–59, 67, 79, 112, 215, 218–219, 225, 296, 302, 317–318, 327.1–2
German Archaeological Institute, Cairo 82, 90, 227.2–3, 228, 229.1–2, 237–238, 245–246, 251–252
German Archaeological Institute, Istanbul 63, 76, 93, 108, 115–116, 151, 182, 187, 189, 192.1–2, 207.1–2, 211, 222, 224, 324
German Archaeological Institute, Rome 3, 4, 10–17, 32, 35, 43, 47, 50, 55, 57, 64, 74, 85, 87, 95, 101, 107, 123–124, 130–132, 136, 138, 145.1–2, 146.1–3, 147.2–3, 158, 166–167, 169.2, 178–179, 319
Giraudon 33.2
Hirmer Verlag 51, 53–54, 62, 65, 83, 86, 92, 96–97, 99, 102, 110, 113, 118–119, 143, 165, 170, 286–287, 298, 303, 305–307, 328
Marburg 299
Research Archive for Roman Sculpture, Cologne 106
Sotheby's, New York 241
TAPA, Athens 291–292

E. Berger 134.1
B.V. Bothmer 254, 325
M.A.R. Colledge 275
J.C. Carter 204
M.A. Dögenci 336
T. Goell 282
A. Houghton 262.1–2
R. Özgan 323.1–2
J. Wagner 283
Author 22, 30, 69, 73, 81, 154, 205–206, 253, 261, 329, 335

In addition to the scholars named above, the author would like to thank P. Bernard, J. Connelly, L. Hannestad, and H.E. Mathiesen for their help in providing illustrations, and especially K.T. Erim for kindly allowing the inclusion of several unpublished sculptures from Aphrodisias.

For correcting and improving this work at all stages, the author is much indebted to S. dell'Isola, N. Thompson, and K. Welch.

INDEX OF ILLUSTRATIONS

Italic figures refer to illustration numbers